GRANTS
for the
ARTS

GRANTS
for the
ARTS

Virginia P. White

PLENUM PRESS
NEW YORK AND LONDON

Library of Congress Cataloging in Publication Data

White, Virginia P.
 Grants for the arts.

 Includes index.
 1. Arts—Scholarships, fellowships, etc.—United States. 2. Art
patronage—United States. I. Title.
NX398.W46 338.4'7'700973 679-18043
ISBN 0-306-40270-X

©1980 Plenum Press, New York
A Division of Plenum Publishing Corporation
227 West 17th Street, New York, N.Y. 10011

To Charles, my son

Preface

The way Americans view the arts and the artist has undergone a radical transformation in the past few years. Up until very recently, we tended to accept Gustave Flaubert's satirical definition of "artist" given in the *Dictionnaire des Idées Reçues,* an anthology of the clichés, platitudes, and "accepted ideas" of late nineteenth century France. The entry under "Artist" reads: "All charlatans. Praise their disinterestedness (*old-fashioned*). Express surprise that they dress like everyone else (*old-fashioned*). They earn huge sums and squander them. Often asked to dine out. Woman artist necessarily a whore. What artists do cannot be called work."[1]

Our definition of the artist changed as we began to learn more about what the artist does and to better understand what art means in our lives. In the past ten years, arts has become one of the major areas supported by private philanthropy and has gained in significance throughout all levels of government.

We lost faith in our ability to create a Great Society at the end of the 1960s, and our belief that advances in science and technology would automatically bring about a better world was eroding fast. Beating the rest of our planet to the moon and pouring money into the burned out, destitute, and crime-infested inner cities had not changed anything; foreign aid had not won friends or influenced anybody very much.

Along with this disillusion came a marked change in patterns

[1] Gustave Flaubert, *The Dictionary of Accepted Ideas,* translated by Jacques Barzun. New York: New Directions Publishing Corporation, 1967.

of philanthropy in both the public and private sectors. Government support for basic research fell off, and concern for the environment deepened. Private organizations began to turn away from international programs upon which they had pinned such high hopes in the first decade following World War II. Even education, the importance of which had never been questioned, lost some of its magical power to gain support with promises of new and better techniques. Social programs were viewed with cynicism, and grantmaking agencies and organizations began to insist that all applications include an item called *evaluation*—a measure to prove that something had been done with the monies made available. A mood of frustration and sadness slowly spread throughout that portion of our society that engages in activities which can best be supported through some kind of grantmaking mechanism—nonprofit educational, social, and welfare organizations.

But, Lo! Suddenly a light appeared—not a great light as on the first day of creation. In the beginning, it was only a tiny pin-point, but it has grown steadily. That light is the "arts." The arts have pervaded American society in a way that almost no one ever believed possible. Who would ever have thought that museum attendance in this country would outdraw sports events? That there would be an international ballet festival in Jackson, Mississippi? Who would have guessed a few years ago that today one of the two places in the world where it is possible to hear Wagner's complete "The Ring of the Nibelung" annually would be Seattle, Washington?

More people in the United States (49%) attend art shows, museums, and crafts shows than attend sports events (47%), and the survey which revealed these figures also indicated that 93% of Americans consider cultural resources important to the quality of life.

We have become a nation of art lovers, and this is reflected in the direction of all grantmaking organizations; support for the arts has increased remarkably during the past 10 years—more than any other field with the possible exception of those related to energy resources.

Foundations led the way as they often do, exercising their relative freedom to venture out of the mainstream, a freedom not enjoyed by governments answerable to a voting constituency or by corporations with a wary eye on their usually conservative shareholders. As government and corporate support for the arts has

mounted, foundations have pulled back, but their contribution in pointing the way was remarkable.

Government support, beginning with the federal level and going all the way down to cities and counties, has increased by leaps and bounds and is still growing, especially at the state and community level. Corporations increased their support of the arts elevenfold in the 11 years between 1967 and 1978 and the upswing continues.

As might have been expected, this increase in the volume of arts support has been accompanied by an increase in competition for the available funds and along with that has come the need for a more professional approach in finding sponsors for arts activities.

The techniques used in seeking support for the arts have their own unique aspects, but the fundamental essential is the same as for grantseeking in all fields, and that is *information*. It is impossible to conduct a well-planned search for grants without knowing how to go about identifying potential funding sources, how to manage the informal negotiations preceding the submission of an application, and, finally, how to prepare the written application.

This book is designed to provide basic information on all aspects of seeking financial assistance for all the arts as well as those fields closely related to the arts.

In attempting to define what should be included in "the arts," one recognizes immediately that there is no consensus. There is general understanding that painting, sculpture, music, drama, literature, and some creative pursuits associated directly with these fields are "arts," but when it comes to those activities spawned by modern technology such as film and video making, or with those that hark back to cottage-industry productions, which we call crafts, uncertainty arises.

In recognition of the fact that dissemination of the arts has been advanced and accelerated through film and video, those fields have been included. The crafts, historic preservation, and other activities that may be considered peripheral to the arts are also included.

In the preparation of this book, I have been assisted by many people in various ways. Some of them talked with me extensively about their experiences in arts funding; others furnished essential data and information; a few read portions of the manuscript and made corrections and helpful comments. All of them were courteous, tolerant, and patient including those to whom I addressed questions

that betrayed a woeful ignorance. It would be impossible to name everyone who gave me assistance in some form, but I will mention a few as an expression of my deep gratitude.

For sharing with me detailed information from their own experiences and/or reviewing portions of the manuscript: W. McNeil Lowry, Robert Mayer, Roger Kennedy, Lonna Jones, Carol Kurzig, Stephen Benedict, Alvin H. ("Skip") Reiss, and Marilyn Goucher.

For research assistance on specific subjects and other help in various forms, listed alphabetically and not ranked by magnitude of the contribution: Harold ("Bud") Arberg, Joanna Barnes, Marjory Bassett, Livingston Biddle, Gideon Chagy, Paul Ebert, Eduardo Garcia, Mary Esther Gaulden, Wayne Karmosky, Mary Keil, Peggy Kenas, Cindy Lyle, Robert McFarland, Granville Meader, Judith Murphy, Frederic Papert, Janice Robbins, Molly Scoville, Clifford Snyder, William Conrad Struna, LuRaye Tate, Fannie Taylor, Ellen Thurston, and Catherine Ungaro.

Special thanks to Patrick Tarantino, with whom I discussed every portion of the book from first concept to final product. He made excellent suggestions, assisted with research, and cheered me on when I was discouraged. Mr. Tarantino also reviewed the completed manuscript, and the final work reflects his constructive criticism.

Ina Greenfield provided invaluable research assistance as well as constructive suggestions and encouragement, particularly in the final stages.

Karla Voth was most helpful with research in the early stages.

Muriel Bennett typed the final manuscript.

This book would have been impossible without the support of the Plenum Publishing Corporation, and I am deeply grateful to all members of the staff who contributed to its realization: Frank Columbus, the staff member with whom I was most closely associated, was supportive at every stage, encouraging, and unflagging in his confidence. Harvey Graveline and his colleagues, who had the thankless task of turning a messy manuscript into a presentable publication, have done a superb job retaining their calm even under the pressure of "author's nerves."

Finally, the two people who are most responsible for this book—without them, I would never have written the first book, and without that, this one would never have seen the light of day. For their

faith in me, my most grateful thanks to Alexander Hollaender and Robert Ubell.

VIRGINIA P. WHITE

December, 1979
New York, New York

Contents

Artists and Patrons

Human love of exercising creative skills is now known to have begun further back in the evolutionary chain than previously had been believed. The image- and symbol-making drives are recognized as having existed from the first emergence of what we know as "modern man." Paintings and sculpture found in caves dating from the first ascendancy of *Homo sapiens* in late Paleolithic times reveal that the human concerns expressed in visual symbols were already established in man's consciousness: birth, fertility, death, what occurs after death, and the ritualization of these events and ideas.

Beautiful ivory "Venus figures," female forms, found in France, Austria, and the Ukraine, date from about 28,000 B.C., and fired clay figures of that same time have turned up in Czechoslovakia. Flutes found in Russia and in France, with six holes—four above and two below—document the knowledge of true, tonal music perhaps 30,000 years ago. And a six-piece orchestra of equal age was found in one cave at the Ukrainian site of Mezin, where mammoth and reindeer hunters of the Upper Dnieper river system lived in permafrost regions of the steppes, built mammoth-bone huts, burned mammoth bones for warmth, and carved mammoth-ivory female images. The musical instruments were also made from mammoth bones, each with a different tone, indicating a specialization among musicians and an importance for the role of music in ceremony that was as advanced in its way as the polychrome paintings of that same era found in the caves of France and Spain.

The discovery of such surprisingly sophisticated work—true carving, painting, and even musical instruments—poses a problem,

for it is not at all "primitive." The sudden appearance of such technically advanced work suggests that art originated still earlier than our most recent discoveries indicate, perhaps as long as 70,000 or more years ago. Archaeologists have evidence that Neanderthal man, with a brain equal to or larger than that of modern man, made use of symbols, used red ocher, and had ritual burials for which ritual objects were fashioned and in which flowers played a part. It also seems likely that these people made simple ornaments, such as pendants, of animal teeth and bones. Thus, we are left to wonder how far back extends man's desire to express in symbolic form his idea of the world and himself in it and how early his imagination produced the concepts leading to the arts as we know them. The Cro-Magnons—who lived 15,000–35,000 years ago, in an age when so much water was locked up in ice that one could walk from France to England—have left us examples of such skillful art that it is easy to believe they were using techniques handed down for thousands of years.

It also seems not only plausible but very possible that some members of the Ice Age social groupings devoted themselves to artistic creation as a full-time occupation, that is, were "professionals." It is unlikely that the hobbyist or the dilettante could have developed and used such refined techniques as carving in the round and in bas-relief using stone, bone, ivory, and clay, as well as engraving and line-drawing on the same materials. Paleolithic painters employed many techniques, ranging from simple finger painting to the use of mineral "crayons" and brushes of hair and fiber; they also knew how to blow paint, probably through hollow bird bones. The polishing of stone was mastered in some areas. It was long believed that the firing of clay began with the early farmers of the Neolithic period, about 15,000 B.C., until findings at the Dolni Vestonice site in Czechoslovakia confirmed that this technique had existed twice that long ago.

If we accept the possibility that there may have been full-time artists in the tribes or communities in the Paleolithic era or earlier, another question immediately arises: How did they make a living in a society where hunting the mammoth, the bison, the deer, and the lion was necessary for a livelihood? Did their talents distinguish them from the ordinary stalkers of beasts, set them apart from the group as "special people," whom the others supported and protected? Were they weaklings, unable to compete in the barbarous

struggle for survival and therefore forced to adapt by developing skills that gave them importance or usefulness to the community at large? It has been suggested that the earliest sculpture, paintings, and music played a part in religious ceremonies. Were the artists, then, cult figures, who officiated at the birth, death, wedding, planting, and harvesting rituals? Were they, for whatever reason, publicly or privately supported? Ice Age Patrons of the Arts? Perhaps we will never know, but we do know that we owe an incalculable debt to these so-called cavemen who hunted the woolly mammoth and gathered seeds across Europe and into the flat steppes of Asia, and who, as they gathered, also sowed some seeds of their own that flowered in Mesopotamia thousands of years later.

The Sumerians, who lived in the valley between the Euphrates and the Tigris rivers in the Late Stone Age and seem to have been the first people to make use of writing, were the first to live in what we call *civilization*. They used sickles made of stone, baked clay, and copper. Their bread was baked in the same fashion as Arabs of today bake bread: in domed brick ovens with a fire built within so that the dough can be plastered on the side. They made woolen and linen cloth, produced remarkable metalwork in copper, silver, and gold, and also made objects from ivory, fine stone, and precious woods. The homes of the wealthy were rather large—some of them were at least two stories high—and contained beautiful furnishings made of wood (chairs, beds, tables, chests), vessels of copper or stone, and baskets. The royal palace at Kish, constructed about 3500 B.C., was built of brick and had huge staircases, large columns, and paneled walls decorated with both human and animal figures.

The sculpture of the Sumerians was extraordinary, as we know from the delicately carved ornaments and weapons found in their graves. A silver vase dating from about 3000 B.C. and a nine-by-seven-foot copper figure of an eagle with a lion's head, above two stags, of about that same time are Sumerian objets d'art that compare favorably with the work of the Greek masters during the fifth century B.C. Two female heads, dating from about 2300 B.C., are almost as perfect as those produced by the Greeks nearly 2,000 years later.

Music was important in the everyday life of men and women of all classes, as indicated by the number of places allotted to music in the Sumerian *mes*, the list of divine laws. Court patronage from early times is reflected in the lavishness of the instruments at Ur in the fourth millennium B.C. Singing and instrumental music were an

important part of temple services, and the custom of including a musical accompaniment with meals began in Sumeria four or five thousand years ago. Female vocalists accompanied by the lyre were popular mealtime entertainment. Trumpets were used by the armies; percussion instruments and timbrels were played in the temples; the harp and the lyre, the most popular instruments in Sumeria, were played for entertainment and were used by bards or minstrels who performed at court.

The Sumerian bards contributed to the growth of the literary tradition by keeping alive the epics and long poems, which they transmitted orally before the development of written language and the appearance of the scribe.

Musicians and artists were considered artisans or craftsmen; they had guildlike groupings, but as the monarchs became increasingly interested in self-glorification, they employed their favorite painters and sculptors to immortalize them with statues and steles.

The most generous patronage of the Sumerian courts went not to the artists, sculptors, and musicians but to the *scribes,* who kept records of historical events such as the king's works and votive offerings and his campaigns and victories. The superior status of these courtiers was probably related to the rulers' interest in self-glorification, but their interpretations of the facts may be no more or less accurate and unbiased than those of modern recorders of historic events, especially the ones employed by, or otherwise enjoying the patronage of, heads of state.

The Egyptians of 3,000 years ago exceeded the Sumerians and even the Scythians in their craftsmanship using gold and precious jewels. They discovered the art of glassmaking and used glass made to look like turquoise and lapis lazuli in jewelry worn to ward off evil and to assure long life. The art of glassmaking was lost for 1,000 years, until it was rediscovered by the Greeks and Romans.

Architects, sculptors, and painters were far more important in Egypt than they ever were in Mesopotamia, as evidenced by our knowing the names of dozens of them, whereas in Asia they perished in anonymity. Imhotep and Amenhotep, sons of Hapu, were sages as well as architects; Hemon, who probably built the Great Pyramid, and the brilliant Senmut were both close to the throne.

Commenting on the status of artists in ancient Egypt, especially after the invasion of the Asiatic Hyksos about 1750 B.C. and the founding of the dynasty known as the New Kingdom, Jacquetta

Hawkes writes:

> It is often said that socially the painters and sculptors belonged to the humble class, yet such a notion offends against all that is probable in human relationships and most of the existing evidence. There would have been numbers of mere craftsmen in the studios, but the men of genius and talent must have lived at least on the fringes of the court. Great men, sometimes even the king, sat for them; architects must have worked closely with them and become their friends. . . . For the reign of Akhenaten there is certainty. Bak, Dhutmose and other artists had good houses in the fashionable parts of Akhetaten: Queen Tiy must have known the sculptor Yuti, from whom she commissioned portraits of her daughter. A little earlier two sculptors at Thebes could afford tombs that show them to have lived in luxury and respect.[1]

Although we know more about the glorious tradition of art established in Memphis and about the somewhat cruder style of Thebes, home of King Tutankhamun's mother-in-law, Nefertiti, fine art was also produced in remoter African outposts, thanks to the patronage of officials who took their favorite artists along with them when they were sent to those ancient equivalents of Siberia. When Prince Hepzefa of Asyut was sent to Kerma as governor, he took with him artists and craftsmen. Our legacy from this circumstance is one of the loveliest female figures from the ancient world, a carving of the prince's wife Sennuwy from Kerman stone, which epitomizes the mingling of Egyptian and African elements that also resulted in hybrid styles in minor arts such as pottery and furniture.

Greek arts and sciences, beginning about the first millennium B.C., evolved under the tutelage of Egyptian (through Crete) and Babylonian masters, but there is unmistakable evidence of genius and independence on the part of the Greeks, and of encouragement and support by the state under the leadership of nonroyal as well as royal rulers.

Athens might never have got its great start in art but for the tyrant Pisistratus (605?–527 B.C.) who welcomed artists of all kinds to his court; encouraged art, music, drama, and literature, as well as commerce and manufacturing; and was one of the first collectors of books. Tyrants came from the ranks of the newly rich businessmen, who had no royal ancestry but were able to hire enough soldiers to seize power. Pisistratus was no better loved than were the other Greek rulers in the Age of Tyrants, between 660 and 480 B.C., but he

[1] *The First Great Civilizations.* New York: Alfred A. Knopf, 1973, pp. 433–444.

was certainly one of the first patrons of the arts, maybe *the* first, who was primarily a businessman.

The public works project launched by Pericles in the fourth century B.C. brought Athens to its zenith of artistic and intellectual accomplishment. The whole city was, in effect, put on the state payroll—all Athenians not already engaged in defending the city against barbarians were thus employed—in a publicly supported arts project that makes the 1930s WPA patronage of the arts in the United States seem like less than a drop in the Aegean Sea. The sculptor Phidias, Pericles' best friend, was put in charge of all the work, and many great artists were employed: Callicrates and Ictinus built the Parthenon; the chapel at Eleusis was begun by Coroebus and finished by Metagenes of Xypete and Xenocles of Cholargus. Smiths, carpenters, molders, founders and braziers, stonecutters, dyers, goldsmiths, ivory workers, painters, embroiderers, and turners were engaged in building beautiful public buildings, statues, and temples.

Phidias was thus, in the "Golden Age of Pericles," enabled by governmental support to accomplish works and arrange for accomplishments by others that stand as some of the great artistic achievements of all time. But the favor of highly placed patrons often has its unpleasant as well as its felicitous side. Phidias was envied and slandered by malicious stories, among them one suggesting that he acted as a procurer for Pericles.

Another artist close to Pericles was his music teacher, Damon, whom Plutarch described as one "(whose name, they say, ought to be pronounced with the first syllable short) . . . [who] sheltered himself under the profession of music to conceal from people his general skill in other things." Gossipy Plutarch doesn't tell us what the "other things" were, but being under the patronage of one so great as Pericles extracted its price in enmity and slander, justified or not.

Damon's teaching appears to have had some good effect, however; Pericles established the annual musical competition at the Panathenaea, for which he acted as judge, and chose the order of appearance of the competitors, who sang and played on the flute and harp. The prize was a golden crown instead of the simple olive branch awarded to Olympic winners, and it is thought by some that this event was set up as a counterweight to the athletic contests.

What motivated Pericles? Love of art? Almost certainly that was

part of it. Love of Athens? Self-glorification? Does it matter? It is as difficult to identify the motivations of patrons as it is to fully assess the results.

When Nebuchadnezzar, king of Babylon about 600 B.C., put his war booty on display and invited the public to come and see it, he obviously wanted to boast of his military successes, and no doubt he appreciated the beauty of his collection of foreign and ancient sculptures, including some Hittite carvings, some Assyrian bas-reliefs and steles, and many fine statues from Mari, dating from the early second millennium. But it almost surely never occurred to him that the atmosphere created by this exhibition would later be described as having a "museum spirit," and that he would be credited with launching the idea 2,500 years ago of institutionalizing the collection and display of artworks.

It was the second century A.D. before we hear about a permanent collection of paintings that was open to the public. And that was on the Acropolis at Athens where a building adjacent to the Propylaea had one hall called Pinakotheke which held paintings that could be seen by the public. The Greek word *mouseion* originally meant a sanctuary dedicated to the muses of Greek mythology. When Ptolemy I (whom Alexander the Great had made satrap of Egypt) set aside a portion of his palace to house the library of Alexander, it was called a *mouseion*, understood to mean "a place of learning." Present-day usage of the term lies in the meaning of "a collection," but the current trend toward assigning to museums an educational function revives the earlier meaning of the word.

In any discussion of patrons of the arts, one cannot overlook the influence of the Christian Church. The early Christians outlined figurative symbols on the walls of their sanctuaries in the catacombs of Rome to fortify and inspire the faithful, and the medieval church, with its richly carved portals, collections of relics, stained-glass windows, mosaics covering the walls, and other treasures, was very much like the museums of modern times. St. Mark's in Venice put its most valuable treasures on display on special occasions, and in the early sixteenth century, the Cathedral at Halle, Germany, even had a printed and illustrated catalog for its extraordinary collection of relics.

When drama and instrumental music were placed under a ban by the Church in the fourth century, they were kept alive only by wandering actors and musicians; such musical notation as had been

developed was preserved by the monks then and for centuries afterward. It was through the industriousness and fidelity of the monks and the troubadours that drama with music, modified and known as *opera,* could be revived at the end of the sixteenth century.

Patrons through the ages made possible the creation and preservation of works of art that have served as inspiration and endured as monuments of beauty for centuries and have influenced the spread of ideas far beyond anything the patrons or anyone else might have imagined.

The influence of the patron has been damned, decried, and denied. Purists take the view that in accepting patronage, the artist must sell his soul, that the very fact of being supported somehow contaminates the creative stream. Pragmatists say starvation can dam up the stream, contaminated or not, and stanch the flow of originality; that man may not live by bread alone, but that a minimum of bread is essential. There is some truth in both claims. Patrons have extracted from their beneficiaries varying degrees of conformity, and artists have resisted or succumbed to the demands of patrons to varying extents and with equally varying results.

Rulers who paid artists to glorify them or their dominions in stone, marble, and paint; warriors who displayed treasures captured in military conquest; and the merely pleasure-loving rich, who enjoyed those things that make life seem a little nicer than it really is— all kept not only artists but the arts alive. In so doing, patrons sometimes exerted their influence on the artist's work directly by persuasion and, at other times, indirectly, by changing his outlook and attitude.

When the Roman Maecenas decided around 34 B.C. to give his friend the Latin poet Horace a villa and a small estate in the Valley of Digentia, now called Licenza, in the Sabine Hills, did he do so in the hope of changing Horace's outlook on life and influencing his work? Whatever his intent, Maecenas's generous gift made Horace financially independent and provided the peace for him to write. It was at the villa, some eight miles up the Tiber Valley above Tivoli, that Horace wrote many of his odes, those lyric poems that were a radical departure from his previous satiric epodes.

Michelangelo's glorious talent would surely have found expression at any time and in any place, but in late fifteenth- and early sixteenth-century Italy, his work was strongly influenced by the several popes and Medici who became his patrons. He was per-

suaded by Pope Julius II to paint the Sistine Chapel and completed nine sections by 1513. Twenty years later, Pope Clement VII insisted that he halt work on the Julian monument, for which he had signed a contract before Julius died, to finish the Sistine ceiling by repainting the great end wall above the alter, adorned until then by frescoes of Perugino. Clement died immediately after Michelangelo started on the sketches, but the next pope, Paul III, was equally insistent that the work be done. Thus, bowing to the will of his patrons, and in spite of his own misgivings, this artist, who thought of himself primarily as a sculptor, devoted seven years to painting what is probably the most famous single picture in the world, *Last Judgment*.

We remember Pope Julius II less for his accomplishments as pope than for the fact that he commissioned those first paintings in the Sistine Chapel and persuaded Raphael to paint the papal apartments and Bramante to draw up plans for the new St. Peter's. And although Cosimo de' Medici was expelled from Florence three times for his oppressive rule, his name, and that of his family, who ruled Florence for most of three centuries, is more likely to be associated with arts benefaction and linked to Donatello, della Robbia, and Botticelli than with the abuse of power and the names of other well-known tyrants of history.

Without his brother Theo's continuing faith, loyalty, and financial support, the tormented Vincent van Gogh may not have left us his paintings, which are known and loved throughout the civilized world. In his last letter to Theo, the artist recognized his brother's contribution: "you have your part in the actual production of some canvases, which will retain their calm even in the catastrophe." Theo's influence was not entirely financial.

And, consistent with life's ironic elements, the absence of a patron can be credited with making at least one artistic achievement possible, the *Prima Parte* of Piranesi. These architectural drawings, made when Piranesi was 23 years old, and published in 1743, were intended as building designs inspired by the Roman ruins. In his dedication he explains that the prints were being published because he could find no patron to finance the buildings. He did give thanks to his friend and supporter Nicola Giobbe for teaching him to admire the beauties of Roman architecture.

When the first permanent English settlements were made in America, that "great English-speaking nation beyond the seas," as Sir Walter Raleigh called it, no one could have guessed that the arts

would ever be of any importance here. Those stouthearted men and women who braved the Atlantic Ocean in tiny sailing ships were motivated by the desire for material gain and for religious and political freedom.

The London Company organized and financed the Virginia settlement at Jamestown in 1607 for the glory of God, the honor of the king, the welfare of England, and the benefit of the company. It was a business enterprise, and its objectives were gold, silver, land, and opportunity for men from a cross section of English life whose prospects, for various reasons, were limited at home.

The later New England settlement at Plymouth was deeply rooted in a religious faith that revered discomfort and hardship and viewed human joy as unpleasing to God. The arts, especially the performing arts, were thought to be the work of the Devil. Church attendance in some of the colonies was long required by law, and on Sundays, according to one chronicle, it was forbidden to "make mince pies, dance, play cards, or play any instrument of music except the drum, trumpet and Jew's harp."

Even religious art was suspect, and the building of beautiful cathedrals decorated with icons and stained-glass windows was abhorred by the Puritans, who viewed it as unseemly concern with worldly things, directly in the tradition of Baalism, that is, idolatry. It must be noted, however, that we have this antagonism to ornamentation to thank for the many beautiful, small white churches with their simple spires that dot the New England countryside and contain some of the finest wooden altars, pews, and pulpits to be found anywhere.

Schools were a rarity in the South, and only the children of planters were educated. Frequently, they were taught at home by tutors, and later, if means were available, the boys were sent to England for further education.

Schools of one kind or another, private and public, were the rule rather than the exception in New England. The common schools taught reading, writing, and arithmetic; Latin or grammar schools prepared boys for college; and academies, which admitted both boys and girls, offered a wider course of study. Religion received much attention in all New England schools. Pupils were taught the catechism at an early age. They read selections from the Bible as exercises in reading, and such textbooks as came into use were strongly impregnated with the Scriptures and Calvinistic theology. Discipline

was extremely severe, and any wanton tendencies toward self-expression on the part of young people were promptly and thoroughly suppressed.

The Jamestown colonists began to prosper when Virginia tobacco, which at first was regarded as inferior and undesirable, was improved in about 1616 by a new curing method, and from then on, the colony had a product that would yield a profit. Planters shipped tobacco to England and received goods in return: expensive wines, furniture, even building materials. Eventually, luxuries such as silk and satin clothing and fabrics, as well as musical instruments, were also imported. This dependence upon European culture continued up to the twentieth century. The most cultivated and intellectual leaders produced by the raw, new nation took for granted that European taste in art, architecture, literature, music, and even the design of furniture and clothing was superior to anything that could be created by those robust adventurers who settled the colonies or even by their descendants.

The first artists that flourished were painters; portraits were treasured as family chronicles and became symbols of wealth and prosperity. Every family of means filled their walls with family portraits. Statues and busts were favored for public figures. Artists were highly respected "craftsmen"; they had no social position themselves, but their daughters could expect to marry well if they were pretty and well-behaved.

Benjamin West is called an American painter because he was born in Pennsylvania in 1738, but when he was 22 years old, he went to Italy to study and after that to England, where he was president of the Royal Academy for 28 years and remained loyal to the throne until his death in 1820. His studio in London attracted young American painters, among them Charles Willson Peale, Gilbert Stuart, John Trumbull, Thomas Sully, and the self-taught John Singleton Copley, one of the finest portrait painters of that time, who also remained loyal to the king. Copley returned to England in 1774, where he painted Lord and Lady North and King George III and his queen. A nineteenth-century plaster bust of Thomas Jefferson, recently relocated at the White House, was probably the work of an American, but it is only a copy of the French sculptor Jean Antoine Houdon's marble portrait of Jefferson done in 1789, which can be seen in the Boston Museum of Fine Arts.

Even before the Revolution, Americans began to put their own

stamp upon the imported culture. When Benjamin Franklin visited London in 1757, he was so impressed by musical glasses or the *Glasspiel* (a musical instrument in which sound is produced by friction upon glass bells), which Gluck had introduced to London in 1746, that he came home and developed a glass harmonica that was finally finished in 1762. The banjo, introduced into this country probably from West Africa, was a small instrument that could be easily transported as people moved West. When "out West" was Appalachia, the banjo was a favorite instrument for playing local adaptations of Elizabethan ballads and Scottish ditties and eventually for composing music indigenous to the Blue Ridge mountains.

While George Washington, Benjamin Franklin, and Thomas Jefferson served the French revolutionaries as inspiring examples of the type of man produced by the overthrow of kings, education of the masses, and the espousal of life, liberty, and the pursuit of happiness, the French along with the Italians left their mark on American architecture of the time. The Virginia State Capitol, which Jefferson designed in 1785, has the lines and the Greek portico of the Maison Carrée at Nîmes, and Jefferson's Virginia home, built atop the hills beyond Charlottesville, has a Greek portico, a Pantheon-like dome, and an Italian name, *Monticello*, "Little Mountain." His building plan for the University of Virginia has been called the finest example of classical architecture in America, reflecting the Neoclassicism that dominated European architecture in the seventeenth and eighteenth centuries.

American composers in the seventeenth and eighteenth centuries were neither numerous nor profound. Musical societies were formed in the large cities, but artists were usually imported from abroad.

About 1785, Thomas Wignell became the first impresario in the new nation and imported the well-known English Shakespearean actor Thomas Abthorpe Cooper. Alexandre Placide, with his company of French pantomimists and dancers, established the French Theatre in Charleston, South Carolina, and several French-language troupes did classic French plays in New Orleans. The first Boston theater opened in 1794.

By 1815, theatrical companies were venturing as far west as Pittsburgh, Pennsylvania; Louisville, Frankfort, and Lexington, Kentucky; and Nashville, Tennessee. And William Chapman was

operating his Mississippi Floating Theater, America's first show-boat.

All of these cultural events and activities were self-supporting. The rich and famous had their favorites: Gilbert Stuart painted George Washington, John Adams, and Thomas Jefferson; and John Singleton Copley painted Samuel Adams, John Quincy Adams, John Hancock, and Thomas Boylston. Also, architects were commissioned by Congress to design public buildings. But these commissions often emphasized the utilitarian function of the structures rather than their artistic appearance. When James Renwick, Jr., was commissioned to design the first building of the Smithsonian Institution in 1846, the instructions were that it be "of plain and durable materials and structure, without unnecessary ornament." Like many congressional edicts, the implementation turned out to be rather different from what the lawmakers envisioned. Renwick, who also designed New York's Grace Church and St. Patrick's Cathedral, came up with something resembling a twelfth-century Norman castle. The structure, with its nine towers and campaniles, chapel-like rooms, and countless niches and traceries, has proved to be durable, but plain it is not. (Almost exactly 131 years after the laying of the cornerstone for that first building, the public was invited to view the newest addition to the cluster of structures known as "the Smithsonian" that stretches along the Mall from the Washington Monument to the Capitol. It is I. M. Pei's inspired East Building of the National Gallery of Art, which, oddly enough, comes closer to meeting the 1846 congressional specifications than did Renwick's design. It is, indeed, without "unnecessary ornament" and "plain" in that it is beautifully simple and simply beautiful. But it was not commissioned by Congress; it was a gift of the Mellon family. The government acts as caretaker and pays the operating costs.)

Philanthropy did not begin to play an important role in the arts in the United States until the twentieth century. Toward the end of the nineteenth century, in that freewheeling pre-antitrust era that Mark Twain labeled "The Gilded Age," energetic entrepreneurs amassed great fortunes and began to wonder what to do with all that money. The peculiarly American mixture of Puritan and capitalist ethics aroused guilt feelings not only about the practices that led to such great wealth but about the very fact of the wealth itself. A few new millionnaires sought to erase the guilt by giving some

of the money away. Having been fully occupied with business all their lives, most of them had developed no interest in or taste for the arts. (Henry Clay Frick and J. Pierpont Morgan were notable exceptions.) Therefore, their first forays into philanthropy were in other fields: medical research and education were the major beneficiaries. It was the next generation—the first to inherit money instead of having to make it themselves—that became interested in the arts. Most notable for support of the visual arts was the Rockefeller family, beginning with John D. Rockefeller, Jr., who owned a collection of Chinese porcelains that once belonged to J. P. Morgan, and whose townhouse was decorated by the Unicorn Tapestries he later gave to The Cloisters. John D., Jr., made many generous direct contributions in support of the arts and helped to make others through the family foundations that were established beginning in the early decades of the twentieth century. No other family or foundation in the United States, or almost anywhere else, approached the Rockefellers in their contributions to the visual arts, and no gifts have ever been made that were more directly identified with the personal tastes of the donors. Fortunately, there was enough money and enough diversity of taste in the Rockefeller family so that gifts were made in support of both modern and medieval art, for restoration projects, especially of Versailles and Colonial Williamsburg, and in support of studies by Egyptologists in the Middle East.

Mrs. John D. Rockefeller, Jr., an early supporter of modern art although her husband despised it, became one of the founders of the Museum of Modern Art in 1929. Her gifts to it, and her participation in its formation, were so great that it was said to have been referred to by the family as "Mother's museum." They might also have spoken of "Father's museum" when referring to The Cloisters, which Mr. Rockefeller bought for the Metropolitan Museum of Art. With its Romanesque arches, Gothic sculpture, and medieval tapestries, it could not contrast more with the Museum of Modern Art. Their son Nelson, in 1969, donated his collection of primitive art to the Metropolitan Museum, which built a special wing to house it. The Michael C. Rockefeller Memorial Wing of the Metropolitan Museum of Art, currently scheduled to open late in 1980, is named for Nelson's son, who had made contributions to the collection and who died in 1961 at the age of 23 while on an expedition in New Guinea. The Rockefellers expressed their individual tastes in art in this way,

and their names will be associated with those museums that they made possible as long as the institutions stand.

When Gertrude Vanderbilt was born in 1875, she was, as her biographer, B. H. Friedman, tells us, "the eldest daughter of the eldest son of the richest American family."[2] Gertrude might well have chosen to spend her life as a social butterfly (she married the rich and social Harry Payne Whitney, who was fascinated by race-horses and polo playing), but she aspired to become an artist. She was a painter and a sculptor and even tried her hand at writing, and although her attainments in the arts were modest, she became the leading patron of American art of her time. She founded the Whitney Museum of American Art, which might be termed a monument to the power and influence of a determined patron; Friedman tells us that if the Metropolitan Museum had not refused the donation of Mrs. Whitney's collection of more than 600 works of contemporary American art in 1929, there would have been no Whitney Museum.

Another "younger" generation arts philanthropist who died in June 1979 at the age of 88 was Lessing Rosenwald, son of Julius Rosenwald the mail-order sales pioneer who headed Sears, Roebuck & Company. Julius was a noted philanthropist who is best remembered for his support of education for blacks, but it was Lessing who put a strain on the family fortune by his passionate interest in collecting art and rare books. He left to the U. S. government a collection estimated to be worth $35 million that includes hundreds of Rembrandt etchings and hundreds of Dürer engravings and woodcuts and more than 5,000 rare books. The prints and drawings went to the National Gallery of Art and the books to the Library of Congress.

The Ford Foundation, the first nationwide patron of the performing arts, introduced to the world a new kind of patron. The foundation programs, unlike the Rockefeller and Whitney philanthropies, do not reflect the taste of the Ford family, which was and is, to state it politely, indifferent to art. The programs express the interests of those people who have been entrusted with the direction of the foundation. In the 1950s, when Henry Heald was president, McNeil Lowry, who believed passionately in the arts, convinced Heald and the board to support an "experimental" program that

[2] *Gertrude Vanderbilt Whitney; A Biography*. New York: Doubleday & Co., 1978 .

under his leadership eventually dispensed $250–260 million for the performing arts. Those who know Lowry and the zeal with which he crusaded for the program doubt that it was ever in his own mind experimental, and the confidence and enthusiasm with which he launched the program would seem to confirm this. It became one of the foundation's major activities and had a profound effect upon the institutionalization of the performing arts in this country. The new kind of patron, introduced by the Ford Foundation, is the person or the organization to whom philanthropic funds are entrusted. The Ford Foundation is an independent entity operating with its own endowment and dispensing patronage that expresses the ideas and the interests of a board of trustees, a "corporate" entity.

Support for the arts by business or industrial corporations, which has burgeoned in recent years, is criticized in some quarters for being too little, and in others—those where business philanthropy is viewed as "self-serving"—as being too much. In spite of the fact, or perhaps because of it, that we are an industrial nation and a more-or-less free-enterprise society, there remains a feeling in some circles that money earned by business is unclean. It is, nonetheless, the corporation that comes closest to being the modern equivalent of the royal court of centuries past as patron of the arts. Corporations support artists through direct commissions to design and build headquarters and other structures, to decorate interiors and malls with paintings or sculpture, and to present music and dance programs for the benefit of employees and the public.

Deere & Co., the world's largest maker of farm machinery, engaged the architect Eero Saarinen to design a new headquarters in the 1950s, a beautiful, prizewinning structure nestled in a wooded ravine on the outskirts of Moline, Illinois, that was the first to be built of Cor-Ten steel, the self-rusting metal that finishes to a warm earth tone. A wing, designed by Kevin Roche in 1978, combines the original structural theme with an even more modern three-story, glass-roofed atrium. Deere sponsors artists-in-residence in its factories who give performances free of charge in towns where Deere has facilities.

Texaco, Inc., has sponsored live radio broadcasts from the Metropolitan Opera for 40 years and recently added live telecasts; in 1978–1979, Texaco made it possible for TV audiences to see the Metropolitan's performances of *Otello, The Bartered Bride, Tosca,* and *Luisa Miller.*

Exxon supports free summer outdoor concerts by the New York Philharmonic and underwrites 39 weeks of radio concert programs to 221 stations in 49 states and Canada.

It is the contributions of the Mobil Corporation that keep New York's Guggenheim Museum and Whitney Museum of American Art open on Tuesday evenings free to the public and opens the Museum of Modern Art's sculpture garden to the public on summer evenings. Mobil, Exxon, Xerox, IBM, and other large corporations help support the Public Broadcasting System, which broadcasts free to the public the finest programs available on a continuing basis through the medium of television.

Critics point out that no business enterprise ever puts money into anything unless they expect a return on it, overlooking the fact that in this, corporations behave exactly in the manner of philanthropists through the ages.

The patron of the arts, whether it is a corporation or an individual, is a different kind of philanthropist and may indeed be the most self-interested of all benefactors in that he gives almost entirely to please himself or to see something achieved that is important to him.

Those who build galleries and museums, who commission operas and new symphonic works, or who endow theaters are not exercising *"philanthropia"* as described by the Roman Emperor Julian in the fourth century as meaning love and mercy for others. The arts philanthropist gives not out of compassion or humanitarian motives but because he loves and believes in the thing that is to be done.

Arts groups and artists are the means by which many sponsors try to make their own dreams come true. Understanding this important fact is essential in establishing a favorable relationship with a grantor.

Every grantmaking organization has at some time experienced deep disappointment in the results of its support for artistic enterprises. Not only were its hopes and dreams not fulfilled, but in some cases, the funds were so poorly managed that their effect was, at best, inconsequential and, at worst, deleterious. In consequence, arts patrons have become much more sophisticated in their selection of the projects or persons they support, much more demanding in their application requirements, and more skilled in determining which applicants are most likely to fulfill the promise of their proposals.

This new attitude puts a special responsibility upon artists and arts administrators who must have outside support for their activities and who face severe competition in seeking that support. Robert Mayer, formerly Executive Director of the New York State Council on the Arts, once wrote, "Foundations are getting as hardnosed as bankers." This can now be said of all grantors. Some of them *are* bankers. The applicant who approaches any funding organization should be prepared not only to make a persuasive and cogent case for support but to assure the potential sponsor that the money will be well administered in terms of artistic standards and also in conformity with acceptable principles of accountability.

Basic Sources of Information

There was a time when information about grants was so scarce that artists and arts groups were almost totally in the dark about the whole mysterious process. When and if they did find out about the availability of funds, it was often just blind luck. The situation now is quite the reverse: there is a plethora of printed material of every type imaginable, as well as an abundance of consultants offering to assist in ferreting out patrons and to guide the applicant through the process—for a fee, of course.

It is safe to say that no organization can afford to buy everything on the market pertaining to its field or fields of interest, and certainly no individual can. Most cannot afford the services of a consultant, and those that can do not know how to select one. Before even considering the engagement of a professional consultant, it is advisable to do some preliminary research to find out how much can be done by the organization's staff or by oneself. This method may yield better information and is usually more economical. It is not easy, but it can be very rewarding in several ways.

In order to weed out irrelevant or worthless references and concentrate on those with pertinent and reliable information, there are some good general rules to follow. The most important of these is never, never subscribe to any expensive periodical or information service without examining it first. As for books, buy only those by authors whose credentials are well established or those recommended by a reputable professional spokesman. Word-of-mouth recommendations from colleagues whose judgment one respects are often the best of all.

The major sources of information about grants in the arts are *libraries, professional associations, subscription information services, workshops and institutes, news media and word of mouth,* and *programs and catalogs.*

LIBRARIES

The first place anyone goes for information is or should be the best available library—"best" means the most accessible and the most complete. This may be the nearest college or university library or the local public library.

University libraries sometimes have special collections in the arts fields. The New York Public Library's arts collections are in two places: the Library and Museum of the Performing Arts at Lincoln Center has an extensive reference collection in dance, music, and theater; the visual arts and film collections are in the Donnell Library Center on 53rd Street between Fifth Avenue and the Avenue of the Americas. The Foundation Center libraries are far and away the best source of information on foundation grants (see Appendix IV).

The reference section of a good library usually contains several standard volumes that will be helpful in beginning the search for financial support. Libraries also subscribe to periodicals that one can review both for useful information and in order to determine whether they are worth the price of an individual subscription.

REFERENCE VOLUMES

Among the reference works found on library shelves are *The Foundation Directory,* which is described in the chapter on "Foundations and the Arts" (pp. 149–201), and the *Catalog of Federal Domestic Assistance,* discussed in "Information Sources—Government Programs" (pp. 139–147).

The *Annual Register of Grant Support* is one of the few directories covering both government and private programs. A publication of Marquis Academic Media, a branch of Marquis Who's Who, the *Annual Register* includes details of the programs of government agencies, public and private foundations, corporations, community trusts, unions, educational and professional associations, and special-interest organizations.

Program descriptions include the type, purpose, and duration

of the grant; amount of funding available for each award and for the entire program or all programs of the organization; eligibility requirements; number of applicants and recipients in the most recent year for which statistics are available; application instructions and deadlines; personnel of the funding organization, as well as its address, founding date, and telephone number; data concerning the organization's areas of interest, cooperative funding programs, and consulting or volunteer services; and other pertinent information and special stipulations.

The *Annual Register* is arranged by interest fields under broad general headings; arts activities are included in the humanities group and are divided into architecture; arts: performing arts, fine arts; history; languages; museums and libraries; and music. Several indexes make it easy to use the guide: subject index; organization and program index; geographic index; and personnel index.

The *Register* can be ordered from Marquis Who's Who, Inc., 200 East Ohio St., Chicago, IL 60611, and the cost of the 1979–1980 edition is $57.50.

The Grants Register, edited by Roland Turner and published every two years, is a very good reference source for the unaffiliated person who is looking for fellowship or scholarship support. It provides information on award opportunities for young professionals, academic staff, advanced scholars, and others, for studies, creative work, projects, or training (not necessarily academic) of an "advanced" nature. Designed primarily for citizens or residents of the United States, Canada, the United Kingdom, Ireland, Australia, New Zealand, South Africa, and the developing countries, it also lists many international awards that are open to students irrespective of nationality.

Scholarships, fellowships, research grants, exchange opportunities, vacation study grants, travel grants, and project grants are included. This volume is indexed by subject and by awarding organizations. It is published by St. James Press, 1a Montagu Mews North, London W1H 1AJ, England, and by St. Martin's Press, 175 Fifth Avenue, New York, NY 10010. The price for the 1977–1979 U.S. edition is $25.

Awards, Honors, and Prizes, a directory of awards and their donors in the United States, includes listings for the performing and visual arts under the subject headings: African arts; architecture; art; art education; art history; arts and humanities; book illustration; cinematography; city planning; communications; cookbook writing; costume design; craftsmanship; culture; dance; drama; design; en-

tertainment; fashion; fiction; graphic arts; interior decorating; journalism; literature; music; painting; photography; radio and television; and sculpture. Edited by Paul Wasserman and Janice McLean, it is published by Gale Research Company, Book Tower, Detroit, MI 48226. The fourth edition (1979) costs $50.

PERIODICAL LITERATURE

A number of good periodical publications give information on grant programs in the arts, many of which may be reviewed or referred to in libraries.

Arts, General

Arts Management, the National News Service for Those Who Finance, Manage and Communicate the Arts, edited by Alvin H. Reiss, tells how to structure arts organizations, raise funds, promote programs, sell tickets, and win foundation and business support: published five times a year; $10.

> Arts Management
> 408 West 57 Street
> New York, NY 10019

The Cultural Post, a bi-monthly publication of the National Endowment for the Arts, gives information on arts activities and grant projects: $6/year.

> Cultural Post Subscriptions
> Program Information Office
> National Endowment for the Arts
> Washington, DC 20506

Grants Magazine: The Journal of Sponsored Research and Other Programs is a quarterly that publishes articles on philanthropy and on grant activities, including those on the technicalities of grant

seeking in all fields including the arts: $22.50/year, individual; $45/year, institution.

> Plenum Publishing Corporation
> 227 West 17 Street
> New York, NY 10011

The Grantsmanship Center News is a guide to program planning and evaluation, identification of funding sources, and the preparation of proposals in all fields, including the arts. Published six times a year: $15/year; $27/two years; $38/three years.

> The Grantsmanship Center News
> 1031 South Grand Avenue
> Los Angeles, CA 90015

The Washington International Arts Letter covers the practical aspects of grants and other forms of assistance to the arts, with special emphasis on the National Endowments for the Arts and the Humanities. This letter service is one of the oldest, having been started in 1962, and back numbers are available. It is edited by Daniel W. Millsaps III, who has authored a number of books on grants for the arts: $32/year (10 issues).

> WIAL
> Box 9005
> Washington, DC 20003

Visual Arts

American Artist Business Letter for Practicing Artists tells the artist how to promote his work, how to find outlets for his art, how to evaluate a prospective dealer, how to draw up contracts, how to set up studio exhibitions, how to get the best tax advantages, how to understand and use the copyright laws, and how to take advantage

of art grants. Monthly, except July and August: $15/year; $28/two years.

> American Artist Business Letter
> Subscription Department
> 2160 Patterson Street
> Cincinnati, OH 45214

Art Letter, published by Art in America, gives grant deadline dates and information on government and foundation programs and announces competitions. Published monthly except July and August: $20/year.

> Art in America, Inc.
> 150 East 58 Street
> New York, NY 10022

Women Artists News, published monthly except July and August, contains funding information for women, minority, and other artists in the United States and Canada: $6/year individual; $8.50/year institutional; $4.50/year student; in Canada, add $2 for postage.

> Women Artists News
> Box 3304
> Grand Central Station
> New York, NY 10017

Film and Video

CPB Report, newsletter of the Corporation for Public Broadcasting, gives funding information in the public broadcasting field and lists grants and contracts made by CPB: free.

> Corporation for Public Broadcasting
> 1111 Sixteenth Street, NW
> Washington, DC 20036

Televisions, quarterly publication of Washington Community Video Center, Inc., provides funding information to independent producers: $10/year, prepaid; $15 billed.

> Televisions
> P.O. Box 21068
> Washington, DC 20009

Film and Video Makers Travel Sheet lists exhibitions and lecture tours by film and video makers to encourage their wider dissemination. An "Announcements" department gives current information on funding sources, competitions, and other notes of interest: $1.80 in United States and Canada.

> Carnegie Institute—Film Section
> Museum of Art
> 4400 Forbes Avenue
> Pittsburgh, PA 15213

Filmmakers Newsletter, monthly publication for professionals and semiprofessionals working in film and videotape in studios, independent production houses, university film departments, TV stations, and corporations. Includes information on grants and scholarships: $10/year.

> Filmmakers Newsletter
> P.O. Box 115
> Ward Hill, MA 01830

Music

Central Opera Service Bulletin. Sponsored by the Metropolitan Opera National Council, this quarterly publication includes national news items, information on federal, state, and city governments and the arts, and opera news on practical as well as artistic matters. Annual membership in the Central Opera Service is $10 for individ-

uals and $25 for groups and includes the *Bulletin*. Separate copies of the *Bulletin* are sold for $2 each.

> Central Opera Service Bulletin
> Metropolitan Opera
> Lincoln Center
> New York, NY 10023

Musical America, published 12 times a year, covers live classical music throughout the United States and abroad in reviews, profiles, background stories, and information on awards, commissions, and appointments in the classical music field: $20/year.

Musical America International Directory of the Performing Arts, published every December, is $15.

> ABC Leisure Magazines, Inc.
> Musical America Publishing House
> Great Barrington, MA 02130

Dance

Dance News has a section on grants and is published monthly except July and August: $9/year.

> Dance News
> 119 West 57 street
> New York, NY 10019

Dance Magazine puts out an annual issue that gives information on grants: $18/year.

> Dance Magazine
> 10 Columbus Circle
> New York, NY 10019

Theater

TCG Newsletter, a monthly publication on theater activities, has a special section on "Money" that gives general funding information, deadline dates for grant applications, award announcements, and "giving" and "getting" commentary: $15/year.

> Theatre Communications Group
> 355 Lexington Avenue
> New York, NY 10017

Literature

Coda: Poets and Writers Newsletter reports on literary grants and prizes in time for readers to apply; prints news of awards and requests by editors for submissions; and notices of book fairs and festivals: $6/year (five issues).

> *Coda*
> Poets & Writers, Inc.
> 201 West 54 Street
> New York, NY 10019

Poets & Writers, Inc., also publishes an annual, *100 Grants, Fellowships and Prizes Offered in the United States to Poets and Fiction Writers*, which gives deadlines, application information, addresses, contact persons, and is indexed: $2.50 from the same address.

OTHER LIBRARY MATERIALS

Some foundations, about 450, issue separately published annual reports; those that do usually distribute them freely to libraries. Annual reports are one of the best sources of information about the giving patterns of a private foundation, and many libraries include these publications in their reference collections.

The *Reader's Guide to Periodical Literature*, found in all good libraries, is a useful index to magazines and newspaper magazine

sections. Articles in those publications concerning foundations and corporations or biographical stories about key people in funding organizations may be invaluable as background information for grant seekers.

PROFESSIONAL ASSOCIATIONS

Arts associations have come to realize that the matter of financial stability is high on the priority lists of their constituencies. In response, many associations hold regular seminars and training programs designed to increase knowledge and improve skills in grant seeking. Some are included in the regular programs of annual meetings when it is convenient for members to participate.

Another means used by professional associations to assist members in learning about grants is the information appearing regularly in their periodical publications. There is so much overlapping in the arts fields that publications of some organizations have good features on grants that may be of interest to those who are members of other arts groups.

PERIODICAL PUBLICATIONS BY ARTS ASSOCIATIONS

Arts, General

ACA Reports is published 10 times a year by the American Council for the Arts (ACA). The central purpose of ACA is to promote the arts on a national level, and its membership includes state arts agencies, community arts councils, arts centers, libraries, and individual members.

Institutional membership dues start at $60 and are based on the budget of the organization; individual memberships are $30. *ACA Reports* is a bimonthly news packet containing arts news on national, state, and community levels and grant and funding information. It is free to members.

ACA also puts out a government report, free to members, called *Word from Washington*, a monthly newsletter containing information on federal legislation and government involvement with the arts.

For information on membership or publications, write to:

ACA (American Council for the Arts)
570 Seventh Avenue
New York, NY 10018

ACUCAA Bulletin is put out by the Association of College, University and Community Arts Administrators. It contains funding information for dance, theater, and music and is free to members. Membership is open to educational institutions or nonprofit public service organizations, libraries, businesses, cultural institutions, students, and other individuals interested in performing arts programs. Dues range from $85 to $175, depending on the type of membership. Details regarding membership are available from:

ACUCAA
P.O. Box 2137
Madison, WI 53701

National Assembly of Community Arts Agencies (NACAA) News-letter is published by the NACAA, which has been functioning as a body within the American Council for the Arts (ACA) structure. NACAA became an independent national service agency for community arts groups in June of 1978, and opened its offices in Washington that November. The *Newsletter,* which goes to all members, publishes information of interest to community arts agencies about what each is doing, about grant opportunities available through federal agencies, and about tools they can use to be more effective as local arts agencies.

NACAA
1625 Eye Street, NW, Suite 725A
Washington, DC 20006

Membership dues are on a sliding scale according to budget, and members of the American Council for the Arts (ACA) are given a special rate.

Visual Arts and Museums

Aviso, the monthly newsletter of the American Association of Museums, gives federal grant information in its "Washington Report"; informs readers of new and proposed legislation affecting museums; and reports on tax regulations, private grant programs, and other topics of interest to museum administrators. *Aviso* is free to AAM members; nonmember subscriptions, $24/year.

For its members, AAM also publishes *Museum News* which contains articles, reports, book reviews, and other information of interest to museum professionals.

American Association of Museums
Suite 428
1055 Thomas Jefferson Street, NW
Washington, DC 20007

CAA Newsletter, published by the College Art Association of America, reports on association activities and other news of professional interest and also contains announcements of grants and awards. The *Newsletter* is included as a membership privilege. The purpose of the association is to further scholarship and excellence in the teaching and practice of art and art history; membership comprises scholars, teachers, artists, critics, museum curators and administrators, art dealers, collectors, art and slide librarians: dues are based on type of membership and personal income.

College Art Association of America
16 East 52 Street
New York, N.Y. 10022

Crafts

Craft Horizons is a bimonthly publication with a special section entitled "Craft World" that contains information on grants, exhibitions, and other practical matters. It is a publication of the American Crafts Council (ACC). Membership in the council starts at $18/year and includes a subscription to this publication; the cost to nonmem-

bers is $3.75 per issue. The council has compiled a bibliography, *Grant References for the Craftsman,* which can be ordered directly from the council for $1.08 prepaid.

American Crafts Council
44 West 53 Street
New York, NY 10019

Film and Video

Afterimage, a publication of the Visual Studies Workshop, reports on film, broadcasting, and photography; announcements about grants and awards to artists are made in the "News Notes" feature. Membership dues of the Visual Studies Workshop are $15 in the United States and $18 elsewhere and include a subscription to *Afterimage.*

Visual Studies Workshop
31 Prince Street
Rochester, NY 14607

AIVF is a monthly newsletter of the Association of Independent Video and Filmmakers, Inc., which contains a wide range of information for filmmakers on screenings, courses, conferences, festivals, and other events. One section is headed "Funds/Resources" and lists grant opportunities as well as production and studio resources. Membership in AIVF is open to all involved or interested in independent video and film production; all members receive *AIVF*: membership dues are $20 for New York City residents, $15 for those outside New York City.

Association of Independent Video and Filmmakers
99 Prince Street
New York, NY 10012

American Film Journal of the Film and Television Arts is published 10 times a year by the American Film Institute (AFI), which was established by the National Endowment for the Arts to preserve the

heritage and advance the art of film and television in America. Grants ranging from $500 to $10,000 are made available through AFI for both beginning and advanced independent filmmakers. Approximately $300,000 was distributed in 1978. Information about AFI grants and other sources of funds are given in *American Film,* which is free to AFI members. Membership dues are $15 annually.

> American Film Institute
> The John F. Kennedy Center for the Performing Arts
> Washington, DC 20566

News from The Film Fund, a quarterly publication of The Film Fund, contains information on grants made by the fund and on other grant programs and sources, including deadline dates. The Film Fund is a new, tax-exempt national organization set up to coordinate the efforts of individuals and organizations seeking to use the visual media to address social issues; it is supported by grants and private donations. In 1979, the fund itself announced a grants program for independent filmmakers amounting to $100,000–$150,000. With a range of $1,000–$25,000, grants are expected to average $5,000–$15,000 each. *News* is currently free, but it is expected that a subscription fee will be set.

> The Film Fund
> 80 East 11 Street
> New York, NY 10003

Film Comment is the bimonthly magazine of the Film Society of Lincoln Center. It covers a broad range of topics and news related to cinema and includes funding information. Subscriptions are $10 annually.

> The Film Society of Lincoln Center
> 1865 Broadway
> New York, NY 10023

Music

Symphony News, a bimonthly publication of the American Symphony Orchestra League (ASOL), gives members information on a

full range of topics, including news about grants in a section titled "Money Matters." Membership is open to orchestras and anyone interested in the orchestra field; dues for orchestras are based on the budget; for individuals, they are based on type of membership. For details, write to:

> American Symphony Orchestra League
> P. O. Box 669
> Vienna, VA 22180

Bulletin, published twice a year by the National Music Council, contains announcements, notices, and news of interest to council members, which are music associations of national scope. The *Bulletin* announces competitions and prints news items on grants. Subscription prices: $2.50 for one and $5.00 for two issues.

> *Bulletin*
> National Music Council
> 250 West 57 Street, Suite 626
> New York, NY 10019

Dance

American Dance Guild Newsletter is published by American Dance Guild, Inc., for its members. It contains news on dance funding sources. Membership is open to anyone interested in dance, and the annual dues include a subscription to the *Newsletter*. Annual dues: regular, $35; student and retired, $15; library, $35; institutional, based on size of budget.

> American Dance Guild, Inc.
> 152 West 42 Street, Room 828
> New York, NY 10036

American Dance Report is published monthly (except July and August) by the Association of American Dance Companies as an informational service to its membership. The *Report* contains general information of interest to dancers and dance companies, including

features on "The Business of the Arts" that deal with raising money. There are three categories of associate membership: individual, $50/year; service organization, $75/year; business, $100/year. Dance companies are participating members, and annual dues are based on the company's budget.

> Association of American Dance Companies
> 162 West 56 Street, Room 203
> New York, NY 10019

Theater

Theatre News comes out nine times a year and is free to members of the American Theatre Association. Nonmembers may subscribe for $10/year. Membership dues are $40/year. The *News* lists grant programs, deadline dates, and other pertinent funding information. The association also publishes every spring an *Annual Summer Theatre Directory*, which lists internships and apprenticeships for the next summer. Members pay $3.00 for the *Directory*; nonmembers, $3.50 plus 50¢ postage.

> Theatre News
> 1000 Vermont Avenue, NW
> Washington, DC 20005

Literature

PENewsletter is a bimonthly publication of P.E.N. American Center, an organization open to all qualified writers, editors, and translators who subscribe to its principle of fostering freedom of expression throughout the world. The *Newsletter* prints news of concern to writers in all fields, annual surveys of grants and awards available to American and foreign writers, and an annual report of writers-in-residence opportunities at academic institutions in the United States and Canada: $4/yearly.

Grants and Awards Available to American Writers, an annual publication of P.E.N. American Center, is a comprehensive list of assistance opportunities for writers in the United States for use at

home or abroad and has a separate listing for Canadian writers. The tenth edition (1979) cost $2.25 plus 50¢ postage. Information about the organization and its publications is available from:

P.E.N. American Center
156 Fifth Avenue
New York, NY 10010

Historical Preservation

Arts organizations often find homes for their groups in buildings or localities of historic significance, and funding for some of their activities might come from those sources that sponsor historic preservation projects. *Preservation News,* published monthly by the National Trust for Historic Preservation, contains news about neighborhoods, sites, and buildings that are being threatened, restored, or saved; meeting information; and other general-interest news in the field. Also included is information about new sources that might be tapped for funding local activities. *Preservation News* and a quarterly magazine, *Historic Preservation,* are free to members. Dues are $10 annually, and membership information is available from:

National Trust for Historic Preservation
740–748 Jackson Place, NW
Washington, DC 20006

WORKSHOPS AND INSTITUTES

Grantsmanship training has emerged in the past few years as a new and growing occupational field. Public and private granting organizations have become more ambitious in their objectives, and as a result, they are more meticulous in their evaluation of potential grantees. Therefore, the competition has intensified, and applicants now recognize the necessity for handling their search for grant funds in a professional manner.

There has been a demand for instruction in the process of re-

searching sources, preparing applications, approaching granting or-
ganizations, and administering grant funds. And as often happens,
the need for such training became widespread before educational
and training institutions that might have been competent to fill the
need became aware of it.

Individual entrepreneurs sprang up, seemingly overnight, of-
fering a wide range of grantsmanship and fund-raising seminars
and training programs, and for a while, they had the field all to
themselves. However, colleges and universities, especially those
with adult education programs, finally recognized that there was a
potential enrollment for courses in grantsmanship and now offer
them. Many community and four-year colleges and universities offer
both credit and noncredit courses.

In general, the noncredit courses offered by educational insti-
tutions are less expensive than those offered by professional, fund-
raising, or management organizations. The classes are likely to be
larger, however, and they extend over a longer period of time. Grants
workshops offered by professionals in fund-raising usually run two
to five days, and a great amount of information must be dissemi-
nated by the instructors and absorbed by the students in a short
period of time.

Special seminars and workshops are given in central locations
and participants may have to travel some distance to attend them,
which adds to the overall cost.

The most important element in making the decision about at-
tending a course on grantsmanship is the quality of the instruction.
And that is best determined by looking into the credentials of the
instructor or the seminar leader. Some of the most beautiful bro-
chures, containing photographs of speakers and offering very ex-
tensive training, are put out by organizations that do not have highly
qualified instructors. The best information on a traveling seminar is
obtained from those who have already taken the course. If it is not
possible to find someone with firsthand knowledge, the only thing
to do is to look into the experience and background of the instructor
and decide whether the cost appears to be justified by the promise.
One can easily spend from $500 to $1,000 attending a three- to five-
day course and get very little in return.

In most cases, and this is by no means always true, it is safer
to take a course given by a local college or university. It is often easy

to find others in the community who have been through the experience and can attest to its quality, and the cost is likely to be much less. If it doesn't turn out to be the best, not much money has been lost.

GRANTSMANSHIP TRAINING PROGRAM

One of the traveling seminar programs that has built a good reputation in the past few years is The Grantsmanship Training Program offered by The Grantsmanship Center, 1031 South Grand Avenue, Los Angeles, CA 90015.

This program has a host organization in each city where seminars are conducted; the host provides space for the workshop, acts as a contact to whom local agencies can address questions, and handles registration. At the last count, there were more than 60 host organizations in large and small cities across the country, from Manchester, New Hampshire, to San Francisco, and from St. Petersburg, Florida, to Fairbanks, Alaska. In the last four months of 1978, 40 seminars were given in 31 different cities. With that frequency and geographic spread, most people can attend without traveling long distances. The training program is a one-week, small-group workshop that focuses on each participant's special needs. Registrants bring their own proposals and ideas to be critiqued, and the aim is for each one to have a completed proposal or the knowledge necessary to complete one by the end of the week. Tuition cost is, at this writing, $325.

UNIVERSITY OF DETROIT

The Division of Continuing Education of the University of Detroit in cooperation with the Public Management Institute of San Francisco, conducts two-day seminars entitled "Successful Fund Raising Techniques" that include sessions on grants. In 1978, seminars were held in Washington, D.C., New York City, and Detroit. Information on these seminars is available from the University of Detroit, The Division of Continuing Education, 4001 West McNichols Road, Detroit, MI 48221.

SUPPORT FOR THE ARTS

A seminar offered in Canada by the Management and Fund Raising Center (MFRC), 287 MacPherson Avenue, Toronto, Ontario, this program includes sessions on "The Arts Board"; "The Economics of the Performing Arts"; "Basic Elements of a Resource Development Program"; "Proposal Writing"; and "Ancillary Businesses," such as bars, restaurants, thrift shops, book sales, and boutiques. These seminars are led by John Fisher, author of *Money Isn't Everything—A Survival Manual for Nonprofit Organizations*, a fund-raising and management reference manual published by MFRC Book service.

SUBSCRIPTION INFORMATION SERVICES

Newsletters, guides to grant programs, and information publications in the grants and fund-raising area have proliferated during the past few years until the nonprofit institution or individual grant-seeker can go bankrupt trying to subscribe to them all. There used to be such a paucity of material that almost any publication could attract a sizable circulation with very little effort—both in compiling the information and in promoting the publication. The picture is now different—though not *entirely* different as many services and publications are ineptly compiled and not worth the price—and the subscriber now has a wide selection. There are some reliable services, but when entering this marketplace, *caveat emptor* should be the watchword.

If a publication is not expensive and if it specializes in the particular field of one's interest, the investment of a trial subscription is not very risky. But it is wasteful and naive to order an expensive system or publication without examining it first. It is also a good idea to question users, whenever possible, for personal evaluations.

It is very difficult for any information system to cover a wide range of fields and to include both public and private grant programs. There are good foundation information services (which are discussed in the chapter on "Foundations and the Arts," pp. 149-201), some estimable government guides, and services that cover special areas, including the arts and humanities.

The search for the publications and services that best meet one's needs is never-ending. New ones are coming out all the time, and old ones sometimes decline or fall by the wayside. Subscription lists should be reviewed continually and each item subjected to an on-going evaluation.

ACADEMIC RESEARCH INFORMATION (ARIS)

One of the most comprehensive and reliable of the general arts, all-sector, periodical publications is the Academic Research Information System (ARIS) Funding Messenger, *Creative Arts and Humanities Report.* It covers government and nongovernment grant programs, including those of private and corporation foundations, professional societies and associations, and religious organizations. It lists grants in theater, dance, the visual arts, architecture, music, landmark preservation, literature, history, libraries, museums, and folk arts, as well as grants for specialized groups such as youth, women, minorities, and the aged. Reports are issued every six weeks; subscribers receive eight reports annually, a total listing of 500–800 programs per year.

Each listing contains the name, address, and telephone number of the funding agency; the name of the person in charge; a description of the program; and the deadline date. The information nearly always appears in time for one to prepare an application and submit it by the deadline. All types of grant programs are included: education and training, touring, workshop, scholarships and fellowships, renovation, historic preservation, research, and development, as well as prizes and awards. Limiting factors are also stated: maximum grant amounts, matching funds, and eligibility requirements.

ARIS supplies application kits for all listed programs at a cost of $3 plus postage per kit. Each entry is coded by number to make it easy to order the kit.

Complete information on this publication can be requested from:

> Academic Research Information System (ARIS)
> Pacific Medical Center
> 2330 Clay Street, Suite 205
> San Francisco, CA 94114

At this writing, subscriptions are $68/year. Be sure to specify *Creative Arts and Humanities Report*. ARIS also publishes a *Medical Sciences Report* and a *Social and Natural Sciences Report*.

ORYX PRESS

ORYX Press, designed primarily for colleges and universities, is a service offering information on all sectors: federal and state governments, foundations, associations, and corporations in all subject areas. The Grant Information System includes four (quarterly) volumes a year covering over 1,700 grant programs in 90 disciplines, and subscribers receive *Faculty Alert Bulletins* in six major categories: creative and performing arts, education, health, humanities, physical and life sciences, and social sciences. The system's subject categories include archaeology, architecture, art, crafts, dance, fine arts, museum programs, music, photography, poetry, theater arts, and writing. Other categories that may also be relevant are graduate education, grants for Canadians, grants for women only, building grants, education, and elementary education.

The cost of this service is $375 a year, plus $30 for first-class postage. It may be ordered from:

> ORYX Press
> 2214 North Central Avenue
> Phoenix, AR 85004

News Media and Word of Mouth

NEWS MEDIA

No matter how carefully a researcher may comb current textbooks and guides, it is impossible to keep up with the latest information on grants without reading a good daily or weekly newspaper. Looking ahead is essential for the arts administrator because performances or exhibitions are usually scheduled a year or more in advance. The best leads for the future are found in current legislative actions and trends, announcements of changes in foundation programs, or news about the directions in which corporation support is going. Three of the nation's best daily newspapers for this type

of news are the *Washington Post*, *The New York Times*, and *The Wall Street Journal*. Three weekly newspapers, all published in New York City, contain news useful to arts administrators and artists:

Variety, published weekly by Variety, Inc., 154 West 46 Street, New York, NY 10036, at $35 a year or 85 cents for single copies, contains news of the theater, film, television, and music worlds. The "show biz" language and style may put some readers off, but the paper is filled with information.

The Village Voice, also a weekly, has departments of art, books, dance, films, music, photography, television, and theater, and covers news of general interest to artists, particularly about legislation, government regulations, and other areas affecting support for the arts. *The Village Voice* is at 80 University Place, New York, NY 10003: $18/year.

Soho Weekly News is a good weekly newspaper for news of all the arts, except for opera. It has features, reviews, and general news stories on painting, music, film, television, theater, and dance. It covers especially well current legislation and other political factors affecting artists. For example, it has been one of the best sources of information on the Comprehensive Employment and Training Administration (CETA) program and its availability to artists. Subscriptions are $18/year. *Soho Weekly News, Inc.*, is at 111 Spring Street, New York, NY 10012.

WORD OF MOUTH

No doubt about it, word of mouth is both the most reliable and the most unreliable source of information about grants. More myths, suppositions, dreams, and lies have been circulated about grants through this medium than through any other. At the same time, the personal experience of someone who has been through the whole process and has come out a winner is invaluable. Caution: just be sure *whose* word and *whose* mouth.

PROGRAMS AND CATALOGS

Information that is not exactly word of mouth and not exactly a publication is found buried in the fine print in theater, opera,

dance, symphony, and film programs and in exhibition catalogs at museums and art galleries: the lists of sponsors or contributors who made the presentations possible. The same information also appears on public television screens and is announced on national public radio in the spots reserved for advertisements during commercial broadcasts. A compilation of potential supporters can be put together for certain activities by noting the interests of particular sponsors. A benefactor, individual, corporation, or foundation that consistently supports dance, music, painting, or sculpture is obviously a likely candidate to support activities in that general field.

Government Support of the Arts

Government support for the arts was a long time coming in the United States, but it is not in this that the wonder lies. Given the obstacles that had to be overcome, the wonder is that it ever occurred at all.

The mixture of Puritan and capitalist ethics that dominated the nation from its earliest days militated against any activity associated with pleasure through the senses. In the Puritan ethic, such pleasures were sinful by their very nature. In the capitalist ethic, the senses, not being rational, were unreliable, thus unprofitable, and therefore also sinful.

As the economy developed, socioeconomic stratification was inevitable, with the rich and the poor at the two extremes of the scale. The privileged class looked to Europe as its cultural bellwether and viewed anything imported as *ipso facto* admirable. Everything imported was expensive, and the arts, being both expensive and nonutilitarian, became a symbol of wealth and social position, which, in what was basically a populist society, rendered them *ipso facto* contemptible.

The seeds of the current "elitism" versus "populism" conflict over the distribution of public funds for the arts were thus sown very early. The debate has been compounded by the growing pluralization of American society. As various cultures entered the "melting pot" (and refused to be melted), the fundamental differences between traditional Old World values and the more individual, freewheeling philosophy of the New World were bound to clash. The conflict worsened as divisions arose within the New World between

indigenous populations competing among themselves, as well as against those with roots in Europe, Asia, and Africa, for recognition and domination in artistic expression.

The elected officials responsible for allocating public funds judiciously avoided the issue for a long time—even those who understood and appreciated the arts and their place in everyday life. A few public figures spoke out from time to time, motivated by various purposes.

In 1840, President Van Buren's Secretary of War, Joel R. Poinsett, promoted the establishment of a National Institution for the Promotion of Science, and when he became its head, he set up in it a department of arts and literature, declaring, "Here, the people reign . . . no expense or pains should be spared to inspire them with . . . a taste for the fine arts. It must originate at the seat of the Government," words one would scarcely expect to hear from a general and a minister of war. Indeed, it appears that Poinsett, an amateur naturalist for whom the showy poinsettia was named, had motives as mixed as his professional and avocational interests. He was trying unsuccessfully to lay hands on the bequest of James B. Smithson, an English amateur naturalist whose 1835 bequest to establish an institution for the "diffusion of knowledge" in the United States was wending its tortuous way through an anti-intellectual, thoroughly unsympathetic Congress. If it had not been for the persistence of John Quincy Adams, the bequest would have been, as Adams feared, "squandered on cormorants or wasted in electioneering bribery," and the Smithsonian Institution might never have been founded in 1847.

Although the Smithsonian is generally thought of as a public, government-supported institution, it was started with private funds that were rammed down the throat of a Congress that reluctantly contributed to its support in order to avoid a scandal over the handling of the bequest when it was first received. That such an inauspicious beginning should have ushered in such an illustrious institution is proof of the marvels that can occur when private donors, politicians, scientists, artists, and the public at large have a stake in the success of an undertaking.

When the International World's Fair was held in New York City in 1853, Benjamin Silliman, Jr., a well-known Yale chemist, expressed the hope that the exhibition would encourage the federal or state governments to establish galleries in museums. But soon after

the fair, the country was torn apart by a great war, and it was 1870 before the art museums in Boston and New York were opened. Up to the end of the nineteenth century, there was little evidence of what John Walker, the first curator of the National Gallery of Art, called "the lust of the eye," which led to the assembling of great private collections, such as that of Andrew Mellon, who founded the National Gallery in the 1930s.

William Butler Yeats's prediction in the 1920s that America was about to launch an artistic revival seems to reveal more of a gift for prophesy than a true picture of the times. When he said, "The fiddles are tuning up all over America," commercialism and fundamentalism were much more rampant than the sound of violins.

The government's anti-Depression Works Progress Administration (WPA) in the 1930s gave jobs to out-of-work artists, but it was designed to deal with unemployment and not as an arts activity. The phrase "support for the arts" would have bewildered the general public of that time, but unemployment was a problem everybody could indentify with. The indigent artist was eager to work, and the fact that the WPA provided millions of Americans with something they could enjoy free or at a price they could afford was a happy by-product.

The Federal Theatre Project (FTP) employed 12,000 artists and produced 830 stage plays and nearly 6,000 radio plays. During the four years of its existence, its productions played to more than 30 million people in more than 200 theaters, as well as on portable stages and in public parks and school auditoriums.

The names of those whose careers were launched or established by the FTP reads like a "Who's Who" of twentieth-century American stage and screen history: Orson Welles, John Huston, Will Geer, Arlene Francis, E. G. Marshall, Burt Lancaster, Arthur Miller, John Houseman, Howard da Silva, Clifford Odets. The first performance of T. S. Eliot's *Murder in the Cathedral* was given by the WPA theater in March 1936.

John Houseman, in a review of *Free, Adult, Uncensored, The Living History of the Federal Theatre Project,* for which he wrote the foreword, said:

> History works in mysterious ways, like bulbs that seem quite dead in the fall and amaze us with their blooms in the spring—it may be that our current theatrical renaissance can, in part, trace its origin to Hallie Flanagan's Federal Theatre—not so much to the actual structure that

Congress condemned and dismantled in 1939 as to the spirit that ani-
mated it, the hope it offered, and the creative energy that it so miracu-
lously generated.[1]

John Houseman headed up the Negro Theatre Project of the
WPA (at a salary of $50 a week) and saw to it that the first Federal
Theatre play in New York was a Negro Theatre production, Frank
Wilson's *Walk Together Chillun!*, which opened at the Lafayette The-
atre in Harlem on February 5, 1936.

A preview performance of the third production of that group,
Macbeth, directed by Orson Welles with music by Virgil Thomson,
drew 3,000 more ticket seekers than the theater would accommodate,
and on the opening night, dozens of police, some on horseback,
were required to clear a path to the Lafayette for the cast and the
audience through a milling throng estimated to be about 10,000.
Welles transferred the locale and the time of *Macbeth* to the island
of Haiti in the early nineteenth century, with the witches as voodoo
priestesses; the production came to be called the *Voodoo Macbeth*.
After 10 weeks at the Lafayette, it moved to the Adelphi theatre on
54th Street, where it had a successful two-month run in competition
with such blockbusters as *Tobacco Road, Three Men on a Horse, Dead
End, On Your Toes,* and *New Faces of 1936.*

Under the Federal Art Project, grass-roots America was intro-
duced to art, particularly modern art, for the first time. Nearly 1,000
murals were completed for public buildings; an uncounted number
of prints were produced; and hundreds of sculptures and tens of
thousands of easel paintings were allocated to schools, museums,
and other tax-supported institutions.

Those who were employed on the WPA were paid a bare sub-
sistence wage, and the works of art—the paintings and sculpture—
they produced did not belong to them but to the government. Some
were of the highest quality, some were worthless; some caused
violent controversy, and some that were denounced turned out to
be prized by later generations. The murals that Arshile Gorky
painted at the Newark Airport in 1936 and 1937 are among those
now considered the most valuable. Gorky worked for the WPA from
1933 to 1940 and in 1936–1937 painted 10 panels at the Newark
Airport, which were covered over with 14 coats of paint when the

[1] Edited by John O'Connor and Lorraine Brown. Washington, D.C.: New Republic
Books, 1978.

airport was taken over by the U.S. Army in 1941. He died in 1948 without knowing that his work would be recovered, as it was recently; two panels have been salvaged and were placed on display at the Newark Museum in 1978. They are especially treasured because so much of Gorky's work was lost in a studio fire, and few examples are left to us.

Alice Neel, another WPA artist, had to wait until the 1970s to be recognized as an outstanding American painter. She tells of rescuing some of her 1930s canvases from being used during World War II to wrap steam pipes for insulation—canvases that were later included in a major New York exhibition. But much of the work of WPA artists was lost or destroyed.

It has been only in the latter part of the twentieth century that the government has come out openly for support of the arts. What little had been done up to then had to be concealed within another program or its purpose disguised. Nelson Rockefeller, Roosevelt's coordinator of the Office of Inter-American Affairs (OIAA) in 1940, organized an array of tours and exchanges with Latin American countries that included art shows and ballet troupes. Lincoln Kirstein's Ballet Caravan, under the artistic direction of George Balanchine, toured 27 countries in the early 1940s, all paid for by OIAA's budget. The tour was justified on the basis of creating goodwill in Latin America.

This emphasis on the usefulness or the practical aspects of the arts continued through the 1950s. Arguments advanced in favor of public support included statements that the arts are "important to the image of the American society abroad"; "a purposeful occupation for youth"; "good for business"; and "components for strengthening moral and spiritual bastions in a people whose national security might be threatened."

Even those proponents who believed that the arts were an expression of something basic in the human spirit and significant in themselves understood that it would be necessary to justify public support by claiming that some specifiable purpose would be served. A sure silencer of almost any objection, "national security," was even invoked, the significance of which can be assessed by noting that by 1978 the annual program budget of the National Endowment for the Arts reached $114.6 million, less than the Pentagon was spending in a single day.

Beginning in the 1930s and continuing up to the present time,

this country has been enriched by an influx of artists seeking to escape social, political, and artistic repression in their native lands. The first waves of this influx occurred just before and just after World War II and had a profound effect upon the development of this country's artistic and cultural development, as it did upon its scientific and intellectual growth. From nations that first sent to these shores the "tired . . . poor . . . huddled masses" began to come the gifted, the creative, and some of the best minds of the time.

This infusion of artistic talent into the nation's cultural bloodstream was bound to have an effect, and coupled with the changes the war itself brought about, the climate for the arts was revolutionized.

The war brought to people of every social and economic class new knowledge about the world abroad, directly or indirectly introducing them to new ideas, new kinds of food and drink, and different types of entertainment. Many who had previously considered anything foreign undesirable, or at least unsuitable for everyday consumption, not only accepted such things but became genuinely and fervently attached to them. It was during World War II that the United States finally broke out of its isolation and even its dreams of isolation from the rest of the world. The effect on the arts in this country was explosive.

Art museums, formerly as silent and dreary as mausoleums, became as lively as the marketplace and so crowded that special showings had to be scheduled to ensure supporting patrons a look at new exhibitions. Storefront galleries made their appearance in large cities, and in smaller ones, art galleries began to take their place alongside the hardware store, Woolworth's, J. C. Penney's, and the local beauty parlor.

Homes from Bangor to San Diego and from Miami to Juneau, where the walls had previously held nothing more sophisticated than a calendar reproduction of "September Morn" or a decorated plate from Niagara Falls, began to fill up with Picasso, Miro, van Gogh, or Braque prints and lithographs and even some oil paintings.

Precise figures on attendance at art museums are impossible to calculate. Most statistics on museums include all types—scientific, historical, and others—and many museums that have art galleries are classified under other headings. Also, counting methods until recently were very unreliable; until 1965, the Metropolitan Museum

of Art used the highly inaccurate hand clickers to count visitors. One 1978 estimate put museum attendance in the United States at more than 50 million annually.

Hilton Kramer, art critic for *The New York Times*, wrote in the Sunday, January 14, 1979 edition that

> the American art museum is one of the outstanding success stories in our culture. . . . Even in a period of economic anxiety and budgetary cutbacks, with inflation making everything from the acquisition of masterpieces to the removal of refuse more costly, museum collections are expanding, the facilities that house them are vastly improved over what they were even a generation ago, and new exhibitions draw ever increasing crowds.

Peter F. Drucker, in *The Wall Street Journal*, October 3, 1978, wrote:

> Fifteen years ago . . . the Seattle Art Museum, known for its first-rate Oriental collections, considered 100,000 visitors a "big year." By mid-November of this year when the King Tut exhibition closes a four-month run in Seattle it alone will have attracted more than one million visitors to the museum—almost all of them people who 15 years ago would never have dreamed of going there.

Although special exhibitions will always attract many one-time visitors, there has also been a dramatic increase in museum membership. The Los Angeles County Museum of Art reported an increase in memberships from 31,000 to 65,000 in 1978, counting those who joined primarily to see the "Treasures of Tutankhamun" exhibition. In 1970, the Metropolitan Museum of Art had 27,000 members, an all-time record, and in 1978, another all-time record was set at more than 51,000, and King Tut had nothing to do with it—the Metropolitan Museum did not give Tut tickets to new members.

Opera, in this country once a diversion of the very rich (in 1883 the Metropolitan Opera was the private property of its 35 parterre box holders, who took their places in the "Diamond Horseshoe" according to bloodlines), began to spread across the purple mountains and fruited plains, reaching even Seattle, a city Sir Thomas Beecham is said to have called an "aesthetic dustbin" when he visited there early in the 1940s. Forty-five of the fifty states in this country now have opera companies. In 1974, when the Seattle Opera was barely 10 years old, it became the only place in the world except the Wagner shrine at Bayreuth where "The Ring of the Nibelung"

is presented every summer—and to an audience 50% larger than that at Bayreuth. Those former occupants of the Diamond Horseshoe might spin in their parterre-box graves if they could see the bumper stickers and lapel buttons around Seattle proclaiming "Wagner Orgy" and "The Ring's the Thing," but the festival attracts first-rank artists, garners excellent reviews, and fills up the house. It also attracts financial support from business, private foundations, the government, and individual patrons. Wall Street banker Otto Kahn, who ran the Metropolitan Opera in the 1920s, would, as critic Martin Mayer put it, "have been astonished at the idea that an opera manager would have to solicit contributions from the public or (much worse) from the government."[2]

Symphony orchestras in the United States have a longer history than most of the performing arts. The American Federation of Musicians was founded in 1896, and most of the instrumentalists employed by orchestras were members. But up until the 1960s, it was a rare musician who could make a living by playing in a symphony orchestra; nearly all of them taught music, and many had to subsidize their musical careers by moonlighting as taxi drivers or Good Humor salesmen or in other jobs unrelated to music.

There are now 31 symphony orchestras in the United States that spend more than $1.5 million a year on their music programs. The Boston and Chicago symphony orchestras spent over $10 million in the 1976–1977 season; Atlanta, in about mid-position, spent $2.7 million; and the Honolulu Symphony, in 31st place, spent $1.6 million. The New York, Boston, Philadelphia, Chicago, and Cleveland orchestras are among the best in the world, and there are excellent orchestras in Pittsburgh, Los Angeles, Detroit, Milwaukee, Minneapolis, and Washington, D.C. These major orchestras are only the cream on top of a solid base of respectable semiprofessional and community orchestras in smaller cities across the country. The American Symphony Orchestra League has records on about 1,500 established symphony orchestras in the United States and estimates that there may be 50% more about which they have no information, for a total of approximately 2,200. Audiences for symphony orchestra concerts were estimated to be around 26 million in 1978.

[2] *The Performing Arts and American Society*, by W. McNeil Lowry. Papers prepared for the fifty-third American Assembly at Arden House, Harriman, New York, November 1977. The American Assembly, Columbia University, 1978.

It was well into the twentieth century before classical ballet came to the United States except for the occasional tour. Sergei Diaghilev's Ballet Russe de Monte Carlo came from Paris in 1916 for a "grand tour" that took them as far west as Kansas City and as far north as Buffalo. Interest in this art form began to take hold here when Lincoln Kirstein and George Balanchine started their School of American Ballet in 1934. In a few years, there were ballet schools in small towns in Montana, Texas, Tennessee, Nebraska, and other unlikely places. The First U.S.A. International Ballet Competition was held in Jackson, Mississippi in 1979.

One study reported that there was a fivefold increase in the number of civic ballet companies between 1955 and 1970, and that there were more than 300 throughout the country during the 1970s. The number of professional ballet companies is difficult to pin down because the criteria for the term *professional* vary among those who compile the figures.

The National Endowment for the Arts Dance Touring Program does not differentiate between the different forms of dance, but the number of companies they funded at the beginning of the program in 1968 was 4, and a peak of 117 was reached in 1977–1978. There was a slight drop for 1978–1979 to 110 companies. The decision was made by NEA to impose higher qualitative standards for the 1979–1980 programs and to require that companies supported demonstrate artistic excellence and emphasize touring.

Accurate figures on ballet audiences are also impossible to calculate, but one study estimated that there had been a 700% increase in the numbers attending performances between 1965 and 1973; in 1978, it was stated by the Kennedy Center Arts Awards program that dance audiences (presumably meaning all forms of dance) now number 15 million annually. But whatever the exact figures, there has been a dramatic upsurge of interest in dance in this country in both classical and modern ballet and in modern dance of all forms. The second Annual National Dance Week was celebrated in April 1979, supported by proclamations by 17 state governors. The National Association for Regional Ballet hopes to have proclamations from all governors and a presidential proclamation by 1980.

Modern dance, like ballet, has seeped into the consciousness of the nation and is hailed in some surprising places. The American Dance Festival, founded by Martha Graham, Charles Weidman, Doris Humphrey, and Hanya Holm at Bennington College in 1934,

and which matured during 30 years at Connecticut College, recently completed its second season in its new home at Duke University in Durham, North Carolina. *The Wall Street Journal* announced the move to Durham in 1978 under the headline, "Our Foremost Modern Dance Fete Moves South."

Modern dance is described by Joseph H. Mazo, dance critic of *Women's Wear Daily*, as "the most idiosyncratic of the performing arts . . . it is the art form of individualists. It is said that if you ask five socialists, you get six opinions; if you ask five modern dancers, you get eight." The fact that it is such a highly individual art may explain why modern dance has flourished in America. It is here that the great teachers Ruth St. Denis and Ted Shawn developed their techniques, and it was their disciples who broke with them, went off to experiment on their own, and formed other companies: Martha Graham, Doris Humphrey, and Charles Weidman. In their turn, they had disciples who left them in the same manner to form new groups: Erick Hawkins, Merce Cunningham, and Paul Taylor all worked with Graham. Taylor alumni include Twyla Tharp, Laura Dean, Senta Driver, and so it goes. Modern dance companies find enthusiastic audiences in this country but they are especially welcomed abroad, and Alwin Nikolais says that he finds foreign tours more financially feasible because of the lower costs in unionless theaters. It was estimated in 1977 that there were 51 modern dance companies in the United States, employing 462 dancers. In general, these companies averaged a higher percentage of income from touring and ticket sales than did ballet companies.

Theater came to America very early, and touring companies traveled deeply into the hinterlands, mainly because drama was financially self-sustaining. Actors traveled in companies and lived on whatever the box office produced. Professional theater records began in about 1750, when Thomas Kean and Walter Murray, with a complete company of English professional actors, brought *Richard III* and Addison's *Cato* to New York and Philadelphia. In 1752, Lewis Hallam and his wife, coming directly from England, opened at Williamsburg in *The Merchant of Venice* and went on to New York and Philadelphia, but found such hostility to actors that they were forced to leave and went to Jamaica. The acting profession was held in very low repute by the American colonists; it was supposed to harbor only men of low morality and women of no virtue, but the British colonists in the West Indies welcomed actors. It was a hundred

years, at least, after the Hallams' departure before members of the acting profession were accepted into "decent society" in the United States. By that time, Manhattan, with a population of over a half million, had six theaters plus several music halls, or so-called gardens, for opera, ballet, concerts, variety shows (later known as vaudeville), and minstrel troupes. By the mid-nineteenth century, New York was already the hub of the American theater.

Up until 1963, the accepted gospel was that resident professional theater outside of New York was impossible, and then the Guthrie Theater opened in Minneapolis, leading the way for the emergence of professional theaters in a number of other cities. The major growth in theater, however, has been in the nonprofit, noncommercial area. Called regional theaters or repertory or resident theaters—and in New York, Off-Off-Broadway—they offer new plays by new authors, the classics, and Broadway and Off-Broadway successes, and they reach a public many times greater than that reached by the commercial theater. Nearly every city in the United States of any size now offers its residents access to theater within convenient traveling distance. By 1979, Actors' Equity Association listed 70 professional resident and repertory theaters operating in 59 cities of 28 states and the District of Columbia; the latest to open is the Alaska Repertory Theater in Anchorage. More than 200 small theater companies are operating nationwide.

Added to and multiplying the effects of World War II on the growth and the dissemination of the arts in the United States was the emergence of a stunning product of technology that became widely available when the war ended, television. Through this medium, the world's greatest painting, opera, dance, drama, and symphony orchestra music began to be brought right into people's homes. Art would never again be something one had to be rich and socially prominent to enjoy. The Metropolitan Opera's production of Verdi's *Otello*, which was broadcast live over television and radio on September 25, 1978, was said to have had more viewers for that one performance than the total who had previously seen every performance of *Otello* since it was premiered at La Scala in 1887.

Given this picture of the dramatic groundswell of enthusiasm for the arts, it might be supposed that public support would be a foregone conclusion, but alas, that is not so.

At least a partial explanation for this seeming inconsistency lies in misconceptions on the part of the public regarding the financing

of arts activities. A 1973 survey of the National Committee for Cultural Resources distributed by the Associated Councils of the Arts (ACA) (now American Council for the Arts) revealed that 71% of the adult population had attended at least one live performance of theater, music, or dance during the previous 12 months; and 49% said that they went to art shows, museums, and craft shows "a great deal." (About 47% said that they attended spectator sports "a great deal.") However, when asked their opinion on government support for the arts, only 38% said that they thought cultural organizations should receive direct government funds to help support them.

A later survey by the same group in 1976 asked somewhat different questions, which threw more light on the attitudes of those surveyed. Although an overwhelming majority of Americans (93%) considered cultural resources important to the quality of life, a great many believed that drama, music, and dance companies were self-supporting or *even that they made a profit.* When asked if they thought federal spending for the arts should be be increased, only 39% said that it should.

This response reflects a misunderstanding on the part of the public regarding the real facts about the financing of the arts. In 1974, the Ford Foundation conducted a survey of 166 professional nonprofit resident theaters, operas, symphonies, ballets, and modern dance companies in the United States and published a report called *The Finances of the Performing Arts.*[3] Covering the years from 1965–1966 through 1970–1971, this report details precisely what occurred from a financial standpoint over those years in 166 groups and also gives an indication of the outlook for the future of the performing arts in American society.

During those six years, the total earned income of 165 groups in the survey increased from $47.8 million to $75.9 million (not including the Metropolitan Opera Company). If the Met is included, the numbers go from $58.8 million to $91.3 million. But *expenditures* for that period went from $76.3 million to $137.7 million without the Metropolitan Opera and from $92.1 million to $157.4 million including the Met.

Very superficial scrutiny of these figures indicates that these

[3] *The Finances of the Performing Arts,* Vol. 1. A Survey of 166 Professional Nonprofit Resident Theaters, Operas, Symphonies, Ballets and Modern Dance Companies. New York: The Ford Foundation, 1974.

performing-arts groups suffered a serious *income gap*, a term introduced by Baumol and Bowen to define the difference between expenditures and earned income in the performing arts in place of the term *deficit*. The income gap is the amount that must be filled by gifts and grants, that is, "unearned income."[4]

Baumol and Bowen have subjected this phenomenon to an economic analysis and have concluded that performing-arts organizations functioning in an industrial technology can never expect to earn sufficient income through ticket sales to cover the labor and goods needed for their performances. The reason is that the level of costs is set by the general economy, which assumes that output per man-hour will increase steadily; in industry, two workers now may produce as much as 100 workers did 20 years ago. But the technology of live performance and artistic creation has no capacity to increase productivity; a play, an opera, a symphony requires the same number of performers working the same length of time as when they were premiered, even if it was hundreds of years ago. The same circumstance applies to the art museum, where operating costs rise with the economy, but it takes the same—or, as collections increase, more—space, facilities, and man-hours to exhibit, store, and manage the collections.

The income gap for 165 organizations in the Ford Foundation survey (excluding the Metropolitan Opera) in 1970–1971 was $62 million, and by 1980–1981, it will rise to $335 million for the groups to maintain the 1970–1971 performance level, assuming only a 7% rate of inflation!

Until the public fully understands the financial picture of the arts and conveys to their legislative representatives a strong desire for assistance through public funds, most elected officials will hesitate to take a strong position in favor of major increases in governmental support for the arts.

Another element that confounds legislators is the debate between the so-called elitists and populists, terms that are loosely used to label those who stand for quality (*elitists*) and those who favor making the arts accessible to everyone (*populists*). It was inevitable that the controversy would focus on the distribution of National Endowment for the Arts funds. Those who feel that quality should

[4] William J. Baumol and William G. Bowen, *Performing Arts—The Economic Dilemma.* New York: The Twentieth Century Fund, 1966.

be the only criterion favor greater support to large national institutions and oppose the widespread distribution of federal funds to activities of primarily local interest, especially those that might be called the *folk arts.*

Comments by some very influential persons in the arts world have not helped to resolve this conflict. Lincoln Kirstein says, "Only a small elite feel that art is a necessity." Robert Brustein, former Dean of the Yale School of Drama, writing in *The New York Times,* suggested derisively that politicians were "spreading them [art and learning] throughout the land like jam" and concluded that "what seems likely now, considering the new consensus policies shaping up at the Endowments, is that the seeds of thought and creation will be allowed to wither away in order to satisfy the aspirations of a larger constituency."

A more balanced, less despondent statement on the subject was that of Thomas Griffith (*The Atlantic,* November 1978) who wrote:

> Happy is the art where the drop-off from the excellent to the popular is not precipitous, where the road between is well-graded and well-marked and traveled in both directions. Where there is no sharp split between the successful and the serious, the not yet popular can be nursed along, and in the gradations between accessibility and worth, the critic plays his familiarizing role. . . . Only an egalitarian romantic would expect to see the best instantly recognized; the original, the difficult, the discriminating takes getting used to. All one can reasonably ask is that it be available.

It might be assumed that the general availability of all the arts through the medium of television would eliminate some of the differences that have polarized those groups that favor "high art" and the support of the major, traditional institutions, and those who favor the support of what is popular and the recognition of regional, ethnic, and cultural tastes in the dissemination of arts funds. The conflict, far from subsiding, has actually been refueled by voices made more audible through improved communications: previously unheard voices released as a result of the civil rights revolution, and voices, inspired by a newfound pride in ethnic roots, calling for a resurrection of the culture of their ancestors.

Politicians in our pluralistic society who must please a constituency composed of various factions with strongly held and opposing views can find themselves in a morass when it comes to issues affecting such sensitive matters as race, religion, and ethnic culture.

Those who shake their heads over the meagerness of federal support for the arts might well marvel that it exists at all and might also do well to work toward a resolution of the conflicts that make it increasingly difficult to administer such public funds as are appropriated for arts activities.

Government support of the arts occurs at three main levels: federal, state, and local. By far the most significant is the federal contribution, some of which is dispensed directly from Washington, but a great deal of which is channeled through state and local governments.

GOVERNMENT PROGRAMS—FEDERAL

A number of government departments—including Commerce; Housing and Urban Development (HUD); Health, Education, and Welfare (HEW); Justice; Labor; State; and Transportation—provide support for the arts in conjunction with major program activities, although the specific classification of "arts" may not always be used in program descriptions. Several independent federal agencies have arts programs that are easily identified.

The most visible federal government arts organization, the one that bears the greatest responsibility for dissemination of funds for the arts and the one that is under the most constant scrutiny and criticism regarding its distribution policies, is the National Endowment for the Arts (NEA). Together with the National Endowment for the Humanities (NEH), the NEA is a unit of an independent agency, the National Foundation on the Arts and the Humanities (NFAH).

When Hubert Humphrey was a freshman senator from Minnesota in 1949, he began to talk about government's responsibility to support the arts, but he was not able to introduce a bill for that purpose until the 1950s. All during the Eisenhower administration, Senators Humphrey and William Fulbright (D-AR) and Congressman Frank Thompson, Jr. (D-NJ) worked toward an arts support program. The White House extended a small gesture of endorsement by appointing a commission, headed by the late Agnes Meyer, to study the feasibility of the establishment of a national cultural center, but there was no aggressive movement toward a federal program until the Kennedy administration.

From the very beginning of the Kennedy years, there was a great deal of talk about government and the arts. The Kennedys themselves were very interested in the arts; they associated with artists and entertained many of them. George Balanchine was one of the first White House guests after the 1961 inaugural, and William Walton, a Washington painter, frequently escorted the First Lady to arts gatherings.

In 1962, President Kennedy appointed August Heckscher as a special White House consultant on the arts, thereby creating a new position on the presidential advisory staff, and serious efforts began toward establishing a mechanism to provide governmental funding for the arts.

After John Kennedy's assassination, Lyndon Johnson became President and in 1964 was elected over Senator Barry Goldwater (R-AZ) in one of the greatest landslide victories of American history, carrying with him an overwhelming majority of Democrats into the Congress. With that majority, he could, and did, write and get passed a stream of legislation for his so-called Great Society. It was then that the idea of a national cultural center, which had started during the Eisenhower years, was revived and given special impetus as a memorial to John F. Kennedy.

In 1964, Senator Claiborne Pell (D-RI) sponsored a bill to establish the National Council on the Arts, which was passed, but no funding was attached; the council was merely an advisory body.

About that same time, the humanists began to band together and lobby for federal support for the humanities. A commission to promote the idea was formed by the American Council of Learned Societies, the Council of Graduate Schools in the United States, and the United Chapters of Phi Beta Kappa. In 1964, the commission published a report, prepared by its chairman, Barnaby Keeney, then President of Brown University, who in 1966 became Chairman of the National Endowment for the Humanities.

A kind of tug-of-war developed between the arts supporters and the humanities supporters, in which some bills were introduced to set up a foundation for the humanities that included the arts, and others were introduced to establish a foundation for the arts to which the humanities might be appended.

Congressman William Moorhead from Pennsylvania and Senator Ernest Greuning from Alaska introduced bills to set up a national foundation on the humanities; Senators Javits of New York, Hum-

phrey, and Pell, and Congressman Frank Thompson, who was on the House Education and Labor Committee, drafted and supported various bills. (McGeorge Bundy called Thompson "the most interesting and best-informed person in Congress on the subject of the arts and humanities.") Even freshman Congressman John Lindsay of New York introduced a bill for government arts support, but the reactionary chairman of the House Rules Committee, Howard Smith of Virginia, successfully squelched that, as he did other similar bills.

Early in 1965, Senator Pell introduced the first bill that called for the arts and the humanities to be established as coequal entities. Frank Thompson, John Fogarty of Rhode Island, and William Moorhead drafted a house bill along the same lines. These bills had the endorsement of President Johnson and of Congressman Adam Clayton Powell of New York, then chairman of the powerful Education and Labor Committee, and became the basis of the administration's final bill.

The idea also had the strong support of Lady Bird Johnson, demonstrating, according to some observers, that the Texas Johnsons were as interested in culture as the Camelot Kennedys.

Lobbying by the humanists is credited with the eventual success of the final legislation that established a National Foundation on the Arts and the Humanities.

On a momentous evening, during an extended session of Congress with the clock stopped, the arts and humanities bill was passed, and on September 20, 1965, it was signed by President Johnson in the Rose Garden of the White House.

Livingston Biddle, now Chairman of the National Endowment for the Arts, Senator Pell's aide at that time and the person who had the most to do with drafting the final bill, says it was the strength of the humanities that made congressional approval possible. Senator Pell himself has said that the arts were "piggy-backed on the humanities," although the eventual recognition achieved by the two Endowments might suggest that it was exactly the reverse.

The National Foundation on the Arts and the Humanities Act of 1965, Public Law 89-209, called for a Federal Council on the Arts and Humanities, the National Endowment for the Arts, and the National Endowment for the Humanities. The two Endowments would be independent agencies with their own advisory councils and would formulate their own programs. Until 1978, the Endowments shared an administrative budget, but since then, program

funds and administrative funds for both agencies have been appropriated separately.

The Federal Council was given responsibility by the Congress for coordinating the programs and activities of the two National Endowments, the Institute of Museum Services, and other federal agencies involved in cultural support, and for planning and coordinating federal participation in major historic national events, but it never played an important role and soon became inactive. President Carter revived the council; appointed Joseph D. Duffey, Chairman of the National Endowment for the Humanities, to be chairman also of the Federal Council; and appointed Joan Mondale, the wife of the Vice President, as honorary chairman. The council began immediately to address the problems of coordinating federal assistance to museums, international cultural exchange, and the arts in education. The revived council works closely with the White House domestic policy staff and assists in reviewing federal cultural programs and policy. The one operating program of the Federal Council is the Arts and Artifacts Indemnity Program, which provides for up to $250 million insurance against theft, damage, or loss for international arts exhibitions. During its tour of United States museums, "The Splendor of Dresden" was insured under this program.

NATIONAL ENDOWMENT FOR THE ARTS (NEA)

The landmark legislation establishing the NEA carried the somewhat diffident statement that "the encouragement and support of national progress...in the arts, while primarily a matter of private and local initiative, is also a matter of concern to the Federal Government," revealing the caution with which this step was taken. Although government support of the arts is now generally accepted, McNeil Lowry, then head of the Ford Foundation's program for the performing arts, says of it, "The government's willingness to make annually recurring grants in the arts was a watershed in American social history."

Caution was expressed not only in the language of the legislation but also in the amount of the appropriation. The program budget was less than $3 million for the first year, when Roger Stevens was the chairman. When Nancy Hanks was appointed to head the NEA in 1969, it had risen to $8.2 million, and by the time

Livingston L. Biddle, Jr., took over late in 1977, the program budget had reached $114.6 million. President Carter recommended an appropriation of $149.6 million for fiscal 1979, and it survived both houses of Congress. The President's recommendation for fiscal 1980 is $154.4 million.

To paraphrase a famous remark of Winston Churchill, however, never has so much been owed by so many to so few appropriated dollars. Some perspective might result from a comparison of the program expenditures of the NEA in its first years and those of the Ford Foundation's Performing Arts Program in the same period. When the Ford Foundation was spending between $20 to $30 million a year on the performing arts alone, the total annual NEA budget was under $3 million; after five years it rose to $15 million.

Starting from such a modest beginning, the achievements of the NEA have been nothing short of remarkable. It has promoted widespread dissemination of cultural resources of the highest quality throughout the United States by the support of major national institutions such as the New York Philharmonic; the Boston and Chicago Symphony Orchestras; the Metropolitan Opera; the Boston, Houston, and San Francisco museums of fine arts; and the Metropolitan Museum of Art. It has, at the same time, encouraged the preservation of the country's diverse cultural legacies by funding folk arts, renovation of historic buildings for contemporary uses, literary magazines, and orchestras, opera companies, theater groups, dance companies, and museums throughout the nation. Some of the support has been direct, and some has been channeled through local organizations with great autonomy in the use of funds.

Chairman Biddle's appointment drew some criticism that the arts program was becoming "politicized," which Biddle does not deny, but to which he responds by defending the political process as an honorable and reasonable system for meeting the needs of the people in art as well as in other areas. Since the voice of the constituent is the one most clearly heard by Congress, Biddle believes that if the arts are to prosper, "their message has to get out to the country."

In a speech before the National Assembly of State Arts Agencies at Edgartown, Massachusetts, in September 1978, Biddle, using a nautical metaphor, stated, "When I came aboard the National Endowment for the Arts as Chairman nearly a year ago I ran three pennants, figuratively speaking, up the masthead of the vessel I

helped to launch in 1965. And they read—quite simply: 'Unity,' 'Quality,' and 'Access.'"

Thus, he attempts to meet the criteria of both camps, to bridge the two words, *elitism* and *populism*, by suggesting that together they can mean "access to the best."

Whether this stance will succeed in dispelling the fear and suspicion that accompanied his appointment remains to be seen. Senator Claiborne Pell, in recommending Biddle for the post, said that he had more experience in dealing with relations between the arts and the federal government than anyone else around. During the drafting of the legislation establishing the arts and humanities Endowments, Biddle must have learned a great deal about survival while taking fire from several sides. While some critics urge that government funds be restricted exclusively to support of the activities they consider most worthy or most important, there are others who oppose any government support for the arts, doubt its value, or question whether it makes a real difference.

James J. Kilpatrick, *Washington Star* columnist, asked in 1977, "What is the federal government doing in the arts business in the first place?" and argued that "there is not one shred of authority in the Constitution for Congress to spend public funds for art."

In his book *The Subsidized Muse: Public Support for the Arts in the United States*,[5] Dick Netzer expresses doubt that the funds disseminated by national programs for the arts foster creativity or even increase the availability of the arts, and he concludes that such funding should not be appreciably increased.

Jerome Tarshis, writing on "Public Art" in *The Atlantic* (November 1978), said, "If our governments—federal, state or municipal—want to subsidize the enterprise of art, that is fine with me. . . . But I don't necessarily want to be forced to see the result." He flatly states, "What happens when a government or a corporation has a program for art is all too often dreadful."

Music critic Martin Mayer says, "There are new reasons—and reinforcements for old reasons—to worry about increasing reliance on tax revenues for the support of the performing arts. As appropriations rise, more and more legislators feel the need to grab a

[5] A Twentieth Century Fund Study. New York: Cambridge University Press, 1978.

piece of this money for their constituents, regardless of the quality of local talent."[6]

And Senator Daniel Patrick Moynihan, who, whatever he thinks, always expresses it in colorful language, has said, "The best way to promote art is to make it illegal."

One denouncement of government support for the arts may be, in actual fact, a glittering endorsement. Tom Bethell (*Harper's Magazine*, August 1977) complained that "today's grantee artist, the beneficiary of government largesse, is not beholden to anyone, functioning almost entirely without oversight. He is a 'free spirit,' he will let you know, given to mocking contemporary mores—to biting the hand that feeds him." That the artist receiving public funds still considers himself a "free spirit" can only be reassuring to those who hesitate to accept such assistance for fear that government support comes accompanied by the government rule book.

Immediately upon entering the post as chairman in 1977, Biddle set about reorganizing the arts Endowment, making some program and policy changes and restructuring the grant-making procedures. One of his first moves was a plan to introduce new viewpoints periodically by limiting the tenure of program directors to five years. A later innovation was the establishment of a special staff position for handling minority concerns when it was revealed that less than 2% of the 1978 program funds had gone to minorities and a task force of black and Hispanic groups charged the NEA with being insensitive to minority concerns.

A general realignment of responsibilities places the activities of the NEA in three major operating divisions:

Policy and Planning has responsibility for policy development, budget, research, evaluation, challenge grants, intern programs, special constituencies, and international activities.

Programs comprises the main body of grant programs of the Endowment: *Design Arts; Dance; Expansion Arts; Folk Arts; Literature; Media Arts: Film/Radio/Television; Museums; Music; Opera-Musical Theater; Special Projects; Theater;* and *Visual Arts.*

Office of Partnership has responsibility for State Arts Agency programs; partnership activities, including local arts organizations; and the *Artist-in-Schools* program.

[6] McNeil Lowry (ed.) *The Performing Arts.*

The NEA makes grants to individuals and to organizations; those made to organizations generally do not provide more than half the total cost of a project; they are said to be "matching grants."

Matching Grants

The majority of Endowment grants to organizations are made on a dollar-for-dollar matching basis, meaning that at least one-half of the cost of a project must be provided from nonfederal sources. Private gifts or foundation grants are the most common sources of matching funds. The Endowment favors this form of grant making as a means of encouraging and stimulating local support for arts activities. It also ensures institutional commitment to a project; the obligation to find support in addition to the NEA grant is too great to undertake unless there is real faith in the undertaking and a willingness to spare no effort in searching for support.

There are two mechanisms for the matching program. Under the *Program Funds Method*, the applicant requests from NEA an amount equal to one-half the funds required for the project and agrees to provide the other half. This match may be in the form of cash or "in-kind" services, such as staff time and other services, or facilities necessary for the project, the cost of which is borne by the institution. These services must, of course, be in addition to the overhead services normally provided by the institution and reimbursed as "indirect costs."

Under the *Treasury Fund* matching method, gifts, which are generally tax-deductible for federal income, may be made directly to the Endowment on behalf of a nonprofit, tax-exempt cultural organization, such as a museum, a symphony orchestra, or a dance, opera, or theater company, which has been notified that the NEA will award it a Treasury Fund grant of a certain amount and under what conditions.

The congressional appropriation for the NEA allocates a specific amount for the Treasury Fund, which means that grants made under this program are limited, but the advantage is that applicants may compete for grants from this source in addition to and quite separately from the regular program fund competition.

Challenge Grants

In the fiscal year (FY) 1977, a new item was included in the congressional appropriation for the NEA called *challenge grants*, which is another type of matching grant under which one federal dollar is provided for a minimum of three from another source, making the word *challenge* in the title very understandable. In the case of construction grants, only one federal dollar is provided for a minimum of *four* from other sources.

These grants are awards to an institution on a one-time basis, and their great advantage is that the use of the funds made available in this manner is at the discretion of the grantee. This is, therefore, a means of providing support for operating costs, eliminating accumulated debts, establishing endowment funds, providing capital improvements, or other purposes that will strengthen the institution—all the things that it is so difficult to find support for in grant programs. In general, the Endowment does not provide funds for deficit funding, capital improvements or construction, or the purchase of permanent equipment or real property.

In 1979, $30 million was awarded to 133 institutions (353 organizations applied for $103 million) in 32 states. Included were 26 institutions in New York City, which got $7.9 million of the total; among them were the American Ballet Theatre, the Guggenheim Museum, the New York Philharmonic, the Carnegie Hall Society, the Whitney Museum of American Art, the New York City Opera, the New York Shakespeare Festival, and the 92nd Street Young Men's and Young Women's Hebrew Association. This is the second year that New York arts groups received approximately $8 million, which means that they must raise about $48 million from other sources to match those awards. The Metropolitan Opera received a $1.5-million grant in 1977 and raised the minimum match of $4.5 million before the end of 1979. The Met says that, with the stimulation of the challenge grant, their annual private donations rose from $8-9 million in 1975-1976 to $12-13 million annually.

Challenge grants for 1979 were very widely distributed. Also among those institutions receiving awards were Washington, D.C.'s Arena Stage and Ford's Theater; the Seattle Art Museum; Ballet West (Utah); the Boston Symphony; the Minnesota Orchestra Association; the Houston Ballet Foundation; the museums of fine arts in Boston,

Houston, and San Francisco; and consortiums of cultural institutions in Cincinnati and Arizona.

The Challenge Grant Program has its critics even among those who have been beneficiaries. Since every grant must be matched by at least three dollars (four for capital improvements) from new donors or increased giving by previous donors, fierce competition arises between arts groups in the same locality that depend upon the same constituency. Richard Coe, drama critic of the *Washington Post*, wrote, "Now, because it has been so successful, the 'matching funds' concept threatens to become a monster. . . . Only true grace under stress will avoid open warfare between these like-minded groups." Corporations are expected to come up with a large portion of matching funds, and they are beginning to resent being pressured to fund programs that they had no voice in creating.

Specific information on challenge grants may be obtained from Challenge Grants, Room 1252, National Endowment for the Arts, 2401 E Street, NW, Washington, DC 20506.

NEA Grants to Organizations

In order to apply for NEA grants, organizations must have tax-exempt, nonprofit status and be prepared to present the documents to prove it. A copy of the Internal Revenue Service determination letter attesting to the organization's tax-exempt status under Section 501 is required with each application.

Any group receiving an award from which payments for services will be made to any other group must agree to comply with the requirements of Title VI of the Civil Rights Act of 1964 and the Rehabilitation Act of 1973 as amended, barring discrimination in federally assisted projects on the basis of race, color, sex, religion, national origin, or handicap. Since May 1979, institutions receiving NEA grants must submit an assurance that the funded program complies with current regulations guaranteeing accessibility to the handicapped.

Compensation from grant funds to all professional performers, related or supporting professional personnel, laborers, and mechanics must be at the prevailing minimum-wage level unless those rates have been specifically waived by negotiated agreement with all

groups and individuals concerned and with the National Endowment for the Arts.

The Endowment has standardized the deadline dates for all grant categories in order to expedite the processing of applications, and the current dates are June 14, October 14, and February 2 for projects beginning December 1, March 1, and June 1. It is expected that these dates will continue to be approximately the same, with minor adjustments when they fall on weekends.

Information on all Endowment programs is published annually in a *Guide to Programs,* which can be requested from the Program Information Office, National Endowment for the Arts, 2401 E Street, NW, Washington, DC 20506.

The NEA urges potential applicants to address requests for information directly to the appropriate grant program. Requests for application forms and information should be addressed to the program by name, for example, Music Program, National Endowment for the Arts, 2401 E Street, NW, Washington, DC 20506

Following are brief descriptions of NEA programs for which organizations are eligible.

Programs

1. *Design Arts* is concerned primarily with excellence in design. It funds activities related to architecture; landscape architecture; urban design; city and regional planning; interior, industrial, fashion, and other recognized design professions. Established organizations may apply for challenge grants in this area.

Funds for assistance in constructing cultural facilities are very scarce, and this program has assembled a packet of information on "Funding Sources for Cultural Facilities," available free upon request, which lists possible sources of assistance for the building of cultural facilities from other federal agencies, from foundations, and from corporations.

2. *Dance* is shaped to meet the needs of dance companies, including resident professional and touring companies for production, management and administration, and general projects; and for choreographers to create new works, for long- and short-term residencies, and for workshop productions. Dance companies are eligible for challenge grants.

3. *Expansion Arts* assists urban, suburban, and rural community arts organizations with proven professional direction. Grants are made on a matching basis to support activities that reflect the interests of the communities, particularly those that reflect ethnic and cultural preferences. Activities in special environments such as prisons and hospitals are also included in this program.

4. *Folk Arts* aims to identify, assist, and honor local men and women of skill and authority in the traditional arts; to provide support for cultural activities in the communities where these artists are located; and to make more visible the meaningfulness of our multicultural heritage. The types of activities funded are presentations by artists; the documentation of traditional arts via radio, recording, videotape, photography, and film; and local, regional, or national conferences on matters of concern to the traditional arts. The Endowment program guide states that unusual and imaginative ideas for folk arts activities are welcomed.

5. *Literature* provides assistance to creative writers through individual fellowships and to organizations that serve the needs of writers and some that provide publication opportunities. Small presses, and literary magazines, and major service organizations are eligible for support under this program. Organizations may apply for grants to partially support writers-in-residence.

6. *Media Arts: Film/Radio/Television* makes grants to major media centers; for exhibition programs in film and video; for the production of film, video, and radio works; and to institutions to provide services and facilities in the field. Individual fellowship support is given to video artists in cooperation with the Visual Arts Program, which provides information and guidelines for applicants. Through the American Film Institute, the NEA provides support for archival programs and for individual filmmakers. Challenge grants are also available in these fields.

7. *Museums* currently assists museums through a variety of funding categories, including support for exhibitions, education programs, cataloging, conservation, renovation (climate control, security, and storage), staff training, and visiting specialists. As of this writing, the NEA Museums Program is under review; changes in policies and programs to support museums are being considered that may narrow the kinds of activities that the endowments have supported in the past. Challenge grants are made to museums.

8. *Music* makes grants to a wide range of organizations and

individuals, including professional symphony orchestras and opera companies; American composers and librettists; music schools; organizations and musicians in the jazz, folk, and ethnic music fields; professional choral groups; and national organizations that provide services to the music field. The jazz program was earmarked for strengthening in 1979. Challenge grants are available to eligible organizations in the music field.

9. *Opera-Musical Theater* was initiated to better meet the needs of opera and musical theater. This program is scheduled for implementation beginning in fiscal year 1980. According to NEA,

> the general concern . . . was that, although the Endowment has funded musical theater projects through a variety of program channels, the field has largely been neglected in the process. It was also felt that many prospective musical composers and librettists were being lost to television and the motion picture industry because of lack of opportunity in this field. In addition, there was a general consensus that both opera and musical theater are part of one music theater continuum, and that each could benefit from closer association with the other.

This program will be separate from and equal to NEA's Music, Theatre, and Dance programs.

10. *Special Projects* cuts across several arts disciplines and funds projects that are not eligible under any other program. Among the types of activities it is currently funding are: Multidisciplinary projects that serve as a testing-ground for new ideas which may come from the general arts community or the National Council on the Arts; arts centers and festivals for organizations that have full-time, year round programs; and services to the field, meaning support for organizations that serve a number of arts disciplines and do not receive aid through other Endowment programs.

11. *Theater* is directed primarily toward nonprofit professional theater organizations, large and small, and seeks to support those with the highest artistic standards and at the same time to aid a broad range of companies at various stages of development. Theaters with standard year-round programs, summer theaters and festivals, small development companies that specialize in developmental work with new playwrights, and theater schools are all eligible, but there are restrictive qualifications, as there are for most Endowment programs. Professional Theater Company grants are made only to those groups with an annual operating budget of at least $250,000; theaters with short seasons, such as summer companies and festivals, must

have budgets of at least $100,000. Theater companies and schools may also apply for challenge grants.

12. *Visual Arts* provides grants for exhibitions, workshops, artists-in-residence, and groups that provide services to the field. The visual arts category includes painting, sculpture, printmaking, photography, and crafts. Eligible institutions may also apply for challenge grants. Under the program *Art in Public Places*, cities, towns, and other nonfederal government units, universities, nonprofit tax-exempt private groups, and state arts agencies may apply for matching grants to commission or to purchase works of art for display at exterior or interior public sites.

Policy and Planning

The *National Endowment Fellowship Program* administered by this division is designed to assist the training of arts administrators. Grants are made to an organization; candidates must be sponsored by a state arts agency, a college or university, or other professional nonprofit, tax-exempt organization, which serves as the grantee. Interns spend approximately two-thirds time working as a member of the professional staff at the NEA and the remainder attending meetings and seminars with Endowment officers, panelists, artists, journalists, federal officials, members of the National Council on the Arts, and other leading arts administrators. Stipends in FY 1980 are $2,660 plus round-trip airfare (coach) between Washington and the intern's home locale. Information and guidelines are available from the Fellowship Program Officer, National Endowment for the Arts, 2401 E Street, NW, Washington, DC 20506.

This division also has responsibility for the Office of International Arts Activities, through which international fellowships are available for two programs: *US–UK Exchange Fellowships* and *US–Japan Exchange Fellowships*. Only five awards are made each year under each program; therefore, the competition is intense. Applicants may apply for these exchange fellowships in all fields supported by the NEA, and application is made through the Endowment program in the relevant field.

Office of Partnership

1. The *Federal–State Partnership Program*, undoubtedly one of the most important activities of the Endowment, is administered in

this office. Chairman Biddle, speaking of the Federal–State Partnership Program in 1978, said, "We are beginning a new chapter to develop a newly-constituted program . . . aimed at strengthening our partnership and at sharing the decision-making process, aimed above all at creating a climate for truly shared responsibility." He established a special committee of the National Council on the Arts to work directly with the National Assembly of State Arts Agencies (NASAA), an organization comprising the arts agency heads from all the 50 states and the special jurisdictions.

The legislation establishing the Endowment provides that at least 20% of each year's program funds must go to the state and regional arts agencies, to encourage the development of arts at the local level. The distribution is made in two ways: each state and the eligible jurisdictions (District of Columbia, Puerto Rico, Guam, the Virgin Islands, American Samoa, and, as of 1978, the Northern Marianas) receive a basic grant; generally speaking, everyone is eligible for the same amount. In FY 1978, basic grants were maximally $243,000 and FY 1979 they were $275,000. This distribution accounts for about 15% of program funds; the remaining 5% is distributed to regional, state, and jurisdictional groups on the basis of competitive applications. The Federal–State Partnership Program is discussed in detail under "State Arts Councils" on page 124.

2. *Artists-in-Schools* is a state-based program primarily concerned with providing opportunities for students and teachers to work with professional artists either in the classroom or in community projects. The principal sources of funds are local and state governments. The program currently provides support for residencies by theater artists, dancers, musicians, craftsmen, folk artists, filmmakers, video artists, architects, designers, poets, writers, photographers, sculptors, painters, and printmakers, and any combination of these fields. Information on this program should be requested from the relevant state or jurisdictional agency.

3. This office also has responsibility for coordinating the NEA's effort in providing assistance to local arts organizations.

NEA Grants to Individuals

Support to individuals is almost exclusively in the form of nonmatching fellowships, which are ordinarily made only to citizens or

permanent residents of the United States who are professional artists of exceptional talent to enable them to devote full time to a creative project or to advance their careers. The Endowment does not give tuition assistance directly to individuals for college or university study in the United States or abroad. Fellowships are available as of this writing for art critics; artists; choreographers; composers and librettists; craftsmen; designers (regions, neighborhoods, buildings, or products); jazz composers–arrangers and performers; filmmakers; museum professionals; photographers; printmakers; sculptors; and writers of fiction, poetry, essays, and drama.

Information on the fellowship programs and their guidelines should be requested directly from the National Endowment for the Arts, 2401 E Street, NW, Washington, DC 20506, addressed to each specific program, as follows:

1. Designers (regions, neighborhoods, buildings, or products): *Design Arts.*
2. Artists, art critics, craftsmen, photographers, printmakers, and sculptors: *Visual Arts.*
3. Choreographers: *Dance.*
4. Composers and librettists; jazz composers–arrangers and performers: *Music* (State specific guidelines requested), and *Opera-Musical Theater.*
5. Filmmakers: *Visual Arts.* Filmmaking is jointly sponsored by *Media Arts: Film/Radio/Television* and *Visual Arts.*
6. Museum professionals: *Museums.*
7. Writers (fiction, poetry, essays, drama): *Literature.*

Samples of NEA application forms for both organizations and individuals are given on pages 259–270.

NATIONAL ENDOWMENT FOR THE HUMANITIES (NEH)

The existence of two independent agencies, one for support of the humanities and another for support of the arts, creates confusion in the minds of many who consider the arts to be included in the broad area called the *humanities*. It has not helped to clear up the matter to have the humanities Endowment sponsor programs that many people identify with the "arts," for example, the television

programs "The Adams Chronicles" and "The American Short Story," and the exhibition of the "Treasures of Tutankhamun." It is claimed by some that the NEH is consistently overshadowed by its more glamorous sister agency, the National Endowment for the Arts, and in the arts community, that probably goes without saying, but as far as the general public is concerned, it is a matter of opinion. It is true, however, that the NEH has been the target of the most criticism, directed mainly at its alleged "elitism." Many of its programs require the involvement of scholars in humanities fields, and as its former chairman, Dr. Ronald Berman, once said (reportedly not talking about himself), "there are very few of us who understand the humanities."

Gordon N. Ray, President of the John Simon Guggenheim Memorial Foundation, defines *the humanities* in this way:

> The cornerstones of the humanities are history, literature, philosophy, religion, and ancient, medieval, and modern languages. They are distinct from the arts, yet the organized study of the past products of the arts is a central province of the humanities, and areas such as art history and musicology are consequently humanistic disciplines. Moreover, subjects such as geography, anthropology, political science, sociology, economics, law, and education can all be viewed from a humanistic perspective, as indeed can science itself.[7]

The wording of the act creating the NEH (P.L. 89–209) indicates that Congress interprets the humanities almost exactly as they are defined by Dr. Ray:

> The Humanities include, but are not limited to, the following fields: history, philosophy, languages, literature, linguistics, archaeology, jurisprudence, history and criticism of the arts, ethics, comparative religion, and those aspects of the social sciences employing historical or philosophical approaches. This last category includes cultural anthropology, sociology, political theory, international relations, and other subjects concerned with questions of value and not with quantitative matters.

The Endowment itself expands upon this definition by adding that the agency exists "not only—or even primarily—for the support of formal work in these disciplines, but to encourage the understand-

[7] Report of an International Conference Sponsored by the Ciba Foundation, Council on Foundations, and Josiah Macy, Jr. Foundation, *Opportunities for Philanthropy— 1976*. John Z. Bowers and Elizabeth F. Purcell, eds. New York: Josiah Macy, Jr. Foundation (n.d.).

ing of ideals, values, and experiences which have been and will be formative in our culture, and to relate the study of the humanities to national concerns."

The much-quoted waggish statement that "Arts deals with people who can write but can't spell; Humanities supports those who can spell but can't write" has just enough truth in it to keep it alive. The arts Endowment is interested in the creation and production of original works of art; the humanities Endowment supports historical, theoretical, and critical studies, and educational programs related to the arts.

Because of the inescapable overlap between the two Endowments in some areas, and merely because it is always a good way to start out, potential applicants should acquaint themselves thoroughly with the programs of both agencies. The NEH, like the NEA, issues an annual program announcement that gives an overall summary of all the areas it supports. It is available free upon request from the National Endowment for the Humanities, 806 Fifteenth Street, NW, Washington, DC 20506. Specific brochures can be requested for the programs that appear to be most appropriate for a proposed project.

The NEH grants programs are administered through six main divisions: the Division of Research Grants; the Division of Fellowships; the Division of Education Programs; the Division of Public Programs, the Division of State Programs; and the Division of Special Programs. The programs most likely to interest arts groups and artists are located in the Education Programs and Public Programs divisions.

Division of Education Programs

The stated goal of the education division is to make humanistic study of the highest quality available to the greatest possible number of students enrolled at all educational levels. In pursuit of this objective, the division encourages proposals in all disciplines of the humanities, and in 1977–1978 special emphasis was placed upon those activities that address the improvement of expository writing within the context of the Endowment's programs.

Faithful to its commitment to students at "all educational lev-

els," it supports projects in elementary and secondary education and those that reach adult nonstudents, that is to say, the general public.

The *Cultural Institutions Program* in the Division of Education Programs is designed to help libraries, museums, and other cultural institutions to become centers of education for their communities. Educational programs at these institutions may include the arts, but the objectives are much broader. Courses offered by institutions with NEH support may be for students or the general public and may or may not be for academic credit. Courses are expected to be related to the collections of the institution or to the geographical area in which it is located, or to any intellectual interest that people may pursue with the aid of the humanities and the social sciences. The Cultural Institutions Program supports educational plans that offer participants an opportunity for sustained and systematic study. Discrete educational events and services at libraries and museums— occasional lectures, interpretive exhibitions—are supported through the Division of Public Programs. A brochure describing the Cultural Institutions Program and all others of the Education Division is available upon request from the Director of Education Programs, National Endowment for the Humanities, 806 Fifteenth Street, NW, Washington, DC 20506.

Division of Public Programs

The mandate of the Division of Public Programs is to foster wider understanding and use of the humanities, and its activities are aimed at the nation's adult, nonstudent population. In order to be eligible for support under the programs of this division, projects must draw upon the resources of the humanities and fall within one of three major areas: *Museums and Historical Organizations Program; Media Program;* or *Program Development.*

As its name implies, the Museums and Historical Organizations Program supports activities designed by museums and historical organizations to convey and interpret the cultural legacy of the United States to the general public. These activities may be in the form of exhibitions of art, artifacts, documents, or other objects of material culture in permanent or temporary collections. This program also supports Interpretive Programs, that is, public symposia,

lectures, seminars, film showings, or slides that explain collections. It does not support preservation or restoration activities, but funds are available for the interpretation of historical structures and sites.

The Media Program encourages film, radio, and television productions that advance public understanding and use of the humanities; are of the highest caliber both in terms of scholarship and in terms of technical production; and are suitable for national or regional broadcast and distribution.

Organizations making application to this program must ensure involvement in the project of fully experienced production personnel and competent scholars in the humanities. Grants from this program are made in the following categories:

1. *Development grants* to finance the research and writing of a full script
2. *Pilot grants* to finance the full production of a pilot film or, in the case of a series, of a program
3. *Production grants* to finance the full production of a project
4. *Planning grants* to support the exploration of ways in which humanists and production professionals can cooperate to develop high-quality humanities programs in new formats

A limited number of grants are made available under Program Development to test new ways of making the humanities increasingly available to the adult public. Public libraries and national professional, civic, social, and serivce-oriented voluntary organizations are encouraged to develop programs that use resources in the humanities to explore topics of interest to their adult members.

Separate program guidelines are available upon request for each program from the appropriate division within the National Endowment for the Humanities, 806 Fifteenth Street, NW, Washington, DC 20506.

COMMUNITY SERVICES ADMINISTRATION (CSA)

Office of Community Action

The Community Services Administration is an independent federal agency, primarily responsible for reducing poverty in both rural

and urban areas of the United States. It operates through a network of nearly 900 Community Action Agencies (CAAs), coordinated under 10 regional offices, to provide and/or administer funds for local antipoverty projects in the fields of health, housing, energy, manpower, and education. Such projects can include the development of cultural centers, crafts cooperatives, and educational and recreational programs whose primary focus is increased self-reliance of participants. In addition to general community assistance, the Senior Opportunities and Services Program and the Summer Youth Recreation Program have been designed to meet the special needs of youth and senior citizens.

Community Action Agencies (CAAs) must be officially designated as such by the CSA. They are eligible to receive federal funds for administrative costs and become eligible to obtain other federal or state funds to operate their basic programs. Any CAA receiving more than $300,000 in federal funds is required to provide a 40% match; for smaller amounts, a 30% match is required.

Senior Opportunities and Services program provides assistance to low-income persons 60 years or older. Basic services in nutrition, health, home weatherization, and transportation are the main concern, but in addition to or in conjunction with these, some groups have initiated cultural programs, have published newsletters, and have sponsored forums on a variety of topics.

Some examples of activities that have been funded by the Community Services Administration in the arts or that are arts-related are:

1. *Campus Crafts,* a local development project in *Annville, Kentucky,* received technical assistance from the CSA to market hand-loomed crafts around the state.
2. In *Columbus, Ohio,* a CSA-funded Cultural Arts Center gave programs in dance, drama, music, and art to 1,500 low-income area residents.
3. In *New York City,* a $300,000 grant was awarded by the CSA to New Cinema Artists, to introduce children to repertory theater.
4. Through the Summer Youth Recreation Program (SYRP), a *nationwide* allocation of $6 million was made to sponsor CETA workers in organizing cultural field trips for low-income youths to historic national parks and monuments.

5. Through the Senior Opportunities and Services (SOS) program, a grant was made to set up a Senior Opportunity Center in *Moca, Puerto Rico*. The old craft of Spanish lace-making was revived, and participants have been able to supplement their incomes by teaching the craft or by selling their handicrafts.

6. The *City of Santa Barbara, California,* in cooperation with senior citizen centers, created a Senior Creative Arts Program for older, low-income seniors. The program included ceramic, sculpture, and movement classes at the regular nutrition sites, either before or after the noon meal. The Area Agency on Aging, which receives and distributes monies from the Older Americans Act, allocated $1,000 from Title III funds for use as salaries for the artists conducting the program, and the Community Action Commission received $1,000 for two kilns for the program. (Title III is the Senior Nutrition Program funded by HEW; neighborhood arts receive funding under guidelines specifying that any nutrition program should offer social and cultural programming as well as health services.) The City of Santa Barbara also contributed $5,200 of its revenue-sharing funds to the program.

For information on community action programs, contact the regional office (addresses of CSA regional offices are found in the *United States Government Manual)* or write to the Office of Community Action, Community Services Administration, 1200 Nineteenth Street, NW, Washington, DC 20506.

Office of Economic Development (OED)

Under this program grants are made to about forty Community Development Corporations (CDCs) throughout the country, usually nonprofit organizations that undertake business ventures to stimulate the economy in areas of increasing or chronic poverty. Such ventures may include crafts-marketing cooperatives, arts retail outlets, or cultural centers. OED provides venture capital, which is supplemented by bank loans and investment funds from foundations and other private sources, to initiate and support new profit-

oriented businesses as well as nonprofit activities. A 10% local match is required.

In addition to CDC grants, the OED funds a network of grantees that do research and provide legal and technical assistance backup to the CDCs. No match is required for these support grants.

Examples of projects that have been funded under this federal program are:

1. *East Los Angeles Union.* Between 1971 and 1978, this Community Development Corporation received more than $11 million, which, in conjunction with CETA and other local monies, the Union used to establish and support the Goez Gallery and the Goez Institute of Murals to preserve and encourage Hispanic art. Over 700 murals depicting the Hispanic experience have been painted in the East Los Angeles area. The gallery is a center for the display and sale of Chicano artists' paintings and sculpture.
2. The *Possum Trot Corporation* in Kentucky designs and makes quality stuffed toys and handbags; it was financed in 1970 by two Kentucky CDCs, with almost $800,000, and is now a successful, profit-making corporation.

For further information, write to the Office of Economic Development, Community Services Administration, 1200 Nineteenth Street, NW, Washington, DC 20506.

Office of Program Development

This office provides research and demonstration grants to stimulate innovative approaches to solving the problems of poverty. It offers a potential for the support of cultural projects such as the establishment of profit-making arts and crafts outlets, designs for multiuse centers, and educational or vocational curriculum designs.

A recent award to the New York School for Circus Arts supports the operation of the Big Apple Circus, a prevocational program in circus arts.

For further information on this program, write to the Office of Program Development, Community Services Administration, 1200 Nineteenth Street, NW, Washington, DC 20506.

CORPORATION FOR PUBLIC BROADCASTING (CPB)

Although television and radio broadcasting are not included in the "arts" as that term is generally interpreted, they are the means by which more people can see and hear artistic performances in one week than the total of all audiences for several centuries past. It is impossible to think about the arts in any developed country without including the broadcast media.

Not only do television and radio broadcast artistic and cultural programs, but they use the talents of trained artists in all of the arts fields: visual, performing, and literary. Writers, designers, actors, singers, dancers, musicians, directors, photographers, and others join their talents for entertainment, educational, and news programs. Artistic film and video makers are concerned with obtaining support for the creative aspects of their work and also for the means of making them available to audiences.

The Corporation for Public Broadcasting was established by the Public Broadcasting Act of 1967, based largely on the recommendations of the Carnegie Commission on Educational Television. Broadened to include radio as well as television, the act called for public broadcasting to become a strong and active nationwide alternative to commercial broadcasting. Since the inauguration of that new era in noncommercial broadcasting, audiences for both public TV and radio have continuously increased. During one 4-week period late in 1977, 42 million households, or an estimated 100 million people, watched public television; public radio is estimated to have 4.2 million listeners regularly.

CPB, funded by a federal appropriation, private donations, and other income, operates as a nonprofit corporation and is charged with the responsibility for making noncommercial radio and television services available to all citizens of the United States. It does this by underwriting the costs of production of public broadcast programs; paying for interconnection services for television and radio; supporting the operations of local stations; and assisting public broadcasters through such activities as audience research, professional training, and applications of new technologies.

Most of the public funds allocated to CPB go directly to television and radio—about 74% to television and 16% to radio. The CPB/PBS Partnership Agreement calls for 50% of the federally appropri-

ated funds to go to public television licensees in the form of community service grants. In 1978, these amounted to $59.6 million.

The congressional appropriations for the CPB are made two years ahead of other federal programs. The 1980 appropriation was $152 million, and $162 million has been approved for 1981. About two and one-half times that much is raised from nonfederal sources. The President's budget request for FY 1982 is $172 million, and for FY 1983, it is $220 million.

It may be pointless to speculate about budgets and programs of the CPB too far in the future, however, because the corporation's future may be in jeopardy. The CPB has, for most of its life, been under attack for its failure to insulate the funds from government interference, and it has been widely criticized for having grown into an unwieldy bureaucracy that duplicates many of the functions of the Public Broadcasting Service (PBS), created by CPB to serve as a national program-distribution agency.

The CPB's board of directors and the board of National Public Radio (NPR) in 1976 suggested to the Carnegie Corporation that the time had come for a reappraisal of public broadcasting in the United States. In response, the Carnegie Corporation established a Commission on the Future of Public Broadcasting in June 1977. The commission issued its report in January 1979, calling for extensive revision of public broadcasting's national structure and system of financing. The report concluded that although public broadcasting has "managed to establish itself as a national treasure" in its first 12 years, major restructuring was necessary in order to resolve its fundamental dilemma: "How can public broadcasting be organized so that sensitive judgements can be freely made and creative activity freely carried out without destructive quarreling over whether the system is subservient to a variety of powerful forces including the government?"

Several significant recommendations were made by the commission, a main one being the elimination of the CPB and its replacement by another central agency, the Public Telecommunications Trust. The trust would provide leadership, long-range planning, and systems and facilities development, and it would act as the system's shield from political interference. The report cited the veto of CPB's congressional authorization in June 1972 by President Nixon when administration officials believed public television had become a vehicle for political criticism of the administration.

Some members of Congress have also been dissatisfied with the CBP, and early in 1979 two legislative proposals threatened it with extinction by calling for extensive reforms in the national system of noncommercial television and radio.

Responding to the mood of Congress and perhaps also to the recommendations of the Carnegie Commission, Robben W. Fleming, who became president of the CPB in January 1979, immediately presented his own plan to CPB's board of directors for a restructuring of the corporation. His proposal was modeled to a degree on the Carnegie Commission's report. It would divide the corporation in two: a management unit and a program fund. The management unit would handle everything except program funding and provide services not connected with program financing, such as research.

The board took up the matter of restructuring the CPB at its August 1979 meeting and approved a plan that becomes effective January 1, 1980. The operations of CPB will be divided into two parts:

1. *Management Services Division*, which will handle everything not associated with the selection and funding of programs, that is, such things as planning and research, nonprogramming grants, system capacity building, station services, training, public affairs, government relations, education, and administrative and legal functions.
2. *Program Fund*, will deal only with the selection and funding of programs.

The Carnegie Commission made very specific recommendations for revision of the funding mechanism, aimed at providing nearly automatic federal support that would be free to the maximum extent possible from partisan politics. It recommended that by 1985 total funding for America's public broadcasting system should grow to about $1.2 billion annually, about one-half of which should be provided by the federal government.

Reorganization of the public broadcasting system must, of course, come as a result of congressional legislation, but it is likely that Congress will give close attention to the Carnegie Commission report. It is to be hoped that any newly mandated structure will retain the spirit expressed by the report in its statement, "The system must locate, at the center of its enterprise, the incentive to create—

a sustained commitment to genuine artistry based upon ingenious use of these powerful media."

The current CPB program includes grants for research and development leading to a television production, in addition to its funding for production of programs that are distributed through the Public Broadcasting Service for television and radio. Grants to provide for the extension of educational broadcasting service facilities are distributed by the Department of Commerce, National Telecommunications and Information Administration (NTIA). (See "Department of Commerce," page 96.)

For information on CPB programs, write to the Corporation for Public Broadcasting, 1111 Sixteenth Street, NW, Washington, DC 20036.

Public Broadcasting Service (PBS)

Public television has become so firmly established as a source of both entertainment and information that it is hard to realize how young it is.

The first noncommercial television station, KUHT Houston, went on the air in 1953. The Public Broadcasting Service was chartered in November 1969 and distributed its first programs in October 1970. There are currently 272 public-television transmitting stations, owned and operated by 159 separate organizations, licensed by the Federal Communications Commission, in four basic categories:

Nonprofit community organizations	61 (38%)
Colleges and universities	54 (34%)
State authorities	26 (16%)
Local school districts	18 (12%)

The PBS was created by CPB and the public television licensees to serve as the national program distribution agency; it was reorganized in 1973 as a membership-supported organization.

The overall public television audience nearly doubled between 1974 and 1977. It is currently estimated that more than 60% of American households owning a television set (about 40 million homes) tune to public television at least once a month, with the average home viewing about eight hours every month. About 27.5

million households (38.7% of all U.S. TV households) watch public TV each week. The overall public TV audience is reasonably representative of the national population. Just over 11% of public television viewers are nonwhite, reflecting their percentage of the total population. The same holds true for households headed by skilled and semiskilled workers: 34% of the total U.S. population and 35% of the public TV audience.

Public TV had quite a year in 1978: Festival '78, public TV's annual fund-raising event, produced more viewer pledges and dollars than ever before. Since 1970, the number of public television subscribers has increased tenfold. Approximately 2.5 million current subscribers have pledged more than $60 million.

The Carter administration has affirmed its strong support for a financially healthy, politically insulated public broadcasting system. In his message to Congress in 1977, the President stressed the need for increased funds for public TV's national programming from a variety of sources, and for the framing of long-range goals for the system.

The Carnegie Commission's report on the future of public broadcasting, issued in January 1979, recommended the creation of a Program Services Endowment as a semiautonomous division of the recommended Public Telecommunications Trust. The purpose of the Endowment would be to support creative excellence and underwrite a broad range of television and radio productions and program services, including public affairs, drama, comedy, educational and learning research, and new applications of telecommunications technology.

The commission's report stated that

> behind the recommendation of the Program Services Endowment is a desire to create a safe place for nurturing creative activity, which will otherwise become a casualty of the many other institutional priorities of this complex enterprise. It seems clear to us that there must be at least one place in the system offering to artists and journalists the principal prerequisite for creative achievement, the freedom to take risks.

As a priority for the television system, the commission recommended "the improvement in its capability to produce programs of excellence, diversity, and substance." In order to achieve this, the recommendation was made that stations spend the bulk of their new resources, available through revised funding procedures, on programming, locally, regionally, and nationally. It suggested that com-

munity service grants—the federal matching grants to stations—be viewed as program service grants. Stations should be supported in their efforts to develop innovative and untried programming ideas in a wide range of genres devised by producers working inside and outside the present system.

The PBS is responsible for the scheduling, promotion, and distribution of the national program service to noncommercial television stations across the country. The PBS does not fund the production of programs but it works closely with the CPB, which does, and it distributes programs to member stations. A major part of the programming distributed by the PBS is produced by the local stations, but the PBS seeks and obtains programming from a variety of local, regional, overseas, and other sources.

The PBS has for distribution a brochure, "A Handbook for Independent Producers," which tells independent producers how to go about submitting completed programs for consideration in the national schedule and how to obtain funding for incomplete projects and for the development and production of new programs. The PBS will advise on funding sources for program development and production.

Four regional networks serving public television acquire programs and, in some cases, fund as well as distribute programs. The addresses of the regional networks are:

Eastern Educational Television Network (EEN)
1300 Soldiers Field Road
Boston, MA 02135

Southern Educational Communications Association (SECA)
928 Woodrow Street
Columbia, SC 29205

Pacific Mountain Network (MN)
Suite 50-B, Diamond Hill
2480 West 26 Avenue
Denver, CO 80211

Central Educational Network (CEN)
5400 North St. Louis Avenue
Chicago, IL 60625

Many programs are funded by more than one underwriter. Typically, these might include the CPB, the National Endowments for the Arts and for the Humanities, the National Science Foundation, the U.S. Office of Education, and a variety of private national and local corporations and foundations.

For the independent producers' handbook and other information on PBS activities, write to the Public Broadcasting Service, 475 L'Enfant Plaza West, SW, Washington, DC 20024.

National Public Radio (NPR)

The Corporation for Public Broadcasting established the National Public Radio in 1971 as the national programming and interconnection service for public radio stations; in May 1977, NPR joined forces with the Association of Public Radio Stations. Membership in NPR is open only to those stations that are "CPB qualified," meaning that they must meet minimum criteria. The CPB has set those criteria as: at least five full-time professional staff members; 18 hours a day on the air, 365 days per year; and an annual operating budget of at least $80,000. There are currently about 170 members operating nearly 200 stations, all eligible to receive company service grants (CSGs) from the CPB. In 1973, $1.7 million went directly to public radio stations in the form of CSGs, and by 1978, the total had risen to $8.4 million. Although the CPB allocation increases each year, so does the number of new stations; on the average 15 new stations qualify for NPR membership each year.

NPR has established an eight-member industry task force to plan for public radio's first national membership and awareness campaign. The comprehensive public awareness, fund-raising, and programming project will be timed to coincide with public radio's 1980 switch to satellite interconnection.

If the recommendations of the Carnegie Commission are accepted, the public radio system will be completed so that it serves the nation in both large and small communities, and the new stations will have a solid financial and community support structure buttressing the service function that each licensee performs in the community.

The commission recommended the development and the activation of an additional 250–300 public radio stations to provide

improved national coverage, greater diversity among licensees, and broader local programming choice in many markets through multiple outlets.

Federal funds derived through new funding procedures would be used for two purposes: improvement of local service and operations, and the financing by station consortiums of programming that transcends strictly local needs.

Public radio, like public television, would be enabled by the Program Services Endowment to produce additional programs and particularly to undertake new and innovative projects. The Endowment would also provide transitional support for the present NPR programming services until such time as stations are able to aggregate funds to support the programs of their choice.

Information on current grant and assistance programs for public radio is provided by a brochure, "Policy for Public Radio Station Assistance," distributed by the Radio Activities Office of the CPB. For that and other information on National Public Radio, write to the Radio Projects Manager, Corporation for Public Broadcasting, 1111 Sixteenth Street, NW, Washington, DC 20036.

INTERNATIONAL COMMUNICATIONS AGENCY (ICA)

Beginning in the late 1940s, cultural presentations abroad that involved performers were handled by the State Department and those that involved things (objets d'art) were handled by the U.S. Information Agency (USIA). In April 1978, the International Communications Agency was established and given responsibility for all programs involving exchange of ideas and culture with people of other nations. Its aim is to disseminate abroad the best possible understanding of American values and policies and to assist Americans in learning about other nations and cultures. President Carter's instructions to the new agency included the statement that "The Agency will undertake no activities which are covert, manipulative or propagandistic. The Agency can assume . . . that a great and free society is its own best witness."

ICA merges the functions and personnel of the former USIA and those of the Bureau of Educational and Cultural Affairs previously in the Department of State.

Cultural Exchange Program

This program includes the following categories relevant to the various fields of art:

1. *Performing Arts.* Major companies in the fields of music, drama, and dance are financed to tour the Soviet Union under the terms of the US–USSR Exchange Agreement. Qualified artists and performing groups are also assisted in arranging private tours in other countries. An adviser for the arts is responsible for maintaining liaison with private organizations and individuals concerned with the visual arts and for helping them resolve problems in international arts exchanges.

2. *Grants in Aid.* The agency extends financial aid to private American organizations when their program objectives abroad complement and enhance those of the U.S. government, that is, increase mutual understanding among peoples.

3. *Films and Television.* The agency both acquires and produces videotape programs and films for distribution through overseas posts. About 100 films are produced a year and more than 300 are acquired from private sources in the United States. Another function is assisting foreign TV teams in producing programs about the United States for telecast abroad.

4. *Academic.* The Fulbright Scholarships Program supports the annual exchange of approximately 1,750 United States and foreign predoctoral students and 1,000 professors and senior researchers in all academic fields. There are also other programs for students, teachers, and scholars in this category.

5. *Foreign Leaders.* Under this program, about 2,000 foreign leaders in government, labor, mass media, science, education, and other fields visit their counterparts in the United States. Programming of these visitors is handled by 90 community organizations, many of them members of the National Council for Community Services to International Visitors (COSERV).

6. *Libraries and Books.* The ICA maintains and/or supports libraries in 253 cultural centers, reading rooms, and binational centers in more than 95 countries. The focus is on materials that will help people in other countries to learn about United States history and culture and about the American people.

7. *East-West Center.* The agency serves a liaison function with the Center for Cultural and Technical Interchange between East and

West in Hawaii. This center is an autonomous institution of learning for Americans and for the peoples of South Asia and the Pacific and has the purpose of promoting better understanding through cooperative programs of research, study, and training.

For detailed information about the ICA and its activities, write Michael Pistor, Director of Congressional and Public Liaison, International Communication Agency, Washington, DC 20547.

SMITHSONIAN INSTITUTION

When James Smithson, an English amateur naturalist, bequeathed his fortune to the United States of America in 1826, "to found at Washington under the name of the Smithsonian Institution, an establishment for the increase and diffusion of knowledge among men," there was nothing in his will or in his activities to suggest that he meant to include the arts in the categories of knowledge to be increased and diffused. In fact, it may have been inadvertent that the congressional legislation establishing the Smithsonian Institution in 1846 provided for a "gallery of art." The somewhat vague wording of the legislation stipulated that there should be a museum, a study collection of scientific materials gathered by the U.S. government, a chemical laboratory, a library, a gallery of art, and lecture rooms. At that time and throughout most of the nineteenth century, museums in the United States were "depositories of curiosities" and did not contain works of art. The Washington Museum, which opened in 1836, had a few paintings among its 400 or 500 "specimens," and only three of these paintings can now be accounted for: one titled *Turkish Battle Piece,* a portrait of Mazarin, and a canvas called *Massacre of the Innocents,* all by unidentified artists (perhaps mercifully so). Even in the decades immediately following the Civil War, labeled the "Gilded Age" by Mark Twain, when a thirst for luxury swept the country, the development of a national art gallery at the Smithsonian looked hopeless.

Barely a hundred years later, however, in 1976-1977, of the 28 million visits made to the Smithsonian, approximately 60% of them (over 16 million) were made to museums that are either entirely or partly devoted to some aspect of the arts. And those figures do not include the 2.7 million visits to the National Gallery of Art (51 days after it opened in May 1978, the National Gallery's new East Building

welcomed the 1-millionth visitor through its portals). Nor do these figures include the attendance of 1.6 million at the more than 1,000 performances in 1977 at the John F. Kennedy Center for the Performing Arts. The National Gallery and the Kennedy Center are both bureaus of the Smithsonian with separate boards of trustees.

Whether Smithson intended it or not, the Smithsonian has become a major institution for the collection, display, and study of the visual and performing arts in this country.

The Smithsonian encourages access to its facilities by visiting scholars and students, offering appointments for research and study in residence. Some appointments carry financial support; others do not. They are made for varying periods of time to qualified applicants wishing to make use of the institution's resources for study in areas closely related to the research interests of staff members, who act as advisers.

The types of visiting appointments offered by the Smithsonian Institution on a regular basis are the following:

1. *Postdoctoral and Predoctoral Fellowship Appointments.* Awarded for not less than 6 or more than 12 months, these appointments are generally not renewable. The primary objective is to further the research training of scholars in the early stages of their professional lives. General fields of study for which appointments are given are history of music and musical instruments; history of American and Oriental art; and American material and folk culture. Stipends for 1979–1980 were set at $12,000 annually for postdoctoral fellows and $7,000 for predoctoral fellows. In addition, fellows receive modest allowances for travel and for research-related expenses.

2. *Open Study Program for Undergraduate and Graduate Students and Other Individuals.* Open study assignments consist of supervised tasks that allow the student an opportunity to learn about specified subjects while participating in the ongoing work of a Smithsonian staff member. The Smithsonian cooperates with schools interested in granting academic credit for open study assignments. No financial assistance is generally available, but in special cases, some support may be given. Inquiries should be sent to the Office of Fellowships and Grants by the school or the individual interested in this program.

3. *Graduate Research Training Program.* Graduate students may apply for 10-week appointments to study and conduct research in the field of art history under the guidance of Smithsonian staff

members. The number of these fellowships is limited, and most are available in the summer. The stipend is $100 per week. March 1 of each year is the closing date for applications for fellowships beginning any time after June 1. Notification of awards is made by May 1.

4. *Short-Term Visits.* Some financial support in small amounts is available to students and scholars who wish to make use of the Smithsonian facilities for a short time, but not less than one week. Inquiries should be directed to the Office of Academic Studies or to the appropriate member of the research staff.

General information on Smithsonian grant programs is available from:

> Office of Fellowships and Grants
> Room 3300, Amtrak Building
> L'Enfant Plaza
> Smithsonian Institution
> Washington, DC 20560

Office of Museum Programs

The Smithsonian Institution supports projects that advance the museum profession—its techniques, approaches, and methods—through its Office of Museum Programs. This office provides assistance to museum professionals, students, and special-interest groups concerned with museum practices through a variety of activities, including workshops and internships on all aspects of museum techniques and management.

Through the National Museum Act of 1966, which the Office of Museum Programs administers, grants are made for research, professional assistance projects, and educational and training activities ranging from seminars and workshops to travel for museum professionals.

The act was established to make possible a continuing study of museum problems and opportunities, both in the United States and abroad; to encourage research on museum techniques; and to provide support for the training of career employees in museum practices. Projects supported under this program should be of substantial value to the museum profession as a whole or must contribute to

the improvement of museum methods and practices or to the professional growth of individuals entering or working in the museum field.

Priority is given to proposals dealing with museum conservation: the study of conservation problems, research leading to new or improved conservation techniques, and the training of museum conservators. The involvement and participation of minority groups in the training and professional improvement opportunities offered by the program are especially encouraged.

Applications must be submitted by museums; academic institutions offering courses in museum theory, practice, and skills; or nonprofit professional museum-related organizations, institutions, and associations engaged in activities designed to advance museum training, studies, and practices. Individuals must apply through the organizations with which they are affiliated.

Matching funds are not required and no strict duration is set, but support is provided for not more than one year at a time.

Detailed information on application procedure may be requested from the National Museum Act, Arts and Industries Building, Smithsonian Institution, Washington, DC 20560.

The Smithsonian Institution Traveling Exhibition Service (SITES) is another activity of the Office of Museum Programs of interest to museum and gallery personnel, although it is not a grant program. Traveling exhibitions offered through this program cover the widest range of subjects imaginable. Some of the exhibits are prepared by Smithsonian bureaus; others come from private leaders, foreign governments and museums, and various United States museums.

Information on the SITES services may be requested from the Smithsonian Institution Traveling Exhibition Service, Barney Studio House, 2306 Massachusetts Avenue, NW, Washington, DC 20560.

History and Art Programs

Under the direction of the Assistant Secretary for History and Art, fellowships are given for visiting scholars in the American Studies Program, the National Museum of History and Technology, the National Portrait Gallery, and the Smithsonian Archives. Insti-

tutional support is available for research in American folk culture and the history of music and musical instruments.

Information about these programs may be obtained from the Office of Fellowships and Grants, Room 3300, Amtrak Building, L'Enfant Plaza, Smithsonian Institution, Washington, DC 20560.

The following museums of the Smithsonian Institution offer internships or fellowships for research and study in their particular areas of art and design:

1. *National Collection of Fine Arts* (NCFA). The NCFA has a summer internship program that requires the applicant to initiate his or her own summer project. Interns who concentrate on one aspect of museum work must be seniors who have just graduated or who have completed their junior year of college or graduate students with a strong background in art history or studio art. Stipends are based on the number of interns chosen. In 1979 they ranged from $800 to $1,000.

In cooperation with universities in the Washington area, the NCFA also offers an M.A. program in art history for students who have completed 12 graduate hours of art history. No financial assistance is given, and the NCFA shares with the university concerned a portion of the tuition paid by the student.

For current information and application instructions on these programs, write to Mrs. Patricia Chieffo, Chairwoman, Committee on Professional Training Programs, National Collection of Fine Arts, Smithsonian Institution, 8 & G Streets, NW, Washington, DC 20560.

2. *Freer Gallery of Art.* Scholarships for the study of Chinese art, especially painting, and for the translation into English of works on the subject of Chinese art are made by the Freer Gallery from a bequest of the late Louise Wallace Hackney, for whom the scholarship is named. The scholarships are reserved for promising graduate students and are not available to those of recognized standing. Candidates must have completed at least three years of Chinese language study at a recognized university, must have some knowledge of or training in art, and must be sponsored by recognized scholars in the fields of Chinese language and culture.

Information on the Louise Wallace Hackney Fellowship is available directly from the Freer Gallery of Art, Smithsonian Institution, Washington, DC 20560.

3. *Hirshhorn Museum and Sculpture Garden.* In the summer of

1978, the Hirshhorn Museum and Sculpture Garden had five under-graduate interns working in various departments and participating in a series of seminars on the museum's collection and organization. Each internship carried a stipend of $1,000 for a 10-week period. Information on this program is available from the Smithsonian Office of Fellowships and Grants.

4. *National Museum of Design: Cooper-Hewitt Collections.* The Cooper-Hewitt Museum, founded in New York City in 1897 by the granddaughters of Peter Cooper, is one of the foremost repositories of decorative arts and design in the world. The Smithsonian Institution took over the museum in 1968, and it was reopened in 1976 as the National Museum of Design. The collection provides opportunities for study and research in the history of art, culture, and manufacture; the comparison of style and design motifs; and the analysis of techniques and materials. For information on the museum's visiting scholars program, write to: Lisa M. Taylor, Director, National Museum of Design, Cooper-Hewitt Collections, 2 East 91 Street, New York, NY 10028.

The National Gallery of Art

The National Gallery of Art and the John F. Kennedy Center for the Performing Arts are nominally a part of the Smithsonian Institution, but they operate independently. The National Gallery of Art, although technically a bureau of the Smithsonian Institution, is an autonomous organization governed by its own board of trustees. A professor-in-residence position is filled annually by a distinguished scholar in the field of art history, and the gallery has a graduate and postgraduate fellowship program to enable younger scholars to pursue research in the United States or abroad, often with internships at the gallery. For information on gallery programs, write directly to the Information Office, National Gallery of Art, 6 Street and Constitution Avenue, Washington, DC 20565.

John F. Kennedy Center for the Performing Arts

The Kennedy Center and the U.S. Office of Education are jointly responsible for the administration of the Alliance for Arts Education

Program for children and youth, designed for participation, education, and recreation. *Arts* is defined, in this program, as including the widest range of activities in the fields of music, dance, drama, folk art, the visual arts and crafts, and the broadcast and cinematic arts. The resources of the Kennedy Center, such as technical and staff assistance, training, and information, are provided by the Kennedy Center, and the center assists in the review of applications for grants and makes recommendations to the Office of Education Commissioner regarding them.

Information on this program is available from the Office of Education, Washington, DC 20202 (see "Office of Education," pp. 102–104); and the Alliance for Arts Education, John F. Kennedy Center, Washington, DC 20566.

Special Foreign Currency Program (SFCP)

This Smithsonian program is of particular interest to scholars who wish to study abroad, since it provides assistance for research and for museum programs in the so-called excess currency countries. Under this program, support is given for research, generally on the postdoctoral level, in countries where the United States has, through the sale of agricultural commodities or other exchange agreements, built up local currencies in excess of the normal requirements of the United States. At this writing, excess currencies exist in Burma, Guinea, Egypt, Pakistan, and India.

In the arts fields, two general categories of support are relevant: archaeology and related disciplines, and museum programs.

Projects supported in the field of archaeology range from investigations of the origins of man to studies of art history or of contemporary folk cultures

Museum programs offer support for exhibits, exchanges, and studies of museum professionals, including exhibits technicians, conservation specialists, and museum-exhibits–related research.

Congressional authority for this program requires that grants be made to United States institutions of higher learning, for example, museums, universities, colleges, and research institutions. Applications must be submitted by institutions on behalf of individuals, who should be recognized scholars in the field of study concerned. Junior researchers, such as doctoral candidates, may participate in

field investigations, provided a senior investigator assumes effctive responsibility for the quality of the research.

No award can be made without formal approval of the project by the host country. Potential applicants are advised to consult with the SFCP program director before preparing a proposal for work in a country with which the principal investigator is not completely familiar. In any case, it is advisable to inquire about current "excess currency" countries and to ask for up-to-date application information from the Director, Smithsonian Foreign Currency Program, Office of International Programs, Smithsonian Institution, Washington, DC 20560.

DEPARTMENT OF COMMERCE

Commerce is probably the last place one would expect to find support for arts activities, but there are at least two programs in this department that have relevance to the arts. One, the National Telecommunications and Information Administration (NTIA), provides facilities for public broadcasting, and the other, the Economic Development Administration (EDA), makes funds available to local governments for construction projects.

National Telecommunications and Information Administration (NTIA)

Legislation on public broadcasting (the Public Telecommunications Financing Act of 1978) passed by the 95th Congress moved the Noncommercial Educational Broadcasting Facilities Program from the Office of Education in HEW to the Commerce Department, National Telecommunications and Information Administration (NTIA).

This program was set up for the purpose of providing financial assistance in the acquisition of transmission equipment for public broadcasting stations and to assure accountability for the use of the equipment.

The 1978 legislation authorized $40 million for the years 1979 and 1980. The appropriation was $18 million for FY 1979, and the President's budget request for FY 1980 was $23.7 million. The legislation requires that 75% of the funds be available for the extension of services, leaving 25% for the improvement of facilities so as to

continue service at the same level. Stations are expected to find other sources for taking care of maintenance costs.

The Secretary of Commerce was empowered to develop a long-range plan, to establish criteria for proposals, and to issue new guidelines.

For information write to: National Telecommunications and Information Administration, Department of Commerce, 1325 G Street, NW, Washington, DC 20005.

Economic Development Administration (EDA)

Under the 1976 Public Works Employment Bill, funds were made available through the Commerce Department's Economic Development Administration for public works to provide economic development opportunities and to assist communities in the construction of useful public facilities with lasting effects on the local environments.

Although cultural projects are not explicitly cited among the public facilities eligible for EDA assistance, many communities have applied for and received funds to help construct and renovate theaters, arts centers, libraries, and other cultural facilities under this program:

Completion of a theater complex for festivals, drama, and experimental theater, San Juan, PR	$4,900,000
Rehabilitation of the Brooklyn Academy of Music, New York City	2,386,000
Complete construction of museum and cultural center, Haines Borough, AK	218,000
Tampa Visual Arts and Children's Museum, Tampa, FL	1,890,105
Renovation of an arts and sciences center building, Rockford, IL	839,995
Renovation of Girard High School auditorium for cultural presentations, Girard, OH	175,500
Construction of a performing arts hall, Grand Rapids, MI	4,999,000
Construction of a new facility for Appalshop, Whitesburg, KY, and operating expenses, including salaries, media equipment, and research. Appalshop uses a variety of media to document the traditional social and working life of the Appalachian region: June Appal Recordings, the Roadside Theatre, a film workshop, and a quarterly review.	390,000

A survey of local crafts throughout Louisiana, Oklahoma, Arkansas, and Kansas has been funded through the Ozarks Regional Commission. One person in each state documents local activities and resources, including the numbers and the level of practicing artists, apprenticeship potential, economic impact, and the need of such services as training, marketing workshops, technical assistance, and other forms of public support.

The city of Winston-Salem, North Carolina has applied to the EDA for a $2,140,000 grant to help convert the Carolina Theater—an abandoned 1920s movie theater and vaudeville house—to a modern 1400-seat theater which will serve as a performing space for local and traveling performances and for the North Carolina School of the Arts.

EDA programs are administered through a unit of local government, which must be the direct grantee although the project may actually be carried out by such agencies as school districts, special authorities, and nonprofit organizations. Eligible applicants are states in the region, alone or cooperatively; agencies of state and local governments; Indian tribes or other groups recognized by the state; nonprofit or tax-supported organizations established to foster and encourage the development of indigenous arts and crafts; and such other organizations as may be approved by the commission. It should be remembered that the primary focus of the program is emphasis on jobs for the unemployed in the less-skilled groups where demand for labor is scarce; thus, projects requiring a large percentage of highly skilled labor are not encouraged.

There are six EDA regional offices where application forms and eligibility procedures are available; inquiries can be addressed to the Economic Development Representative at:

> 600 Arch Street, Philadelphia, PA 19107
> 1365 Peachtree Street, NE, Suite 700, Atlanta, GA 30309
> 32 West Randolph Street, Chicago, IL 60601
> 909 Seventeenth Street, Denver, CO 80202
> 221 West 6 Street, Austin, TX 78701
> 1700 Westlake Avenue North, Seattle, WA 98101

DEPARTMENT OF HEALTH, EDUCATION, AND WELFARE (HEW)

In this largest of all federal government departments, with its labyrinthine bureaucracy and its gigantic programs for health, social

security, and other public welfare services, the arts might have been overlooked entirely except for the *E* in the middle—which may be removed if a new Department of Education is set up by the 96th Congress as it may well be.

It was years after the establishment of HEW that the importance of education in and through the arts began to gain some recognition. Once considered a kind of educational stepchild or an unnecessary frill, the arts scarcely entered into the average child's education at all, and many students did and still do graduate from high school without having been introduced to the arts in any form.

President Kennedy's Special White House Consultant on the Arts, August Heckscher, in a report published in 1963, *The Arts and the National Government,* urged that

> consideration be given to increasing the share of the Federal Government's support to education which is concerned with the arts and the humanities . . . the predominant emphasis given to science and engineering implies a distortion of resources and values which is disturbing the academic profession throughout the country.

As social unrest mounted during the 1960s, doubts arose concerning theories about education, and new approaches were sought. Arts education and the use of arts in education began to find favor with educators and the general public, or at least a willingness to consider and experiment with the idea if the government paid for it.

The Elementary and Secondary Education Act of 1965 included provisions for arts and humanities programs if school officials chose to incorporate them into their proposals.

By the middle of the 1970s, a number of books and articles had appeared that dealt with the significance of the arts in American education, and the very fact of their appearance, considering that up to then little or nothing had been written on the subject, was testimony to the change that had occurred.

Unfortunately, at just about that same time, many programs that had flourished in the 1960s were being curtailed as economic pressures began to be felt, and the arts were among the first to be axed. Junius Eddy, former arts education specialist with the Arts and Humanities Program at HEW's Office of Education, wrote in 1977:

> Classroom teachers who, in schools without access to specialists, are responsible for what little arts learning children may receive, possess few of the skills necessary for quality instruction in these disciplines. Arts specialists themselves are being eliminated from school faculties

under the double-barreled pressures of rising costs and decreasing school populations.

Mr. Eddy went on to say:

And yet, in the face of all these disheartening and frustrating signs, there is beginning to be significant evidence that countervailing forces are gathering. An Arts Education Movement is, indeed, emerging within American education.[8]

If such a movement is truly emerging, the efforts, modest though they may be, of the Office of Education must be credited with providing some of the impetus.

At the instigation of the American Council for the Arts in Education, the Office of Education, the National Endowment of the Arts, and several private foundations funded a two-year research study on *Arts, Education and Americans,* under the chairmanship of David Rockefeller, Jr. The 25 panel members who conducted the study represented the arts, education, mass communications, labor, arts patronage, government, and other fields. Their findings and conclusions were published in a book that stands as one of the most important documents—perhaps the most important—of the time on the subject of the arts in education. It is called *Coming to Our Senses,*[9] with the subtitle, *The Significance of the Arts for American Education.* No author is given; it is presented as the report of the panel, and the chairman was largely responsible for it.

The back cover carries this statement by Chairman Rockefeller: "If we want our world to be still, gray and silent, then we should keep the arts out of school, shut down the neighborhood theatre, and barricade the museum doors. When we let the arts into the arena of learning, we run the risk that color and motion and music will enter our lives."

This eloquent warning, presenting the nether side of the picture—what happens *without* the arts in education—is a forceful plea for continued and increasing effort to move the study, practice, and appreciation of the arts toward the center of the educational experience.

[8] *Arts Education 1977 in Prose and Print: An Overview of Nine Significant Publications Affecting the Arts in American Education.* Prepared for the Subcommittee on Education in the Arts and the Humanities of the Federal Interagency Committee on Education, 1977.

[9] *New York:* McGraw-Hill Book Company, 1977.

There are two agencies in HEW where programs that support arts activities have been established: the Institute of Museum Services and the Office of Education. Two other funding agencies under the *E* of HEW—the National Institute of Education and the Fund for the Improvement of Postsecondary Education—also support arts projects if they meet broad educational objectives.

Institute of Museum Services (IMS)

This program began in 1978 and was designed to help ease the increasing operating costs borne by museums as a result of their increasing use by the public; to encourage and assist museums in their educational and conservation roles; and to assist museums in modernizing their facilities so that they may be better able to conserve our cultural, historic, and scientific heritage.

Museum is defined by the institute as "a public or private nonprofit institution which is organized on a permanent basis for essentially educational or aesthetic purposes and which, using a professional staff, owns or uses tangible objects, whether animate or inanimate, cares for these objects, and exhibits them to the public on a regular basis." Aquariums and zoological parks; botanical gardens and arboretums; museums related to art, history, natural history, science, and technology; and planetariums—all are included. In order to be eligible for grants under this program, a museum must be located in one of the 50 states, the Commonwealth of Puerto Rico, the District of Columbia, Guam, American Samoa, the Virgin Islands, the Northern Mariana Islands, or the Trust Territory of the Pacific Islands. It must have at least one staff member, paid or unpaid, who devotes his/her time primarily to the acquisition and/or care of the exhibition.

The emphasis is on operating expenses, and 75% of the first year's funds were earmarked for that purpose, the other 25% going to special projects, especially education and conservation.

In the first year of the program, the institute received 859 applications and made 256 grants, averaging $14,000 each, for a total of approximately $3.7 million. The maximum award of $25,000 went to 66 museums. Thirty percent of the funds went to museums with operating budgets under $1 million.

The program budget for the IMS for fiscal year 1979 was $7.4

million, which enabled IMS to make 403 grants, keeping the ceiling at $25,000. Museums with budgets of $100,000 or less received 48% of the awards. The President's budget request for FY 1980 is $10.4 million, and IMS expects to make around 500 grants.

In general, the IMS grants a museum no more than 50% of its proposed operating or activity budget, but some exceptions are possible. One unusual feature of this program is the commitment to an approval/disapproval time of two to four months. This is an unexpected and welcome change in the general federal pattern.

For current information, guidelines, and application materials, write to: Peggy A. Loar, Institute of Museum Services, Room 326H, Hubert H. Humphrey Building, 200 Independence Avenue, SW, Washington, DC 20201.

Office of Education (OE)

Although there are not many programs in the Office of Education that bear the "arts" label, arts activities are components in the achievement of broad educational goals of the OE. Arts funding often appears as one element in programs for special types of education, such as education for the handicapped, career or adult education, or programs to improve reading skills or to provide special education for gifted and talented students. Many projects supported through these programs include the arts indirectly as a vehicle for achieving a particular educational objective.

It is therefore essential in seeking support for an arts project that applicants think in very broad terms. Garrett Hardin, the economist–ecologist, observed that "you can never merely do one thing," and this is particularly true in the activity of teaching. All learning overlaps, and the techniques of learning often convey as much information as the subject of study. Activities that make use of the arts in education thus often turn out to provide education in the arts.

In 1977, Commissioner of Education Ernest Boyer made the decision to bring arts education into serious focus at all levels, and he made that decision public in his remarks before the Annual Meeting of the International Council of Fine Arts Deans in Minneapolis in October of that year. He outlined his plan for an "arts are basic" initiative in the OE and emphasized his convictions with such statements as: "It's time to declare that art is an essential part of the common core of education . . . it's time to reaffirm that art is

not a frosting or a frill . . . I'm convinced the time has come for the U.S. Office of Education to promote the cause of the arts in education."

The plan called for the establishment of a framework to (1) coordinate an effective structure with the existing programs in the arts; (2) encourage interagency cooperation at the federal level; (3) obtain more funds for arts education; and (4) encourage "saturation" programs that engage whole communities and concern themselves with arts education within the schools, colleges, and universities.

Boyer began to implement that plan in 1978 by the appointment of a full-time arts education coordinator, directly responsible to the commissioner, for the infusion, integration, and dissemination of information from the various programs, projects, and activities in arts education.

That new office launched three separate but overlapping projects as part of the "arts are basic" initiative: the Federal Council on the Arts and the Humanities Working Group on Arts Education; the Arts in Education Forum; and the Inter-Bureau Task Force. Commissioner Boyer himself chaired the Special Committee of the Federal Council, which defined its purposes as:

1. To introduce communication between the different Federal agencies . . . which are involved in arts education
2. To provide a clearinghouse for information
3. To develop federal policy in regard to arts and education
4. To give visibility to distinguished programs throughout the country

In August 1979, the Federal Council on the Arts and the Humanities appointed an arts-education coordinator, with a mandate to build a bridge between the OE and the NEA.

The Arts in Education Forum is designed to promote communication between nongovernmental associations with interests in arts education and the federal government and to provide the OE with a channel for obtaining suggestions for arts education programs from sources other than governmental.

The Inter-Bureau Task Force is composed of representatives from programs and bureaus within the OE that consider ways to enhance the arts in their programs.

Boyer's declaration that the Office of Education intends to pro-

mote the cause of the arts in education is very encouraging; and his initiative in devising a mechanism for coordination of federal arts education activities is laudable. But Boyer resigned as Commissioner of Education as of June 1979, and it remains to be seen whether the commitments he made will be honored by his successor. As with all OE programs, it also remains to be seen how the establishment of a new cabinet-level Department of Education will affect the arts education initiative.

The most significant commitment made by Boyer was to work toward obtaining more funds for arts education. This, in the final analysis, is the fulcrum upon which the future role of the arts in the lives of school-age children depends. Coordinating committees and advisory bodies are very important, but without funds to implement their recommendations, a great deal of excellent work can go for naught.

Arts and Humanities Staff (AHS)

Since 1965, there has been an office within the OE with responsibility for improving the educational status of the arts and the humanities. With funding made available under Title IV of the Elementary and Secondary Education Act of 1965, the Arts and Humanities Program (AHP) mounted nearly 200 research and development projects focused on the arts in education, both the visual and the performing arts, and initiated some projects in the humanities. A detailed report of the work of this office by Judith Murphy and Lonna Jones was published in 1976.[10] This publication provides a chronological history of the achievements of the OE's program of research in arts education over a 10-year period.

Some of the responsibilities of the Arts and Humanities Staff have been assigned to the Commissioner's Arts Education Coordination Office, but the AHS still has responsibility for several arts education programs, and serves as an advocate for the arts and humanities in education and as a central information and referral center. The office has the advantage of having been headed by the same person for a number of years, Dr. Harold "Bud" Arberg, who

[10] *Research in Arts Education: A Federal Chapter.* Washington DC: U.S. Department of Health, Education, and Welfare/Office of Education [HEW Publication No. (OE)76-02000], 1976.

represents the OE and the commissioner on more than a dozen policy-making boards, councils, commissions, and advisory groups concerned with education in the arts and humanities. This continuity enables Arberg to follow the shifting sands of congressional appropriations and his office fills a much-needed role as an information source for arts and humanities programs in HEW.

Arts Education Program. The appropriation for OE's arts education program was increased by $500,000 in FY 1979 bringing it to the $3 million level, where it remained for 1980. Indications are that the 1981 appropriation will be the same—a parsimonious $3 million for three major programs.

In periods of inflation (and the present one seems to have become a permanent condition), funding at a constant level is in reality a decrease of support. Moreover, as of 1980, eligibility for funding under the Arts Education Program has been broadened and the average size of grants enlarged, meaning that the scanty funds are available to a larger population while the *number* of grants must be reduced.

Before 1980, only State Education Agencies (SEAs) and Local Education Agencies (LEAs) were eligible for arts education funding from OE under these programs (See Appendix II for listing of Arts Coordinators in SEAs.) This was expanded by the 1980 legislation to include "nonprofit public and private organizations." The average size of grants, previously $10,000, was increased with no specific upper limit. A number of other changes were made, perhaps the most significant being in the cost-sharing requirement; now OE will fund a maximum of 50% of a project, but the cost sharing can be "in kind" and not necessarily "hard cash."

The arts education programs administered by the Arts and Humanities Staff currently receive allocations as follows: State and Local Programs, $1.25 million; Alliance for Arts Education, $750,000; and National Committee, Arts for the Handicapped (NCAH), $1 million.

1. *State and Local Programs* had a budget of $750,000 in 1978 and made 79 grants to school boards and other educational agencies in 44 states and one in the District of Columbia, of approximately $10,000 each (see Table 1). With a $500,000 budgetary increase in 1979, grants averaging the same amount were made to 44 state and 39 local education agencies. With the changes in eligibility requirements and an increase in the average size of grants beginning in

TABLE 1. ARTS EDUCATION PROGRAM AWARDS (FY 1978)[a]

State	Recipients	Project title	Amount
Alabama	Piedmont City Schools	Piedmont's Arts Education Curriculum Development Program	$ 8,514
Arizona	State Department of Education	Arizona Comprehensive Arts Program	10,000
Arkansas	Little Rock School District	Arts in Education	10,000
California	State Department of Education	The Arts in School Improvement	10,000
	Contra Costa County	Contra Costa County Fine Arts Curriculum	9,702
	Glendale Unified School District	Arts Partnership Dissemination	10,000
	San Carlos School District	Arts Education Project	7,046
	Westminster School District	Mainstreaming Arts into the Curriculum	9,849
Colorado	State Department of Education	State Plan in Arts Education	10,000
	Jefferson County Schools	Jeffco Arts in Education Program	10,000
Connecticut	State Department of Education	Comprehensive Arts Planning Project	10,000
	Hartford Public Schools	The School Is a Theatre	10,000
Delaware	State Department of Public Instruction	Delaware Arts in Education	10,000
District of Columbia	District of Columbia Public Schools	Capital Arts Project	10,000
Florida	State Department of Education	Florida Alliance for Arts Education Council	5,786
Georgia	State Board of Education	Arts Education Program	6,000
Hawaii	State Department of Education	Comprehensive Arts Education Program	10,000
Idaho	State Department of Education	New Curriculum Guides in Visual Arts, Drama and Dance	10,000
	School District 91, Idaho Falls	Project Integration	9,980
Illinois	State Office of Education	Arts in General Education Project	10,000
	Giant City Consolidated School District	Focus on Folk Arts	9,876
Indiana	State Department of Public Instruction	Indiana Inter-Agency Arts in Education Program	10,000

State	Organization	Program	Amount
	Indianapolis Public Schools	Inservice Preparation and a Curriculum Infusion Vehicle for an Arts in Education Program	9,984
	Lafayette School Corporation	Arts in Education Program	10,000
	North Lawrence Community School Corporation	Comprehensive In-Service Plan	10,000
Iowa	Vigo County School Corporation	Arts in Education	10,000
	State Department of Public Instruction	Arts in Education	10,000
	Bettendorf Community School District	Bettendorf Arts in Education Program	10,000
Kansas	State Department of Education	Interrelated/Comprehensive Arts Program	6,431
Kentucky	Owsley County Board of Education	Owsley County Schools Arts Education Program	10,000
Louisiana	State Department of Education	Guide for Integrating the Arts into Elementary Schools	8,000
	Orleans Parish School Board	Learning through the Arts	10,000
	Rapides Parish School Board	Collage	10,000
Maryland	State Department of Education	Developmental/Technical Assistance to Local Education Agencies	10,000
Massachusetts	State Department of Education	Arts-in-Education Advocacy Program	8,000
	Lawrence Public Schools	Environmental Arts in an Urban Setting	9,950
	Topsfield Public Schools	Integrated Arts Project	10,000
Michigan	State Department of Education	Arts in Education	10,000
	Marquette-Alger Intermediate School District	Arts: Awareness, Adaptation and Implementation	9,888
Minnesota	State Department of Education	Arts in Education	10,000
	Independent School District 709	Unique Comprehensive Arts in Education	10,000
Mississippi	State Department of Education	Arts in Public Education	8,000
	Holmes County School District	Promoting Arts Appreciation for the Culturally Disadvantaged Student	10,000
	Starkville Public Schools	Integrated Allied Arts Education Program	10,000
Montana	State Office of Public Instruction	"What Ought to be the Size and Scope of Arts Education in Montana Schools"	8,000

Continued

TABLE 1 (*Continued*)

State	Recipients	Project title	Amount
Nebraska	State Department of Education	Shared Arts Team	$10,000
	Imperial Grade School	Pilot In-Service Program	9,366
New Hampshire	State Department of Education	The Arts: Apart, Together, Alive	7,000
New Jersey	State Department of Education	Developing a Plan for Arts in Education	8,000
New Mexico	State Department of Education	Arts in General Education	10,000
New York	State Education Department	Integrating the Arts into General Education	10,000
	City School District, New Rochelle	Arts in the Schools	10,000
	New York Community School District 1	Integration of Arts into the Curricula II	10,000
North Dakota	State Department of Public Instruction	Coordination of Arts and Cultural Agencies	10,000
Ohio	State Department of Education	Ohio Plan for Comprehensive Arts in Education	10,000
	Springfield City Schools	Coordinated Arts Program	10,000
Oklahoma	State Department of Education	Arts Communication Training II	10,000
	Oklahoma City Public Schools	Fifth Year Comprehensive Arts Program	10,000
Oregon	State Department of Education	Arts Education Project	9,999
Pennsylvania	State Department of Education	Comprehensive Plan for Arts in Education	10,000
	Central Susquehanna Intermediate Unit	Project Arts	9,990
Rhode Island	State Department of Education	Arts Education Planning Institute	10,000
South Carolina	State Department of Education	Arts in Education	8,000
	Kershaw County School District, Camden	Teaching Middle School Language Arts through Movement Experiences	9,461
	Lancaster County Board of Education	Sharing a Learning Space	10,000
South Dakota	State Division of Elementary and Secondary Education	Arts Education Project	10,000
	Midland School District	Project Arts	10,000

State	Agency	Project	Amount
Tennessee	State Department of Education	Tennessee Arts Education	9,989
Texas	State Education Agency	Arts Integration: Inservice Training of Elementary Teachers	10,000
	Denton Independent School District	Aesthetics in Education	10,000
	Elgin Independent School District	Arts Education Project	9,297
Utah	State Board of Education	Planning Pilot Projects in Arts Education	10,000
	Edith Bowen Laboratory School, Logan	Arts Education in Elementary Schools	9,890
Vermont	State Department of Education	Comprehensive Arts Project	7,000
Washington	Office of Superintendent of Public Instruction	Comprehensive Arts in Education Project	10,000
West Virginia	State Department of Education	Arts Education	10,000
Wisconsin	State Department of Public Instruction	Comprehensive Arts Education Implementation	9,582
	Oshkosh Area School District	Arts Education Program	9,420
Wyoming	State Department of Education	Development of Arts Education	8,000

a Source: *American Education*, December, 1978.

1980, it is anticipated that there will be fewer grants made to a broader range of recipients.

Funds awarded under this program may be used for the training of classroom teachers, administrators, and specialists; curriculum planning and development; the services of visiting artists; festivals and conferences; and maintenance support for state Alliance for Arts Education committees.

Information on this program appears in the *Federal Register* in the spring, and applications are due at the end of the year for projects beginning during the coming year. For guidelines and further information, write to Special Arts Projects, Office of Education, DHEW, Washington, DC 20202.

2. The *Alliance for Arts Education* (AAE) was created in 1973 and is a joint project of the John F. Kennedy Center for the Performing Arts and the Office of Education. The national AAE assists state and local AAE organizations by providing a conduit for information and a forum for cooperation. With a budget of $750,000, the AAE supports regional meetings and arts festivals, and creates at the Kennedy Center projects that serve as education models for the arts community. Any state organization that has a primary concern for the arts in education is eligible for membership in the alliance.

The stated goals of the AAE are:

- To facilitate a network for communication and cooperation among arts and education groups and agencies. This effort is implemented by scheduling and coordinating national and regional meetings; by promoting "action-oriented" arts education programs, including those for the handicapped; and by disseminating information and materials on arts education.
- To provide, at the Kennedy Center and elsewhere, a showcase for exemplary arts education programs to serve as models for the arts community. Current programs are the Children's Art Series and Festival and the American College Theatre Festival.
- To provide technical assistance to state AAE organizations.

For further information on this program, write to the Alliance for Arts Education, John F. Kennedy Center for the Performing Arts, Washington, DC 20566.

3. The *National Committee, Arts for the Handicapped (NCAH)* has

been administered by the OE's Arts Education Program since 1975. The committee was formed as a result of several conferences on arts for the mentally retarded that were funded by the Joseph P. Kennedy, Jr. Foundation, but its current programs extend to include the physically as well as the mentally handicapped. The OE now provides operating funds for the committee and some program funds; the total budget has been $1 million for several years and is expected to remain at that level.

The major goals of the committee are:

- To research and disseminate information about curriculum and instruction in the arts to the handicapped
- To exemplify model arts programs that may be successfully used with the handicapped
- To increase the number of handicapped students served by the arts programs by 200,000 per year for five years

In 1977, one of the major programs of the NCAH was the establishment of Very Special Arts Festivals at pilot sites to give handicapped people the opportunity to sing, play an instrument, dance, act, and display their artworks.

For information on NCAH programs, write to the National Committee, Arts for the Handicapped, 1701 K Street, NW, Washington, DC 20006.

Special Projects

Education in the arts and the humanities in OE is also funded through the Emergency School Aid Act, Career Education, the Gifted and Talented Program, the Ethnic Heritage Program, the Teacher Corps, Bilingual Education Program, Follow Through, the College Library Resources Program, and Titles I and IV of the Elementary and Secondary Education Act. Three programs of particular interest are Emergency School Aid—Special Arts Program; Emergency School Aid—Children's Television Series, and the Ethnic Heritage Program.

Emergency School Aid—Special Arts Program. This program provides opportunities for interracial and intercultural communication and understanding through direct contact with professional artists from various art disciplines and from various racial and ethnic backgrounds.

Applicants must be state arts councils or state education agencies. Eligible school districts apply to the appropriate state arts council or state education agency (see Appendix II). Eligibility is based upon minority enrollment and the existence of a plan to prevent minority-group isolation.

Total funds appropriated are $1.5 million; approximately 15 grants are made each year. A national panel of professional artists and school administrators selects 15 of the most promising proposals, and only one is given to a state.

Typical disciplines are crafts, dance, film, music, poetry, theater, and the visual arts.

For guidelines, program information, application forms, write to: ESAA-Special Arts Program, Equal Educational Opportunity Programs, Bureau of Elementary and Secondary Education, U.S. Office of Education, 400 Maryland Avenue, Washington, DC 20202.

Emergency School Aid—Children's Television Series. Beginning in 1973, children's television series for minority and nonminority children have been funded by the Emergency School Aid Act (ESAA-TV), a program under Title VII of the Education Amendments of 1972.

Administered by the Office of Education Bureau of Elementary and Secondary Education, Equal Educational Opportunity Programs, ESAA-TV announces annually that proposals will be accepted for the production of children's educational television series that address content areas and needs related to the reduction, elimination, or prevention of minority-group isolation; results of desegregation; or aid to students in overcoming deficiencies resulting from minority-group isolation.

There are eight program categories within which proposals are solicited annually, but not all categories are funded every year. Those to be funded are published each year in the *Federal Register*.

The general level of funding for this program in the past—which is expected to continue—is approximately $6.45 million per year plus a discretionary $2.15 million. TV production is a very expensive business, and this budget normally supports three large productions, averaging about $2 million each, and five smaller ones at a maximum cost of $300,000 each.

Although there is no category that specifies arts subjects as a content area, performing arts might well be used in producing series

that meet the specific criteria in several categories: the promotion of interracial and interethnic understanding among elementary-school-aged children; bilingual programs in which no one language is used more than 60% of the time; and programs to improve the cognitive skills of minority and nonminority secondary-school-aged children in one or more areas, such as mathematics, science, social studies, or language.

Since 1973, some of the series all or partly supported by ESAA-TV are *Watch Your Mouth; Infinity Factory; Que Pasa, U.S.A.?; As*We*See*It; Villa Alegre; Vegetable Soup; Carrascolendas;* and *La Bonne Aventure.* At this writing twelve series are in production, some of them continuations of national series. New ones are: *Native Americans of Southern New England; Black Teen Drama; Franco-American; Pearls;* and *Bean Sprouts.*

Funds are made available through a mechanism called *contracts of assistance,* which is halfway between a grant and a contract, and unsolicited proposals are not accepted. Announcements concerning the categories to be funded are made annually.

The regulations concerning this program are extensive and difficult to follow; therefore, the ESAA-TV office has prepared an announcement packet that contains a summary of the guidelines. Television producers who are interested should write for information to the ESAA-TV Program Manager, Special Projects Branch, Equal Educational Opportunity Programs, Bureau of Elementary and Secondary Education, U.S. Office of Education, 400 Maryland Ave., SW, Washington, DC 20202.

Ethnic Heritage Program. In recognition of the heterogeneous composition of our nation and of our multiethnic society, and to bring about a better understanding of our various cultural heritages, Title IX of the Elementary and Secondary Education Act of 1965 was amended in subsequent years to include an Ethnic Heritage Studies Program.

Grants and contracts are made to and with private and public nonprofit educational agencies, institutions, and organizations to assist them in planning, developing, establishing, and operating programs in ethnic heritage studies. Included as eligible organizations are ethnic, community, and professional associations, as well as local and state education agencies and higher education institutions, including community colleges.

Major grants are made for one-year periods, not to exceed $50,000, for the purposes of:

1. The development of curriculum materials for use in elementary or secondary schools or institutions of higher education relating to the history, geography, society, economy, literature, art, music, drama, language, and general culture of the group or groups with which the program is concerned
2. The dissemination of curriculum materials for use in schools and institutions of higher education
3. The provision of training for persons using, or preparing to use, curriculum materials developed under this title
4. Cooperation with persons and organizations with a special interest in the ethnic group or groups with which the program is concerned, to assist them in promoting, encouraging, developing, or producing programs or other activities that relate to the history, culture, and tradition of that group or [those] groups

Approximately 15 "minigrant" awards of $15,000 are made annually for projects designed to try out innovative curriculum components for workshops or similar activities. Some of these grants are similar to "demonstration" projects.

The Ethnic Heritage Program has been racked with uncertainty from the beginning, having been regularly deleted from the presidential budget (the first Carter budget was a notable exception) and then restored by the Congress, often at the last minute. Long-range planning has been impossible, to say nothing of the difficulty of maintaining the morale of those people assigned to administer the projects funded under this legislation. In fiscal year 1978, the appropriation was $2.3 million and 56 projects were funded; the appropriation was only $2 million in 1979 and the number of projects had to be reduced. Again for fiscal year 1980, the program was deleted from the presidential budget, and again the House Appropriations Committee restored it at a level of $3 million. Its fate is still uncertain at this writing but, if past history is any indicator, it will probably be approved at a level below that proposed by the Appropriations Committee. A further question concerning the future of this program arises from the possibility that a new Department of Education may be established. The Ethnic Heritage Program might, in that case, be

subsumed under the new department or it might be moved into the National Endowment for the Humanities.

Examples of arts-related projects funded under this program are:

1. "Drama and Theatre of Baltic-American Youth," Southern Illinois University at Carbondale, IL; $19,000
2. "The Traditional Arts and Oral History of Chicanos of Greater Los Angeles," University of California, Center for the Study of Comparative Folklore and Mythology, Los Angeles, CA; $39,000
3. "American Ethnic/Folk Music," Denver School District, Denver, CO; $35,000
4. "The Folklore of Black America: A Television-Based Curriculum for Ethnic Heritage Studies," Greater Washington ETA Association, Inc., Arlington, VA; $38,500
5. "Intercultural Understanding through Art," Denver Art Museum, Denver, CO; $20,245
6. "Ethnic Performing Arts Research and Training Program," Youth Theatre Interactions, Inc., Yonkers, NY; $15,000
7. "Preserving the Cultural Heritage: Ethnic Museums, Art Galleries, and Libraries in the United States," Kent State University, Kent, OH; $37,761
8. "Advocates Children's Theatre," Affiliated Tribes of Northwest Indians, Advocates for Indian Education, Spokane, WA; $42,554
9. "Ethnic Heritage Studies Program: Television Program on Culture and Tradition of Montana Indians," College of Great Falls, Great Falls, MT; $26,000

Information on the program, guidelines, and applications materials are available from the Ethnic Heritage Studies Branch, Division of International Education, Bureau of Higher and Continuing Education, Office of Education, U.S. Department of Health, Education, and Welfare, Washington, DC 20202.

Until 1978, the OE made grants for Noncommercial Educational Broadcasting Facilities, but this program has now been moved to the Department of Commerce and placed in the National Telecommunications and Information Administration (NTIA). The appropriation for FY 1979 was $18 million; $23.7 million was requested by the President for FY 1980. The legislation stipulates that 75% of the

funds must be spent for extension of service, expansion of facilities, etc., leaving only 25% for the improvement of facilities for continuation at the same level. Grants made by the OE under this program will continue to be administered by the OE, but beginning in FY 1979, the Department of Commerce took over all activity of the program (see "Department of Commerce", pp. 96–98), and a new set of guidelines has been prepared by the department.

So many of the programs funded by the OE are administered by the state education agencies that potential applicants should establish and maintain communication with the coordinators of the arts programs in their states. The current list of state education agency (SEA) arts directors and coordinators is given in Appendix II.

DEPARTMENT OF HOUSING AND URBAN DEVELOPMENT (HUD)

Community Development Block Grants

Community involvement is essential for all projects supported by HUD funds. Cultural groups that are interested in applying for grants must work with the public agencies and civic organizations most active in their areas to ensure a realistic response to the needs of the public to be served. All requests for funding through the Community Development Block Grant program must be submitted and supported by the chief elected official of the applicant city or county. The governmental unit then distributes funds, usually in the form of grants, to organizations within the community to carry out projects that have the approval of the city or county. This procedure injects a political factor into the process, an inevitable postulate of decentralized funding decisions. On the other hand, local officials are more sensitive to needs of the local communities and may approve ideas that would find a cool reception in far-off Washington, D.C.

Community Development funds are distributed to states and units of local government for such purposes as: the restoration and preservation of properties of special value for historic, architectural, or esthetic reasons; the expansion and improvement of community

services, especially for persons of low and moderate income; the better use of land and arrangement of residential, commercial, recreational, and other activity centers; and the promotion of increased diversity of neighborhoods through the revitalization of deteriorating areas.

Specific support for cultural activities is provided for in the language of the rule governing allocations of Community Development Block Grants, which reads:

> Acquisition, construction, reconstruction, rehabilitation, or installation of certain publicly owned facilities and improvements. This may include the execution of architectural design features, and similar treatments intended to enhance the esthetic quality of facilities and improvements receiving block grant assistance, such as decorative pavements, railings, sculpture, pools of water and fountains, and other works of art.

Funds are allocated to cities and counties on a formula based on the population density, the extent of the poverty, and numbers of disadvantaged groups in a given area. This means that projects designed to serve the needs of economically or otherwise deprived groups are favored. The Secretary of HUD has a limited discretionary account that may be distributed directly for areawide projects or for unusual or innovative community development projects.

Several arts groups have designed projects to serve special groups within their communities; and groups within economically disadvantaged communities have initiated activities to serve their own needs, for which this program is primarily designed.

The President's FY 1980 budget which was presented to Congress early in 1979, recommended reduced spending and the elimination of some programs, but it requested an increase of $150 million for Community Development Block Grants, indicating the President's continuing interest in the improvement of living standards in economically depressed areas. It appears that this program as well as others designed for that purpose will continue to be sources of support for certain kinds of arts activities.

Information on HUD programs should be requested from the nearest Federal Regional Office of HUD. Listings of these offices are given in the current *United States Government Manual* or may be obtained by writing to the Headquarters Office, Housing and Urban Development Building, 451 Seventh Street, SW, Washington, DC 20410.

Livable Cities

In 1978, as part of his urban policy recommendations, President Carter called for a new Livable Cities program "to help renew and develop the artistic and cultural spirit of the urban environment." Although the majority of the members of Congress seemed to approve of the idea, the appropriation had hard going and was not approved as part of the FY 1979 budget, or as part of the supplemental FY 1979 budget. The President requested $5 million in his FY 1980 presentation; it was reduced to $3 million by Congress, and its fate is still uncertain.

The program provides for support through grants and contracts to nonprofit organizations including neighborhood associations, societies, local and state arts councils, public agencies, local and state governments, and others to initiate specific projects that will use and develop artistic, cultural, and historic resources for the following purposes:

1. The revitalization of cities and neighborhoods
2. The provision of more suitable living environments
3. The initiation or expansion of cultural opportunities for the residents of these areas
4. The stimulation of economic opportunities for community residents

Emphasis is on projects in which the use of artistic and cultural resources is oriented toward community development and other concerns of the various urban communities.

Information concerning the status of the program and the availability of guidelines and application information can be obtained from Kathy Dexter, Office of Neighborhoods, HUD, Room 4100, Washington, DC 20410.

DEPARTMENT OF JUSTICE

Law Enforcement Assistance Administration (LEAA)

The idea that the arts can inject a humanizing element into the dehumanizing environment of correctional institutions, presented

to the LEAA by the American Correctional Association, led to a $1-million grant in 1977 for a project named with an eye to what might be the ultimate acronym: *Creative Use of Leisure Time Under Restrictive Environments (CULTURE)*.

The plan was for LEAA to provide seed money for one year to get the program started and to attract support from local, state, and private funding sources. CULTURE proved to be so successful—both in attracting other funding and in its demonstrated impact on the institutional community—that in 1978, the LEAA agreed to continue supporting it for a second year at the level of $800,000. An exhibition under the sponsorship of CULTURE was held in Washington, D.C., at the General Services Administration building in July 1978 and garnered reviews from critics with plaudits such as, "Either more good artists are going to jail these days, or the jails are producing better artists," and "the best prison art show to date" *(Washington Post,* July 12, 1978).

Second-year support of the project was not expected, and future funding by the LEAA is not planned, but its singular success might provoke rethinking on the part of the Department of Justice and the LEAA regarding the potential of the program to contribute to their search for better ways to focus the energy and the spirit of inmates in various types of correctional facilities throughout the nation.

Information on CULTURE can be requested from the American Correctional Association, 4321 Hartwick Road, Suite 319, College Park, MD 20740

DEPARTMENT OF LABOR

Comprehensive Employment and Training Act (CETA)

In 1973, legislation was passed that inadvertently turned out to be the most ambitious artist-employment program since the WPA in the 1930s. The Labor Department's Comprehensive Employment and Training Act (CETA) was aimed at alleviating the pressures of unemployment and is administered through "prime sponsors": states, cities, towns, and counties with at least 100,000 population. Funds are allocated in categories for training and placement programs; for public service jobs; and for the support of projects that enrich the quality of life while preparing the participants for even-

tual employment outside the CETA program. The 95th Congress reauthorized the Act for four years, beginning October 1, 1978, and revised it to emphasize its primary service to the job-disadvantaged and the long-term unemployed.

When the program was inaugurated, state and local governments used the funds, in most cases, to maintain positions that would have been eliminated because of fiscal shortages, such as jobs for policemen, teachers, firemen, and sanitation workers. But an imaginative arts administrator in San Francisco, John Kreidler, perceived that there were several categories under which artists might qualify and sold his city on the idea. In 1975, San Francisco provided jobs for 24 artists at first and promptly raised the number to 94. This action opened up a whole new concept of the artist in the community, as other prime sponsors in other cities followed San Francisco's lead. It became such an important source of support for artists that Nancy Hanks, former Chairman of the National Endowment for the Arts, is said to have quipped that "CETA stands for Comprehensive Enjoyment of the Arts."

Although CETA jobs are not grants, they serve much the same purpose; they enable artists to earn a living while doing the thing they do best and want to do most.

The program also provides communities the opportunity to experience the arts in new ways, and it has brought to communities the significance of the arts in their own right and as a resource for achieving other ends: stronger communities, livable cities, the prevention of crime and delinquency, a richer use of leisure time, a better life for the aging, and more effective education.

Prime sponsors develop a "Comprehensive Manpower Plan" which they submit to a regional director of the Department of Labor. The plan details the sponsor's employment strategies in accordance with community resources and needs. The sponsor must coordinate the plan with the Central Manpower Services Council in each state, which includes representatives of the community and its major civic and corporate organizations. Arts councils should be aware of these procedures and should inform their representatives on the manpower council of their interest in having the local plan include projects for artists; state arts agencies can, of course, become prime sponsors.

Of the seven categories in CETA, there are four that could

include arts projects:

Title I provides grants for recruitment and placement, classroom and on-the-job training, and transitional employment for the unemployed, the underemployed, and the economically disadvantaged. Job counseling and recruitment centers for artists, as well as skills training, are funded under this Title.

Title II provides public service employment. Artists can be appointed under this Title to residencies in local oraganizations, to conduct workshops, to execute public works of art, to manage civic festivals, or to produce and present touring performances and exhibitions in rural areas.

Title III provides access to arts training and development through short-term programs for special groups, such as youth, native Americans, offenders, older workers, and migrant farm laborers. Artists in these programs may be both trainees and instructors.

Title IV, the best known of CETA categories, is aimed at providing employment for the long-term unemployed and those with job market disadvantages. Since there are few restrictions on the type of positions created under this title, a variety of public-interest jobs can be supported. Eligibility criteria for artists are quite strict, and some areas claim a short supply of trained "professionals" who can meet the standards specified by the Department of Labor for annual income ceiling and length of unemployment time (currently 15 weeks).

These criteria are somewhat abridged by the methods of calculating annual income and unemployment time. The maximum annual income is computed only from the previous three months, unless income during that time exceeds typical earnings for the year. "Family income" does not apply if the artist is an adult who is liable to reporting his own income, even if he lives with parents or other relatives. Employment in "survival jobs" (e.g., as a taxi driver or a waitress) disqualifies some artists whose periods of unemployment as artists have been broken up by such temporary jobs. Artists are therefore urged to register with unemployment offices as *unemployed artists*.

Residency requirements are strict, and applicants must live in the jurisdiction of the prime sponsor.

CETA salaries are low but may be supplemented by local artists'

unions or collectives or by grants or other funds available to the sponsoring organization.

In 1979, there were 600 CETA arts projects in 200 localities, employing about 10,000 artists and accounting for approximately $200 million in federal funds. Examples of successful CETA arts programs reported by the Cultural Resources Development Project of the National Endowment for the Arts, coordinated by Deirdre Frontczak, include the following:

1. *The CETA/Compas Project in Compas, Minnesota.* This project reports a high success rate in preparing artists for nonsubsidized employment. Of the 52 artists who have left the program, 23 are employed in related work with other organizations, and 10 are self-employed (artists involved in marketing artwork or in related projects).

2. *The Idaho Commission on the Arts* received support from CETA for a one-year project to train 18 interns in arts management. After four months of in-house training, each intern is placed with an arts organization in Idaho for eight months of field training. The goal is to encourage arts organizations to use more professional administrators as they continue to grow.

3. *The Port Authority of New York,* in collaboration with 13 CETA artists of the Cultural Council Foundation Artists Project, launched a threefold pilot project aimed at upgrading, renovating, and promoting the city's subway stations. The first component of this project was the installation of 48 ceramic tile pictures which were produced from 12 original prints by 12 different artists and installed by a tile ceramicist in the 9th Street PATH (Port Authority Trans-Hudson Corporation) station in Greenwich Village. The ceramics were placed in 48 poster frames already present in the station for advertising purposes. The second phase was the unveiling of a 50-foot mural, which was completed in the fall of 1979, in the rotunda of the World Trade Center. The third phase called for artists to prepare designs for the renovation of the Christopher Street PATH station. When the designs were presented, they were so impressive that funds to execute them were sought from the city's Urban Mass Transportation grant, and a complete renovation is now under way. In this manner CETA programs have stimulated other kinds of support. Another outgrowth of this pilot project is a joint project between the *Mass Transportation Authority of New York* and the Cultural

Council Foundation Artists Project to renovate and upgrade several New York subway stations.

The New York Cultural Council Artists Project employs 325 artists in various fields.

4. *The Central Islip Psychiatric Center*, Long Island, New York, designed a therapeutic–educational program to redevelop the auditory and visual skills of long-term chronic hospitalized psychiatric patients through the use of music and art therapy, which was staffed with CETA funds. Within six months, an exhibition of patients' artworks and a series of musical shows with patients as performers were organized.

For information on local CETA programs, contact a local prime sponsor, the regional office of the Department of Labor, or the office of the mayor or the city manager. For general information on CETA programs, write to the Cultural Resources Development Project, National Endowment for the Arts, Washington, DC 20506. The NEA's Cultural Resources Development Project publishes the *Bulletin on Federal Economic Programs and the Arts*, which is issued at irregular intervals as significant information develops.

GOVERNMENT PROGRAMS—STATE AND LOCAL

The states began to recognize the importance of the arts many years before the federal government established the National Foundation for the Arts and the Humanities. In 1899, only three years after entering the Union, the state of Utah, at the behest of a woman legislator, Representative Alice Merrill Horne, created the Utah Art Institute. There is no evidence that the fine arts received extensive support at that time, and the objectives of the program were not very clear, but the state's interest in the arts has survived, and in 1979, Utah's appropriation for the arts was the fourth largest in the nation on a per capita basis.

The next oldest currently functioning equivalent to a state arts council was established more than half a century later, not in a state but in one of the special jurisdictions, Puerto Rico. In 1955, the *Instituto de Cultura Puertorriqueña* (State Arts Agency) was created to "contribute to, preserve and enrich the cultural heritage and values of the people of Puerto Rico for present and future generations, to

stimulate creative historic and artistic work and to aid and encourage cultural and artistic organizations." The Institute of Puerto Rican Culture had a budget of almost $4 million in 1978, second only to New York State that year in total dollars.

The New York State Council on the Arts, with a current annual budget of approximately $30 million, about as much as the budgets of all the other state agencies combined, was set up in 1960. Between then and 1965, when the National Endowment for the Arts (NEA) came into being, state agencies were established in California, Georgia, Minnesota, Missouri, and North Carolina.

Exact figures on the numbers of state arts agencies that existed at any one time in past years are impossible to validate because of the differences in types of organizations and the differing views on what constituted a "state arts council," but there were about 8 in 1965, and the number had risen to more than 20 by the time the NEA began to make basic grants to state agencies in 1967.

If accurate statistics are hard to assemble on state arts groups, the task is infinitely more difficult for community arts councils. The idea of local arts councils within governmental units below the state level was introduced in the early 1950s, and the best available estimates put the current number of active organizations at about 2,000.

As a general rule, the search for funds for arts groups should begin as close to home as possible; obviously, the competition on a city, county, state, or regional level is less intense than on the national level. Also there is generally greater understanding of local needs by administrators and officials who are familiar with the cultural, ethnic, economic, and historical factors that influence the development and the acceptance of arts programs in a particular area. The other side of the coin, of course, is that local and regional prejudices can influence decisions regarding arts programs.

National federal arts administrators are insisting more and more on local participation in the support of arts activities, and this ground should be well covered before appealing to a national-level agency.

STATE ARTS COUNCILS

By the end of 1978, there were 56 state-level arts organizations, one in every state and one in each of six special jurisdictions: the

District of Columbia, Puerto Rico, Guam, the Virgin Islands, American Samoa, and the Northern Marianas. The Northern Marianas established their eligibility in 1978 after voting in 1975 to become a commonwealth of the United States rather than continue their U.S.-U.N. Trust Territory status, which had existed since 1947. The U.S. Senate granted them commonwealth status in 1976, and their 14,500 inhabitants are now eligible to receive a basic grant from the NEA under the same conditions as the 50 states and the other five special jurisdictions.

The legislation establishing the National Endowment for the Arts included a provision that 20% of program funds must be distributed to the state and regional councils, and the practice has been to divide 15% in the form of basic grants among the states and jurisdictions that apply, and to allocate the remaining 5% for regional councils and special projects by application on a competitive basis.

There is no question that the catalyst for the establishment of most state arts agencies was the availability of federal funds through the NEA, but even so, as late as 1973 some states were still not including the arts in their own state budgets. The following year, every state and jurisdiction appropriated funds for the arts ranging from $5,100 in North Dakota to $16.5 million in New York; the total state and special jurisdiction appropriations in 1974 amounted to almost $30 million.

By fiscal year 1979, state appropriations were more than $79 million, up from about $67 million in 1978. Sixteen states appropriated more than $1 million for 1979; nine of those were above $2 million; three were more than $3 million; Michigan appropriated slightly more than $5 million, and New York State topped $32 million.[11]

New York State has consistently appropriated almost as much for the arts as all the other states combined, but with its large population, it is only in second place on a per capita basis, with $1.797 per person. American Samoa, with a population under 30,000 and an appropriation in 1979 of $60,846, ranks first with $2.11 per capita.

Obviously, it can be misleading to assume that per capita figures are true barometers of local interest in the arts or an accurate measure

[11] ACA Reports, January-February 1979, Vol. 10, No. 1.

of their availability to the general public. Some state appropriations include line items designating a portion of the funds for a specific use, reducing the amount available for general purposes or distribution within the state on the basis of application. North Carolina appropriated $3,320,582 for 1979, all of it in line items. Approximately one-fourth, $873,492, was earmarked for the North Carolina Arts Council, and the remaining three-fourths went to named organizations or activities. North Carolina's per capita rate would be 61 cents per person, based on the total amount appropriated. Based on the one-fourth that will be given general distribution ($873,492), the per capita rate is 15.8 cents.

Texas, on the basis of per capita state appropriations, ranks at the bottom, with less than 3 cents per person, but there is great interest in the arts in Texas and a great deal of funding from private sources.

Basic grants from the NEA are not automatically made to each state agency. They must be applied for, and each applicant must justify its request by indicating that it can use the funds well and that it will provide some type of matching funds. The first basic grants, made in fiscal year 1968, were for $39,383; by 1974, they had reached $150,000. In 1978, they were $243,000, and $275,000 in 1979.

Basic grants made by the NEA are the most stable source of funds for the arts that most states and special jurisdictions can count on. These grants have also provided a powerful incentive for local support and have inspired most state legislative bodies to appropriate amounts at least equaling the basic grants. In 1979, two-thirds of the states and jurisdictions made appropriations exceeding $275,000.

The state arts agencies design their own grant programs and establish their own criteria for the distribution of funds. Therefore, local arts groups have a great advantage in dealing with a state agency instead of competing on the national level. Each state and jurisdiction is, in some way, unique, and its programs can be tailored to its special character and to take into account the cultural preference of the people in that particular location. It is easier for an organization to make a case for its program with a local representative than to convince a national agency that must think in terms of nationwide relevance and priorities.

Although each state agency can make its own policies, there are many similarities. Most of them do not make grants to individuals

or for operating or construction costs. Some of them do fund organizations through which individual artists can be supported. Most require some kind of matching contribution by the grantee. Nearly all state agencies distribute a newsletter or other informational publication free of charge, and nonprofit arts groups or artists interested in grants should arrange to receive the publication of their state arts agency regularly.

The names and addresses of all state and jurisdictional arts agencies are given in Appendix I.

The federal–state partnership program of the NEA has been so successful in making the arts more widely available to the American public that if the NEA had done only that and nothing more it would have justified its existence. It has, of course, done a great deal more.

The state arts agency is, as it should be, one of the first places that an arts organization looks for assistance, and it is useful to understand how the federal–state partnership works.

That partnership is undergoing some changes, particularly with regard to the system for distributing NEA program funds to the state and regional arts groups.

Until 1979, each state or special jurisdiction received a basic grant, accounting for three-fourths of the portion of NEA's program funds which must by law be distributed to the state and regional councils. The remainder was distributed in the form of categorical grants—the major categories being program development and community development—and in funds for the regional program and for services to the arts field.

Two or more state arts agencies could apply jointly for support of activities that involved a wider area than a single state through a regional program. Eight regional arts organizations serve as few as 3 or as many as 10 states (see Table 2). There are also 11 regional representatives who coordinate NEA activities of all state agencies (see Table 3).

During the transition year of 1979, the basic grants system remained the same; that is, each council was eligible for a specific sum. The categorical grants program was replaced by a program of priorities funds: monies available to each state to be used as they wish, provided the use is rational and meets the national goals of the Endowment. Each council's priority fund is determined by a formula: 50% is based on need, defined as population; and 50% is based on state effort, as represented by per capita investment in the

TABLE 2. REGIONAL ARTS ORGANIZATIONS—NATIONAL ENDOWMENT FOR THE ARTS

Regional arts organizations	States
The Arts Exchange, Inc. Clint Baer, Jr., Director Peter D. Smith, Chairman Phenix Hall 40 North Main Street Concord, NH 03301 (603) 228-1624	Maine, New Hampshire, Vermont
New England Foundation for the Arts, Inc. Thomas Wolf, Director of Programs Alden (Denny) Wilson, Chairman 8 Francis Avenue Cambridge, MA 02138 (617) 492-2914	Connecticut, Maine, Massachusetts, New Hampshire, Rhode Island, Vermont
Southern Arts Federation Anthony Turney, Executive Director Rick George, Chairman 225 Peachtree Street, Suite 712 Atlanta, GA 30303 (404) 577-7244	Alabama, Florida, Georgia, Kentucky, Louisiana, Mississippi, North Carolina, South Carolina, Tennessee, Virginia
Affiliated State Arts Agencies of the Upper Midwest David Haugland, Director Charlotte Carver, Chairman 430 Oak Grove Street, Suite 402 Minneapolis, MN 55403 (612) 871-6392	Iowa, Minnesota, North Dakota, South Dakota, Wisconsin
Mid-America Arts Alliance Henry Moran, Executive Director James Olson, Chairman 20 West 9 Street, Suite 550 Kansas City, MO 64105 (816) 421-1388	Arkansas, Kansas, Missouri, Nebraska, Oklahoma
Western States Arts Foundation Richard L. Harcourt, President Mary Dunton, Chairperson 428 East 11 Avenue, Suite 201 Denver, CO 80203 (303) 832-7979	Arizona, Colorado, Idaho, Montana, Nevada, New Mexico, Oregon, Utah, Washington, Wyoming

TABLE 2 (*Continued*)

Regional arts organizations	States
Great Lakes Arts Alliance Lara Mulholland, Executive Director Sister Kathryn Martin, Chairperson 630 South 3 Street Columbus, OH 43206 (614) 221-4322	Illinois, Indiana, Michigan, Ohio
Consortium on Pacific Arts and Culture Ira Perman, Program Coordinator % Arts Alaska, Inc. 619 Warehouse Avenue Anchorage, AK 99501 (907) 272-3429	Alaska, American Samoa, California, Guam, Hawaii, Northern Marianas

arts by the state or the jurisdictional governing body, taking the tax base into account. Thus, a state with a large population whose per capita investment is small might still have an increase based on population; and a state with a small population and a large per capita investment might also receive an increase based on state effort. States with small populations whose governmental bodies do little for the arts will not fare as well as the others.

The major significance of the priorities fund is that it decategorizes grants made to the states by the Endowment and leaves the determination of how these funds will be used largely in the hands of local organizations.

The regional program will be replaced by one titled Multi-State Activity. The 1979 annual allocation for each region remained at the previous year's level, but the distribution system changed. Every state council received $40,000, and states affiliated with regional arts agencies were required to contribute their allocation to the regional group for the first two years. This plan allows the regional organizations to restructure their funding and to refocus their activity in terms of the priorities and the options of the member states. Those states not affiliated with a regional agency in 1979 could choose to join one and to contribute their multistate allocation to that group. After a state agency received its $40,000 grant, it could apply for special project grants from the funds remaining in the regional allocation, and those grants were awarded on a competitive basis.

TABLE 3. NATIONAL ENDOWMENT FOR THE ARTS

Regional Representatives	States
New England Rudy Nashan 30 Savoy Street Providence, RI 02906 (401) 274-4754	Connecticut, Maine, Massachusetts, New Hampshire, Rhode Island, Vermont
Mid-Atlantic Eduardo Garcia 113 Valley Road Neptune, NJ 07753 (201) 774-2714	Delaware, Maryland, New Jersey, Pennsylvania
Mid-South Gerald Ness 2130 P Street, NW, Apt. 422 Washington, DC 20037 (202) 293-9042	District of Columbia, Kentucky, North Carolina, South Carolina, Tennessee, Virginia, West Virginia
Gulf (vacant)	Alabama, Florida, Georgia, Louisiana, Mississippi
South Plains Frances Poteet 601 East Austin, #1410 Alamo, TX 78516 (512) 787-6756	Arkansas, Kansas, Missouri, Oklahoma, Texas
Great Lakes Bertha Masor 4200 Marine Drive Chicago, IL 60613 (312) 525-6748 *or* 782-7858	Illinois, Indiana, Michigan, Ohio, Wisconsin
North Plains Joanne Soper 3510 Lindenwood Sioux City, IO 51104 (712) 258-0905	Iowa, Minnesota, Nebraska, North Dakota, South Dakota
Southwest Bill Jamison P.O. Box 1804 Santa Fe, NM 87501 (505) 982-2041	Arizona, Colorado, New Mexico, Utah, Wyoming

TABLE 3 (*Continued*)

Regional Representatives	States
Northwest	
Mr. Terry Melton	Alaska, Idaho, Montana, Oregon,
728 Rural Avenue, South	Washington
Salem, OR 97302	
(503) 581-5264	
Pacific	
Mr. Dale Kobler	American Samoa, California, Guam,
P.O. Box 15187	Hawaii, Nevada, Northern Marianas
San Francisco, CA 94115	
(415) 863-3906	
New York Caribbean	
John Wessel	New York, Puerto Rico, Virgin Islands
110 West 15 Street	
New York, NY 10011	
(212) 989-6347	

Under the revised state-federal program, it is expected that the NEA will continue to fund a few service organizations such as the National Assembly of State Arts Agencies (NASAA); the National Assembly of Community Arts Agencies (NACAA), a national service agency for the more than 1,800 community arts agencies in the United States; and the American Council for the Arts (ACA), which administers a technical assistance program for the NEA.

Local decision-making regarding the use of federal funds for the arts worries some critics, particularly those who prefer quality over availability as the major criterion for government arts support. They perceive centralized administration as being more likely to favor support for major institutions, and they fear that local control will result in the frittering away of the money in "artsy-craftsy" activities, street fairs, ethnic festivals, and other projects that are not considered "high art." The NEA formula is designed to substantially support the nation's finest artistic programs and institutions and still to recognize local and regional preferences. It allocates 20% of program budget to the states and regions for discretionary use, and 80% is distributed according to decisions approved by a national council and based on national priorities.

On this point, it should be noted that the large institutions have no corner on the quality market; artistic talent often appears first and is first recognized by small, nontraditional groups and is only later embraced by the great institutions. As Robert Mayer, Executive Director of the New York State Council on the Arts, wrote in *Grants Magazine* in March, 1978, "There are no oracles who can foresee the fountains from which will spring the next generation of creative artists."

STATE HUMANITIES COMMITTEES

The barrage of criticism of the "elitist" stance has been directed much more forcefully at the National Endowment for the Humanities (NEH) than at the NEA, mainly because of what appears to be reluctance on the part of the NEH to decentralize programming to the states and regions as the NEA has done.

The NEH is under the same mandate as the arts Endowment to distribute 20% of its program funds through local organizations. The NEH state-based program was late in beginning. In 1970, 6 state committees were formed; there are currently committees in all 50 states, in the District of Columbia, and in Puerto Rico (see Appendix III).

The humanities committees differ from the state arts councils in some ways. The most important difference is that the state humanities organizations are referred to as "private citizens' committees" and are not state agencies as the arts councils are. The funds do not go through the state, and generally they are not supplemented by state appropriations. The governor may appoint a certain number of committee members, and in some cases, a state may join with the committee in support of certain projects. There are approximately 14 state arts councils that have "humanities" in the name, and in those states, funds may be used for the support of humanities projects as well as of the arts.

The state humanities committees are like the state arts councils in that each is entitled to an equal share of the program funds allotted to the states as "basic grants." Of the mandated 20% that goes to the states, 75% of that amount is distributed equally among the state groups, and 25% is made available as discretionary grants. For 1979, the grants to each state committee were about $300,000.

Discretionary grants are made on a basis that takes into account both population and the merit of proposals. Awards are made to the committee, the "grantee," in the form of two-year grants; therefore, proposal budgets must cover a two-year period. Payments are made annually, and each annual payment must be approved following congressional budget allocations.

Since 1976, each humanities committee has been free to shape its own program guidelines in accord with what it considers to be the best means of providing support for local humanities projects.

Many activities in arts fields are relevant to the humanities, and some humanities areas are a direct outgrowth of the arts, for example, art criticism, art history, and art theory.

The New York Council for the Humanities supports programs "which introduce the contributions and perspectives of the humanities to out-of-school audiences in the State of New York. Eligible projects include lectures, conferences, workshops, exhibits, symposia, radio and television broadcasts, films, and scholars-in-residence." The listing of disciplines in that committee's programs includes literature; archaeology; and the history, theory, and criticism of the arts. Recent projects of the New York committee were an exhibition of photography at the Brooklyn Museum, a planning grant to the Studio Museum for the development of an exhibit entitled "Living Space," and a lecture at the Museum of Modern Art on "Why Art is Indispensable."

Arts groups and humanists whose work is arts-related ought to become familiar with the programs of the humanities committees in their states or jurisdictions. A listing of State Humanities Committees with addresses is given in Appendix III.

COMMUNITY ARTS COUNCILS

Each town, city, or community is so different that it is difficult to define precisely what a community arts council is. Someone has said that an arts council begins with "a group of citizens who share a dream." The particular dream is unique in every place; it is sometimes rooted in the traditional American aspiration to give the next generation more advantages, better education, or just more pleasure than the last one had. Or it may be the simple desire to improve the environment or to build a more cohesive community.

The structure, like the motivation, is also unique to the locale and depends on the resources, the needs, and the inclinations that exist within the community. Sometimes the arts council is a part of the city government, usually in a quasi-official status, but even those that are "private citizens'" organizations must work very closely with the primary governing body.

Public officials in most municipalities already understand the social and economic advantage to the community of a lively arts program and are enthusiastic in their support. Those that still have to be convinced need only to be shown the improvements in business, the schools, the churches, and the community spirit, that result from an active arts program of high quality.

A lively arts program can exist without a community arts organization, but as soon as the programs and groups reach a certain density, a means must be found of coordinating fund raising, scheduling, advertising, membership campaigns, and related activities. The primary function of a community arts council is to provide a forum for coordination.

In some places, the coordination has extended to the conduct of one annual fund drive for all local groups, a kind of United Fund for the arts. Business people seem to prefer this; they are approached once a year for all local groups and are not besieged all through the year by first one and then the other.

Scheduling is critical for arts groups struggling to attract audiences, since the same people seem to be interested in dance, music, theater, and the visual arts, and in each locality, there seems to be a hard core of supporters who attend everything.

The existence of a community arts council also provides a mechanism for the city or county and for local businesses or national corporations with an interest in the community to make a single donation or appropriation for the benefit of all the arts activities. A favorite excuse for declining to support a local group is "If we give to you, we will have to give to all the others."

A major function of a community arts council is to act as a lobbyist for the inclusion of arts activities in the annual budget of the city, town, or municipality. It is easy for local governing bodies to assume that the arts will be paid for by private support or to leave their support up to the state and federal governments. The united efforts of all local arts groups through an arts council can be much

more effective than the splintered effort of each individual arts organization.

A community arts council is also in a much better position to apply for grants to a state arts agency, a national agency, a private foundation, or a corporation. It can build a stronger image of credibility based on a larger budget, more diversified board membership, and greater stability—if one group goes under, the council is still viable.

The combined efforts of local arts organizations can be much more effective in obtaining support from governmental arts agencies, especially those at the national level. One of the biggest money games now is the challenge-grant program of the National Endowment for the arts, which dispensed $30 million in 1979.

In 1977, four highly regarded cultural institutions in Cincinnati applied for challenge grants, and all were turned down. The following year, they combined into a consortium, with the Cincinnati Institute of Fine Arts as the umbrella organization, and were awarded the NEA's largest grant, $2 million. Livingston L. Biddle, Jr., called this "an excellent example for the country as a whole." Since challenge grants must be matched by $3 from the community for every $1 from the NEA, it is obviously easier to raise the matching funds by combining the efforts of all the city's cultural groups.

Cincinnati arts groups have combined their fund-raising efforts for many years, and in 1978, they raised about $2 million; they must now raise $6 million for the required match of the challenge grant, and their organizational structure and past experience with group fund-raising will be a valuable asset.

The history of community arts councils in the United States is unclear, but it is generally thought that the first was started in Winston-Salem, N.C., in about 1950. That was certainly one of the first to be nationally known, and from the beginning, it had the support of the business community. Another very early local arts council, devoted primarily to black arts, is Karamu House in Cleveland.

It is estimated that there are now about 2,000 community arts councils in the United States, and the National Assembly of Community Arts Agencies (NACAA) had identified 1,800. The NACAA became a national service agency for community arts groups in June 1978 and opened their office in Washington in November of that

same year. Membership dues for community arts agencies are based on the size of the budget; affiliate members' dues are $50 a year. The NACAA provides community arts groups with information about what each is doing, about opportunities available to them through federal agencies, and about tools they can use to be more effective as local arts agencies. The National Assembly executive is a representative of local arts agencies in Washington, D.C. and is responsible for voicing the concerns of these agencies when policies are being formulated that relate to the arts at the local level. The address of NACAA is 1625 Eye Street, NW, Suite 725A, Washington, DC 20006.

The National Endowment for the Arts has lately come to pay more attention to community arts programs. In 1978, a 14-member Task Force on Communities' Program Policy was appointed by L. James Edgy, Jr., Deputy Chairman of the National Endowment, to develop overall Endowment policy of support for local cultural activity. Chaired by Eduardo Garcia of Neptune, New Jersey, former Director of the Monmouth County Arts Council, the Task Force held a series of meetings in various parts of the country where they heard both prepared testimony and open discussions on significant issues regarding interaction between the arts Endowment and local arts communities.

Among those presenting testimony in early sessions were Mary Regan, Director of the North Carolina Arts Council and author of *Community Development through the Endowment*; James Backas, Director of the American Arts Alliance and author of a 1977 report prepared for the NEA, *The Arts at the Community Level*; Joseph Golden, who spent four months on leave from his job as head of the Cultural Resources Council of Syracuse, N.Y., to work on community arts at the NEA; and Ann Darling of *Opera America.*

The Task Force was charged with the responsibility of making recommendations for NEA policy with regard to community arts and considering such matters as eligibility standards for community arts councils, funding mechanisms and alternate funding sources, and the establishment of criteria for the functions and services of community arts agencies. For working purposes, a local arts agency has been defined by the Task Force as follows:

> A local arts agency is a public or private not-for-profit organization whose primary purpose is to provide the support system and network to develop, sustain, and deliver arts activities in the community.

Its primary function is to provide some or all of the following services: promotion of arts activities, fundraising, information, technical assistance, workshops, seminars, grant-making, space provision, and central administration services for arts organizations. A local arts agency often serves as a forum for citizens' opinion and acts as an advocate for public and private support of the arts. In addition, a local arts agency may sponsor programs in cooperation with local and neighborhood organizations, or on its own as a catalyst for audience development and new programming.

There are a great variety of local arts agencies in the country differing in structure, program and service as well as in the geographic area they serve.

The Task Force completed its work and submitted a policy report to NEA's National Council in August 1979. The report did not attempt to prescribe a type of organization that should exist at any local level nor an automatic funding mechanism that would ensure a continuing means of federal support for "favored" agencies. Its approach was to suggest appropriate ways of supporting those "mechanisms that best respond to the full range of artists and organizations as they already flourish at the local level."

The Task Force recommended that monies be made available to community arts groups for:

1. Services to the arts in the community, meaning such things as newsletters, centralized purchasing, computer mailing systems
2. Administrative expenses for arts organizations and for the operation of facilities for use by artists
3. Technical assistance and training in publicity, grantsmaking, and other fields to assist the arts in the community
4. Purchase of arts programs such as touring events, performing groups, and arts exhibitions
5. Subgranting to the arts in the community to provide support for programs which maintain or seek to achieve a standard of professional excellence in the arts

The report was referred to the Policy Planning Committee of the Council; until action is taken on it, there will be no ongoing source of communities' support at the Endowment.

Information on the Task Force can be obtained from Deirdre Frontczak, Task Force Director, Intergovernmental Activities, Room

1332, National Endowment for the Arts, 2401 E Street, NW, Washington, DC 20506.

By the end of 1978, 14 cities had participated in the NEA's pilot City Arts project, which is conceived of as a three-year plan to help increase support for neighborhood arts programs by getting local governments to provide funding and technical assistance. Through its Expansion Arts program, the NEA awarded 14 matching grants of from $30,000 to $75,000 to city agencies and community arts councils for fiscal year 1978 to the following cities: Atlanta; Baltimore; Boston; Buffalo; Charlotte (N.C.); Chicago; Dallas; Detroit; Knoxville; Los Angeles; Miami; Minneapolis; San Antonio; and Seattle. All were matched totally by city or county governments except those for Charlotte and Boston, where private sources contributed part of the match.

An organization known as Affiliate Artists has been placing artists in congenial communities across the country for about 10 years and has been supported in the program by communities, businesses, and both public and private agencies.

In 1978, a project called Community Arts Residency Training (CART) was launched to develop expertise in organizing and running a successful arts program in 10 southern states. It was jointly sponsored by Affiliate Artists, the Southern Arts Federation (SAF), the National Endowment for the Arts, the Ford Foundation, and several state arts councils and a number of communities. The program, which is administered by Affiliate Artists, concentrates on training community leaders to organize and manage local programs in Alabama, Florida, Georgia, Kentucky, Louisiana, Mississippi, North Carolina, South Carolina, Tennessee, and Virginia. The Ford Foundation made a grant to cover Affiliate Artists' operating costs for the CART program; additional support comes from corporations and cooperating groups. Information on the CART and other programs of Affiliate Artists is available from Affiliate Artists, 155 West 68 Street, New York, NY 10023.

A Washington, D.C., organization, started several years ago to develop additional support for neighborhood arts organizations and programs, is the Neighborhood Arts Programs National Organizing Committee (NAPNOC); its regional effort is designed to encourage membership among those involved in nontraditional, neighborhood-based arts programs. The NAPNOC currently has six operational regions and three categories of membership: national network

representatives who are involved in multiarts programming, regional members, and associate members. The committee is interested in developing a new distribution network for reaching small neighborhood arts groups and in finding new distribution systems and new strategies to generate funds. Information about the program is available from the Washington office of the NAPNOC, 2013 Columbia Road, NW, Washington, DC 20009.

A publication that community arts agencies would find useful is *Community Arts Agencies: A Handbook and Guide*, which provides "how to do it" information for community arts councils. It includes chapters on organizational structure, fund raising, management, services, programming, and marketing, plus related reading lists. It also lists name, address, budget size, legal status, activities, programs, staffing, and age of all community arts agencies in the United States that responded to the ACA survey conducted for the *Handbook*. This book was published in 1978 with assistance from the Donner Foundation, the National Endowment for the Arts, and the Shell Companies Foundation, Inc. It can be ordered from Publications, ACA, 570 Seventh Avenue, New York, NY 10018, for $12.50.

INFORMATION SOURCES—GOVERNMENT PROGRAMS

The best source of information about government programs at any level and in any agency is the most direct one. If it is possible to identify a specific program that funds activities carried on in an arts organization or that offers assistance to individual artists, a letter or a telephone call is the most efficient way to request guidelines and application forms.

Every organization that depends on government funds for support of its programs should have a research library of carefully selected publications and should also know where additional references may be found.

Many of the publications, especially the periodicals, listed in the chapter on "Basic Sources of Information" contain information on government funding programs that apply to particular fields in the arts, and the pertinent ones should be in every art organization's basic library. Newsletters and program guides of the National Endowments and those of the state arts and humanities agencies, most of which are free, are essential. In addition to these publications

that deal with the arts in general or with specific fields, there are a number of basic references that everyone needs for researching government funding sources and for keeping up on a regular basis with the changes brought about by congressional actions or executive orders.

In order to approach the task of finding support from government sources, the first step is to have some understanding of the way that the federal government is organized. A guide to the organization of the federal government that gives the addresses of agency and department offices, telephone numbers, and other information is the *United States Government Manual.*

UNITED STATES GOVERNMENT MANUAL

For sheer quantity of information, this official handbook of the federal government cannot be matched anywhere even at many times the price. It describes agency and department structures, programs, and activities, and it gives the addresses, telephone numbers, and contact points for specific kinds of information. Program descriptions are sketchy but sufficient to determine whether it is worth writing for complete details. For anyone who needs to understand the organization of the federal government and to be clear about the location of an agency or a program within an executive department, this is an essential reference.

The manual is indexed by personnel, subject, and the names of federal agencies, and it is well edited. It is published by the Office of the Federal Register, National Archives and Records Service, and General Services Administration, and sold by the Superintendent of Documents, U.S. Government Printing Office, Washington, DC 20402. The 1978–1979 edition cost $6.50.

FEDERAL REGISTER (FR)

No government publication, even the *Government Manual,* is completely up-to-date by the time it appears in print. The only way to keep current with changes that take place through the federal bureaucracy is by reference to a daily publication that prints the public regulations and legal notices of all government departments

and agencies, including announcements regarding federal grant programs, the *Federal Register*.

This daily publication updates all other published materials on federal grant programs, but it is so voluminous that one must learn how to use it efficiently.

Beginning in August 1978, the FR added a weekly feature, "Reminders," which appears every Wednesday and lists all grant-related items that appeared during the previous week. Unless there is a great hurry to get new information, therefore, daily numbers can be held until Wednesday to determine which items are of interest.

Another service offered by the FR to make it easier to use is called "Dial-a-Reg," for those who are awaiting information scheduled to appear or who need advance notice. This is a recorded summary of the highlighted notices given over the telephone on the day before they are printed, and it is available in the following cities: Washington, DC—(202)523-5022; Chicago—(312)663-0884; and Los Angeles—(213)688-6694.

Some agencies have volunteered to publish their notices on assigned days of the week, and readers can then examine the FR on the pertinent days. For example, documents about some programs of the Departments of Agriculture and of Health, Education, and Welfare appear only on Tuesday and Friday. Community Services Administration notices appear only on Monday and Thursday. As of this writing, the NEA and the NEH may publish on any day.

The *Federal Register* is sold by the Superintendent of Documents, U.S. Government Printing Office, Washington, DC 20402; $50/year for domestic nonpriority mailing; first-class mailing costs a lot more.

CATALOG OF FEDERAL DOMESTIC ASSISTANCE (CFDA)

This is one publication that should be in the basic library of anyone or any organization that expects to apply for government support on a regular basis.

A compendium of government programs that provide assistance to both profit and nonprofit organizations, to state and local governments, and other specialized groups, this volume lists over 1,000 programs administered by about 60 federal agencies.

The catalog has eight separate indices: agency program index;

applicant eligibility indices for individuals, for local governments, for state governments, and for nonprofit organizations and institutions; a functional index summary; a popular name index; and a subject index.

Included is an excellent description of the government's application and award process, and there is a reference to documents that set forth the administrative requirements for federal grant programs.

The weakness of the *CFDA* is one that plagues all publications; that is, it uses the most current data available at the time it is compiled or updated, and this information may be out-of-date by the time it appears in print. Before 1979, the *CFDA* was published in May and updates were issued in November. The updates contained more material that reflected recently enacted legislation; thus, they were very important and had to be perused as carefully as the basic edition when a funding program was being researched. Beginning in 1979, the annual publication of the *CFDA* was discontinued and it is now being issued irregularly. Subscribers may order the *1979 Revised Basic Manual and Supplementary Service.* The supplements, which will be issued for an indefinite period of time, are expected to keep the information in the basic publication updated.

The *CFDA* is published by the Office of Management and Budget; subscription orders should be sent to the Superintendent of Documents, U.S. Government Printing Office, Washington, DC 20402. The cost is $20 for domestic mailing, and orders must be accompanied by a check or money order made payable to the Superintendent of Documents. The *CFDA* is also available on magnetic tape from National Technical Information Service, Springfield, VA 22151 (tel. 703-557-4650) for $125.

Table 4 shows an entry in the *CFDA* for the programs under "National Foundation on the Arts and the Humanities, National Endowment for the Arts," with explanations keyed to each section.

Late in 1977, the Congress appropriated funds for computerizing much of the information in the *CFDA* through a program called the Federal Assistance Program Retrieval System, known by the inevitable acronym as FAPRS.

The programming of FAPRS is based on the indexes of the *CFDA*, divided into 8 major categories and 83 subcategories. It can be accessed through terminals located in federal regional offices; in college, university, and hospital libraries; and at other places. Three

companies have been licensed to use FAPRS:

> Dialcom
> 1104 Spring Street
> Silver Spring, MD 20910

> General Electric
> 1050 Seventeenth Street, NW
> Suite 400
> Washington, DC 20036

> Service Bureau Company
> 2101 L Street, NW
> Washington, DC 20037

The price of a search varies according to the company and the kind of information requested. FAPRS is, of course, more expensive than the printed catalog, and at this point, there is some question about whether it is either timesaving or more efficient. Some searches must be ordered and delivery may take a few days. In the meantime, a few hours with the *Catalog*, making use of its excellent indexes, can yield the same information.

There is a mystique about computers in our society that causes many people automatically to assume that any information a computer spits out is somehow more reliable and more up-to-date than any other. FAPRS does attempt to keep the information current, and in that sense, it has an advantage over the printed *Catalog*. But computers can only produce information that has been stored previously in their data banks, and the compilation and storing of information for computers is prey to the same drawbacks as the compilation of data for publication. It takes time, and it may be out-of-date when it appears. The decision to pay for a search through FAPRS must be made by each organization based on its own needs and resources. A "test case" or two should prove whether it is worth the time and cost involved.

Information about the nearest access point might be available from the Federal Regional Office or from your local congressman.

NATIONAL FOUNDATION ON THE ARTS AND THE HUMANITIES
NATIONAL ENDOWMENT FOR THE ARTS

45.001 PROMOTION OF THE ARTS—
ARCHITECTURE, PLANNING, AND DESIGN

(1) **FEDERAL AGENCY:** NATIONAL ENDOWMENT FOR THE ARTS, NATIONAL FOUNDATION ON THE ARTS AND THE HUMANITIES

(2) **AUTHORIZATION:** National Foundation on the Arts and the Humanities Act of 1965; Public Law 89-209 as amended by Public Law 90-348, Public Law 91-346, Public Law 93-133, and Public Law 94-462; 20 U.S.C. 951 et seq.

(3) **OBJECTIVES:** To provide grants for projects, including research, professional education, and public awareness in architecture, landscape architecture, urban, interior, fashion, industrial, and environmental design. The program attempts to encourage creativity and to make the public aware of the benefits of good design.

(4) **TYPES OF ASSISTANCE:** Project Grants.

(5) **USES AND USE RESTRICTIONS:** Grants may be used for projects fostering professional education and development, environmental education and public awareness, research, and design projects. There are no funds for construction of facilities.

(6) **ELIGIBILITY REQUIREMENTS:**
Applicant Eligibility: Grants may be made to: 1) nonprofit organizations, including State and local governments and State arts agencies, if donations to such organizations qualify as charitable deductions under Section 170 (c) of the Internal Revenue Code; and to 2) individuals (ordinarily U.S. citizens only) who, according to Public Law 89-209, Section 5(c) must possess exceptional talent.
Beneficiary Eligibility: Same as Applicant Eligibility.
Credentials/Documentation: Applying organizations are required to submit a copy of their Internal Revenue Service tax exemption determination letter with their applications. For State and local governments making application, allowable costs will be determined in accordance with FMC 74-4. For institutions of higher education, hospitals, and other nonprofit organizations making application, allowable costs will be determined according to OMB Circular No. A-21.

(7) **APPLICATION AND AWARD PROCESS:**
Preapplication Coordination: The standard application forms as furnished by the Federal agency and required by OMB Circular No. A-102 must be used for this program for State and local governments only.
Application Procedure: Applicants should request guidelines for this program area and appropriate standard applications (NEA-2 for individuals, NEA-3 for organizations) from: Director for Architecture, Planning, and Design Program, National Endowment for the Arts, 2401 E Street, N.W. Washington, DC 20506. This program is subject to the provisions of OMB Circular No. A-110.
Award Procedure: The Chairman of the Endowment makes the final decision on all awards based on recommendations from the National Council on the Arts (the NEA advisory body) and the consulting panels to the agency. The Endowment Headquarters will determine on a case-by-case basis those applicants who can further disburse grant money to sub-grantees. Notification of the grant award, if made to any subdivision of a State or local government, must be made to the designated State Central Information Reception Agency in accordance with Treasury Cicular 1082.
Deadlines: Different for various projects. Information available from headquarters office listed below.
Range of Approval/Disapproval Time: Dependent on meetings of the National Council on the Arts.
Appeals: None.
Renewals: Renewal grants may be made but are processed as new applications.

ASSISTANCE CONSIDERATIONS:
Formula and Matching Requirements: Grants to organizations, with few exceptions, must be matched, at least dollar-for-dollar, with non-Federal funds.
Length and Time Phasing of Assistance: Length and time may vary with projects. Generally, request may be received at any time for payment not to exceed what is needed for a 90-day period (or monthly for grants over $100,000).
POST ASSISTANCE REQUIREMENTS:
Reports: Financial report within 90 days after termination of grant period or as requested, plus three copies of narrative of accomplishment.
Audits: As determined by the Endowment.
Records: Financial records to be retained by grantee for 3 years following termination of grant, or as determined.
FINANCIAL INFORMATION:
Account Identification: 59-0100-0-1-503.
Obligations: (Grants) FY 78 $4,068,963; FY 79 est $3,736,800; and FY 80 est $3,700,000.
Range and Average of Financial Assistance: Individuals: Up to $10,000; $5,000 average. Organizations: Up to $20,000; $15,000 average.
PROGRAM ACCOMPLISHMENTS: In fiscal year 1978, grants were made to 55 individuals and 191 organizations.
REGULATIONS, GUIDELINES, AND LITERATURE: The following publications are available from Information Processing, National Endowment for the Arts, 2401 E Street, N.W., Washington, DC 20506: "National Endowment for the Arts, Guide to Programs" and "Architecture, Planning and Design Guidelines" for appropiate fiscal year. For information on available publications about architecture and design projects, contact Architecture, Planning, and Design Program, National Endowment for the Arts, 2401 E Street, N.W., Washington, DC 20506.
INFORMATION CONTACTS:
Regional or Local Office: None.
Headquarters Office: Director, Architecture, Planning, and Design Program, National Endowment for the Arts, 2401 E Street, NW, Washington, DC 20506. Telephone: (202) 634-4276 (Use same 7-digit number for FTS).
RELATED PROGRAMS: 14.152, Mortgage Insurance-Experimental Homes; 14.153, Mortgage Insurance-Experimental Projects Other Than Housing; 14.154, Mortgage Insurance-Experimental Rental Housing; 45.003, Promotion of the Arts-Education; 45.006, Promotion of the Arts-Media Arts: Film/Radio/Television; 45.009, Promotion of the Arts-Visual Arts; 45.010, Promotion of the Arts-Expansion Arts; 45.011, Promotion of the Arts-Special Projects; 45.012, Promotion of the Arts-Museums.
EXAMPLES OF FUNDED PROJECTS: 1) A study exploring the possibility of restoring the Bangor (Maine) Opera House; 2) A series of mini plays to be presented in the New York City area depicting neighborhood improvement projects; 3) Preparation of a manuscript on the works and drawings of master landscape architect Jens Jensen; 4) To develop a strategy for the revitalization of the oldest commercial area in downtown Lincoln, Nebraska; 5) To reconstitute and redesign "Urban Design" magazine and its related publications and to commence publishing them under the auspices of the newly created nonprofit Institute for Urban Design.
CRITERIA FOR SELECTING PROPOSALS: All applications are reviewed according to the following standards: artistic quality, the merit of the project, the applicant's capacity to accomplish it, and evidence of local support for the project.

TABLE 4. KEY TO SAMPLE PAGES FROM THE CFDA

(1) FEDERAL AGENCY
The name of the agency responsible for the program.

(2) AUTHORIZATION
Reference to the legislation that created the program. For more detailed information, the act itself can be read. Evidence of familiarity with the provisions contained in the legislation by references to specific portions of it may strengthen a proposal. Copies of legislative acts can be found in federal depository libraries, ordered from the U.S. Government Printing Office, or requested from a congressman.

(3) OBJECTIVES
Defines the purposes for which the program was established; provides one basis—perhaps the main basis—for determining if the proposed activity fits within the program.

(4) TYPES OF ASSISTANCE
One element in determining eligibility for the program. For example, block grants and formula grants are made to governmental subdivisions; project grants and research grants may be made to educational and other nonprofit institutions and to individuals. This item with item (6) will usually clear up any question of eligibility.

(5) USES AND RESTRICTIONS
Describes what the money can be used for: indicates what budget items may be requested. Also states specific purposes for which the funds may *not* be used.

(6) ELIGIBILITY REQUIREMENTS
Indicates specifically what categories of applicants are eligible to apply and to serve as administrators of the funds; also who may benefit by the disbursement of the funds; and what documentation must be submitted as evidence of eligibility.

(7) APPLICATION AND AWARD PROCESS
Information on preapplication consultation and procedures; application deadline dates; submission procedures; and information on the procedures that will be followed for award announcements. Estimate of the time lag between submission date and aware announcement; provisions for appeals or renewals.

(8) ASSISTANCE CONSIDERATIONS
Defines the timing and method of payment of the award; requirement for matching funds or any special stipulations that must be agreed to or qualifications to be met.

Continued

TABLE 4 (*Continued*)

⑨ POSTASSISTANCE REQUIREMENTS
Accounting, reporting, and auditing procedures to be followed.

⑩ FINANCIAL INFORMATION
A very important entry—indicates the amount of funds available in the program for fiscal year of record. This item can never be considered up-to-date, and the data, if significant, should be confirmed with the regional or national office administering the program.

⑪ PROGRAM ACCOMPLISHMENTS
Reports on activities already funded; number of grants awarded in latest year of record.

⑫ REGULATIONS, GUIDELINES, AND LITERATURE
Those listed may be ordered directly from the agency shown in ①; worth ordering for any programs of interest to the applicant, not only as a guide for preparation of a specific application but as an addition to a basic library on federal programs.

⑬ INFORMATION CONTACTS
Regional and national offices to which queries should be directed or applications submitted.

⑭ RELATED PROGRAMS
A system of cross-referencing the *CFDA*. May indicate other sources of grants, fellowships, and training grants in the applicant's area of interest and activity.

It can be requested from the agency that started FAPRS:

Rural Development Service
U.S. Department of Agriculture
14 and Independence Avenues
Washington, DC 20250

THE CULTURAL DIRECTORY: GUIDE TO FEDERAL FUNDS AND SERVICES FOR CULTURAL ACTIVITIES

This directory was compiled under the guidance of the Federal Council on the Arts and Humanities and edited by Linda C. Coe. It lists programs of the federal government that offer assistance to individuals and to cultural organizations. *Culture* is used broadly

and includes, but is not restricted to, the arts. It describes a number of programs that provide assistance through mechanisms other than grants, such as consultation services, educational opportunities, and advisory services.

The first edition of the *Directory* appeared in 1975; an updated edition is scheduled for publication December 1979. It can be ordered from The Smithsonian Institution Press, 900 Jefferson Drive, SW, Washington, DC 20560, for $8.

The American Council for the Arts (ACA), a private nonprofit arts service organization that receives support from the National Endowment for the Arts, publishes and distributes guides for grant-seekers in all sectors. The address is Publications, ACA, 570 Seventh Avenue, New York, NY 10018.

Two ACA guides to governmental sources of arts funding are:

1. *Cities, Counties and the Arts* is a handbook giving models of what some local governments around the country are doing for the arts. It includes information on arts commissions, grants programs, neighborhood arts, zoning, taxes, and outside funding sources. Paperbound: $1.00

2. *Local Government and the Arts*, by Luisa Kreisberg, is a book of strategies for local elected officials. Written in plain language, illustrated, and organized in a loose-leaf binder, it places the arts within the context of municipal priorities: economic development, urban design, transportation, public safety, human resources, and recreation. It emphasizes practicality and highlights successful civic programs using the arts that can work in a city. The National League of Cities Task Force on the Arts assisted in the research for this book; 250 pages, $12.50.

Foundations and the Arts

Scientists say that when one makes an important discovery, it is very difficult to recapture the way one thought prior to the new finding. That can also be said about foundation support for the arts; it is now taken so much for granted that it is difficult to realize what a daring thing it was even as late as the 1950s.

The first charitable trusts or foundations to be formed in the United States were based upon the English pattern of the eighteenth and nineteenth centuries, which was inspired by religion, patriotism, and the needs brought about by the Industrial Revolution. The primary aims were to exercise benevolence, to do good works, to aid the less fortunate, to improve education and medical care, to encourage the love of God, and to create a better and, incidentally, more prosperous society. The earliest American philanthropists were businessmen who devoted themselves to making money with such wholehearted dedication that it became a kind of religion. Successful men of that time understood the importance of education, good medical care, healthful nutrition, and adequate housing. But it is unlikely that Commodore Vanderbilt, Henry Ford, John D. Rockefeller, Sr., or even Andrew Carnegie, who at least liked church music, would have been very receptive to the suggestion that they endow a ballet school, finance a street theater production, or support a budding actor, composer, or sculptor.

It is impossible to speculate as to what their reaction might have

been to the statement by their fellow businessman Winton M. Blount, Chairman of the Board and President of Blount, Inc., in Alabama, at the 1978 Business Committee for the Arts Awards dinner in Los Angeles. Former Postmaster General of the United States, past President of the Chamber of Commerce of the United States, and past Director of the National Association of Manufacturers, Blount said, "I would place art in the category of law and capital and freedom and opportunity as a fundamental requirement for maintaining any society fit for the human spirit."

The idea that "arts are as universal among human cultures as communal eating and sex—they just have to happen," expressed by Joseph H. Mazo in his book, *Dance Is a Contact Sport*,[1] would have invited their disgust and anger if, indeed, they had happened to read such things, which would have been unlikely.

It was the children and grandchildren of America's first tycoons who extended philanthropy beyond its traditional boundaries and included the arts in their largesse. Commodore Vanderbilt's granddaughter, Gertrude Vanderbilt Whitney, founded the Whitney Museum of American Art in 1930; John D. Rockefeller, Jr., agreed to finance the restoration of Williamsburg in the 1920s and gave The Cloisters to the Metropolitan Museum of Art in the 1930s. His wife, Abby Aldrich Rockefeller, was one of the founders of the Museum of Modern Art in 1929, and their sons, especially John D. Rockefeller, 3rd, spread their philanthropy over all the arts fields.

The men who made fortunes, in most cases going literally from rags to riches, understandably expressed their philanthropic impulses through education, health, and those things that promoted physical and economic well-being. Even the next generation certainly did not view the arts as a social necessity. The foundation mechanism was used by them as a convenient, and tax-deductible, conduit through which funds for certain projects were filtered.

Some of the large foundations made a few grants for arts activities in the first half of this century. The John Simon Guggenheim Memorial Foundation gave fellowships to writers, composers, painters, sculptors, and later to choreographers, directors, and filmmakers.

Andrew Carnegie gave money to provide churches with pipe organs— the music was the only part of the church service he enjoyed—and he set up the Carnegie Institute of Pittsburgh as a civic

[1] New York: Da Capo Press, 1976 (paperback); E. P. Dutton, 1976 (hardcover).

gallery and museum in 1896, but the focus was education. Upon the advice of Elihu Root, Carnegie established the Carnegie Corporation in 1911 as a charitable trust, which chiefly supported libraries and medical education. Under the direction of Frederick P. Keppel, who became president of the corporation in 1923, the arts were included in the adult education program, but the emphasis was on education and not support for creative artists. Even that element of the program was phased out in 1938, when the corporation decided that "the place of the arts in our secondary schools and colleges need no longer be regarded as an object of foundation solicitude. Certainly there seems little need here for further direct financial stimulation."[2]

The Rockefeller Foundation made some grants for American music and, along with other foundations, supported arts education activities.

Exact information on support for the arts by foundations prior to 1957 is impossible to calculate because many of them supported projects that contained an education element, and arts organizations learned to include the term *education* in all their programs. But most arts grants made by foundations before the 1950s were given as favors to friends or in the exercise of that venerable philanthropic ritual known as horse trading: "You support my thing and I'll support yours." No private foundation in the United States included the arts in its broad program objectives prior to the second half of the twentieth century.

It is impossible to trace all the events and to understand all the motivations that led to the quite daring decision by some foundations to incorporate the arts into their broad program objectives, but it is enlightening to review a few case histories.

Andrew W. Mellon, who served as Secretary of the Treasury under three Presidents—Harding, Coolidge, and Hoover—and later became Ambassador to the Court of St. James, was said to have been embarrassed when visiting European dignitaries asked to be taken to our (nonexistent) National Gallery of Art. Mr. Mellon responded by inviting them to his home to view his personal collection, which the great art dealer Joseph Duveen had helped him to assemble and which Mellon eventually presented to the U.S. government, along with a structure to house it. Some cynics, Duveen's biographer S. N. Behrman among them, have suggested that Mellon was really

[2] Carnegie Corporation of New York, *Annual Report, 1938*, p. 19.

blackmailed into founding the great gallery by Duveen, who testified at Mellons's 1934 trial for tax evasion that the Mellon Trust had been set up in 1930 and that $3 million worth of art had been turned over to it, but that it was being held in the Mellon apartment in safe-keeping until it could be given to the government, complete with its own building. Be that as it may, Mellon did eventually spend more than $70 million to build the National Gallery of Art, and the Mellon family has since added the magnificent East Building, which was completed in 1978. The Andrew Mellon Foundation is today the leading supporter of the arts among foundations in the United States in dollar amounts, estimated at $14 million in 1977, $11 million in 1976, and $12 million in 1975. About half of that goes to the National Gallery.

Rockefeller interest in supporting the arts began in 1921, when John D. Rockefeller, Jr., hired Beardsley Ruml to survey the Metropolitan Museum of Art, the American Museum of Natural History, and the New York Public Library, to which he proposed to give $1 million each. Ruml, who had a doctorate in psychology from the University of Chicago, became a director of the Laura Spelman Rockefeller Memorial Fund (named for Mrs. John D. Rockefeller, Sr., who had died in 1915), which had become largely inactive. He revitalized it and began to concentrate its resources on the improvement of the social sciences to make them more applicable to modern institutions and modern problems.

The Reverend Frederick Taylor Gates, Secretary of the American Baptist Education Society, had guided the philanthropies of John D. Rockefeller, Sr. He convinced Rockefeller to cease what he termed "retail giving" and to begin making large gifts to national, international, state, municipal, and denominational agencies, or "wholesale giving." It was Gates who convinced Rockefeller to take the lead in founding the University of Chicago, to create the Rockefeller Institute for Medical Research (now the Rockefeller University), the General Education Board, the Rockefeller Sanitary Commission for the Eradication of Hookworm Disease, and, in 1913, the Rockefeller Foundation.

Although Gates continued to hold positions on the Rockefeller philanthropic boards until 1928, John D. Rockefeller, Jr., chose as his philanthropy advisor Arthur Packard, a former field secretary for the World Peace Foundation, who soon had a large staff to assist him with the task of investigating possible recipients for Rockefeller

benefactions. There was almost nothing beyond consideration. Peter Collier and David Horowitz, in their fine book *The Rockefellers, An American Dynasty*, said that Junior, as his colleagues and staff referred to him, seemed to have a talent for spending money that equaled his famous father's for making it: "His checkbook seemed to hang suspended above every new development in American life, and he himself seemed to be involved in everything from helping rebuild war-ravaged Versailles to supporting Egyptologists on missions into the Middle East," wrote Collier and Horowitz.[3]

Thus, John D. Rockefeller, Jr., began a tradition of giving that culminated in the establishment of several foundations and Rockefeller gifts to museums, libraries, restoration projects, and performing-arts organizations as well as individual artists. John D. Rockefeller, 3rd, followed in his father's footsteps; without his leadership, it is hard to believe the Lincoln Center for the Performing Arts would have become a reality. He was responsible for expanding the concept from a music center to one that included all the performing arts, and he served as the first chairman of the Lincoln Center board. He also became deeply attracted to Asia and Asian art (he gave more than 300 pieces of art to Asia House at one time) and also supported the Japan Society's Japan House.

The Rockefeller organization that is currently the most active in support of the arts is the Rockefeller Brothers Fund, which was set up in 1940 by John D. Rockefeller, 3rd, and his brothers, Laurance, Nelson, Winthrop, and David. It was comparatively modest in size until 1951, when John D., Jr., donated $58 million and made it the fourth largest foundation in the country at that time. In 1977, the Brothers Fund ranked 17th among foundations in size and 6th in giving for the arts; its grants in the arts for that year were estimated to be $2.25 million.

Unlike that of the Mellon and Rockefeller Foundations, the decision of the Ford Foundation to support the arts did not emanate from a personal interest on the part of one or more members of the donor family. The attitude of the Ford family toward the arts seems to be and to have been—to put it in the most favorable possible light—indifferent.

The Ford Foundation's decision to launch a national program

[3] New York: Holt, Rinehart and Winston, 1976.

for the performing arts was, according to witnesses who were present at the time and who have written or spoken on the subject, due mainly to the persuasiveness and the efforts of W. McNeil Lowry. The Ford program, which Lowry created, exceeded in size and scope anything that had ever before been done by a foundation in support of the performing arts. It now seems a certainty that a number of opera, theater, and dance companies and several symphony orchestras might not exist today but for the massive support given to them by the Ford Foundation in the years from about 1957 until early in the 1970s.

In 1955, Lowry was Director of Educational Programs at Ford, and he began to talk about moving into humanistic scholarship and the arts. He started a modest program in the humanities that year, and in 1957, he added the arts, combining the two programs and including not only education but the creative and the performing arts as well. The arts and humanities program was launched on a five-year exploratory basis with a budget of $2 million, later raised to $3 million. By 1961, it was recognized that the program would be renewed, and plans were made for the next decade.

Between 1957 and 1975, the Ford Foundation spent hundreds of millions of dollars in the arts and the humanities, most of it in the arts and most of it under Lowry's direction.

In theater, the foundation directly supported the operating budgets of resident professional companies; gave technical assistance to nonprofit companies; supported Off-Off-Broadway theaters and experimental workshops; helped to establish or develop black theater companies and to increase opportunities for the professional training of young blacks; and set up a Cash Reserve Grants Program to assist nonprofit companies in eliminating deficits and to provide reserves of working capital. The foundation, from the early 1960s through 1977, committed some $43 million to the development of nonprofit professional theaters as alternatives to the commercial theater.

In ballet, Ford enabled professionals from the School of American Ballet and the San Francisco Ballet School to visit dance studios across the country to select the most gifted students for advanced instruction and to compete for places in the corps de ballet of those two professional companies. In 1963, $8 million was allocated to assist classical dance in America, and during the next 10 years, every professional ballet company of a minimum size and performing

season was involved in the foundation's program. Eventually, $29.8 million was spent on ballet.

Without the aid of the Ford Foundation, both the Metropolitan Opera and the City Center of Music and Drama (the managing company for New York City Ballet and Opera and New York State Theater) would have been delayed for an indefinite length of time in making the move to the new Lincoln Center for the Performing Arts in 1963 and 1965, respectively; they each received $3 million from the Ford Foundation to make the move. Opera companies in San Francisco, Santa Fe, Chicago, New Orleans, and other cities were also assisted; many young singers were given opportunities for training, apprenticeship, and debut appearances; and American composers were supported and encouraged. By 1974, 27 opera companies had shared a total of $16 million from the Ford Foundation.

It has been said that there was a time when the Ford Foundation could save an entire art form, and its rescue of symphony orchestras may be an example. In 1966, a program was conceived with the objective of improving both the income level of instrumentalists and the performance standards of the orchestras, and ultimately of making a player's career more attractive for talented young musicians. The bulk of the $80 million committed by the Ford Foundation to the program went into a 10-year trust in which the orchestras held varying shares, to be matched by each according to individual ratios. In 10 years, the foundation and matching funds totaled $164.6 million. The economic viability of the instrumentalist's career was distinctly changed. In 1971, the average low salary for a season for members of the American Federation of Musicians was $6,958; in 1977, the starting salary in the seventh highest paying orchestra, Detroit, was $20,800.

There are between 25,000 and 30,000 foundations in the United States today, and it is estimated that approximately 95% of them were established following World War II. Increases in taxes on capital gains and excess profits did a great deal to stimulate the proliferation of the so-called eleemosynary institutions. Profits were very high during and immediately following the Korean War in the 1950s and the coffers of established foundations began to fill up beyond anything that had been anticipated. The appeal of the traditional beneficiaries was still very strong, however, and most foundations simply extended their support for those activities that had always been their major concerns.

At approximately the same time, two new developments occurred that brought about some reexamination of foundation programs. We were plunged into a new international struggle, in which the United States vied with Russia for technological superiority, and the Supreme Court decision of 1954 outlawing school segregation projected us into a domestic struggle to make good on the promises of the Declaration of Independence and the Constitution regarding human rights. Foundations, particularly the larger ones, began to channel more funds into scientific education and research, and many, of all sizes, became active in supporting projects designed to ameliorate the pressing social problems of the time.

In a very short time, there was hardly a serious grant-making foundation of any size that was not funding some kind of program related to social issues—urban crime and violence, civil rights, drug abuse, family planning—or that did not have a strong science program. The targets were improvement of educational, economic, and social conditions, and the assumption was that the improvement of living conditions by the eradication of slums and the provision of greater educational and employment opportunity would resolve most of the problems.

Only a few visionaries saw a role for the arts in dealing with the problems of the inner city, or those of an increasingly older population, or reaching the isolated, the alienated, and the incarcerated. The contributions of the Ford Foundation to the arts are impressive, not only in the amount of dollars given and in the specific results achieved but in pointing the way for other foundations. Ford's impact on the arts appears to have ignited a spark in the foundation world that fired up others, especially the middle-sized and small foundations.

Any assumptions about how foundations make the decision to set up a broad program in a certain field are necessarily very general and do not apply in a large number of cases. Waldemar Nielsen says, "most of the big foundations are more reactive than active, relying upon the initiatives of others."[4] Dr. John Bowers, President of the Josiah Macy, Jr. Foundation, says just the opposite, that if they waited for ideas to come in over the transom they would be in bad shape. "Our best plans come from board members," he says,

[4] *The Big Foundations.* New York: Columbia University Press, 1972. Copyright The Twentieth Century Fund.

"that is what a board is for. They are selected for their ability to give direction to the foundation."

Obviously, it is neither simple nor easy for a philanthropic organization to decide what purposes its finite resources can best serve.

Julius Rosenwald, who made a fortune from the Sears Roebuck mail-order business and set up a foundation to aid black education, is supposed to have said, "I've made millions and spent millions, and I sometimes think spending it is harder than making it." Rosenwald had discovered that it is impossible for a philanthropist or a philanthropic organization to be loved by everybody. The genesis of the antipathy lies in the age-old conflict between the have's and the have-not's. Since their beginning, foundations have been viewed by the American public as the have's, and the two have been locked in a love–hate relationship. Foundations are courted and wooed, but they also provide a natural target for the expression of frustration and resentment by unsuccessful applicants.

In a recently published book, *The Future of Foundations: Some Reconsiderations*, John Knowles, President of the Rockefeller Foundation, says:

> I think that business is goddamn mad at foundations . . . the government doesn't like us. . . . That takes care of two potential supporters. Now comes the third. We at Rockefeller have 10,000 applicants a year. Five hundred of them we fund and they think we should have given them more. The other 9,500 feel absolutely rotten and dislike us for our stupidity and callous indifference. Both feel an ultimate hostility, which they can't express to us.[5]

Thus, Dr. Knowles expands upon a statement that's frequently, and one supposes facetiously, attributed to foundation executives: "If we could manage to fund one out of every ten proposals we receive, we would only succeed in creating nine enemies and one ingrate."

A great deal of the suspicion and animosity that are directed toward foundations by the general public, however, is due simply to misinformation. There is, to begin with, a general lack of understanding about what a private foundation really is. The name *foundation* is often used by organizations that appeal to the public for

[5] Landrum R. Bolling *et al.*, *The Future of Foundations: Some Reconsiderations.* New Rochelle, NY: Change Magazine Press, 1978.

funds, act as trade associations for industrial or other special groups, function as endowments, or are, as that eminent foundation watcher, the late F. Emerson Andrews, once said, "pressure groups or outright rackets."

The best and clearest definition of a foundation appears in the sixth edition of *The Foundation Directory;* it is "a nongovernmental, nonprofit organization, with funds and a program managed by its own trustees or directors, and established to maintain or aid social, educational, charitable, religious or other activities serving the common welfare primarily through the making of grants."[6]

The Council on Foundations, Inc., identifies foundations according to the sources of their funds and places them in three major categories: corporate, community, and independent.

Corporate foundations are created to maintain an established level of giving and to exempt philanthropy programs from the fluctuations of company profits from year to year.

Community foundations serve a city or a region and derive their funds from various bequests and gifts of donors; their boards are usually representative of community interests.

Independent foundations receive their funds from a single person or a few individuals or a family. Many in this category, especially the smaller ones, are under the direction of members of the donor family. However, others that bear a family name—for example, Rockefeller, Ford, or Mellon—have independent boards of trustees and are managed by a professional staff, although the family may have great influence in determining program priorities or even in the designation of specific grantees. The Ford Foundation, the largest foundation in the United States in terms of capital assets, has no member of the Ford family on the board of trustees and no Ford Motor Company stock in its portfolio. Benson Ford resigned from the board in March 1976. Henry Ford II resigned from the foundation's board in December 1976 because he disagreed with the majority of the other members on matters of program policy and was unable to persuade them to his way of thinking.

Independent foundations may function as *operating foundations* or as *grant-making* foundations. Operating foundations use their endowment to provide a service rather than giving money to others to do so. Examples of operating foundations are homes for the aged,

[6] Edited by Marianna O. Lewis. New York: Columbia University Press, 1977, p. ix.

day-care organizations, museums, or correctional rehabilitation institutions. Operating foundations may make grants for certain purposes, but that is not their primary mode of functioning.

Grant-making foundations fall into two general groups: endowed general-purpose foundations and endowed special-purpose foundations. The *general-purpose* foundations make grants for a wide range of human services, education, health, social welfare, scientific research, arts, and cultural activities; the *special-purpose* foundations confine their benefactions to a specific field, such as music or, as in the case of the Robert Wood Johnson Foundation—the second largest in the country in terms of capital assets—to health. The Jerome Foundation is an independent foundation that has determined to focus its program on the arts and the humanities.

An understanding of these terms will help to clarify the information given in reference sources about foundation funding programs, and it is essential for correctly identifying potential funders for particular activities.

Although the independent general-purpose foundations spread their giving over a wide area and usually describe their purposes as including the support of health, international activities, education, the arts and the humanities, scientific research, and social welfare services, they tend to favor some areas of giving over others. For all foundations, it takes only a little research to show where their interest is focused, and some of them are very precise in their statement of purpose.

The Jerome Foundation was founded by the late J. Jerome Hill as the Avon Foundation; the name was changed after Mr. Hill's death in 1972 to more closely identify the foundation with its founder. Mr. Hill was a talented creative artist who excelled in painting, composing, and filmmaking. It is therefore not surprising that the major program focus of the foundation is the arts and the humanities. Cinematography currently receives the largest portion of the Jerome Foundation's grant funds.

Grant-making of the JDR 3rd Fund directly reflects the interests of the founder and is concentrated in two programs: Asian culture and arts in education. The Asian Cultural Program began in 1963 as a result of the fascination of John D. Rockefeller, 3rd, with Asian art and his desire to support cultural exchange in the arts between Asia and the United States. The Arts in Education Program began four years later, inspired by Mr. Rockefeller's concern that the arts

touched the lives of too small a percentage of Americans, and its first step was to explore the question "Can the arts become an integral part of the education of children in American public schools?" In 1977, these two programs divided more than $1 million between them.

The Meadows Foundation in Dallas was founded by Algur H. Meadows, an independent oil executive, who was said to have valued the gifts of great artists as the ultimate contribution to society. Meadows founded the Meadows Museum at Southern Methodist University in 1965; it now has one of the finest collections of Spanish art in the Western hemisphere. He also made gifts for the endowment of the Meadows School of the Arts at SMU, which enabled it to develop into a major center for the study of the arts.

Following Meadows's death, as a result of an automobile accident in 1978, SMU established as a memorial to him the Meadows Award for Excellence in the Arts. The annual award of $25,000 recognizes international achievement by an artist for "distinguished contributions to, and a lifetime of, exceptional achievement in the creative and performing arts," including history, aesthetics, or philosophy of the arts. No honoree has yet been named as of this writing, but this award, because of its size and prestige, may come to be thought of as the "Nobel Prize of the Arts." Isamu Noguchi has been commissioned to create a sculpture symbolizing the award. Meadows was a civic leader, and the Meadows Foundation supports, in addition to the arts, education, youth agencies, hospitals and medical research, and community funds, primarily in Dallas.

Although it is difficult to identify the source of a corporate foundation's determination to emphasize one kind of activity in its grant-making, there is ample evidence that certain of them do show marked favoritism in their selection of the projects they will sponsor.

The Dayton Hudson Foundation, the corporate foundation of a department store chain, concentrates its support on the arts and on social action programs for disadvantaged populations and restricts its grants primarily to localities where there are corporate installations. In the year ending January 31, 1979, approximately 43.6% of Dayton Hudson's grant dollars went to the arts. Many company-sponsored foundations limit their giving to those communities where their headquarters, factories, stores, or other units are located. One can surmise that this decision is rooted in the reasoning that any program contributing to the improvement of living conditions

in a community will make it a more attractive place for employees to live and will aid in recruiting new personnel and in maintaining employee morale. It has recently also come to be recognized that arts programs can have a marked effect on business activity. Restaurants, public transportation, baby-sitters, automobile service stations, and even florists and retail clothing stores realize higher income when a flourishing theater or music program is introduced into the community. An arts festival can be a real boon to local business.

The NCR Foundation, the company-sponsored foundation of NCR Corporation, the nation's largest producer of electronic cash registers and one of the top five computer makers, has traditionally favored higher education in their grantmaking. However, they have increased their support for the arts, from $36,000 in 1977 to about $182,000 in 1978, part of which was in equipment.

Community foundations are by their very nature primarily focused on local needs. Decisions about what activities they will support come from a wide range of voices, many of them the voices of those who are eligible to become beneficiaries. Community foundation funds may come in the form of gifts or bequests from individuals who stipulate exactly what the money is to be used for, or from local fund-raising campaigns, or from taxes. It is significant, therefore, that nearly all community foundations give some support to the arts, indicating local and regional recognition of the importance of the arts. The Pittsburgh Foundation gives about 18% of its grant dollars to the arts, an amount second only to education in that community foundation's priorities. The San Francisco, Cleveland, and Northwest Area Foundations and the New York Community Trust allocate about 10% of their funds to arts and culture.

Speaking before a group of community foundation representatives in Kalamazoo, Michigan, in September 1978, Russell G. Mawby, President of the W. K. Kellogg Foundation, sounded the warning that "the only private foundations in tomorrow's world already exist today. Under current tax law, the birth rate of new foundations is virtually zero." He pointed, therefore, to the growing importance of community foundations and urged that their most effective role is as a "catalyst for identifying critical community needs from among the maze of shifting societal problems." He cited as an example the $400,000 grant by the Kalamazoo Foundation for front-end money leading to $14 million of investments in a new downtown civic center. "That action will have positive impact on

the economic vitality of the Kalamazoo community for generations to come," he predicted.

The way foundations go about deciding to include a particular field among their beneficiaries, intriguing though the subject may be, is of less concern to the applicants than the process whereby certain applications are selected for approval and others rejected. Lindsey Churchill, a former foundation program officer, replying to a question about this process, said, "It was one of the most bizarre experiences of my entire life to see this work. You can go to a number of foundations and you will find staff members who don't know how decisions are made—and that is true of every foundation I have ever heard about. Decisions frequently 'emerge' out of meetings, somewhat in the Quaker style."

A much more specific account of the process was described by the *New York Times* drama critic Mel Gussow, who was invited to observe a meeting of judges to select eight winners of the Rockefeller Foundation's Playwrights in Residence awards in December 1977, which appeared in *The New York Times* on Sunday, January 1, 1978.

Rockefeller has been giving grants to playwrights in this program since 1971, with the objective of stimulating playwrighting and with the hope of selecting each year eight "semiarrived" writers who are just about to emerge as important voices in the theater. Playwrights do not apply for the grants themselves; they must be nominated by one of approximately 50 institutional theaters that Rockefeller invites to submit candidates, and a key qualification is to have had at least one major production, not necessarily in New York. The foundation makes up the list of nominees from those submitted and may add names of its own choice; a panel of judges convenes to make the selection, and the judges also nominate candidates from the floor. The 1977 panel, consisting of seven eminent directors, critics, and playwrights, was presented with the names of 63 nominees; their own nominations brought the total to 79.

Gussow's description of the selection procedure, written in straightforward reportorial style, was a glittering testimonial to the role played by the judges in the whole process and to the value of a "friend at court." On the first ballot 52 of the candidates were eliminated, among them an unknown named T. Y. Joe, a Rockefeller Foundation nominee. The judges clearly had their favorites and were not shy about speaking up for them; 5 of the 8 chosen had been nominated by the judges from the floor. The other 3, who had strong

support from one or more of the judges, were all authors of successful New York plays: Arthur Kopit (*Oh Dad, Poor Dad,* 1964); Miguel Piñero (*Short Eyes,* 1974); and Joseph A. Walker (*The River Niger,* 1972). A very close runner-up was June Havoc, a vaudeville, stage, and film actress whose *Marathon 33* was produced on Broadway in 1963; favorite of at least one judge, she missed out in the last stages of balloting. Gussow winds up his story by asking, "What if T. Y. Joe had had a friend in the house!" There was no suggestion that the winning playwrights were personal friends (although they may have been that, too) of the judges, but they were obviously candidates whose work was known to and admired by the panel members who spoke up for them.

The object lesson in this instance seems not to be that it is necessary to know somebody but rather that it is necessary to *be known by somebody.*

In another foundation that is among the largest arts supporters, the program officer for the arts insists that "many people get grants who do not know *anybody.*" She also says that there is no reason that people in arts groups or individual artists cannot *get to know* foundation officials, and she outlined some of the ways this can be done. Foundation staff members with the responsibility for administering arts programs spend most of their time outside of regular working hours going to performances or exhibitions in order to keep abreast of what is being done in the visual arts and performing arts fields. And yet, according to this foundation official, very few groups that are in need of funds go to the trouble of inviting foundation people to their productions or exhibitions. She suggests that sending notices, flyers, or reviews and inviting foundation personnel to programs or events is the best way to get acquainted with them and to acquaint them with the work of a group. Then, when a representative of the arts organization writes or calls to ask for an appointment to discuss a grant, the responsible foundation official will have some background knowledge about the nature, quality, and purpose of the group.

Statements of this kind by foundation personnel are quite common but are likely to fall on disbelieving ears, such is the distrust and suspicion that exists between the American public and foundations, a mutual distrust that is nourished by disappointing experiences in dealing with each other. Foundations have been beguiled by silver-tongued salesmen into funding projects that were

worthless; and because foundations receive many times more re-
quests than they can possibly approve, there are bound to be more
disappointed applicants than successful ones.

Roger Kennedy, who was vice-president for finance and then
became head of the arts program at Ford—a move he described as
being "recast from the role of Scrooge to Siegfried"—says, "I have
never known anyone who, when presented with the hard decision
between keeping people alive and supporting the arts, would opt
for the arts; therefore, in order to justify using money for arts in
preference to other things like social welfare and education, you must
make a difference, and that means *risks* must be taken." The safe
things will be done by others, according to Mr. Kennedy, and he
has backed up his belief in risk-taking by giving strong support to
modern dance and to theater groups that do new American plays.
In 1978, the Ford Foundation gave five-year grants for financial
stabilization to the Merce Cunningham, Paul Taylor, and Murray
Louis dance companies and to the Alwin Nikolais Dance Theater;
the latter two were made through the Chimera Foundation for
Dance. Additional stabilization grants also went to the Joffrey Ballet
and to the Dance Theatre of Harlem. Ford had already given a five-
year grant to the Alvin Ailey Dance Theatre in 1974. In 1978, Ford
also distributed $1.5 million in New York City to five nonprofit
theater groups that were producing plays by new American writers.
The Foundation made several grants totaling $524,469 in 1978 to the
42nd Street Redevelopment Corporation in New York, a project es-
tablished to restore that main artery of the city's theater district to
its former glory by joint efforts of the theater and business com-
munities. The grants were used in part to complete Theatre Row, a
group of small theaters created from six old tenements. The Foun-
dation also made a $250,000 loan in 1978 to help finance the recycling
of other buildings in the area. Ford Foundation's support for film-
making goes, for the most part, to groups and not to independent
filmmakers. Ford is just beginning to explore its role in arts and
communication, and this may lead to more direct support for radio
and television programs.

The record set by the Ford Foundation in the past for support
of the performing arts is not likely to be matched again, by it or by
any other foundation, but Ford still ranks second or third in dollars
given by foundations for the arts; its total in 1977-78 was approxi-
mately $4 million.

In terms of making the arts more available to the general population, the most significant support for the arts today is that given by the smaller independent foundations and by corporate and community foundations.

When we look at the total amounts given to the arts by each foundation, it is the largest foundations that impress, but a closer look at the distribution shows that on the whole, they tend to give a few grants of large amounts to institutions of national importance. The most extreme case is that of the Charles A. Dana Foundation, which in 1977 gave $2.5 million to the arts in the form of one grant to the Philharmonic Symphony Society of New York for the Dana Distinguished Conductors Fund. The smaller foundations generally distribute their support over a wider area; that is, they give smaller grants but more of them.

Tables 5 and 6 for the years 1975–1976 and 1976–1977 are derived from figures compiled by The Foundation Center from reports sent to them by foundations. Not all foundations report grant information to The Foundation Center, but most of the major ones do, and the center's statistics include more foundations and are more reliable than those from any other source. In these figures, only grants of $5,000 or more are included, and the 1976–1977 figures are "first estimates."

In order to make comparisons, it is necessary to establish some arbitrary criteria for *large, middle-sized,* and *small* foundations; therefore, in discussing the figures reflected in these two charts, we will assume that *large* refers to foundations with assets exceeding $500 million, that *middle-sized* includes those with assets from $100 million to $499 million, and that *small* means those with assets of $99 million or less.

We see that in both years only four large foundations ranked in the top 10 in dollar amounts: the Andrew W. Mellon, Ford, and Kresge Foundations and the Lilly Endowment. In number of grants made, only two of the large foundations ranked in the top 10 in 1977 (Ford and Mellon), and three in 1976 (Ford, Mellon, and Rockefeller). In dollar amounts given, only one middle-sized foundation appears in the top 10 in 1977 (Rockefeller Brothers Fund) and three in 1976 (Moody, Bush, and McKnight). Five of the largest in dollar contributions to the arts in 1977 and three in 1976, therefore, were "small" foundations with assets of less than $100 million.

It is notable that of the 14 foundations that ranked in the first

TABLE 5. FOUNDATION GRANTS FOR THE ARTS—1975-1976[a]

Ranked by dollar amounts

Rank order		Total amount[b]	Number of grants	Rank in number of grants	Capital assets (thousands)
1	Andrew W. Mellon Foundation	$10,931,500	22	6	$ 776,000
2	Ford Foundation	5,751,486	32	1	2,100,000
3	Lilly Endowment	4,611,856	13	14	761,000
4	Moody Foundation	1,630,000	4	c	117,000
5	Vincent Astor Foundation	1,236,580	9	c	60,000
6	Samuel H. Kress Foundation	1,194,500	10	16	32,000
7	Bush Foundation	1,097,500	13	14	195,000
8	S. H. Cowell Foundation	1,070,000	6	c	30,000
9	Kresge Foundation	1,040,000	13	14	710,000
10	McKnight Foundation	990,000	7	c	210,000

Ranked by number of grants

Rank order		Number of grants	Dollar amount[b]	Rank in dollar amount	Capital assets (thousands)
1	Ford Foundation	32	$ 5,751,486	2	$2,100,000
2	Helena Rubinstein Foundation	31	473,500	22	40,000
3	San Francisco Foundation	30	904,618	12	53,000
4	Atlantic Richfield Foundation	29	229,650	41	11,000
5	Edward John Noble Foundation	25	464,350	25	54,000
6	Dayton Hudson Foundation	22	285,450	36	5,000
	Andrew W. Mellon Foundation	22	10,931,500	1	776,000
7	Rockefeller Foundation	20	337,950	30	750,000
8	A. W. Mellon Educational and Charitable Trust	19	963,015	11	21,700
	William Penn Foundation	19	878,869	13	125,669
9	Rockefeller Brothers Fund	18	471,500	23	209,000
10	Surdna Foundation	17	471,259	24	98,000
	Morris & Gwendolyn Cafritz Foundation	17	801,908	14	42,000
	Ahmanson Foundation	17	752,500	15	85,000

[a] Source: The Foundation Center, New York, NY.
[b] Includes only grants of $5,000 or more.
[c] So many foundations give fewer than 10 grants annually that rankings are meaningless.

TABLE 6. FOUNDATION GRANTS FOR THE ARTS—1976-1977[a]

Ranked by dollar amounts

Rank order		Total amount[b]	Number of grants	Rank in number of grants	Capital assets (thousands)
1	Andrew W. Mellon Foundation	$14,063,450	44	1	$ 776,000
2	Kresge Foundation	2,834,000	13	14	710,000
3	Ford Foundation	2,640,058	27	5	2,100,000
4	Howard Heinz Endowment	2,506,000	14	13	65,000
5	Charles A. Dana Foundation	2,500,000	1	c	83,000
6	Rockefeller Brothers Fund	2,250,600	23	8	209,000
7	Dayton Hudson Foundation	1,660,777	37	2	5,000
8	Lilly Endowment	1,638,750	6	c	761,000
9	Mary Flagler Cary Charitable Trust	1,421,856	29	4	66,000
10	Edward John Noble Foundation	1,394,000	9	c	54,000

Ranked by number of grants

Rank order		Number of grants	Dollar amount[b]	Rank in dollar amount	Capital assets (thousands)
1	Andrew W. Mellon Foundation	44	$14,063,450	1	$ 776,000
2	Dayton Hudson Foundation	37	1,660,777	7	5,000
3	Helena Rubinstein Foundation	30	420,300	26	40,000
4	Mary Flagler Cary Charitable Trust	29	1,421,856	9	66,000
5	Ford Foundation	27	2,640,058	3	2,100,000
6	Mary Duke Biddle Foundation	26	227,747	35	10,000
	Frank E. Gannett Newspaper Foundation	26	300,500	29	158,000
7	San Francisco Foundation (Community Foundation)	24	604,767	18	53,000
8	Rockefeller Brothers Fund	23	2,250,600	6	209,000
9	Jerome Foundation	22	501,529	21	17,000
10	Robert Sterling Clark Foundation	19	298,661	30	30,000

[a] Source: The Foundation Center, New York, NY.
[b] Includes only grants of $5,000 or more.
[c] So many foundations give fewer than 10 grants annually that rankings are meaningless.

10 places (some were tied) in number of grants made for 1976, only two were also in the top 10 in dollar amounts. The Helena Rubinstein Foundation, with assets of approximately $40 million, was not in the top group according to dollars either year, but it ranked second in 1976 and third in 1977 in number of grants given.

Large foundations, even those that make a sizable number of grants, often give most of their dollars to major, established, or national institutions. The Andrew W. Mellon Foundation gives about 50% of its arts money to the National Gallery of Art and makes large grants to the American Museum of Natural History, the Brooklyn Institute of Arts, the Pierpont Morgan Library, and the Whitney Museum of American Art. In 1976, the Lilly Endowment gave almost one-fourth of its arts dollars, $1 million, to one recipient, the Indianapolis Museum of Art.

Some interesting observations about the giving patterns of foundations across the country can be gleaned from the Foundation Center's reports for 1977 of grants made in three arts areas: dance, theater, and the performing arts (one list); music; and museums (see Table 7).

In five states (Colorado, Missouri, North Carolina, Texas, and Wisconsin) and in the District of Columbia, grants were reported by foundations in all three arts fields, and none were reported as given outside of the state where the foundations are located. Connecticut foundations reported grants in all three fields, but only one grant went outside the state, and that to neighboring New York; Illinois foundations made one outside grant in Nebraska; Massachusetts foundations gave in all three fields only within the state except for one grant to a Texas organization; and Washington State foundations made grants in all three fields, all within the state except for one to bordering Oregon.

Several foundations, some of the major arts supporters among them, gave all their grants in one location; the Howard Heinz Endowment, for example, which ranked in the top 10 in dollar amounts in 1977, restricted its giving to Pennsylvania. The Ahmanson Foundation, in the top ranks in number of grants made, gave only to California recipients. Other foundations that, according to The Foundation Center data, gave arts grants only within their state in 1977 are the Zellerbach Family Fund, California; the McInerny Foundation, Hawaii; the Woods Charitable Fund, Illinois; the Polaroid Foundation, Massachusetts; the Webber Charitable Fund, Michigan;

the Bush Foundation (which was among the top 10 in 1976), Minnesota; the Gund Foundation, Ohio; and the Mellon Educational and Charitable Trust (among the highest ranking in number of grants given in 1976), Pennsylvania.

A breakdown of all grants reported to The Foundation Center (grants of $5,000 or more) in the three arts fields for 1977 indicates that the overwhelming number were given within the home state of the foundation (see Table 7).

The chances of finding support for activities in the arts fields from a local foundation are immensely greater than those of being supported by one of the large, national foundations. Arts organizations, therefore, do well to start the search for funds with those foundations that are close to home: the community foundations, the corporate foundations that have local installations, and the small or medium-sized independent foundations that concentrate their contributions within one state or region.

More and more foundations are getting into the arts. For one thing, a small amount of money goes a long way, compared with science, health, or education projects. A small foundation can show some real accomplishment with relatively modest sums by assisting a modern dance group or supporting an exhibition of the work of a young artist. Therefore, foundation support for the arts has increased, but along with the quantitative change has come a qualitative change. Many are combining their interest in the betterment of society, improved opportunity, and general social welfare with their arts interest and are funding projects for special rather than general audiences. Just as arts groups in the first half of the century

TABLE 7. FOUNDATION GRANTS IN THE ARTS, 1977[a]

Activity	Number of foundations reporting[b]	Number of grants		
		Total	In-state	Out-of-state
Dance, theater, and performing arts	159	380	318 (83.7%)	62 (16.3%)
Museums	128	290	229 (79%)	61 (21%)
Music	98	272	227 (83%)	45 (17%)
		942	774 (82%)	168 (18%)

[a] Source: COMSEARCH Printouts, The Foundation Center, New York, N.Y.
[b] Most foundations reported in all three areas.

learned to include an educational element in their proposals, now they are learning to include the handicapped, the aged, and the disadvantaged in their projects. This new interest poses serious questions regarding the motivation of some arts groups who apply for grants. Nonprofit organizations often become susceptible to the "bandwagon" effect under the pressures for survival, and they easily succumb to the temptation to go into a program that is readily fundable, even though it may not fit into their overall artistic goals.

This ploy may solve an immediate problem but will prove self-defeating in the long run. On the other hand, many arts groups already include within their programs activities that appeal to special groups, but they neglect to point this out in presenting their case for funding.

As a preliminary step to beginning the search for foundation funding, arts organizations should thoroughly examine their overall objectives to determine their strongest appeal for funding and to discover how much latitude they have within the program for incorporating elements that may not be central to the program but that might make the proposal more attractive to a foundation.

The ultimate goal of every arts organization is to maintain a steady flow of support, which can be achieved only by viewing the whole matter of outside support in terms of the long run. Foundations have a right to expect that their objectives as well as those of the grantee will be fulfilled; it is not in the long-term interest of the group to apply for support unless there is a reasonable expectation that this can be done.

INFORMATION SOURCES—FOUNDATIONS

Foundations used to be shrouded in an aura of mystery and awe, but that is no longer the case. It takes some effort to be informed about foundation programs and activities, but the information is available in abundance for those who know how to go about uncovering it.

Although some foundations seem reluctant to give out information about their programs and grant-making activities, the primary factor that limits dissemination of information by serious grant-making organizations is lack of sufficient staff, as well as the decision not to spend funds for that purpose. The best current es-

timates available indicate that only about 212 foundations have any full-time staff, and about 133 more have some part-time staff. Therefore, of the approximately 22,000 foundations in the United States, only 1.5% have any staff at all. Roughly 19,000 foundations have assets of less than $1 million and are too small to support a staff or to make grants in large amounts as a rule. About 3,200 foundations (about 14.5%) make grants totaling $100,000 or more annually or have assets of $1 million or more; some very active foundations are therefore operating with only part-time or no staff, and it is not surprising if they do not respond readily to requests for information.

In recognition of the need for a central foundation information source, The Foundation Center was established in New York in 1956 for the sole purpose of collecting factual information on foundations and making it available to the public. The center, which is partially supported by foundation grants—271 in 1978—collects data on foundations and their activities and disseminates information in various forms. It provides a central source to which foundations can refer information requests, and through its nationwide chain of cooperating collections, its services are accessible to most of the population in the United States and also in Mexico City.

The most complete collections of reference works on foundations to be found anywhere are those in the libraries operated by The Foundation Center in New York; Washington, D.C.; San Francisco; and Cleveland. Every foundation directory of any value, such as the directories of foundations within a given state, as well as general books on the history of foundations and those that describe programs, advise on proposal preparation and tell how to approach foundations, are all to be found in these libraries. Many are also in the regional cooperating collections, although those libraries concentrate on the foundations in the state or region of their coverage.

The Council on Foundations, Inc., publishes a bimonthly journal, *Foundation News*, that contains articles, news, and features on foundation activities, pending legislation, tax matters, book reviews, and conference and meeting announcements. The Council on Foundations is a service organization for member foundations and major corporations with philanthropic programs. The current membership of approximately 900 represents 50% of foundation assets.

Foundation News contains a removable *Grants Index* compiled by The Foundation Center, a listing of all grants of $5,000 or more reported to the center by foundations, indexed by key words and

phrases and by recipients. The index is the best compilation of current foundation grant-making published anywhere. "Using the Grants Index to Plan a Funding Search," an article by Karin Abarbanel that appeared in *Foundation News* in the January–February 1976 issue, is an excellent detailed guide for making use of the index; a reprint is available upon request from *Foundation News,* 1828 L Street, NW, Washington, DC 20036. Subscription orders for *Foundation News* may be sent to Box 783, Old Chelsea Station, New York, NY 10011. Nonmember subscriptions cost $20 a year.

There is a legal requirement that every foundation must prepare an annual report and make it available for public inspection, but, very few foundations put out separately published annual reports. They are expensive to produce and to distribute. Annual reports are one of the best and most current sources of information on foundations; about 400 foundations publish them and will usually mail them out upon written request.

The number of newsletters being published by foundations has increased in recent years. A survey in 1974 showed only about 10 foundation newsletters; now approximately 40 are being published, and 8 associations of grant makers issue periodical publications for their constituencies (see Table 8, pp. 198–200).

There are subscription services that provide information about foundations, many of them produced by management-service business organizations, and some arts groups find them to be effective.

News items about foundation activities appear in the daily press, in periodical publications, and on television. Nearly every library has a collection of reference volumes, directories, and other guides to foundation programs.

There are very few organizations so remotely situated that they cannot find some source of information on foundation giving policies and patterns, but foundation programs are not immutable and this search is a continuing process. Programs and policies of foundations may be determined by the general needs of the society, by the biases of the donor, by the perceptions and influence of board members, or by motivations not readily identifiable. Indeed, the inner workings of foundations often seem as incomprehensible to most grant seekers as those mysteries cited in the Book of Proverbs: "The way of an eagle in the air; the way of a serpent upon a rock; the way of a ship in the midst of the sea; and the way of a man with a maid." But another proverb contains an excellent guideline for

deciding which foundations are potential supporters for a particular activity: "Even a child is known by his doing." The best clue to a foundation's interest is found in the kinds of projects it currently funds; recent grants made by any philanthropic organization are the most accurate indicator of its interests.

Research for foundation funding sources should be conducted with some essential facts in mind:

1. The proposed project must fall within the known scope of interest of the foundation.

2. Some foundations prefer to support certain types of organizations, such as schools for the handicapped or people with handicaps, but not "educational" institutions; or they may be willing to fund schools but not performing-arts organizations, or vice versa.

3. Many foundations limit the geographic area within which they make grants.

4. Certain foundations are concerned mainly with specific populations, such as the disadvantaged, the aged, the poor, or preschool children.

5. All foundations have some restrictions on their grants. Some do not fund construction projects or give money for operating costs; some give only in one area—music, or the performing arts, or arts education; and all have some kind of dollar limitation.

6. Few foundations have set deadline dates for the submission of applications, except for special competitions or fellowship awards. If there is a cutoff date, it should be noted—it may rule out a foundation for a particular project.

Since it is most important to begin the foundation search as close to home as possible, one of the first steps is to consult a directory of foundations within your state or region if one is published for your area. Thirty-four states are now covered. Most state foundation directories include small and medium-sized foundations as well as the large ones, and they are an invaluable reference source for the small arts group or the individual artist.

STATE FOUNDATION DIRECTORIES

Until recently, state foundation directories were a rarity; in 1975, a search turned up only 11: 1 for the District of Columbia, and 1 each for 10 states. There has been such a proliferation since then

that Patrick Kennedy, editor of *Foundation News,* wrote in the May–June 1978 issue, "Hot Dawg! We're getting some 'competition' in the matter of the publication of state directories. We're also getting more quality and information."

It is true that taken as a whole, the directories are improving, but the quality ranges from very poor to excellent and some are still little more than listings with telephone-book–level information. There is wide variation in the criteria used for inclusion in these directories: some of them omit operating foundations, most do not include community foundations; many exclude those organizations that give to predesignated beneficiaries; and many foundations decline to submit information or refuse to be included in a directory.

What is needed—and will probably be established eventually—are clear ground rules for state guides that set criteria for the types of institutions to be included, the amount and kinds of data for each entry, and the basic indexes that each volume ought to contain.

Perhaps the most important element accounting for the nature and quality of each directory is the expertise of the compiler. The knowledge, industry, and assiduity of the editor who puts any directory together are easy to measure through the most superficial examination of the publication. The sources and organization of the material included, the kinds of indexes and the accuracy with which they are prepared, and the completeness and currency of the data given for each entry can be ascertained, and all these items should be noted before investing in any publication, especially the very expensive ones.

The compiler is, to some extent, limited by the cooperation that he or she receives from the foundations, since up-to-date information can best be obtained directly, and the record of foundations in this matter is generally very poor. It was reported that when foundations in Massachusetts were sent questionnaires asking for information to be included in the directory for that state, described below, about 70% did not reply.

The two CETA employees who put together an Oregon directory, under the auspices of the Tri-County Community Trust in Portland, reported that they were pressured to omit two foundations who, according to them and others involved in the project, threatened to withhold funding from certain organizations if their foundations were listed. Since most of the information is contained on forms submitted to the Internal Revenue Service and easily obtain-

able by anyone, and since every private foundation is required by law to prepare an annual report and make it available for inspection by the public for 180 days, it seems to be not only uncharacteristically antisocial behavior for a philanthropic organization to deny the information to a compiler but also quite futile.

The financial activities of tax-exempt, nonprofit organizations are now recognized as being information that the public has a right to know, and foundations that attempt to restrict the publication of information about themselves are playing with federal regulatory fire. They are also risking the embarrassment of just looking foolish, as did the two Oregon foundations when *Foundation News* published information from their IRS reports along with a review of the Oregon directory.

When foundations refuse to cooperate, the best information available is from the most recent IRS return. Those forms are filed several months after the end of the fiscal year, and it takes time for the IRS to process them for distribution, so they are always out-of-date. Foundations should welcome the opportunity to update information for a foundation guide; it is to their advantage to have accurate and current information about their organization disseminated.

There seems to be little or no correlation between the amount and quality of information in these directories and their cost. The well-indexed Pennsylvania directory described below, which gives information on 1,078 foundations, costs $14; whereas the New York guide, which has no subject index and boasts about its omissions, costs $29.95. Many of the most expensive ones have no subject index—it is surprising how many omit this very important reference tool—and some of the least expensive ones are very well indexed. State directories can be found in reference libraries and in The Foundation Center cooperating libraries. It is a good idea to inspect a copy thoroughly before buying one.

Directories are now available for 34 states and for the District of Columbia. They are not all in separate volumes. *A Guide to Foundations of the Southeast,* for example, comes in four volumes, and each volume includes two or more states.

States for which there are no directories have very few foundations for the most part. Only one, Missouri, has more than 500 foundations listed in The Foundation Center's *National Data Book.* (Information in the *National Data Book* is taken from Internal Reve-

nue Service information returns—Forms 990-AR and 990-PF—filed annually by private foundations. It is the most complete listing available of all United States foundations regardless of size. Since not all community foundations are classified as private foundations and therefore do not file Forms 990-AR and 990-PF, many are not included in the *National Data Book* listing.) Of the other states without directories, only one, in addition to Missouri, has more than 250 foundations: Iowa. Only three—Arizona, Delaware, and Nebraska—have more than 100. The other 11 states without directories and the number of foundations in each are Hawaii (95), Idaho (40), Montana (48), Nevada (23), New Mexico (34), North Dakota (32), South Dakota (27), Utah (84), West Virginia (48), and Wyoming (24). Alaska has only 6.

These figures, from the most recent issue of the *National Data Book,* indicate that nine states have fewer than 50 foundations, and a directory for those states may not be worth compiling, as it may not be even for those with approximately 100 foundations. But it is unfortunate that no guide has been published for Missouri and its approximately 600 foundations or even for Iowa, for which the *National Data Book* lists about 250.

Some states have more than one directory, and those selected for listing here met one or more of the following criteria: it is the only one, the most recent one, or the one that includes a greater number of foundations and the most information. For two states, Minnesota and Virginia, two directories are cited; otherwise only one directory is listed for each state.

Alabama

A Guide to Foundations of the Southeast, Vol. IV, edited by Jerry C. Davis, 1976. Davis-Taylor Associates, Route 3, Box 289, Mt. Morgan Road, Williamsburg, Kentucky 40769. 165 pp. $25.00.

This volume includes foundations in Alabama (126), Arkansas (105), Louisiana (173), and Mississippi (69), many of them with assets of less than $5,000. Louisiana has 16 foundations with assets above $1 million; Alabama has 14; Arkansas has 3; and Mississippi shows no foundations with assets of $1 million. The financial data are from the IRS 990-PF and 990-AR forms, and therefore community foundations are not generally listed; the Greater Birmingham Foun-

dation in Alabama, for example, is omitted. The small foundations in these states (only one foundation in all four states had assets of more than $10 million at the time this directory was compiled) quite understandably concentrate their giving in local areas. An alphabetical list of officers is included. This is an expensive publication, but it can be referred to in The Foundation Center cooperating libraries; some arts groups may find it worth the price.

Arkansas

See Alabama.

California

Where the Money's At, How to Reach Over 500 California Grant Making Foundations, edited by Patricia Blair Tobey with Irving R. Warner as contributing editor, 1978. ICPR Publications, 9255 Sunset Boulevard, 8th Floor, Los Angeles, CA 90069. 536 pp. $17.00.

A compilation of 525 foundations, arranged alphabetically by foundation name, and indexed by name of foundation, within Northern or Southern California, by county, and by names of personnel.

For the purposes of this listing, *foundation* is defined as a "nongovernmental institution that makes grants," and only those that had assets of more than $500,000 and/or that made grants amounting to at least $15,000 in the three years previous to the compilation are included.

The format is clear and the directory is easy to use.

Colorado

Colorado Foundation Directory, prepared by the Junior League of Denver, Inc., the Denver Foundation, and the Attorney General of Colorado, edited by Bonnie P. Downing, 1978. Junior League of Denver, Inc., 1805 South Bellaire, Suite 400, Denver, CO 80222. 61 pp. $5.50 prepaid.

This publication, which lists 259 foundations, is the first effort to produce a complete directory of Colorado foundations. It is ar-

ranged alphabetically by foundation and includes charts by assets, grants, and fields of interest. It also includes pointers on proposal writing and suggestions for approaching foundations, tells about the availability of application forms, and gives some sample grants.

Connecticut

A Directory of Foundations in the State of Connecticut, 3rd ed., by John Parker Huber, 1976. Eastern Connecticut State College Foundation, Inc., P.O. Box 431, Willimantic, CT 06226. 168 pp. $7.00 prepaid; otherwise $8.00.

This volume lists 590 foundations arranged alphabetically by foundation name. The market value of assets is given for each foundation instead of "net worth," which was given in previous editions. Indexed by geographical area, purposes, and largest single grants.

District of Columbia

The Guide to Washington, D.C. Foundations, 2nd ed., by Francis G. de Bettencourt, 1975. Guide Publishers, P.O. Box 5849, Washington, DC 20014. 58 pp. $8.00.

Information on 282 foundations arranged alphabetically by foundation. There is also an index of officers, including trustees, and directors. The 1972 edition edited by Margaret T. de Bettencourt listed 357 foundations in 62 pages.

This new edition actually has 73 new foundations. The reduction in numbers from the previous edition represents the elimination of discontinued foundations and those classified as public charities, operating foundations, and restricted trusts.

Florida

A Guide to Foundations of the Southeast, Vol. IV, edited by Jerry C. Davis, 1975. Davis-Taylor Associates, Inc., Route 3, Box 289, Mt. Morgan Road, Williamsburg, KY 40769. 309 pp. $25.00.

This volume includes foundations in Florida (487) and in Georgia (340), arranged alphabetically within each state.

Florida has 3 foundations with a net worth exceeding $10 million and 25 with net worth between $1 million and $10 million. Foundations in Florida are more likely to make grants outside of the state than are foundations in other states. According to the editor of this volume, this is probably because there are many retired persons in Florida who maintain an interest in their native states.

Georgia has 50 foundations with a net worth exceeding $1 million, but *net worth* does not always give the true picture of foundation wealth. In this volume, for example, the Emily and Ernest Woodruff Foundation is listed at a net worth of $9 million in the same year it made grants of over $22 million. The market value of the foundation's assets was then estimated at $205 million. The important Southern Education Foundation, which has its principal office in Altanta, is not included in this directory because it is chartered in New York State.

Georgia

See Florida.

Illinois

Illinois Foundation Profiles, edited by James H. Taylor, 1976. Davis-Taylor Associates, Inc., Route 3, Box 289, Mt. Morgan Road, Williamsburg, KY 40769. 99 pp. $29.95.

This directory includes only 319 of the foundations in Illinois, plus a paper supplement with 19 more—those that have a net worth of at least $400,000 and that make grants of at least $100,000. The very large Chicago Community Trust, a community foundation, is not included, but the W. K. Kellogg Foundation Trust, which makes one grant to the W. K. Kellogg Foundation in Michigan, *is* included. There is no geographical index or index by fields of interest. The idea of this volume is to provide information based on foundation profiles. It is not clear what the editor sees as the function of this directory; state directories are useful mainly to local organizations, and excluding small foundations that make small grants eliminates some of the information most useful to local arts organizations. The

price tag on this volume is exorbitant. By all means, look for it in a library and inspect it thoroughly before making the investment.

Indiana

A Guide to Indiana Foundations, edited by James H. Taylor, 1975. Davis-Taylor Associates, Inc., Route 3, Box 289, Mt. Morgan Road, Williamsburg, KY 40769. 111 pp. $29.95.

Another overpriced directory with many of the same flaws as the Illinois guide. The 334 foundations listed for Indiana have assets of more than $5,000; omitted are operating foundations and those with fixed recipients. There is no geographic or subject index, and there are several glaring errors in spelling of foundations names and in alphabetization. Not worth the price.

Kansas

Directory of Kansas Foundations, 2nd ed., edited by Molly Wisman, 1977. Association of Community Arts Councils of Kansas, 509-A Kansas Avenue, Topeka, KS 66603. unpaged. $1.25.

This directory lists all Kansas foundations, even those with zero assets and grants; therefore, the total of 240 means very little, although 14 of the foundations listed have over $1 million in assets. Since this directory was compiled under the auspices of the Community Arts Councils of Kansas, the entries for each foundation list arts-related grants, which makes it useful for Kansas arts groups. The price is certainly reasonable; at today's prices, almost any information is worth $1.25.

Kentucky

A Guide to Foundations of the Southeast, Vol. I, edited by Jerry C. Davis, 1975. Davis-Taylor Associates, Inc., Route 3, Box 289, Mt. Morgan Road, Williamsburg, KY 40769. 255 pp. $25.00.

This volume lists a total of 676 foundations in three states of the Southeast: Kentucky (119), Tennessee (238), and Virginia (319). Kentucky has only 1 large foundation, the James Graham Brown Foundation with a net worth of $56 million, and only 7 more with over

$1 million. Tennessee has 18 and Virginia 22 with assets of $1 million or more.

Foundations are listed alphabetically by state, and for each entry, information, where available, is given on address, telephone number, officers' names, areas of interest, and net worth. Grants data include the number of grants, their total value for the recorded year, and distribution by states, and the larger grants are listed by recipient and dollar value. There is an index of officers, but no subject index. Community foundations are omitted.

The Southeast foundation guides are not perfect, but they contain information for local organizations that is available nowhere else.

Louisiana

See Alabama.

Maine

A Directory of Foundations in the State of Maine, 1978. Center for Research and Advanced Study, University of Southern Maine, 246 Deering Avenue, Portland, ME 04102. 46 pp. $2.50 prepaid.

The main section lists 160 foundations alphabetically. Other sections feature a geographical listing of foundations, categories of giving, a monetary ranking of the grants awarded, and highlights on the larger foundation gifts. Unfortunately this useful directory lists only the principal officer for each foundation instead of a complete roster of officers and trustees.

Maryland

1977 Annual Index Foundation Reports. Office of the Attorney-General, One South Calvert Street, 14th Floor, Baltimore, MD 21202. 33 pp. $3.20.

There are 278 foundations arranged alphabetically by foundation in this guide. There are no indexes.

Massachusetts

Directory of Foundations in Massachusetts, prepared by the Office of the Attorney General of the Commonwealth of Massachusetts and the Associated Foundations of Greater Boston, 1977. University of Massachusetts Press, Box 429, Amherst, MA 01002. 135 pp. $7.50 prepaid.

There are several Massachusetts directories, but this one is based on the most recent data and is the most reasonably priced. It is a compilation of 726 foundations categorized in two parts: foundations that make grants primarily to organizations and foundations that make grants primarily to individuals. The appendixes detail grant amounts, geographic restrictions, purposes, loans, nonscholarship loans, and scholarships of various kinds segregated by purpose and restrictions.

Michigan

Michigan Foundation Directory, Edition II, prepared by the Council of Michigan Foundations and the Michigan League for Human Services, 1978. Michigan League for Human Services, 200 Mill Street, Lansing, MI 48933. 89 pp. $7.50 prepaid.

This edition contains basic information on 507 foundations and substantial information on 291. They are divided and alphabetized to fall within two categories of assets and/or grant-making levels. There is also a survey of Michigan foundation philanthropy with several appendixes: an alphabetical listing of foundations, various geographical foundation listings, a list of terminated foundations, a foundation survey by field of endeavor, a survey of those making grants to private and public institutions, and instructions on proposal writing and assessment. The alphabetical list of "donors, trustees, and administrators" is very useful.

Minnesota

The State of Minnesota has at least two directories and they may, in a certain sense, represent the two extremes of such publications. One gives extensive, detailed, and continuing information

on Minnesota foundations (*Minnesota Foundation Directory III* at $250), and the other lists the foundations and gives very little more but at considerably less cost (*Guide to Minnesota Foundations*, $10).

Minnesota Foundation Directory III, by Beatrice J. Capriotti and Frank J. Capriotti III, editors–publishers, 101 Boy Scouts of America Building, 5300 Glenwood Avenue North, Minneapolis, MN 55422. 390 pp. $250.

This publication contains complete, accurate, and up-to-date information on 601 foundations. It includes an update service and sends to purchasers the annual reports of foundations long before their IRS returns are available. Addresses, officers, telephone numbers, shifts in interest, new deadlines and guidelines, and grant announcements are sent quarterly to purchasers of the directory. Organizations that seek substantial support from foundations in Minnesota will find this service very useful.

Guide to Minnesota Foundations, edited by Judith Healy, is published by the Minnesota Council on Foundations, Suite 413, Foshay Tower, Ninth and Marquette Avenues, Minneapolis, MN 55402. It is 73 pages long and costs $10. This directory is prepared mainly for small organizations or individuals who cannot afford the more extensive directory; however, it is clear that a 73-page directory cannot give much more than a listing of the names and addresses of approximately 600 foundations, especially since it includes a guide to program planning and proposal writing, a piece on questions that foundations are likely to ask, and information on The Foundation Center's regional collection.

Mississippi

See Alabama.

New Hampshire

Directory of Charitable Funds in New Hampshire, 3rd ed., 1976. The Attorney-General, State House Annex, Concord, NH 03301. $2.00.

There are approximately 400 foundations listed alphabetically; indexes indicate geographical areas for those that have restrictions, and purposes.

New Jersey

Directory of New Jersey Foundations, compiled by Janet A. Mitchell and Mary R. Murrin, 1977. Janet A. Mitchell, P.O. Box 2313, Princeton, NJ 08540. 81 pp. $9.45 prepaid or $9.90 for New Jersey residents.

There are 359 foundations listed in the main part of this directory, Section I. Criteria for inclusion are assets of $1,000 or more and/or grants totaling at least $5,000 for the year reported (usually 1975). Section II contains data on 25 foundations that make scholarship grants only. Whereas the previous two sections give detailed information about each entry, Section III is simply an alphabetical index of 449 smaller foundations not included in the other sections, with name, address, and IRS Employer Identification Number (EIN).

New York

New York Foundation Profiles, edited by James H. Taylor, 1976. Davis-Taylor Associates, Route 3, Box 289, Mt. Morgan Road, Williamsburg, KY 40769. 259 pp. $29.95.

This volume lists 950 foundations arranged alphabetically by foundation. The editor states in the introduction that "No claim of perfection is made for this guide. It would be almost impossible to publish a perfect listing of foundations for any state." While that statement cannot be refuted, it can be said that some of the imperfections of this directory could have been avoided.

The criteria for inclusion in the volume are a net worth of $500,000 or over and/or grants amounting to $100,000 for the year of report. These criteria exclude some of the very small foundations, about which information is obtainable from no other source. One of the chief justifications for state directories is that they list those grant-making organizations too small for other directories. But there is one measure on which this volume is probably unrivaled, and that is in the area of pure, ungenerous cheek. The editor warns in the introduction that "Among those foundations which have been intentionally omitted are those 50 foundations which represent excellent prospects for the institution with which the editor of this publication is associated." Presumably, this is possible only because the editor is also the publisher, since it is hard to believe that other

publishers would accept what purports to be a guide to state foundations that openly admits to withholding some listings to benefit the editor's affiliates. The price tag of this volume, which, incidentally, has no subject index or indication of regional limitations, is so unreasonable that the publication would not be mentioned here except for the fact that it is the only New York foundation guide available. Too bad.

North Carolina

A Guide to Foundations of the Southeast, Vol. II, edited by Jerry C. Davis, 1975. Davis-Taylor Associates, Route 3, Box 289, Mt. Morgan Road, Williamsburg, KY 40769. 200 pp. $25.00.

There are 546 foundations included in this volume: 415 in North Carolina and 131 in South Carolina. Foundations are listed in alphabetical order for each state; there is an index of officers.

This volume has the same major drawbacks as Volume I (Kentucky, Tennessee and Virginia): community foundations are not included, and there is no subject index.

Ohio

Charitable Foundations Directory of Ohio, 3rd ed., 1978. Charitable Foundations Directory, Attorney General's Office, 30 East Broad Street, 15th Floor, Columbus, OH 43215. 185 pp. $4.00 prepaid.

The 3,500 listing in this directory are arranged alphabetically. Indexes provide information on location by county and fields of interest divided into 17 categories. The county index includes a list of 53 out-of-state organizations that make grants in Ohio. There is a huge body of information in this volume for Ohio grant seekers.

Oklahoma

Directory of Oklahoma Foundations, edited by Thomas E. Broce, 1974. University of Oklahoma Press, 1005 Asp Avenue, Norman, OK 73069. 304 pp. $9.95.

There are 269 foundations in this directory—all the private foun-

dations in Oklahoma regardless of size—arranged alphabetically. Of these, 167 have assets of less than $100,000; some report assets of zero. The directory section provides detailed information on each entry, but the financial data are based on IRS returns for 1971 or 1972 and some even older. There is a grant-activities index divided into six subject areas and indicating foundation contributions in each area.

Oregon

The Guide to Oregon Foundations, produced by the Tri-County Community Council, a United Way Agency, 1977. Available from the Tri-County Community Council, 718 Burnside, Portland, OR 97209. 263 pp. $7.50 plus 50 cents postage.

A compilation of 282 foundations, trusts, and scholarship funds based in Oregon and certain foundations that are active givers in Oregon. Each entry includes foundation name, address, and contact person; funding restrictions; market value of assets; total grants and grant ranges; sample grants; type of contact preferred; and funding cycle. There are 12 appendixes giving information on grant giving by foundations, and there is an index of foundation names, but no subject index.

One of the appendixes lists Oregon foundations that are not included, but that list does not include two that were originally selected to appear, the Rosemary Dwyer Frey Trust and the Adams Foundation. *Foundation News* reported in its May–June 1978 issue that those two foundations were said to have objected to being listed because they feared a "loss of privacy." They might as well have agreed to be included, because *Foundation News* published the information from the IRS forms 990-AR for both those foundations in the May–June 1978 issue for readers who may be interested in looking them up.

Pennsylvania

Directory of Pennsylvania Foundations, edited by S. Damon Kletzien, was called a "model directory" by *Foundation News.* Pennsylvania is second only to New York in number of foundations; it has

more than 2,000, with combined assets of approximately $3 billion, 10% of all foundation assets in the country.

This directory includes 1,078 foundations organized by geographic area and analyzed both geographically and by program. It contains several useful tables such as those that reflect the portion of foundation assets represented by Philadelphia and Pittsburgh entities. There are also aids to grant seekers. It appeared in 1978 and has 304 pages.

The directory may be ordered from the Free Library of Philadelphia, Logan Square, Philadelphia, PA 19103, for $14, including postage and handling.

Rhode Island

A Directory of Foundations in the State of Rhode Island, 2nd ed., edited by John Parker Huber, 1975. Eastern Connecticut State College Foundation, Inc., P.O. Box 431, Willimantic, CT 06226. 39 pp. $5.00.

There are 117 foundations organized alphabetically in the main section of this directory. There are also indexes by city or town, interests, asset amounts, and amounts of grants. Rhode Island has only two foundations with assets of more than $10 million: the Thomas J. Watson Foundation with $15.5 million and the Rhode Island Foundation with $13 million.

Also included are details of gifts in Rhode Island by the Ford Foundation (New York) and the Edward E. Ford Foundation (Connecticut).

South Carolina

See North Carolina.

Tennessee

See Kentucky.

Texas

Directory of Texas Foundations, 2nd ed., compiled and edited by William J. Hooper, 1978. Texas Foundations Research Center, P.O. Box 5494, Austin, TX 78763. 184 pp. $15.75 prepaid.

This guide lists 1,400 foundations in alphabetical order: detailed data are given on 1,100 foundations that have assets over $20,000 and/or that have made grants totalling over $1,000. Approximately 300 foundations that do not meet those criteria are listed separately. Omitted under entries in both categories is a complete listing of officers and trustees. Foundation income is included in the data, and there is a very useful appendix highlighting approximately 50 areas of interest. For example within "The Arts" category, foundations are keyed according to their specific interest in 10 different art areas. In most cases, the degree of support for each subject or field of interest is not indicated except in the cases where all of the income of a foundation goes to one activity. Updated information in the form of three supplements was sent to purchasers of the first edition. That edition contained some unfortunate omissions, which have for the most part been corrected in this one.

Vermont

A Directory of Foundations in the State of Vermont, 2nd ed., edited by Denise M. McGovern, 1975. Eastern Connecticut State College Foundation, Inc., Willimantic, CT 06226. 24 pp. $3.00 prepaid.

This revised edition uses a stricter definition of *foundations,* reducing the number from 70 in the first edition to the current 41 organizations in this volume. Financial data are generally drawn from 1972 IRS reports. Eight non-Vermont foundations that have made large grants in Vermont are listed in the appendix.

Virginia

Virginia Directory of Private Foundations, by the State of Virginia Office of Human Resources, 1977. Department of Intergovernmental Affairs, Fourth Street Office Building, 205 North Fourth Street, Richmond, VA 23219. 70 pp. $2.00 prepaid.

A compilation of data on 102 foundations, arranged alphabetically by foundation. Indexes provide a four-section categorization of foundations according to the areas in which they have given grants as well as a distribution of foundations by location.

See *Kentucky* for Virginia listings in *A Guide to Foundations in the Southeast, Vol. I.*

Washington

Charitable Trust Directory, 3rd ed., 1975. Compiled from 1974 records in the Washington Attorney-General's Office. Office of the Attorney-General, Temple of Justice, Olympia, WA 98504. 92 pp. $3.00 prepaid.

Just under 500 charitable trusts and organizations are presented alphabetically in this edition. However, many would not fall under the definition of *private foundation*; for example, Boy Scout funds and employees' organizations are included. Although the organizations selected for inclusion limit the usefulness of this directory for grant-seeking arts organizations, the information presented is accurate and clear, and the price is modest. There are no indexes.

Wisconsin

Foundations in Wisconsin: A Directory, 3rd ed., compiled by Margaret J. Marik, 1978. The Foundation Collection, Marquette University Memorial Library, 1415 West Wisconsin Avenue, Milwaukee, WI 53233. 337 pp. $12.50 prepaid (plus 48 cents sales tax or Wisconsin tax-exempt number).

This directory is a revision of the one compiled by Barbara Szyszko in 1975, of which F. Emerson Andrews (in *Foundation Directory*, Supplement No. 2, January 1976) said, "This is a good directory."

This edition lists 645 foundations selected with no size qualifications; assets vary from those with more than $10 million to a substantial number that report no assets and no grants made.

Foundation interests are coded by category numbers 1 through 36, which are explained in the appendix. This appendix provides the grant seeker with a complete alphabetical listing of foundations

making grants in each of the 36 categories. Other appendix materials include listings of terminated Wisconsin foundations, foundations by county location, and trustees and principal officers, with the foundation connection listed for each.

THE FOUNDATION CENTER

The Foundation Center is the only independent, not-for-profit organization in the United States dedicated entirely to the gathering, analysis, and dissemination of factual information on philanthropic foundations. It serves as an information resource for anyone interested in applying to grant-making foundations for funds, and it has a national chain of cooperating library collections through which its facilities and resources are accessible in all 50 states, in Puerto Rico, and in Mexico City.

The center collects significant reference works of all kinds on foundations; maintains computerized files on foundations, including organizational details and grants information; receives from the Internal Revenue Service the private foundations' annual returns; publishes a number of directories, guides, and reference volumes, which are regularly updated; collects annual reports and newsletters of the foundations that publish them; and makes all these materials available in some form to the public. The libraries are all open to the public, and all the items in the collection may be used freely; some documents may be purchased in paper copies or on film, in microfiche.

The libraries operated by the center in New York and Washington, D.C., have the fullest range of materials, publications, and services available on all foundations in the United States, as well as some foreign ones.

Field offices were established in Cleveland and San Francisco to expand the information service of The Foundation Center in areas where there is a high density of users. Field representatives operate library facilities, visit and cooperate with regional collections in their regions, organize and participate in meetings and seminars, demonstrate the center's computerized data-retrieval systems, and publicize the center's publications and services in their region.

The New York and Washington libraries and the field offices give free weekly orientation sessions on use of The Foundation Center's Resources; reservations can be made by telephone.

The Foundation Center's Regional Cooperating Collections are located within host institutions, primarily public and academic libraries and the offices of foundations or associations of foundations. The center maintains strong communication ties with the regional affiliates, sends out regional bulletins, and holds conferences, usually in connection with other related professional meetings. Every regional collection has at least one copy of all publications of the center, and their collections concentrate on the foundations in the region or state of their coverage.

The hours each library is open to the public and the general services offered are under the jurisdiction of the institution in which each is located; those in college or university libraries, for example, usually have hours that coincide with the academic schedules, whereas those in foundation offices are normally open five days per week from 9 A.M. to 5 P.M.

The space of some regional collections is very limited, and they request that visitors make appointments to use the resources; it is always a good idea to telephone before going to one of the cooperating collections, to ascertain what hours it is open to the public, whether appointments are necessary, and what facilities (copying machines and microfiche readers, for example) are available.

A list of the national and regional cooperating libraries and their addresses is given in Appendix IV.

Associates Program

This program is designed for individuals and organizations that need customized information on grant-making foundations and whose requirements for information are frequent and extensive. For a membership of $200 annually, associates have access to a special toll-free telephone line to request research assistance; they can also ask for reference assistance in writing. They may order custom computer searches for a basic minimum charge of $50 for a listing of grant records up to a maximum of 75, and 30 cents each for records beyond the 75th. Associates have access to three foundation computer files for information on foundations and to government grants through the Federal Assistance Program Retrieval System (FAPRS), the computerized *Catalog of Federal Domestic Assistance*.

The organization that seeks foundation support for sizable programs may find the special services of the Associates Program well

worth its cost. For detailed information on this program, write to The Foundation Center, Associates Program, Dept. P, 888 Seventh Avenue, New York, NY 10019.

The other services and facilities of The Foundation Center that follow are available to the general public free or at reasonable cost.

COMSEARCH Printouts

Foundation grants recorded in the Foundation Grants Index Data Base provide the information for an annual series of printouts listing grants within more than 55 of the most heavily funded giving areas. These lists are available in $8\frac{1}{2}'' \times 11''$ paper copies or on microfiche. Each record listed gives the following information: the name of the granting foundation and its state location; the amount awarded; the name, city, and state location of the recipient organization; the date of the grant authorization; and a description of the activity funded. The 1978 list contained 58 subjects, including several in the arts and humanities: art and architecture; dance, theater, and performing arts; music; museums; historical projects; films, documentaries, media, and audiovisuals; television, radio, and communications. Numerous other subjects, which may overlap with arts activities, are available, such as: youth programs; minorities—general; blacks; native Americans, Hispanics, and Orientals; women; the aged; and the handicapped.

COMSEARCH Printouts in paper copies cost $11 for each subject at this writing. Each microfiche is $3.00. The fiche have a reduction ratio of 24:1 with a maximum of 50 frames per card. A microfiche reader is necessary to view these records.

Internal Revenue Service Returns

Private foundations report to the Internal Revenue Service each year on two forms: 990-PF provides fiscal details on receipts and expenditures, compensation of officers, capital gains or losses, and other financial matters; 990-AR provides information on foundation managers, assets, and grants paid and/or committed for future payment. A foundation's form 990-AR is perhaps the most complete

and accurate record of its grant making that is available anywhere. However, reports to the IRS are made at the end of the fiscal year, which varies among foundations as it does among corporations, and it takes some time for the IRS to process and film the reports. The Foundation Center libraries receive monthly shipments of IRS returns. During 1979, for example, the center received and made available 1978 foundation returns on a monthly basis. August and September are the heaviest months for the receipt of returns, as the calendar year returns, which are filed by May 15, are sent out about that time after IRS processing and filming.

The center's libraries in New York and Washington maintain files of IRS reports on all private foundations in the United States, and they may be reviewed by the general public. The cooperating libraries maintain files largely on those foundations located in their states.

Many community foundations are classified as public charities and thus report to the IRS on Form 990. The Foundation Center currently receives reports only on those community foundations that are classified as private foundations and report to IRS on the 990-PF and 990-AR forms. It also collects information directly from many of the larger community foundations, including annual reports and informational brochures.

Foundation returns may be ordered from the Internal Revenue Service Center, P.O. Box 187, Cornwells Heights, PA 19020, in paper copies or on film in the form of aperture cards. Orders should include the following information: the full name of the foundation, the city and state in which it is located, the year of the return desired, and, if available, the employer identification number. The cost for aperture cards or paper copies is $1.00 for the first page or card, and 13 cents for each additional one regardless of the number of foundations requested. The number of papers or cards contained in each report varies, and the price for aperture cards for a whole state ranges from $3.00 for Alaska to $1,628 for New York.

The Foundation Center National Data Book

This two-volume publication provides brief information on over 21,000 United States foundations. It is based on information from the Internal Revenue Service and is therefore the most comprehen-

sive listing of grant-making foundations available. An introduction by Carol M. Kurzig, Director of Library Services, describes how to make use of the *Data Book*.

Volume One is arranged alphabetically by foundation name, making it easy to look up any active grant-making foundation. A statistical chart analyzes the foundation community by state, showing the number of foundations and totals and percentages of foundation assets and grants in each. Volume Two lists foundations by state in descending order of grant totals. Thus, all foundations in a particular state or city can be identified and their overall grant-making record checked. The 3rd edition which became available in 1979 is based on data for IRS records for 1975–1977.

This publication is especially useful for locating the small foundations in any community, since other foundation directories include only the large organizations. The *National Data Book* may be referred to in any of the national or cooperating libraries of the center, or it may be ordered from The Foundation Center, 888 Seventh Avenue, New York, NY 10019. The cost is $40 for the two volumes.

The Foundation Directory

The 6th edition of this directory, edited by Marianna O. Lewis, included foundations in the United States with assets of at least $1 million or that make grants of more than $100,000 annually. They number 2,818, only about 12% of all foundations, but they account for over 80% of all foundation grants in the country and 90% of total foundation assets.

Each entry includes complete descriptive information on the foundation: name and address; telephone number; names of donors; statement of purpose (including any special limitations); financial data (assets, gifts received, expenditures, total grants made, number of grants paid, highest and lowest grants); and names of officers and trustees. This edition contains a new feature, grant application information, suggesting the best initial approach, giving application deadline dates or stating that there are none, and listing the dates of board meetings.

There are four indexes of the Foundation Directory:
1. Fields of interest
2. State and city locations (to help identify locally oriented foundations)
3. Personnel (names of donors, trustees, and administrators)
4. Foundation names

The *directory* may be referred to in any of the center's national or cooperating libraries, or it may be purchased from Columbia University Press, 136 South Broadway, Irvington, NY 10533. The 7th Edition, published in late 1979, includes about 3,200 foundations and costs $40.

Foundation Annual Reports

One of the best sources of current information on foundation activities is the annual report, which usually comes out before the Internal Revenue Service reports are available. Annual reports list the officers and trustees, describe the purposes of grants, and usually give a list of awards made. Many of them discuss future policy and plans of the foundation.

Most foundations that publish reports (about 450) are willing to send out copies upon written request. The Foundation Center libraries regularly receive all those that are published, and they may be seen there or purchased in microfiche reproductions; they are available on microfilm in the regional collections. The *Foundation Directory* and *The Foundation Center National Data Book*, Volume One, indicate which of the foundations listed do publish an annual report.

The Foundation Grants Index

This annual publication compiles all listings that appeared in *The Foundation News* during the previous year as *The Foundation Grants Index Bimonthly*, with additional grants included. The 1978 edition contains about 4,700 additional grants, a total of 15,409 entries. It comprises all grants of more than $5,000 reported to The

Foundation Center and is indexed for simple reference. A key-word index helps to pinpoint grants in very specific areas; the index of recipients indicates which organizations have received grants; and the subject category index organizes all grants into seven major subjects and over 70 subdisciplines. Each grant is identified by amount, name, and location of the recipient, and the grant description and date. A copy of *The Foundation Grants Index* is in every library of the center, and it may be ordered from Department FC, Columbia University Press, 136 South Broadway, Irvington, NY 10533. The 1978 edition costs $20.

The Foundation Center Source Book Profiles

This is a subscription service offered by The Foundation Center that provides detailed profiles on the top 1,000 foundations in a two-year cycle (Series 1 and Series 2), with 500 new profiles issued annually. The profiles, which average about four pages each, analyze the giving patterns of the foundations and update information on financial data, officers, policies, guidelines, and application procedures. This service is the most up-to-date reference tool available for those foundations that have the largest grant-making programs. The 500 new foundation profiles prepared each year are distributed to subscribers at the rate of about 80 every other month. A subscription also includes updates of the Source Book Profiles listing changes or new information about any of the top 1,000 foundations. New subject, type of support, and alphabetical and geographical indexes are also sent every other month. The indexes include all of the top 1,000 foundations. Subscriptions are $200 for each series. Series 2 subscribers receive bimonthly updates of the previously profiled foundations in both series and 500 new foundation profiles. Both series may be ordered for $350 from The Foundation Center, 888 Seventh Avenue, New York, NY 10019.

Foundation Grants to Individuals

Grant funds for individuals are scarce, since a great many foundations will accept applications only from organizations. This vol-

ume, edited by Carol M. Kurzig, Director of Library Services of The Foundation Center, lists over 1,000 foundations that have made individual awards to over 40,000 persons. The first edition appeared in 1977 and is sold out, but a copy may be used in all center libraries and cooperating libraries. The second edition, published late in 1979, is available from The Foundation Center, 888 Seventh Avenue, New York, NY 10019, for $15.00.

FOUNDATION NEWSLETTERS

Another form of foundation information that has proliferated in the past few years is the newsletter or bulletin. Five years ago, only about a dozen periodical publications were distributed by foundations. There are now almost two dozen private foundation and 17 community foundation newsletters; 8 associations of grant makers in the United States issue bulletins or information reports on a regular basis. Table 8 is a listing of newsletters and bulletins issued by foundations and associations.

SUBSCRIPTION INFORMATION SERVICES

Most commercial organizations offering information about grants specialize in one sector, usually the government or foundations. Some that offer guidance in more than one sector are mentioned in the chapter titled "Basic Sources of Information."

The oldest and most enduring of the commercial foundation information services is the Taft Corporation in Washington, D.C. For several years, Taft published the *Foundation Reporter*, but this has recently been replaced by their *National Foundation Reporter* and nine *Regional Foundation Reporters*. The *National Foundation Reporter* contains information about 238 major foundations that make grants without regional preference; the nine *Regional Foundation Reporters* cover foundations that make grants in specific geographic regions.

This new approach recognizes that many foundations restrict their grant making to the state or region in which they are located— the same circumstance that has resulted in the publication of an increasing number of state foundation directories. Taft makes no

TABLE 8. FOUNDATION NEWSLETTERS AND BULLETINS

PRIVATE FOUNDATIONS

Battelle Memorial Institute Foundation
100 East Broad Street, Suite 605
Columbus, OH 43215
Community Report

Carnegie Corporation of New York
437 Madison Avenue
New York, NY 10022
Carnegie Quarterly

David C. Cook Foundation
850 North Grove Avenue
Elgin, IL 60120
Interlit

Danforth Foundation
222 South Central Avenue
St. Louis, MO 63105
Danforth News and Notes

Ford Foundation
Office of Reports
320 East 43 Street
New York, NY 10017
Ford Foundation Letter

Hogg Foundation for Mental Health
University of Texas at Austin
Box 7998
Austin, TX 78712
Hogg Foundation News

Martha Holden Jennings Foundation
2339 South Overlook Road
Cleveland Heights, OH 44106
Pro Excellentia

W. K. Kellogg Foundation
400 North Avenue
Battle Creek, MI 49016
Profiles

Charles F. Kettering Foundation
5335 Far Hills Avenue
Dayton, OH 45429
"New Ways"

Charles Stewart Mott Foundation
510 Mott Foundation Building
Flint, MI 48502
Charles Stewart Mott Foundation Letter

The Newspaper Fund
P. O. Box 300
Princeton, NJ 08540
The Newspaper Fund Newsletter

Research Corporation
405 Lexington Avenue
New York, NY 10017
Research Corporation Quarterly Bulletin

Resources for the Future
1755 Massachusetts Avenue, NW
Washington, DC 20036
Resources

The Rockefeller Foundation
1133 Avenue of the Americas
New York, NY 10036
R F Illustrated

Alfred P. Sloan Foundation
630 Fifth Avenue
New York, NY 10020
Work in Progress

Twentieth Century Fund
41 East 70 Street
New York, NY 10021
Twentieth Century Fund Newsletter

COMMUNITY FOUNDATIONS

Ann Arbor Area Foundation
2301 Platt Road
Ann Arbor, MI 48104
Ann Arbor Area Foundation Newsletter

Bread and Roses Public Foundation
1425 Walnut Street
Philadelphia, PA 19102
Keeping In Touch

TABLE 8 *(Continued)*

The Bridgeport Area Foundation, Inc.
35 Union Avenue
Bridgeport, CT 06607
Newsletter

Greater Charlotte Foundation, Inc.
301 South Brevard Street
Charlotte, NC 28202
*Greater Charlotte Foundation, Inc.
 Newsletter*

Chicago Community Trust
208 South LaSalle Street, Suite 850
Chicago, IL 60604
Chicago Community Trust Newsletter

Cleveland Foundation
700 National City Bank Building
Cleveland, OH 44114
Cleveland Foundation Quarterly

Columbus Foundation
17 South High Street, Suite 707
Columbus, OH 43215
Commentary

Dallas Community Chest Trust Fund,
 Inc.
Fred M. Lange Center
4605 Live Oak Street
Dallas, TX 75204
Trust Fund News

Hartford Foundation for Public Giving
45 South Main Street, Suite 310
West Hartford, CT 06107
Greater Hartford Needs

Haymarket Peoples Fund
120 Boylston Street, Room 707
Boston, MA 02116
Haymarket News

Liberty Hill Foundation
P.O. Box 1074
Venice, CA 90291
News from the Hill

The Lincoln Foundation, Inc.
215 Centennial Mall South
Lincoln, NE 68508
Lincoln Foundation Activity

Milwaukee Foundation
161 West Wisconsin Avenue, Suite
 5146
Milwaukee, WI 53203
Milwaukee Foundation Newsletter

The Mobile Community Foundation
1514 First National Bank Building
Mobile, AL 36602
*The Mobile Community Foundation
 Reporter*

New Hampshire Charitable Fund
1 South Street
P.O. Box 1335
Concord, NH 03301
Newsletter

The New York Community Trust
415 Madison Avenue
New York, NY 10017
New York Community Trust Newsletter

North Star Fund
1133 Broadway, Room 1427
New York, NY 10010
North Star News

The Oklahoma City Community
 Foundation, Inc.
1300 North Broadway
Oklahoma City, OK 73103
Building for the Future

Rhode Island Foundation
15 Westminster Street
Providence, RI 02903
Rhode Island Foundation News

Rochester Area Foundation
315 Alexander Street, Room 205
Rochester, NY 14604
Rochester Area Foundation Report

Continued

TABLE 8 (*Continued*)

San Francisco Foundation
425 California Street
San Francisco, CA 94104
San Francisco Foundation Newsletter

Vanguard Public Foundation
4111 24 Street
San Francisco, CA 94114
Vanguard Public Foundation Newsletter

The Winston-Salem Foundation
229 First Union National Bank Building
Winston-Salem, NC 27101
Mirror

ASSOCIATIONS OF GRANT MAKERS

Clearinghouse for Midcontinent
 Foundations
P.O. Box 8102
Kansas City, MO 64112
The Foundation Exchange

The Donor's Forum of Chicago
208 South LaSalle Street
Chicago, IL 60604
The Forum

Kansas City Association of Trusts and
 Foundations
127 West 10 Street

405 Board of Trade Building
Kansas City, MO 64105
Comments

Michigan Council of Foundations
18 North Fifth Street
Grand Haven, MI 49417
The Michigan Scene

Minnesota Council on Foundations
712 Foshay Tower
Ninth and Marquette
Minneapolis, MN 55402
Minnesota Foundations Forum

Northern California Foundations
 Group
P.O. Box 5646
San Francisco, CA 94101
Newsletter

Pacific Northwest Grantmakers Forum
13th Floor, Norton Building
Seattle, WA 98104
Newsletter

Southern California Association for
 Philanthropy
1100 Glendon Avenue, Suite 1414
Los Angeles, CA 90024
The Grantmaker

claim of listing all foundations in every state, but they do attempt to cover the nation and therefore their regional volumes contain some of the foundations located in states for which no state directory exists.

Commercial subscription services were at one time so much more expensive than the information produced by The Foundation Center that it was hard to justify their purchase for most nonprofit organizations. But the gap between the center and Taft has narrowed in recent years. Taft's Foundation Reporter Package, including the *National Foundation Reporter*, one *Regional Foundation Reporter*, and

12 issues of the *News Monitor of Philanthropy*, with current information on foundation grants and other information, costs $195.

Organizations that have a need for continuing and detailed information on foundations should examine the Taft service.

The address of the Taft Corporation is 1000 Vermont Avenue, NW, Washington, DC 20005.

Corporations and the Arts

The 1950s saw a major breakthrough in foundation giving for the arts; in the 1960s, the federal government formally recognized the nation's cultural development as one of its legitimate concerns. The big news in the 1970s was the unprecedented rise in support for the arts within the business community.

In a 10-year period, corporate contributions to the arts increased 10-fold, from $22 million in 1967 to $221 million in 1976, and reached $250 million for 1978.

There is widespread evidence that business organizations are undertaking a more active role in the artistic and cultural life of the communities in which their headquarters, plants, retail outlets, or other corporate units are located.

A few businesses have, of course, supported the arts for many years. Texaco has sponsored the Saturday afternoon Metropolitan Opera radio broadcasts for nearly 40 years; and Exxon began sponsorship of the Sunday radio broadcasts of the New York Philharmonic in 1948. Those companies and others were, it is interesting to note, supporting the arts for several years before the legality of corporate philanthropy had been tested in the United States courts.

It comes as a surprise to many people to learn that until 1935, corporations were legally forbidden to give money to "charitable" causes, including the arts. In 1881, a Massachusetts court concluded that the Old Colony Railway had exceeded its corporate authority in

underwriting the cost of a music festival to be performed along its right of way. This decision was in line with the views of the British courts of that time. In the case of *Hutton* v. *West Cork Railway*, a British jurist in 1883 stated that "charity has no business to sit at boards of director *qua* [in the function of] charity."

Legislation was passed in 1935 that allowed corporations in the United States to contribute money to charitable causes, but it was not tested in the courts until 1953, when A. P. Smith Corporation's gift of $1,500 to Princeton University was contested. The right of the corporation to make such a gift was upheld in a ruling now called the "Magna Carta of Corporate Giving," which included the statement, "modern conditions require that corporations acknowledge and discharge social as well as private responsibilities as members of the communities in which they operate."

Many shareholders in this country, nevertheless, continue to agree with the nineteenth century opinion of the British and American courts. The policy of making contributions to philanthropic causes was challenged by shareholders of Chas. Pfizer & Co. in 1968. Chase Manhattan Bank's and the American Telephone and Telegraph Company's stockholders followed suit in 1970. As recently as 1978, IBM faced a similar challenge at its annual meeting when a proposal appeared on the agenda that would have mandated: "No corporate funds of this corporation shall be given to any charitable, educational or similar organization, except for purposes in direct furtherance of the business interests of the corporation." In the previous year, IBM had made philanthropic gifts totaling about $22 million.

One theory holds that those actions indicate that shareholders prefer to receive maximum benefits from their holdings in the form of dividends and to determine for themselves how much to dispense as charitable gifts, but there is no statistical evidence to back this up. The Conference Board, a research group for the business community, conducted a survey which showed that 400 top executives expressed the belief that 70% of their stockholders had no opinion one way or the other about corporate contributions; that 5% could not decide whether they were for or against; and that 3% were mostly against contributions. Presumably, 22% could be considered to be in favor of contributions.

In spite of the small number of executives surveyed and the dubiety of their ability to interpret accurately the shareholders' point of view, there is evidence to support the idea that the majority of

shareholders do not in the final analysis oppose corporate philanthropy. None of the anticontribution proposals brought to the shareholders of major corporations has been successful. The 1978 proposal at IBM was defeated resoundingly by 112.1 million votes against restricting corporate contributions to only 2.2 million for it.

There is still a good deal of opposition to the idea in other quarters, some of which is voiced regularly in the broadcast and print media. *New York Times* columnist William Safire believes that corporate charitable contributions should be unlawful. The sociologist Michael Harrington suggests that corporate assistance in the attack on social ills will result in the attack's being blunted because business will be more concerned with profits than with solution of the problems. Milton Friedman, the Nobel prize-winning economist, says that the social responsibility of the businessman is to maximize profits for shareowners.

When it comes to the arts, corporate support is a gift horse whose mouth is continuously inspected very closely. Critics are exceedingly cynical as to corporate motives, and they are concerned that unfair gains may be derived from such patronage.

In a recent article, Gideon Chagy, Vice President of the Business Committee for the Arts, colorfully described the conflict in our society regarding corporate arts patronage:

> The swift rise of the corporate arts patron has not been accompanied by widespread rejoicing among artists or among those who choose to speak for them. In fact, discussions of corporate involvement with the arts often have all the elements of the French morality plays of the early 15th century: personifications of good and evil, their qualities and motives glaringly evident even to the unsophisticated observer, temptation to sin, and the struggle to avoid the fall from grace. Our contemporary *l'homme juste* is the artist, in whom all virtues, including altruism, generosity, sensitivity, intellectual acuity, and wisdom, naturally reside. *L'homme mondaine* is the business executive, inherently and incorrigibly crass, philistine, incapable of actions that do not serve his own self-interest, motivated by narrow-minded goals addressed only to maximum possible profit.[1]

In the same article, Chagy points out that to most artists the business corporation is a remote, mysterious, powerful entity about which they are ready to believe anything reprehensible. Mr. Chagy is describing a feeling that is not new, that has existed as far back

[1] *Grants Magazine,* Vol. 1, No. 1, March 1978.

as the days of the Industrial Revolution, when the businessman was regarded as materialistic, methodical, and rational, and as someone possessing neither ethical nor artistic sensibilities, who therefore dealt only in "tainted" money.

This same thinking led to severe criticism of George Bernard Shaw's play *Major Barbara*, written in 1905, in which the Salvation Army accepted support from a distiller and a munitions maker. (In reply, Shaw quoted a Salvation Army captain who said that the Army "would take money from the devil himself and be only too glad to get it out of his hands and into God's.")

Vestiges of this same trend of thought can be observed in the current suspicion surrounding sponsorship by the large oil companies of public television programming, which has been massive enough to inspire the waggish comment that PBS really stands for Petroleum Broadcasting System.

New York Times television critic John J. O'Connor routinely deplores this sponsorship on the basis that the oil companies are buying an improved image at bargain prices and out of fear that public TV will become so beholden to those sponsors that they will be unable to resist corruption. No specific charges are made, but the implication is that faced with a choice between knuckling under to the unscrupulous demands of a corporate sponsor and losing financial backing, public television executives would lack the moral rectitude to do the right thing. These implications are couched in such pointed questions as "Can public television be bought? Are they [the oil companies] powerful enough to block Public TV investigation of the energy crises or multinational conglomerates? Do they have enough clout to possibly censor 'sensitive' material in cultural presentations?"

Television critics do not seem to have the same concerns in connection with commercial sponsorship, for which the cost is many times as great; one can draw the inference that corporate support of cultural presentations is all right provided that it costs a great deal of money; the main objection is to the purchase of such leverage, or possible leverage, at such a low cost!

In response to such criticism, John Jay Iselin, President of New York's public television station, says, "we have no experience with corporate sponsors trying to encroach, and we have a lot of experience with the federal government saying how public television should administer itself and direct its funds." When Robert MacNeil

of PBS's "MacNeil/Lehrer Report" was asked about interference from sponsors of his show, Exxon and Allied Chemical & Dye, he replied, "It is probably the cleanest money we have" and explained that both underwriters had stipulated from the beginning that they wished to have nothing to do with the editorial side of the program.

Thinking the worst of corporations is not confined to art critics, artists, and the media through which the fine and performing arts are made available. According to Irving Kristol, that attitude has permeated the entire American society. In an article in *The Public Interest*,[2] Mr. Kristol wrote, "most Americans are now quick to believe that 'big business' conspires secretly but most effectively to manipulate the economic and political system." Kristol somewhat obliquely refutes this idea by adding, "an enterprise which, in prosaic fact, corporate executives are too distracted and too unimaginative even to contemplate."

The conflict between the artist and the business world is in reality an extension of the disaffection that has always existed between benefactors or potential benefactors and those who seek or receive their endowments. Royal courts or tyrants or church leaders of the distant past who had it in their power to open doors to recognition and prosperity for artists were as suspect in their motivations as today's corporations. Yet, in spite of the persistence of this inherently antagonistic relationship, it has never been strong enough to bring on a massive boycott of benefactors from any sector. Government largesse is excoriated but seldom scorned; foundation grants are often suspected but almost never rejected; and damnation of the corporate patron rarely leads to repudiation.

Although the adversary relationship between donor and donee is long-standing and well established, there seems to be something especially bitter in the feeling about corporations. A Harris Poll taken in 1966 indicated that 55% of those surveyed expressed "a great deal of confidence" in the heads of large corporations. The same survey in 1975 revealed that only 15% expressed the same amount of confidence—a 40% drop in 10 years.

Additionally, the corporate sector has always seemed to be beyond the reach of any corrective measures. Until Ralph Nader took on General Motors, the very idea of opposing a large corporation was viewed as tilting against windmills, and Nader's success is still

[2] No. 41, Fall 1975.

viewed as a phenomenon unlikely to be repeated. The government presumably can be improved by voter action; foundations can be brought to heel by taxation or regulatory mechanisms. But corporations! Who can do anything about them?

Part of the answer probably lies in the simple fact that "big business" is the inevitable whipping boy of a capitalistic society. When the "robber barons" were caught in the act of attempting to corner the market on the resources of the United States early in this century, and when more recently some corporations were found to be using bribery as a routine technique for attracting foreign business, the whole corporate community shared the opprobrium.

What do corporations say to all this? Why do they, knowing as well as or better than anyone else, the cynicism with which much of their philanthropy is viewed, not only continue it but steadily increase it, especially in the arts?

R. F. Neblett, Exxon's Contributions Manager, says, "What we do makes for a better world. We participate in that world and what is better for society is better for us. I assume also that if we conduct ourselves in a responsible way, we will enhance our reputation. That's an incidental by-product."[3]

In a statement of policy issued in 1978, the American Telephone and Telegraph Company said:

> We in the Bell System recognize our responsibility to be good citizens . . . we have a responsibility to the future—to do what we can to help restore where it has been lost—and maintain where it has not—a social environment conducive to the community's security and health and to its progress. It is to this end that each of our Associated Companies conducts its own conscientiously administered program of contributions.

A spokesman for Philip Morris, when asked in 1971 why his company had sponsored exhibitions such as "American Folk Art" (more recently, Philip Morris funded the very successful Jasper Johns exhibitions at the Whitney Museum), said, "It's a lot cheaper than taking out ads saying how great we think we are."[4]

In an address at the Indianapolis Museum of Art on June 21, 1977, Cummins Engine Company, Inc.'s Chairman of the Executive and Finance Committee, J. Irwin Miller, said "The artist at his best

[3] *The New York Times,* January 1, 1978.
[4] *Wall Street Journal,* March 31, 1978.

helps each of us to discover what our best might be, helps us truly to see our neighbor, helps him to see us . . . the artist helps us to be at home with ourselves and in so doing can help us to make America a home for all its members."

Frank Koch, Vice President in charge of public relations of Syntex Corporation, says, "A revitalized sense of corporate mission for a more active and broader role in society will reduce the isolation of corporate leaders and begin to turn around the current negative public attitude toward business."[5]

Paul Elicker, President of SCM Corporation, enumerates in one succinct statement the main reasons that corporations support the arts:

> We have not sponsored the Treasures of Early Irish Art at the Metropolitan or any of the other eight major exhibitions over the past four years out of the goodness of our hearts. We do it because it's good for the arts, it's good for the millions of people who get pleasure viewing great works of art, and—not least—it's good for SCM Corporation.[6]

Andrew Heiskell, Chairman of the Board of Time, Inc., says "Corporate giving is the last valve we can open and we must turn it now."[7]

So much for why corporations support the arts. What have they actually done? Generally speaking, the corporate contributions program has not been a high-priority item or an assignment given to the brightest, most promising young executives. But this is changing. More care is going into the design of the contributions program, and top executives are taking more interest. This is at least partially because of the kinds of people who become business executives today. The stereotype of the business leader that prevailed at the time of the Industrial Revolution—the hard-bitten, tightfisted, unimaginative, money-mad monster whose education was mainly in the "school of hard knocks," and whose only interest in the society around him was in its susceptibility to exploitation—is scarcely recognizable in today's corporate community. The modern executive may very well have had a liberal arts education and may have acquired an interest in painting, music, drama, or the dance during

[5] *The New Corporate Philanthropy: How Society and Business Can Profit.* New York: Plenum Press, 1979.

[6] *Wall Street Journal*, March 31, 1978.

[7] *Grants Magazine*, Vol. 2, No. 1, March 1979.

the college years or earlier. As the United States has matured in its appreciation of the arts, cities and towns across the nation have provided opportunities for schoolchildren to be exposed to the arts, and even though the quality may vary from place to place, it is now possible for children of almost any economic or social level to become acquainted with the arts in some form by the time they finish high school, if not sooner. Some of today's corporations are being run by third-, fourth-, or fifth-generation children of the nation's first entrepreneurs, and they have been able to travel; to visit the great museums, theaters, and opera houses; and to view the architectural splendors of Europe and other parts of the world. It can no longer be assumed that the businessman is an uneducated boor.

In 1967, a group of business leaders got together at the suggestion of David Rockefeller, Chairman of the Chase Manhattan Bank, and set up the Business Committee for the Arts (BCA), a national organization of business leaders whose purpose is to encourage business support of the arts. C. Douglas Dillon, Chairman of the Board of Dillon, Read & Co., Inc., and former Secretary of the Treasury, was the first chairman of BCA. W. H. Krome George, Chairman and Chief Executive Officer of Aluminum Company of America, was elected as BCA chairman in 1978.

The membership of the BCA includes the presidents and board chairmen of some of the country's and the world's largest corporations, but the philosophy of the organization is that every business, no matter how small its size, can support the arts of its community in some manner.

Like arts giving in other sectors, exact amounts of total corporate gifts are impossible to calculate, mainly because of the different headings under which grant makers categorize their gifts. An example is the report by The Foundation Center in 1977 that Cummins Engine Foundation (the philanthropic arm of Cummins Engine Company, Inc.) gave 33% of its grants to education and only 3% for cultural programs. But in the listing of grants, a large gift to the Indiana University Music Arts Center was listed under "Education," and some of the gifts that appeared under the heading "Civic" were also arts-related. It is not unusual for arts grants to educational institutions, social service groups, or civic organizations to be reported under headings other than "Arts." The estimate of $250 million as the total corporate giving for the arts in 1978 was made by the BCA and is the best figure available. The significance of this

amount can be seen by a comparison with congressional appropriations that same year for programs of the National Endowment for the Arts: $114.6 million. Business support for the arts for 1978 was therefore more than twice as much as that of the NEA.

For many years, foundations accounted for about 10% of all philanthropic giving in the United States, almost twice the proportion of the business sector. But the gap has narrowed in recent years, and in 1978 foundations were credited with 5.5% and corporations with 5.0%. (The major portion of all private giving in this country is still by individuals, 82.9%—with bequests accounting for another 6.6%.)

Giving USA, the annual report of the American Association of Fund-Raising Counsel, Inc. (AAFRC), estimated that corporate gifts for 1978 were $2 billion, 1.01% of pretax profits, an increase of 17.6% over 1977 gifts which totaled $1 billion. The AAFRC surveyed 814 corporations to determine the distribution of their philanthropy. Health and welfare ranked first among categories of corporate gifts with 38.3% of the total; education was a close second with 35.7%; civic causes received 11.5%; and 9% went to cultural and arts organizations.

These figures are at variance with the report of Mr. Robert W. Sarnoff of the Business Committee for the Arts in May 1978, stating that the arts now receive nearly 12% of total corporate philanthropy, but again, this is probably a question of the categories in which gifts are placed by different reporting systems.

By any means of calculation, business support for the arts has increased, and the range of activities supported has increased. According to a BCA study, in 1973, companies supported an average of 2.3 art forms; three years later, that number had increased to 4.8. Symphony orchestras, museums, and theaters are the most frequently cited recipients: 68%, 53%, and 42%, respectively. Although museums were not the most cited recipient, they receive most of the money, 22 cents of every corporate arts dollar, compared with 19 cents for public radio and television; 12 cents for symphony orchestras; 9 cents for art-cultural centers; and 7 cents for theaters. The portions of the business dollar that go to other arts activities are arts funds–councils, 5 cents; opera, other music, historical and cultural restorations, dance, and cultural programming of commercial radio and TV, 3 cents each; purchase of art, arts education, and libraries, 2 cents each; exhibits of art, 1 cent; individual artists, films on art

matters, and crafts, one-half cent each; and all other arts activities, 4 cents. (These are rounded figures, so that the total is slightly more than one dollar.)

In 1977, approximately 23% of the companies surveyed indicated an intention to increase their arts support in the future; 57% planned to maintain the same level of support; 4% expected to decrease arts giving; and 16% were undecided. This means that about 40% might possibly increase their giving in the future, counting the undecided companies as potential increasers.

Forbes magazine and the BCA jointly make annual awards to corporations for outstanding support programs in the fine arts and the performing arts. Since 1966, when the competition was created, 259 companies have received awards, and 264 have received honorable mention. Awards have gone to companies in 186 cities in 48 states and in 6 cities in other countries: South Africa, England, Japan, and Canada. Several corporations have been repeated award winners, among them, Aluminum Company of America; Atlantic Richfield Company; Exxon Corporation; International Business Machines Corporations; Mobil Corporation and Mobil Foundation, Inc.; Philip Morris, Inc.; and Southeast Banking Corporation. In 1977, awards were made to 41 corporations, 21 of them repeat winners. Of the 1977 winning companies, 11 gave more than $1 million each to the arts during that year.

First-time winners in 1977 were Aetna Life and Casualty Company; Electronic Data Systems Corporation; Gannett Newspaper Foundation; General Mills, Inc.; William R. Hough & Company; International Multifoods Corporation; International Telephone and Telegraph Corporation; KFAC AM/FM, Los Angeles; Liberty National Bank and Trust Company of Louisville; Metropolitan Life Insurance Company; R. J. Reynolds Industries, Inc.; Security Central National Bank; Security Pacific National Bank; South Central Bell Telephone Company; United Oklahoma Bank; U.S. Pioneer Electronics Corporation; and Valley Bank of Nevada.

Most of the *Forbes* magazine–BCA winners are large national corporations, many of them with affiliates or operational units scattered throughout the country. Almost invariably, preference is given by corporations to requests for support that come from the locale of the major headquarters or those places where the company has a plant, an outlet, or other representation. For example, Hanes Dye and Finishing Company in Winston-Salem, North Carolina, one of

the few corporations that contributes to philanthropy 5% of its pre-tax income, allocates 52% of its total gifts to the arts, all in North Carolina. Eastman Kodak Company concentrates its arts support in Rochester; the Ford Motor Company Fund supports the Detroit Symphony and also contributes to museums, performing-arts centers, theaters, and arts festivals in communities of major Ford employment; and Philip Morris, Inc., with headquarters in New York, has provided funding for art exhibitions in New York, Paris, Cologne, London, and San Francisco and also supports arts organizations and institutions throughout the United States. The Dayton Hudson Corporation of Minneapolis, another company that annually distributes more than 5% of pretax profits, has received the *Forbes*–BCA award twice and honorable mention three times for its arts support. In 1978, Dayton Hudson gave over $3 million to the arts, about 43.6% of their total contributions, and more than $1 million, to civic and public affairs activities, some of which indirectly foster the arts.

The aim of the Business Committee for the Arts is broad and general; it encourages support of all the arts in every community and on every level. Other groups have begun to form recently for the purpose of increasing corporate support to one specific art form. The pioneering organization was the National Corporate Fund for Dance, Inc., founded in 1972 by a group of businessmen interested in dance and cognizant of the need of major American dance companies for general operating support.

The Corporate Fund conducts an annual campaign for nine dance companies that they believe to be among the finest in America, each of which meets these three criteria: (1) it has an annual operating budget in excess of $750,000; (2) it tours the United States extensively; and (3) it pays professional union wages to its dancers and staff.

The National Corporate Fund for Dance is a united-fund appeal to corporations on behalf of its member dance companies; its creation represents the first attempt of organizations within the same art form to cooperate in fund raising. Participation in the fund restricts the individual fund-raising prerogatives of each member company, but the record of the united effort in its first five years of life has been so successful as to make that sacrifice worthwhile. In 1973–1974, $68,500 was raised from 14 corporations, and in 1978, 125 corporations donated a total of $234,150. The goal for 1979 was $350,000. All contributions go to the dance companies; administra-

tive costs are funded by foundation grants. Each dance company's share of the annual total is carefully worked out by a formula based on the ratio between the company's operating budget and the aggregate operating budgets of all nine companies.

The experience of this group is serving as a pilot for others, and the Corporate Fund for Dance recently helped to establish a Corporate Theatre Fund, which will act as a united fund-raising organization for major regional theaters in the United States. Already, 16 leading corporations have joined in support of the Corporate Theatre Fund: the American Can Company Foundation; American Telephone and Telegraph Company; Exxon Corporation; Grace Foundation, Inc.; Inland Steel; International Business Machines Corporation; International Paper Company Foundation; Lever Brothers Company; Pfizer, Inc.; RCA Corporation; Sterling Drug, Inc.; Time, Inc.; Times Mirror Company; U.S. Industries, Inc.; United States Steel Foundation, Inc.; and Warner Communications, Inc. The founding members of the fund that have formed this national consortium to increase their support from the business community are the Long Wharf Theatre, New Haven, CT; the Guthrie Theatre, Minneapolis; the Mark Taper Forum, Los Angeles; the American Conservatory Theatre, San Francisco; and the Arena Stage, Washington, D.C.

The large performing-arts centers and other arts organizations have set up separate fund-raising committees to concentrate on increasing contributions from the corporate sector. Frank T. Cary, Chairman and Chief Executive Officer of IBM Corporation, is the current chairman of the Corporate Fund for the Performing Arts at Kennedy Center. Cary succeeded Donald S. MacNaughton, Chairman and Chief Executive Officer of the Prudential Insurance Company of America, who led the Kennedy Center Fund during its first year (1977), when it met its goal of $1 million.

One of the outstandingly successful corporate campaigns for arts support is that conducted by Lincoln Center for the Performing Arts. Lincoln Center is the umbrella organization that provides services to all performing-arts groups in that complex and conducts a fund-raising program independent of those waged by the opera, theater, dance, and symphony groups and the Juilliard School, which are housed in the center. They annually appeal to approximately 2,000 corporations and get contributions from nearly 500. Often, these are very large gifts. The 1978 list of patrons of Lincoln Center (patrons

contribute $10,000) included 52 corporations, 17 of which contributed through their company foundations.

Lincoln Center's Consolidated Corporate Fund Drive for 1977–1978 reported the following gifts:

Number of corporations	Gift category
19	$25,000–$100,000
40	10,000– 24,999
63	5,000– 9,999
73	2,500– 4,999
26	2,000– 2,499
38	1,000– 1,999
80	1,000
78	500– 999

Another recent trend in corporate giving for the arts is the encouragement given to employees by the companies they work for to make contributions to cultural causes. The Quaker Oats Company of Chicago initiated a program in 1978 to match employee gifts to cultural organizations on a $3-to-$1 basis. If a Quaker worker donates $25 to an art institution, the company will donate $75. The program also includes gifts to affiliates of the Public Broadcasting Service and National Public Radio and any Quaker employee's membership in a cultural organization.

The Bank of America also has a matching-gift program and in 1978 reported that their foundation had matched a total of $18,487 in 129 gifts made by employees to symphony orchestras, opera and dance companies, public broadcasting systems, museums, historical societies, and supporting organizations.

These matching-gifts programs resemble those that many corporations have established to encourage contributions for support to education.

Even without the encouragement of a matching-fund program, fund raising by arts institutions among corporate employees has been very successful when the cause to be supported promises to benefit the community. In 1978, more than 3,800 employees of General Electric Company's aircraft-engine plant in Ohio donated $70,-000 to the campaign headed by the Institute of Fine Arts for all Cincinnati cultural institutions, the largest contribution to the arts from any group of employees in the country that year. This is a

model of successful fund-raising by community arts groups on a united basis.

Although critics often lump all corporate sponsors together if they are in the same line of business—referring to the "oil companies," for example—there is no evidence that they act as a group or even that they favor the same kinds of activities.

Public television's 1979-1980 presentation of the Shakespeare plays produced by the British Broadcasting Company was underwritten by an oil company (Exxon), an insurance company (Metropolitan Life Insurance Company), and a bank (Morgan Guaranty Trust Company of New York). Exxon turned down the chance to support Jacob Bronowski's highly successful "Ascent of Man" series, which was funded by Mobil Oil Company. Exxon also turned down "The Adams Chronicles," even though they had made a planning grant to the project, on the basis that it was not a sufficiently promising series; that series was finally sponsored by Atlantic Richfield, the National Endowment for the Humanities, and the Andrew W. Mellon Foundation. Mobil Oil agreed to rehabilitate the New York Public Library's lions after Exxon had declined to do so.

Exxon has funded art exhibitions at the Whitney Museum of American Art in New York, the Museum of Fine Arts in Houston, and the Oakland (California) Museum. They sponsored the "Theater in America" series produced by New York City's WNET Channel 13 and commissioned works by Latin American composers. The American Symphony Orchestra League presented Exxon with its Gold Baton Award in 1978 for its sponsorship of the Exxon/Arts Endowment Conductors program.

The most mysterious aspect of corporate funding is the system for determining what will be supported. As in foundations, the philosophy and the mechanisms differ across the entire sector, and even within each corporation, one can find seeming inconsistencies.

One explanation for the variation is that there is more than one method used by business organizations to dispense their philanthropic gifts. A number of companies, about 400 at the last count, have established company foundations, which are discussed in the chapter titled "Foundations and the Arts." But even those corporations with foundations do not necessarily make all their contributions through the foundation. The chief executive may reserve the right to make direct gifts or disbursements of various kinds, or this

prerogative may be delegated to a senior officer, such as a vice-president for public relations.

Most corporations, including those that have company foundations, assign responsibility for the company's philanthropic program to one office. It may be the public relations or the community affairs or the public service office or one bearing some other name, but it can usually be identified by the implication that it serves as the liaison between the corporation and the public. Many companies have, in these offices, a "contributions officer." The person in that position may be very high up in the company and may report directly to the president, or he may head up one unit in the public relations or another department. There are, therefore, two routes by which one may approach a corporation: through the company foundation or through the office that handles the contributions program.

The variation in the mechanisms has very little to do with the giving philosophy, which is almost always determined by the company's top decision-makers. Decisions regarding specific requests may involve numerous company officials and, in some companies, even committees of employees, but the overall policy is a major corporate decision. Some companies are willing to consider suggestions from the outside, but many subscribe to the policy of the Xerox Corporation, which prefers to initiate their own programs rather than waiting to hear from others. Edward Truschke, Xerox's manager of corporate responsibility, told N. R. Kleinfield of *The New York Times*, "We get about 6,000 requests a year, some for oddball things like mountain climbs and comic book archives. We respond to some worthier ones, but we like to get the ball rolling ourselves."[8]

Exxon likes to fund projects for which it can supply expertise as well as dollars. They have, for example, funded one program to teach college officials how to run a better school, and they provided consultants from their own organization.

Under pressure from their shareholders to make dividend payments instead of grants to nonprofit organizations, corporations are beginning to favor the support of something that benefits the public in a very visible manner: a performance, an exhibition, or a festival. AT&T recently announced a major commitment to sponsor nationwide tours by seven of America's leading symphony orchestras,

[8] *The New York Times*, January 1, 1978.

beginning in 1979. By 1982, the orchestras will have played in more than 100 towns, cities, and college campuses across the country. Hoffman-La Roche, Inc., of Nutley, New Jersey, gave $5,000 to the Classic Ballet Company of New Jersey to support its "Free Programs for Schools and Community Organizations." SCM Corporation made a grant of $25,000 to the American Federation of Arts to underwrite the exhibition "Tibet: A Lost World, the Newark Museum Collection of Tibetan Art and Ethnography" and the publication of the catalog. The exhibition will travel to Cincinnati; Worcester, MA; Denver; Buffalo; and Purchase, NY.

Most grant seekers complain not so much about the philosophy but about the fact that it is hard to get information on corporate programs. Several large companies have taken positive steps toward involving more employees in the decision-making process and toward wider dissemination of information about their contributions. Lockheed Aircraft Corporation, Levi Strauss, Xerox, and IBM are among these. Frank Koch of Syntex is a leading exponent of the idea that shareholders, community leaders, and grant seekers have a right to be informed about the philanthropic activities of a corporation. Koch has elucidated upon this principle in his book.[9]

Edward M. Block, Vice President for Public Relations and Employee Information of AT&T, writing in *Grants Magazine* (Vol 1, No. 3) says:

> If it were solely up to me, personally, I wouldn't hesitate to declare contribution policy far and wide, marking it boldly and with an asterisk. . . . I would list plainly for all who are interested the specific organizations to which the funds were allotted and the amounts, making clear that *no* organization has an automatic lock on the same funds for next year.

Exxon made a very unusual disclosure by publishing in *Dimensions, 1977* a list of every donee in the United States with the amount received—$21.9 million from Exxon and $3.8 million from the Exxon Foundation—in 1977. Other corporations are beginning to make similar disclosures.

The responsibility for better communications between business and the arts should not rest entirely with the corporate community. Arts groups, especially those located in cities and towns where support from business and industry is vital, should take the initia-

[9] *The New Corporate Philanthropy*, pp. 23–33.

tive in making local business leaders aware of the opportunities that partnership offers to each of them.

A few years ago, a nonprofit organization was established in New York City to provide a link between small arts groups and business by various activities, including publications, seminars, and the staging of artistic events for corporation employees. The Arts and Business Council (ABC) has a membership composed in equal numbers of corporations and arts organizations, and one of its most important services is to send specially trained volunteer business-people to the aid of financially troubled arts groups. Its executive director, Sybil Simon, who started ABC, emphasizes their interest in small groups. She says, "We're not dealing with Lincoln Center." This may be a model for other communities that wish to bring the managerial and administrative expertise of corporate executives to small arts groups and to create a closer bond between the business community and local arts organizations. The Arts and Business Council, Inc., is located at 130 East 40 Street, New York, NY 10016.

As more information is exchanged between arts groups and business organizations, it will become easier for grant seekers to identify possible funding sources. General guidelines for approaching all corporations do not exist, but a few fundamental tenets underlie business philanthropy programs that should be borne well in mind by organizations seeking corporate support. J. Moreau Brown, who was for 18 years a member of the pioneering corporate-level educational relations and support component of the General Electric Company and an officer of the General Electric Foundation, says that businesses are interested in supporting projects or activities that, in some way, relate to their needs. It may not always be obvious, particularly in support of arts programs, what need is being met, but Brown gives some examples:

1. *Personal needs of corporate executives.* If the chairman of the board wants to be identified as a patron of the arts or has a genuine interest in a particular art form, this can be a decisive factor.

2. *Influence on corporate profits.* Although support for the arts may seem to have little bearing on profits, they can be an important motivator. Corporate sponsorship of cultural programs on public television is often regarded by the sponsor as a business expense because its advertising value is so great. It is at the same time often a very real contribution to the arts.

3. *Improvement of the environment in places where corporate affil-*

iates are located. This serves to foster high morale among local employees and aids in the recruitment of executive staff as well as production and service workers.

4. *Good public relations.* Every company knows the value of a good public image, and philanthropy is one of the most effective means of creating goodwill for a business organization.

Brown also says that the nature of the business affects the types of grants made, and this is very true in some areas of philanthropy, particularly in scientific research and development or in education. In the arts, the link is not always easy to observe. However, there are examples. AT&T's interest in sponsoring high-quality television programming may not be motivated primarily by their interest in the TV industry, but it is not unrelated. It is easy to see the connection between the Columbia Broadcasting System's business and their gift of $2,158,000 to 12 civic and artistic groups in Los Angeles, where many CBS shows originate and a more recent gift of over $2 million to 22 Chicago youth-oriented organizations. These grants were part of a program designed for awards in cities where CBS has major operations.

Every corporation, like every human being, is unique, and generalizations have limited value. The preapplication research for potential grantors from the business community must therefore be conducted with great diligence, in order to bring about that most felicitous of events, the meeting of an applicant with an idea and a willing funder.

Information Sources—Corporations

It requires a great deal of initiative and ingenuity to find out about corporate philanthropy programs. The main obstacle is that many corporations cloak their charitable contribution activities in almost as much secrecy as that with which they protect new product research and development. Some of this secrecy may be just a spillover from the security mentality that becomes almost second nature in highly competitive commercial enterprises. It is the same kind of mentality that pervades some government agencies, particularly those that have any connection with national defense, where specifications for a water cooler may appear to be guarded as carefully as information about the latest weapons systems.

Another obstacle for the seeker of information about corporate programs is that there is no central organization where such information is collected and made available. Before the establishment of The Foundation Center, information about foundations in the United States was also very difficult to obtain. It is not exactly easy now, but the task of researching foundations has been facilitated immeasurably by the services and publications of the center and its national network of cooperating libraries. Perhaps, in time, as corporate philanthropy continues to grow and to become more significant, some kind of central point for the collection and the dissemination of information on business giving will be set up. A few steps in this direction can be observed already: guides to corporate giving are beginning to appear and organizations are forming to encourage business support for the arts. These specialized organizations not only work toward increasing arts support in the business community but also assist their constituents in identifying and approaching potential corporate sponsors. Some organizations work with nonprofit organizations to improve their administrative operation, strengthen their boards of directors, and upgrade their fiscal accountability in order to make themselves more attractive grantees to the corporate community.

The direct approach to a potential business sponsor is usually the best way to start out collecting information, but this approach is feasible only under certain circumstances. In the cities or towns where businesses are located, company executives are frequently active in local civic, cultural, or religious organizations. Even those officials not directly associated with the contributions program can be helpful in directing nonprofit organizations to the appropriate office or in collecting printed materials setting forth the policy and programs of the company. Always keep in mind that decisions about corporate gifts may be made at the headquarters level, and even the local plant superintendent or manager may not have the last word. Formal requests are usually made to the top local official, after the proper groundwork has been done by the board and the staff of the nonprofit group. That groundwork often consists of informal discussions between an influential board member and the company executive to whom the request is finally sent.

In medium-sized or large cities where there are many businesses, the search for potential sponsors must be conducted along the same lines as that for a foundation sponsor, and the main sources

of information are *libraries, professional associations, commercial information services,* and *news media* and *printed programs.*

LIBRARIES

Libraries that contain basic reference volumes on grant giving are also likely to have at least one of the very few guides now available for corporations. The Foundation Center libraries have a limited amount of information available on grant giving in the business community, and of course, they have information on company foundations.

Late in 1978, two new directories appeared that contain the most information that has so far been assembled about corporations and the arts. It is still too early to assess their effectiveness because so few groups have had a chance to use them. The mere fact of their existence is a great achievement, however, and any nonprofit organization seeking support from businesses should examine both of them.

A Guide to Corporate Giving in the Arts, edited by Susan Wagner and published by the American Council for the Arts (ACA), details total contributions to the arts, activities eligible for support, priorities and restrictions, geographic giving area, factors affecting giving, and the future plans of 359 of America's leading corporations. The mere disclosure of this much information by that many corporations is evidence of the growing confidence between the business and the arts communities. Those companies that agreed to contribute to the publication indicate, by so doing, their willingness to be approached by artists and arts organizations whose activities and projects fall within their guidelines.

This paperbound book may be ordered from the American Council for the Arts, 570 Seventh Avenue, New York, NY 10018, for $12.50 prepaid, postage included.

The *National Directory of Arts Support by Business Corporations,* 1st edition, by Daniel Millsaps and the editors of the *Washington International Arts Letter,* is a listing of about 700 corporations, with addresses, names of officers, and 2,812 affiliates, divisions, subsidiaries, and their locations. The companies included are those that have supported the arts in some way, through corporate art collections, artists-in-residence, or general philanthropy. Unfortunately,

there is no subject or field-of-interest index to help identify specific interests, but there is an index of officers.

The most obvious value of this new publication is as a guide to the location of corporate affiliates; the information on where large national corporations have installations is very important as an indicator of interest in a particular locality.

This paperback book has 221 pages and sells for $65. According to the publisher, it is being distributed to public and educational libraries, where it is available to those who cannot afford to buy it. It may be ordered from WIAL, Box 9005, Washington, DC 20003.

There are a few general books on the subject of corporate support for the arts that may be found in libraries. One of the most knowledgeable and gifted writers on this subject is Gideon Chagy, Vice President of the Business Committee for the Arts. His book, *The New Patrons of the Arts,* published by Harry N. Abrams, Inc., New York in 1972, explores the ways in which the value of the arts and the interests of business are joined.

Another noted authority on the modern corporation and the arts is Richard Eells, Graduate School of Business, Columbia University. Eells has written several books about corporations in contemporary society; among them, *The Corporation and the Arts,* published by The Macmillan Publishing Company, Inc., New York, can be found in many libraries. Although it appeared in 1967, the message of this book is still valid, as summarized in Eells's preface:

> Avoid the narrow view that corporate financial support of certain of the arts is the main issue. Try to conceive of the arts broadly and to consider the implications of their interplay with the corporate world of business. Try to imagine what business corporations, on the one hand, and the art world, on the other, can do apart and in collaboration with one another to achieve their common objectives.

Standard reference works found in most libraries and all business libraries that contain information about corporate officers can be helpful in identifying an appropriate person or officer to approach for information.

Standard and Poor's Register of Corporations, Directors and Executives, which lists executives and their titles, is published by Standard & Poor's Corporation, 25 Broadway, New York, NY 10004.

Million Dollar Directory and *Middle Market Directory,* published by Dun and Bradstreet, 99 Church Street, New York, NY 10007,

contains useful information on the organization and officers of some leading business concerns.

The periodical publications that cover the arts generally and those that serve special art forms include corporations in their reports on arts support.

Arts Management, published five times a year, by Alvin H. Reiss, 408 West 57 Street, New York, NY 10019, reports on activities of corporations in support of the arts. Reiss is the author of a book on business and the arts, *Culture & Company: A Critical Study of an Improbable Alliance,* published in 1972, of which the president of American Airlines at that time said, "This book . . . is good reading for businesses already participating in the Arts and *compulsory reading* for those that are not." It is also useful reading for those who look to business for contributions. A copy may be found in many libraries; information about its purchase may be requested from *Arts Management.*

PROFESSIONAL ASSOCIATIONS

The Business Committee for the Arts, Inc. (BCA) was established in 1967 as a private, national organization created to encourage business and industry to assume a greater share of responsibility for the support, growth, and vitality of the arts.

Membership in the BCA consists of approximately 150 chief executive officers of corporations and about 100 participating corporations and corporate foundations.

The BCA does not intercede in the grant-seeking process in the role of "broker," but it publishes materials that contain valuable information for arts organizations that seek to receive or increase their corporate support. The organization also encourages business to support the arts by making information available to members concerning the needs of the nonprofit sector and the significance of the arts in society, and jointly with *Forbes* Magazine, it makes annual awards to companies for outstanding contributions to the arts.

BCA publications are free or are priced very reasonably. Single copies of the following booklets are free to individuals; arts or business organizations may request 25 copies of any four booklets (for

a total of 100) at no cost. Any number in excess of the 100 (of four or more different titles) costs 25 cents per copy:

- *Approaching Business for Support of the Arts*—guidelines for arts organizations who seek business support
- *The Arts and the Art of Survival*—a speech by Robert W. Sarnoff
- *Business and the Arts . . . A New Challenge*—a speech by J. Irwin Miller
- *Business and the Arts: A Question of Support*—guidelines for businessmen who support or are contemplating support of the arts
- *Business Support of the Arts, 1978*—a statistical study with highlights and charts
- *One Hundred Twenty-Six Ways to Support the Arts*—ideas and suggested projects by which business can significantly assist the arts in a community
- *To Benefit the Community as a Whole*—a speech by Frank Stanton
- *United Fund Raising for the Arts* (revised 1976)—by Michael Newton

A special brochure, *2,507 Examples of How BCA Companies Supported the Arts in '78 and '79*, summarizes corporate arts support programs by disciplines. Single copies are free. Multiple copies may be purchased for 50 cents each.

The BCA publishes a quarterly, *BCA News*, and a monthly, *Arts Business*, which are free to business or arts organizations. They may be requested from Business Committee for the Arts, Inc., 1501 Broadway, Suite 2600, New York, NY 10036.

BCA News reports on corporate grant making for the arts, announces new programs or opportunities for both grant seekers and grant makers, and gives current information about the activities of the BCA.

Arts Business is a listing of national and international awards made by corporations, and those awards made within each state are listed alphabetically by state. It is a brief, informative, monthly rundown on the interaction at all levels between the arts and the business communities.

The recognition by businessmen of the significance of the arts in all aspects of society, including the economy, has led to programs within local chambers of commerce and other businessmen's organizations to encourage the growth of the arts in communities across the country.

These groups serve as a meeting ground where cooperation between arts councils or other local cultural groups and the business community can be established and through which business leaders can be approached.

Professional associations in the various art forms, as mentioned in the chapter on "Basic Sources of Information," provide their constituencies with some news and guidance about corporate support, but more could be done by these groups. The formation of organizations such as the Corporate Fund for Dance and the Corporate Theatre Fund are models that might well be followed by artists and arts groups in particular fields, especially in those localities where there is a heavy concentration of business and industry.

COMMERCIAL INFORMATION SERVICES

Most of the subscription services offered to nonprofit groups concentrate on foundations and the government. Even for the professionals, finding out about corporate programs and obtaining approval for the publication of such information is not easy. But there is enough overlap between foundations and corporations so that some of the information supplied for philanthropic organizations is also useful in seeking corporate support.

The Taft Corporation, which has for 11 years been a major provider of information on grant opportunities in the United States, is best known for its collection and dissemination of information on foundations. The approach of Taft has been characterized by its emphasis on the decision makers, those people in the organizations who are responsible for determining what kinds of activities and which groups or individuals will be supported. Taft's materials, therefore, generally contain more personal data than are available from other sources. Political affiliations, social club memberships, and religious preferences are often indicated in the biographical data on philanthropic leaders. Some people, especially those reported upon, find this objectionable, but subscribers to the Taft services

have reported great satisfaction with them for a number of years, and Taft has outlasted many such organizations.

Taft takes the position that corporate giving is highly personal, that is to say, that the interests and concerns of the decision makers in the company are the most influential factor. On this basis, Taft assumes that the more a grant seeker can find out about the personality of those to whom an appeal will be directed, the greater the chances of success will be.

Taft Corporate Foundation Directory is a guide to 318 company foundations. The general information that each entry gives on the corporation is useful for those who wish to apply directly to the contributions officer of the company as well as for those who prefer to approach the foundation. The total sales figures of the company, the corporate operating locations, the major products produced, and the names of the officers and the board members of the foundation are included. Obviously, many company foundation board members are top-ranking executives in the company. The 1979–1980 edition of the directory sells for $125.

Another Taft publication designed primarily for foundations but useful also in research on corporations is *Trustees of Wealth*, which gives biographical data on 6,500 individuals from more than 3,000 foundations. Many of these people are not only foundation board members but also business executives; in fact, most of them direct small foundations that do not have a full-time professional staff whom applicants may approach. The trustees in those organizations must be approached by applicants directly. Information about their business connections and personal interests may be useful background for nonprofit organizations that wish to apply to the corporations with which these people are associated. The price of *Trustees of Wealth* is $90.

Information on Taft's services and publications may be obtained from Taft Corporation, 1000 Vermont Avenue, NW, Washington, DC 20005.

NEWS MEDIA AND PRINTED PROGRAMS

Periodical publications aimed primarily at the business world, such as *Forbes* Magazine and *Business Week*, report on corporate philanthropy, and *The Wall Street Journal*, published by Dow Jones

& Company, frequently carries stories about corporate support of the arts.

Every television or radio program that acknowledges support from a corporation may be viewed as a source of information concerning the interests of that particular corporation. The same is true of every art exhibition catalog or performing-arts program that lists corporate sponsors.

The artist or arts administrator should note carefully those companies that support his or her art form, and a collection of catalogs or programs will very soon indicate whether the interest of one company is sustained or whether it is a one-time foray into an arts field to accommodate a friend or a relative of the company's chief executive.

Programs from large centers for the performing arts, such as Lincoln Center or the Kennedy Center, contain the most extensive listings, but the names of sponsors from the business community appear on very modest catalogs of sculpture and painting exhibitions by unheard-of artists in the plainest SoHo studios or on programs of the most obscure Off-Off-Broadway plays. The naturally conservative business community is more likely to favor the traditional, large, national institutions. Sponsorship of activities carried on in such places and by such groups entails little risk of embarrassment of any kind—social, political, or even financial—although there have been cases where the use of money in very respectable institutions has been questioned. That type of sponsorship also guarantees maximum visibility for the company. The name of a sponsoring corporation may be disseminated in hundreds of thousands of copies of Lincoln Center programs, whereas the sponsor of an Off-Off-Broadway production can expect a distribution of programs in the hundreds, at most.

Those who seek support for arts projects, therefore, are well advised not only to be always alert to which companies sponsored a dance, drama, music, or visual arts program but to be aware of the size and scope of the activity funded by a particular sponsor. There are now more corporations willing to take chances on new groups than there used to be, but the most significant factor is that smaller companies are beginning to see that they, too, can become patrons of the arts to their own benefit as well as to the benefit of the donee. As a matter of fact, arts sponsorship is a particularly attractive form of philanthropy for the small giver because a small

amount of money can make a visible difference. A company that might be unable to fund a slum-clearance project might be persuaded to help a dance or drama group for young people in that same neighborhood.

The historical approach to grant givers is to offer the patron something he wants or to offer to do something he wants to see done. One of the best clues to what companies want to do or to see done is found in the activities they have already supported.

The Application

WHAT TO DO BEFORE YOU APPLY

The chances are much better than fifty-fifty that any arts organization starting out to apply for its first grant, or even its second or third, is not ready for it. Program directors in foundations, corporations, and government agencies, when asked about the most common failings of applicants, invariably cite poor organization and general lack of preparation.

Most groups that approach funding sources are badly structured, poorly informed, and unclear about their objectives, and more likely than not, they are in the wrong place.

Some grant makers have responded to grant applications by offering, in place of the requested grant, assistance in restructuring the organization and improving its management capability. The Syntex Corporation joined with the San Mateo Foundation in California to subsidize workshops for nonprofit organizations in accounting, taxes, and other management areas. The Levi Strauss Foundation funded a series of management workshops for nonprofit agencies in New Mexico and Texas. The New York State Council on the Arts sometimes provides consultants to assist groups in getting their house in order to improve the chance that grant funds awarded to them later will be well managed.

Individual artists are no more likely to be well prepared for a grant search than organizations—as a matter of fact, they are less likely to know what to do.

Before actually sitting down to prepare a formal application for

a grant, preparation must take place within the applicant institution, and preliminary discussions must be held with potential funding organizations. The preparatory phase is thus divided into *internal preparation* and *interaction with funding organizations*.

INTERNAL PREPARATION

There is some basic information that everyone should have even before beginning the search for financial support. Otherwise, a lot of effort is likely to be expended on worthless leads or fruitless attempts to get facts.

The first thing to do is to learn the "language of grants." The grants field, like all others, has its own jargon, and familiarity with the meaning of certain terms is essential.

Language of Grants

Among the least understood terms are those used by most granting organizations to provide support for artists and art groups: *grant, contract, fellowship,* and *scholarship*.

The word *grant* has come to be used in a generic sense meaning any form of assistance, including, in addition to grants, *contracts, fellowships,* and *scholarships*. Each category has specific purposes, and each is used selectively to support certain kinds of activities.

Contracts

The contract is used for the exchange of money for services and/ or goods in dealing with profit-making organizations; a nonprofit organization may also be a party to a contract, although this mechanism is seldom used for funding creative work. The federal government makes known to potential bidders its specifications for contracts that are available through "Request for Proposal" packages, frequently referred to as RFPs. Once a bid has been accepted and the contract awarded, the awarding agency, the *contractor*, maintains close control over the project and may monitor it quite meticulously. The Office of Special Projects of the National Endowment for the Arts uses contractual agreements as well as technical assistance ar-

rangements and grants-in-aid to fund a variety of interdisciplinary programs, including folk arts, arts centers and festivals, and service organizations.

The Children's Television Series (see program description on pp. 112–113) uses a mechanism that is halfway between a grant and a contract, called *contracts of assistance*. Unsolicited proposals are not accepted, but proposals ("bids") may be submitted in response to announcements concerning the categories to be funded. These announcements are sent out regularly and are available to anyone upon request.

Fellowships

This is the mechanism most often used to provide assistance directly to individual artists to enable them to complete certain work or to advance their careers. Fellowships are funded by government agencies, by private foundations, and by corporations directly and also through their "apron string" foundations. The artist with no institutional affiliation who is looking for support should explore fellowship programs first of all.

Scholarships

Educational support for undergraduate students is available from numerous sources without regard to field of interest. The student who wishes to go directly from high school to a school for training in one of the arts fields should check with the professional schools that specialize in the chosen field. The financial aid officers at those schools have information on available student aid. Eligibility for scholarships is usually based on a combination of talent, proven or potential, and need. The need may have to be documented, no matter how great the potential; and the talent may have to be evident, no matter how great the need. General information on scholarship programs is available in a booklet called "Don't Miss Out," published annually by Octameron Associates, P.O. Box 3437, Alexandria, VA 22302, for $1.50.

The Citizens' Scholarship Foundation of America organized a program in 1961 that is popularly called "Dollars for Scholars," and chapters now exist in over 300 cities, towns, and school districts. One unique aspect of this program is that it assists scholars who

wish to pursue any kind of post-high-school education program, including, but not restricted to, college. Students who wish to enter schools for vocational training, including training in the arts, are eligible for scholarships under this program. Information about "Dollars for Scholars" and the location of community chapters may be requested from the Citizens' Scholarship Foundation of America, One South Street, Concord, NH 03301.

Grants

This is the most common form of financial support, as evidenced by the use of the term for assistance in general. A grant is an award by which money (or property in lieu of money) is paid to a *grantee* (the recipient) by the *grantor* (the donor or funding organization) to accomplish a specific agreed-upon project. Grants are made to tax-exempt, nonprofit organizations, and the purpose is almost always based upon ideas originating with the grantee. Once the award has been made, the involvement of the grantor is minimal. The grant instrument sets forth in clear terms the obligations devolving on both the grantee and the grantor and should *always* be in writing.

There are numerous types of grants, and their size and scope are virtually unlimited. Awards may be very small or may soar into the millions of dollars. The types of grants most applicable to the arts fields are the following:

1. *Block* (or *"bloc"*) grants are federal funds distributed through state or local units of government. The money is federal and the general support area is specified, but the decision on using it is made by the state or municipality. Most education funds are disseminated through this mechanism, including some arts education programs. Applications for funds distributed in this manner are directed to the unit of government that determines their use.
2. *Conference* grants provide support for meetings, symposia, or seminars. They may include necessary travel, per diem and administrative costs, and the cost of publishing the proceedings.
3. *Consortium* grants are given when two or more institutions apply jointly for funds to carry out a project. One of the

institutions is usually designated as the fiscal agent and assumes accountability for the entire program.

4. *Construction* grants support building, expanding, or major alterations to physical facilities.

5. *Demonstration* grants are used to illustrate the effectiveness of a certain procedure or methodology, for example, establishing the feasibility of an art restoration method or a system of dance notation.

6. *Planning* grants are for planning, developing, designing, and establishing the means of accomplishing a major objective. Often they are used in the first stage of a large project, to cover the cost of the preliminary steps leading up to the actual project. Support of a planning grant indicates definite interest in the idea, and the funder is often a source of at least partial assistance for the final project.

7. *Project* grants are one of the most flexible types of grants, in that any activity acceptable to the funding agency can be supported by this mechanism. Special exhibitions, performances, training programs, research, productions of work in any field, and program activities all may be done as project grants.

8. *Research* grants are used for experimentation or investigation aimed at the discovery and interpretation of facts, the revision of accepted theories in the light of new facts, or the application of such new and revised theories.

9. *Staffing* grants provide support for the salaries of professional and technical staff members, plus in-service training in many cases.

10. *Training* grants defray the costs of training existing staff, students, or potential staff in the techniques or procedures pertinent to a particular organization or to a particular field.

11. *Travel* grants cover travel expenses to meetings and the costs of research or study. The purpose of the travel and the stature of the applicant in his/her field are major criteria.

The term *matching grant* does not define a specific kind of grant but may apply to several of the types listed; it means that a portion of the cost of an activity must be funded by the applicant organization or by sources other than the grantor who makes the matching

grant. *Matching* sometimes implies hard cash and sometimes "in-kind" services and facilities. Federal grants require that the portion provided by the grantor as a match be from a nonfederal source. The grantor establishes the matching basis, which may be one-for-one or two-for-one, that is, one dollar awarded for each dollar provided by the grantee, or two dollars for each one raised by the grantee from other sources.

In 1977, the National Endowment for the Arts (NEA) introduced another kind of matching grant, called the *challenge grant*, to encourage new and increased support for cultural institutions. Challenge grants require a three-for-one match; that is, the NEA awards one dollar for every three from other sources, except for capital improvement projects for which they award one dollar for every *four*, making the term *challenge* quite appropriate. These are one-time, multiyear grants; the institution may have three years to come up with its portion.

Some grants require the institution to share in the cost of the project on a "cost-sharing" basis. In this arrangement, the sharing may be in actual cash contributions but is more likely to be in in-kind services, such as professional staff time, use of physical facilities and equipment, and administrative services. A specific percentage of the total project may be designated as the amount of the cost to be provided by the grantee; it may be 1% of the total project and is seldom more than 20%.

Revenue-sharing funds are federal funds returned to the lower governmental levels for the discretionary use of the units to which they are distributed, and therefore, they may be thought of as a kind of block grant. Of the approximately 37,000 localities that received revenue-sharing funds totaling $1.89 billion in 1978, the majority were municipal governments. Many towns and cities use those awards to make up deficits between tax revenues and the cost of providing public services, but some places have supported the construction or operation of cultural facilities. The small city of Clinton, Tennessee used $478,000 of its 1978 revenue-sharing allocation to help build a new community center that cost $1.8 million and provides facilities for recreation and for cultural programs to the 30,000 residents of Anderson County, for which Clinton is the county seat.

The use of revenue-sharing funds is controlled by elected officials, which means that local taxpayers can have a voice in determining how these funds are spent. Any effort to acquire support

from these funds requires negotiations with local agencies to which the funds have been assigned or with the officials who are responsible for their distribution.

Review of the various grant mechanisms reveals that more than one may be applicable to a particular project; by recognizing this, the applicant can identify the available options. Very large projects that require more than one sponsor might be funded by different organizations, through different types of grants for each separate phase.

The individual artist may look into fellowship programs and simultaneously explore the possibility of establishing an affiliation with an institution through which an application can be processed and a grant administered.

Acronyms

Another element in the "language of grants" is the acronym. This is particularly important in dealing with the government, where new acronyms proliferate and old ones disappear as new agencies are established and old ones are abolished or renamed. Acronyms appear to occur by happenstance, but very few organizations nowadays decide upon a name or a program title without considering the result of combining the first letter of each word. Consider, for example, the thought that must have gone into the title for an arts program for prisoners (Creative Use of Leisure Time Under Restrictive Environments, or CULTURE) if you doubt the necessity for becoming acquainted with the most commonly used acronyms. The acronyms for organizations, agencies, and programs discussed in this book are listed in Appendix VI.

Organization and Structure

Since only tax-exempt, nonprofit organizations are eligible to apply for grants as a rule, one of the first acts of a newly organized arts group is to establish its nonprofit status with the Internal Revenue Service. For IRS purposes, a tax-exempt, nonprofit organization is defined as one in which no part of earnings inures to the benefit of a private stockholder or individual and to which donations are

allowable as a charitable contribution under Section 170(c) of the Internal Revenue Code of 1954 as amended.

Some grantors, especially in the government, require that a copy of the Internal Revenue Service determination letter certifying the applicant's tax-exempt status under Section 501 accompany applications for assistance.

A newly formed organization may need legal assistance in obtaining IRS determination of its tax-exempt status. Professional help may be required by new or established groups to deal with other legal matters such as ticket-selling regulations, copyright matters, execution of contracts, and compliance with laws covering hiring practices, workmen's compensation, health insurance, and pension plans.

Volunteer Lawyers for the Arts (VLA)

Legal assistance is expensive, and groups that cannot afford regular legal fees should be aware of the Volunteer Lawyers for the Arts (VLA), which was formed in 1969 to assist artists and not-for-profit organizations in dealing with arts-related legal problems. By the end of 1979, there were more than 400 attorneys, in approximately 41 cities of 25 states and Washington, D.C., and one in London, England, dealing with questions of copyright, record keeping, becoming a nonprofit corporation and qualifying for tax exemption, and other matters (see Table 9).

VLA publishes a quarterly journal called *Art and the Law*, which explains current legal issues involving the arts. The current subscription price is $15 a year, and it may be ordered from Volunteer Lawyers for the Arts, 36 West 44 Street, Suite 1110, New York, NY 10036. VLA has also published a useful pamphlet titled, *Arts Organizations and Private Foundations: A discussion focused on Private Foundations as defined under Section 509 of the Internal Revenue Code*, which arts groups would find useful.

After the tax-exempt status of an arts group has been established, the next step is to ensure that its management expertise is adequate for fulfilling the obligations that will devolve upon the organization as a result of receiving grant support. The core of the group's expertise lies in its board of directors. Without a strong board, no group can hope to survive and accomplish its mission. Building such a board is not easy. Generally speaking, the best place

to look for help is in the sector that knows all about boards of directors, the corporate community, but arts groups want something more than good management; they want good *arts* management, and that is very specialized.

Volunteer Urban Consulting Group (VUCG)

There is one nonprofit organization that offers assistance to nonprofit health, social service, arts, housing, education, and community organizations in determining the skills that are needed at a board level and in recruiting candidates for consideration who possess those skills. It is the Volunteer Urban Consulting Group, Inc. (VUCG), a nonprofit organization founded in 1969 by the Harvard Business School Club of Greater New York. VUCG is funded by the Office of Minority Business Enterprise (OMBE) of the U.S. Department of Commerce and by grants from close to a hundred foundations and corporations. It receives volunteer support from eight business-school alumni clubs scattered throughout the country, and it offers assistance in virtually every management-related area, including accounting, financial planning and budgeting, personnel and organizational planning, marketing, internal operations and systems, insurance, and real estate.

The VUCG's Board Candidate Service is funded by The William H. Donner Foundation, Inc., Exxon Corp., Charles Stewart Mott Foundation, Rockefeller Brothers Fund, and The Shubert Foundation, Inc. To get the service underway, Citibank loaned VUCG staff member, Mary Keil, who was Director of the Board Candidate Service from October 1978 until November 1979.

Organizations that need to strengthen their boards of directors can apply to VUCG for assistance. Acceptance of applications depends upon the funding source requirements and the types of organizations that the VUCG is currently assisting—they want to maintain a mix between arts and social service organizations. For information, write to Brooke W. Mahoney, Director, Volunteer Urban Consulting Group, Inc., 300 East 42 Street, New York, NY 10017.

Ampersand Inc.

A number of organizations offer assistance in "grantsmanship" at various levels. Some will take over the entire task—for a fee, of

TABLE 9. VOLUNTEER LAWYERS FOR THE ARTS ORGANIZATIONS

NATIONWIDE—Existing V.L.A. type groups and persons in the process of forming a V.L.A. type group.

Alabama
John D. Saxon
Alabama Volunteer Lawyers for the
 Arts Committee
Sirote, Permutt, Friend
2222 Arlington Avenue S
P.O. Box 3364A
Birmingham, AL 35205
(205)933-7111

Alaska
Ira Perman
Executive Director
Arts Alaska, Inc.
619 Warehouse Avenue, Suite 216
Anchorage, AK 99501

California
Melissa Benedek
Mitchell, Silberberg & Knaff
1800 Century Park East
Los Angeles, CA 90067
(213)556-4423

Barbara Kibbe
Bay Area Lawyers for the Arts
Fort Mason Center, Building 310
San Francisco, CA 94123
(415)775-7200

Connecticut
Jane Herlan
Connecticut Commission on the Arts
340 Capitol Avenue
Hartford, CT 06106
(203)566-4770

Delaware
Judith Kidd
Delaware State Arts Council
9th and French Streets
Wilmington, DE 19801
(302)571-3540

District of Columbia—Maryland
Joshua Kaufman

2700 Q Street, N.W.
Suite 204
Washington, DC 20007

Florida
Ann Lynn Millonig
Director
Broward Arts Council
105 East Las Olas Blvd.
Fort Lauderdale, FL 33301

Mary Hausch
Artistic Co-Director
Hippodrome Theater
1540 N.W. 53rd Avenue
Gainesville, FL 32601

Howard L. Dale
Pajcic Pajcic and Dale
Attorneys at Law, Suite 440
The Galleria
333 Laura Street
Jacksonville, FL 23302

Arthur W. Milam
Milam and Wilbur
1700 Barnett Bank Building
Jacksonville, FL 32202
(904)346-4211

Robert Landon II
Smathers and Thompson
1301 Alfred I. duPont Building
Miami, FL 33131
(305)379-6523

Thomas R. Post
Thomas R. Post & Associates
25 West Flagler Street
Miami, FL 33130
(305)379-7667

Robin Reiter
The Dade County Council of Arts and
 Sciences
73 West Flagler, Room 2004
Miami, FL 33130

TABLE 9 *(Continued)*

Earl G. Schreiber
Executive Director
Arts Council of Tampa-Hillsborough
 County
512 North Florida Avenue
Tampa, FL 33602

Georgia
Robert C. Lower
Georgia Volunteer Lawyers for the
 Arts, Inc.
100 Colony Square
Suite 1910
Atlanta, GA 30303
(404)588-0300

Illinois
Tom Leavens
Lawyers for the Creative Arts
111 North Wabash Avenue
Chicago, IL 60602
(312)263-6989

Iowa
Barry A. Lindahl
Iowa Lawyers for the Arts
One Dubuque Plaza
Dubuque, IA 52201
(319)556-8552

Maine
Jill Gilman
Maine State Commission on Arts and
 Humanities
State House
Augusta, ME 04333

Massachusetts
Kent Davey
Harvard Advocates for the Arts
Harvard Law School
Cambridge, MA 02138
(617)495-4702

Linda McKinney
Lawyers for the Arts
Artists Foundation
100 Boylston Street

Boston MA 02116
(617)482-8100

Minnesota
Frederick T. Rosenblatt
President
Minnesota Lawyers for the Arts
1200 National City Bank Building
Minneapolis, MN 55402
(612)339-1200

New Jersey
Harry Devlin
Cultural Law Committee
New Jersey State Bar Association
Trenton, NJ 08608
(201)232-2323

New York
Carolyn Anderson
Albany League of the Arts, Inc.
135 Washington Avenue
Albany, NY 12210
(518)449-5380

Maxine Brandenburg
Arts Development Services
237 Main Street
Buffalo, NY 14203
(716)856-7520

Robert J. Kafin
115 Maple Street
Glen Falls, NY 12801
(518)793-6631

Cindy Kiebitz
Huntington Area Arts Council, Inc.
12 New Street
Huntington, NY 11743
(516)271-8423

Helen L. Vukasin
Executive Director
Ulster County Council for the Arts
286 Wall Street
Kingston, NY 12401

Judith N. Stein
Volunteer Lawyers for the Arts

Continued

TABLE 9 *(Continued)*

36 West 44 Street, Suite 1110
New York, NY 10036
(212)575-1150

Leonard Ryndes
Upper Catskill Community Council of
the Arts, Inc.
101 Old Milne Library
State University College
Oneonta, NY 13820
(607)423-2070

Naj Wikoff
Dutchess-Hackett Cultural Center
9 Vassar Street
Poughkeepsie, NY 12601
(914)454-3222

McCrea Hazlett
Arts Council of Rochester, Inc.
930 East Avenue
Rochester, NY 14607
(716)442-0570

Carol T. Jeschke
Director of Programming
Civic Center
411 Montgomery Street
Syracuse, NY 13202

North Carolina
Rufus L. Edmisten
Attorney General
Douglas A. Johnston, Esq.
Associate Attorney General
State of North Carolina
Department of Justice
P.O. Box 629
Raleigh, NC 27602

Anne Slifkin
Thorp & Anderson
913 BB & T Buildings
P.O. Box 470
Raleigh, NC 27602

Lorraine P. Laslett
Coordinator, Affiliate Galleries
North Carolina Museum of Art
Raleigh, NC 27611

Ohio
Sally Bemis
Volunteer Lawyers for the Arts
c/o Cleveland Area Arts Council
108 The Arcade
Cleveland, OH 44114
(216)781-0045

Arnold N. Gottlieb
421 North Michigan Street
Toledo, OH 43624

Oregon
Professor Leonard Duboff
Susan Legros
Lewis and Clark College
Northwestern School of Law
Portland, OR 97219
(503)244-1181

Pennsylvania
Louis Polis
Executive Director
c/o Philadelphia College of Arts
Broad and Spruce Street
Philadelphia, PA 19102
(215)545-3385

Rhode Island
Stephen T. O'Neill
Rhode Island Volunteer Lawyers for
the Arts
c/o Adler Pollock & Sheehan
One Hospital Trust Plaza
Providence, RI 02903
(401)274-7200

Tennessee
Sally Thomason
Executive Director
Memphis Arts Council
263 South McLean
P.O. Box 468
Memphis, TN 38104

Texas
Jay M. Vogelson, Esq.
Steinberg, Generes, Luerssen &
Vogelson

TABLE 9 (*Continued*)

220 Fidelity Union Tower
Dallas, TX 74201
(214)651-1712

Sharon Lorenzo
Volunteer Lawyers for the Arts
c/o Ray & McCreight
2919 Allen Parkway, Suite 204
Houston, TX 77109
(713)529-5454

Utah
Douglas F. Kridler
2287 Suada Drive
Salt Lake City, UT 84117

Melvin G. Larew, Jr., Esq.
Suite 430
Ten Broadway Building
Salt Lake City, UT 84101

Virginia
Patricia Prime, Executive Director

Metropolitan Arts Congress of
 Tidewater, Inc.
P.O. Box 11052
Norfolk, VA 23517

Washington
Barbara Hoffman
Washington Volunteer Lawyers for the
 Arts
University of Puget Sound Law School
55 Tacoma Way
Tacoma, WA 98402
(206)756-3327

OVERSEAS

England
Artlaw Services, Ltd.
125 Shaftesbury Avenue
London WC2, England
01-240-0610

course—but this can be expensive because the services must be paid for whether a grant is received or not. In the long run, it is much better for arts groups to develop in-house expertise in project planning, grant application, and grants management. For specific knowledge, it may be worthwhile to seek outside help that is obtainable on a consultant basis that permits tight cost control.

One young organization in North Carolina has a fine track record for helping nonprofit groups, predominantly in North Carolina, by providing services in the areas of board development, grantsmanship, proposal development, program development, grant administration and evaluation, and other areas. It is called Ampersand, Inc., and its chief executive officer is R. Philip Hanes, Jr., who has had years of experience in industry and in the arts. He and other members of the Hanes family have been leaders in the arts community in Winston-Salem and in the entire state of North Carolina for 25 years. Ampersand offers its services to all nonprofit groups, but its expertise in the arts qualifies it to be of special service to arts organizations. It has, as an example, successfully guided 10 groups

through the National Endowment for the Arts challenge grant program. Other similar groups are forming around the country, most of them spearheaded by corporate executives who are interested in the arts and believe that good management will enhance the effect of the funds made available for arts support.

For detailed information, write to Ampersand, Inc., 820 Buxton Street, Winston-Salem, NC 27101.

One of the most decisive elements in obtaining financial support is the credibility of the institution, not only in regard to its artistic merit but also in such matters as good management and fiscal responsibility. After potential funders have been assured of a group's competence to carry through on the artistic aspects of the proposed activity, they will want to be assured of its ability to manage the grant in such a way as to get the best results possible. A strong, effective, and influential board of directors and a competent staff are indicators of an organization that is legally and administratively prepared to bring a project to fruition.

Compliance with Government Regulations

Funding organizations have a decided preference for making awards to institutions rather than to individual applicants. One of the major reasons is that as federal regulatory mechanisms have grown more pervasive, grant-making agencies and organizations find that maintaining compliance is easier when dealing with a few institutions instead of with many individual grantees.

Organizations receiving governmental support must certify that in the conduct of their operations, they are in compliance with the requirements of Title VI of the Civil Rights Act of 1964 and the Rehabilitation Act of 1973, as amended, which bar discrimination on the basis of race, color, national origin, or handicap; and with Title IX of the Education Amendments of 1972 prohibiting discrimination on the basis of sex. Many private funding organizations also require grantees to comply with these laws.

Blanket certifications of compliance can be filed with federal government agencies, and organizations are advised to do this and thus eliminate the necessity for separate certification with each grant application.

If human subjects are involved in an activity or a project, the

organization must set up an institutional human subjects committee to review the provisions in the project design for the protection of those subjects. This regulation may seem to have little relevance to arts groups, but there are various situations in which the matter might arise. Children and handicapped or elderly persons who participate in an experimental arts-education project are "human subjects," and the applicant must establish either that they run no personal risk in participating or that they are adequately protected against possible risks. If there is any doubt about the possibility of risk, it is better to err on the cautious side and provide for adequate protection. Risks may be encountered by transporting subjects to a central location for some activity, by certain kinds of physical activity, or by any action that can be interpreted as invasion of privacy or exposure to personal embarrassment. Any participants in projects judged to involve risk must give their consent in writing to participate in the project, or in the cases of minors and certain handicapped persons, the legal guardians must give written consent. The regulations specify that such consent must be "informed." *Informed consent* means that the subject or the guardian has been fully briefed about the risks.

An example of a project that involved an arts group was one in which a researcher planned to watch rehearsals at a Shakespeare festival to see if some actors regularly followed the director's suggestions while others did not, and then see if it made any difference in the kind of reviews each received. The institutional review committee told the researcher that she would have to tell the actors— that is, get their informed consent—before carrying out the study. Dr. Charles R. McCarthy, director of the Office for Protection from Research Risks of the National Institutes of Health, says, "Being observed makes most of us feel uncomfortable, even if our actions are being done in public."

For complete information on current regulations regarding human subjects, write to the Office for Protection from Research Risks, National Institutes of Health, DHEW/PHS, Westwood Building, Bethesda, Md 20205.

Internal Coordination

Once an organization is legally, structurally, and organizationally ready to apply for grants, it is ready to plan a project that is

suited to its artistic and professional capabilities and that is consistent with its overall objectives.

A proposed project is often the brainchild of one person on the artistic staff, or occasionally, it is the idea of an outsider who would like to use the facilities of the institution for a production, an exhibition, or the achievement of a particular purpose.

Whether the idea originates within the group or is proposed by someone who wishes to affiliate with the group, every person, department, or unit that will be affected by the project should be consulted before the final decision is made.

One of the most common mistakes is to assume that if someone can bring in a project and arrange for it to be funded it is automatically a good thing. Obviously, its appropriateness for the organization from an artistic standpoint is the most critical element, but some projects may meet that criterion and still be unsuitable.

Many groups have discovered to their embarrassment and sorrow that their contribution to a grant-funded project in terms of services, staff time, facilities, and other resources far outweighed the advantages it brought. Occasionally, this will occur after the most careful analysis, but usually it can be avoided by an objective assessment of the costs in relation to the potential gain at the time of application. Following is a checklist that will help to determine whether a project is feasible for a group to undertake:

1. Does the project fall within the main area or one of the main areas of interest of the applicant organization? If not, does it fall within a peripheral area that overlaps with a major one?
2. Will it interfere with other projects to the detriment of either?
3. Does the proposed activity meet the standards of the institution?
4. Is the size of the project appropriate for the organization? Will it dislocate a disproportionate share of talent and facilities?
5. Are the qualifications of the personnel to be involved sufficient to carry out the project successfully?
6. Is the required space available?
7. Will specialized equipment or instruments be required, and how much will they cost?

8. Will the required facilities be available at the time they are required? (Such items as freight elevators, parking space, loading docks, auditoriums, lighting equipment, overnight accommodations, recording equipment, and soundproof or special temperature rooms.)

9. What additional work load will be placed upon the institution's administrative service units, such as the personnel department, the purchasing and accounting offices, the security staff, and the maintenance staff?

10. Will the project place an increased burden on other facilities, such as the cafeteria, the editorial office, the public relations staff, the elevators, the seating space, and the educational services personnel?

11. Will the cooperation of other institutions be required, and if so, have they agreed to participate?

12. Are there likely to be adverse reactions from the surrounding community? Noise, unusual traffic, night lighting, and the need for extra services from the police and fire departments are all factors that may affect the community.

13. Will the necessary staff, both professional and support personnel, be available? Will there be outside consultants? If so, have they agreed to participate? Does the recruitment of additional personnel pose a problem?

14. Do the personnel policies of the institution conform to all federal, state, and local requirements as to hiring practices; salary scales; health, unemployment, and retirement insurance; and other protective measures?

15. If matching funds are required, is the institution ready and able to arrange for its share? In the case of in-kind matching, is it willing to furnish the necessary amount?

16. Has an indirect (overhead) cost rate been established, or is the appropriate institutional official prepared to negotiate a federal government rate or agree to a satisfactory arrangement with a private organization?

Once these questions have been answered to the satisfaction of everyone concerned and the decision is made to go ahead and seek outside funding for the project, the preapplication negotiation with potential funders is ready to begin.

INTERACTION WITH THE FUNDING ORGANIZATION

There is no field in which the preliminary approaches to a potential funder are more important than in the arts. This is true because there is no field in which the decisions are so much a matter of opinion—even, in some cases, of personal taste. Objective criteria for art do not exist, but there are objective criteria by which an arts organization can be evaluated, and the grant seeker should be prepared for such evaluation.

One of the very first indications that a potential funder receives regarding the capability of the applicant is the timing of the initial approach. The breathless plea that bankruptcy is a certainty unless new funding arrives within the next few days reveals deficiency in planning, at least, and perhaps total incompetence. Efforts to arrange for a preliminary discussion of funding should be initiated well in advance of the deadline for the submission of formal applications and well ahead of the moment when funds will be needed for the proposed project.

The first informal approach to a potential funder may be in the nature of a personal contact, by letter or by a telephone call. The most effective approach, particularly appropriate in dealing with foundations or corporations, is to have the first contact made between a member of the board of directors of the applicant institution and the appropriate official at the funding organizations.

If a personal approach cannot be arranged, the approach preferred by many officials in grant-making organizations is to write a brief letter, one or two and not more than three pages, describing the proposed activity and to follow it up with a telephone call asking for an appointment. Obviously, this approach can be used only with local funding organizations or governmental agencies that are within easy traveling distance. For large, comprehensive grants, it may be necessary and worthwhile to travel across the country for a discussion, but this is the exception, not the rule.

One approach that is particularly appropriate for performing arts and fine arts groups or for individual artists and that is often overlooked is inviting the key official in a funding organization to a performance or exhibition.

This is a good idea even when no grant application is pending or planned. Every arts group ought to have on its invitation list the names of local people who are involved in grant making or who are

influential, and these people should be routinely invited on special occasions so that they may become acquainted with the group. One music school has been very successful with its monthly "president's luncheons," to which it invites community leaders, foundation staff members, or government officials who might be helpful with funding problems at some future time. These are not formal fund-raising sessions, but when the school officials want to apply for funds, they have a wide acquaintance among those in the community who can be helpful.

Some approaches tend to be more effective with one sector than with another.

Government Agencies

In dealing with the federal government, once all the printed material, guidelines, and application forms have been received, it is a good idea to telephone the program officer. It will establish a personal contact with the program officer, and no matter how far away from Washington you may be, a telephone call is the most efficient way to get information from the federal government. In spite of the hundreds of thousands of government workers in our nation's capital, there is still a shortage of clerical personnel, and many program officers do not have private secretaries—in fact, very few of them do. It may therefore take a long time to get a reply in writing, whereas the chances are very good that you can get instant information by telephone.

Between the time printed materials are issued by a government office and disseminated to the public, a lot of changes can take place. Even though you have all the available information in print and have followed up on the latest revisions in the *Federal Register* or other federal reporting services, you should check on the current deadline dates and even current program interests, the dates on which the reviewers meet, and the anticipated decision dates. It is also an opportunity to sound out the program officer with regard to your project and to get his or her opinion on its appropriateness for the program. Many government people in such positions can and will be very helpful to applicants. The National Endowments for the Arts and the Humanities, the two agencies that are most likely to be approached by people in the arts, have from their beginning usually

had an extremely cooperative and helpful staff. Like most consci-entious government employees, they seem to be as interested in distributing the agency's funds for good purposes as applicants are to have their work supported. There may be disagreement about the policies of these agencies, and the staff people cannot change them, but within the established guidelines and programs, the staff can be very helpful.

One factor in approaching the NEA and the NEH is that they are small enough so that one doesn't get caught up in a labyrinthine bureaucracy in trying to get to the right office, as can occur in the monstrous Department of Health, Education, and Welfare, especially in the Office of Education. Fortunately, when Dr. Ernest L. Boyer was Commissioner of Education, he set up in his own office a coordinator of arts programs, which is a good place to start if there is a question about the appropriate office.

As noted in the section on sources of government information (p. 140), the *United States Government Manual* is a guide to the addresses and telephone numbers of many federal programs, and the *Federal Register* usually includes an address and a telephone number for further information.

Some federal agencies indicate in their printed program guides that they prefer to have a brief letter describing a project before a complete application is submitted; the National Endowment for the Humanities is an example. Others will suggest the same thing as a follow-up to a preliminary telephone call.

After sending a brief description to the agency, by all means follow the suggestions made as a result. Some staff members say they occasionally find that their suggestions are ignored or even resisted by applicants. This is a fatal error. Program staffers usually prepare the applications for submission to reviewers and sometimes sit with review committees, and their opinions may carry great weight with those committees. But even in situations where they do not actively participate in the final decision, staffers soon learn the partialities and prejudices of the committee members and can steer an applicant away from a particular element in a project that would ensure its failure, or they may suggest a particular slant that would enhance its possibility of acceptance.

It is often, for reasons of simple geography, easier to arrange meetings with state and local government officials than with those of the federal government in Washington. It is also much more likely

that you will have a board member or other influential friend who can pave the way for talks with local agency personnel.

State arts councils usually have application forms and detailed guidelines for their programs; make certain that the forms in hand and all the printed information are still current. City agencies and community arts councils are less likely to have detailed application forms, and personal contacts are indispensable in negotiating with them.

It is a fact of life that every descending level of bureaucracy has an ascending level of politicization. Regional preferences, artistic, ethnic, religious, and political, are likely to be strong influences in local grant-giving. And bandwagons form locally just as they do nationally; when some particular activity is in favor, it is much easier to find support for it than at other times. Discussions with officials may yield helpful suggestions to incorporate into proposals elements that make them more attractive. Arts in the schools and programs with a special feature for the handicapped, the elderly, children, or disadvantaged groups are elements that can often be incorporated into an arts activity to make it more attractive to local funders without altering the major concept. This is a very good reason for holding preliminary discussion—to learn about such things—and it is very important to heed suggestions made by agency officials.

Foundations and Corporations

There is a great deal of similarity in the way foundations and corporations dispense their grants. Some corporations have established company foundations through which applications for assistance are channeled, and they operate like other foundations. As a rule, corporations also make other gifts directly, and these are negotiated by an executive who functions in a manner not unlike that of a foundation program officer.

In foundations and corporations, personal contacts are unquestionably the most effective approach. When the research for potential funders has been completed and a list of organizations to be approached drawn up, the next step is to circulate that list to the members of the applicant's board of directors. If the board has been well selected, it is possible that some of the members will know

someone in the organizations selected as potential supporters. An informal inquiry by a board member will at least open the door for consideration, and, in fact, that may be all that should be attempted at first. The most important question to ask at first concerns the eligibility of the project, to confirm that the funding organization is truly interested in that type of activity. The next step is to find out the name of the person in the foundation or corporation with whom the matter can be discussed and to ask for an appointment. This stage of the negotiation requires delicate handling and the sensitivity to arrange meetings between those people who will be most comfortable together. The discussion should include the person responsible for the proposed artistic activity. Many artists and artistic directors are reluctant to speak for themselves, but it is very important that potential funders hear about a proposed arts project from the person who generated the idea and who will play the major role in carrying it out.

If earlier preliminary actions have been taken to acquaint foundation officials and business executives with the productions of the group, they will already have a certain amount of background information that will facilitate the conduct of the meeting. No matter how "preliminary" the discussion may be considered, the applicant should always carry a brief written description of the project that tells what is to be done, why it is important that it be done, who will do it and that person's credentials for doing it, how long it will take, and approximately how much it will cost. A brochure that gives the history, purpose, and officers of the group and any other descriptive literature that is brief but clear, and photographs of the facility where the activity will occur, or other visual documentation, might also be included in the meeting materials. It is very important to leave something with the representative of the funding organization, no matter what the outcome of the discussion (unless, of course, you are thrown out of the office). Even if you are told it is unlikely that the organization will be able to fund your project, always, if you can, leave at least the project description and brochure. They will be reminders that might prove useful in the future.

Visits or telephone conversations with potential funders should be carefully planned. Be prepared to answer questions about the applicant organization and about the proposed project. Also, be prepared with questions of your own; it is a good idea to have those questions written down. Under the stress of interviews, it is easy

for an applicant to leave without acquiring some fundamental information.

Following is a checklist of important facts that every applicant ought to know before attempting to prepare a formal application. These questions might serve as a guide in preparing for a preliminary discussion of a proposal:

1. Does the planned activity fall within the program guidelines of the funder?
2. What is the maximum amount of money that the project can include?
3. What categories of cost will the grantor find acceptable? Travel, salaries, equipment items, conferences, or any other elements necessary to the proposed project should be specified.
4. How about overhead costs? Can they be included in the budget, and if so, in what category, how much, and what is the proper terminology?
5. How much information should the written proposal contain? Is there a generally acceptable length? Should any special information be included?
6. How many copies of the application does the granting agency need?
7. Is there a set date for submitting the application? If so, what is it? When is the next deadline date following that?
8. How is the decision made and how long will it be before the applicant is notified?
9. If the application is approved, how will the money be paid, and how soon can it be expected after the decision?
10. If the project will result in copyrightable material, who will hold the copyright?
11. What are the prospects for continuation or follow-up, and how should it be negotiated? This question applies primarily to pilot projects or planning grants when it is anticipated that the project might serve as a model for later work or for dissemination to others.
12. If the project is rejected in the first meeting, ask for suggestions of other funders whom it may interest.

The admonition given regarding the acceptance of suggestions

made by government program officers applies as well to foundations and corporations. Always take the suggestions made by the insider; that person can become your advocate if you eventually submit a formal application and will be much more easily enlisted as an ally if you have incorporated his or her suggestions into the application.

Also, no matter what the outcome of the meeting may be, try to end it on a pleasant note. Even if the atmosphere has been decidedly cool and the prospects for assistance look hopeless, thank the officials for their time, and express the hope that you will be able to continue the discussion further or to present them with a proposal for another activity in the future. Always keep in mind that the nonprofit organization must think in terms of continuous funding, and the organization that turns down one application may be very favorable to another activity at a later time.

Suppose there is no one in the organization who can make a personal contact with the potential funder. The next best thing is to try to find someone who can introduce the artistic director, or a board member, to someone in the funding organization. The main purpose of such introductions is to assure the foundation or the corporation officials that they are dealing with a legitimate, respected arts group and will not be wasting their time. It is easy to feel resentment when officials in philanthropic organizations seem to be impossible to see without the intercession of a friend, but the fact is that they are under the same constraints as everyone else to use their time well. If they maintained an open-door policy, there would not be enough hours in the day to see everyone. And even with the screening process that usually occurs before meetings can be arranged, funding officials say that many of the people they talk to have proposals that are unsuitable for them.

In the worst of all situations—that is, when no board member and no friend can introduce you to a foundation or corporation official—the only thing to do is to write a letter. The preliminary letter should be brief, but it should contain enough information for the granting agency to fully understand what the proposed project is and what support is being requested.

Suggestions for the preparation of the introductory letter from arts organizations to business concerns were drawn up by a foundation executive for the Business Committee on the Arts (BCA). With minor revisions to suit each individual case, they apply equally

well to the preparation of letters to foundations, corporations, or any grant-making association:

1. The letter should be on the organization's stationery, which should have printed on it a list of those who are officially connected with the group and a return address.
2. It should be as personal as possible and individually typed. A mechanically reproduced letter should never be used in applying for a grant.
3. The addressee should be the executive determined as the best person to approach.
4. The letter should be concise but should include:
 a. A brief statement of the proposal.
 b. The reason for approaching the addressee.
 c. The total sum needed. Indicate what percentage of this sum is hoped for from the business community [the grantor] and what percentage is assured from the government, individuals, and foundations [other sources]. Include some mention of the usual distribution of support of the arts organizations among the business community, showing the variety, if possible.
 d. The suggested contribution requested in money or other form.
 e. The background of the arts organization. Usually this will be simply a reference to attached materials.
 f. A concluding statement in which the writer asks for an appointment with either the addressee or an executive he might designate.
5. If there is no reply within a reasonable time, a telephone call might be appropriate.

Many grant-making organizations suggest that instead of waiting for a reply, the arts organization should always follow up the letter with a telephone call requesting an appointment.

The successful outcome of a preliminary discussion or letter is that the funding organization agrees to consider a formal proposal from the applicant. Occasionally, it may be possible to receive an assurance of funding in a personal conversation, but this is not usual and should not be expected. In small foundations where discussions are conducted with the person who makes the funding decisions,

this may occur. In large organizations and in any government agency, assurance of funding can seldom be given by the representative who discusses the project with the applicant.

If all goes well, the next step is the preparation of a complete written grant application.

WRITING THE PROPOSAL

For many people, the most distasteful step in the entire grant-seeking process is writing the application. It cannot be stated with certainty why this is so, but one main reason seems to be lack of knowledge about what ought to be included.

So much nonsense has been said and written about what to conceal and what to reveal, what to lie about and what to be truthful about, and what kind of fancy binding and gold lettering to encase the proposal in that applicants approach the task of writing a proposal with fear and revulsion.

Successful grant-getters all have their own favorite hints about such things as "fat" in the budget, and using impressive "buzz words," and whether the length should be 300 pages or 3. Most of these suggestions are worthless, as they are little more than superstitions. There is absolutely no hard evidence to indicate that a leather-bound, 300-page application peppered with all the latest jargon has any more chance of being funded than one 3 pages long, held together by a paper clip, and written in plain English in simple declarative sentences. As a matter of fact, no study has been done—and it is hard to see how one could be done—that proves that any kind of written application will guarantee success; it is, after all, only one of the steps in the grant-seeking process.

The importance of the written proposal is greater in some fields than it is in others; the application for a scientific research project is exceedingly important to the final decision. And in some cases, the written application is the only communication that the applicant has with the funding organization. Most fellowships are awarded mainly on the basis of information submitted in writing; very few funding agencies can interview all who apply.

For most arts projects, however, the written proposal is often of less importance in the determination of the final outcome than the preliminary discussion. The formal document may do little more than state and confirm what has already been at least preliminarily

agreed to in the preapplication negotiations. In some cases, especially in foundations, if the discussions have been extensive and detailed, the program officer might even assist in preparing the budget, since the foundation has its own format and its own acceptable categories of cost. As a matter of fact, if the preliminary negotiations have been well handled and the right kinds of information exchanged, writing the final application should be one of the easiest parts of the grant search.

GOVERNMENT APPLICATIONS

Nearly all federal government agencies and most state and local governments provide applicants with a form to fill in. The hardest job then is collecting the information; the form tells what is to be included and where it goes.

The National Endowment for the Humanities has one of the simplest forms and it is a beautiful example of the kind of application form that might serve as a model for other government agencies. However (and is it surprising?), rumor has it that the NEH form is being revised to make it more complicated. Let us hope that is untrue.

The Office of Education has numerous forms and some of them are very complicated, but among the most difficult forms that applicants in the arts have to wrestle with are those used by the National Endowment for the Arts. Rumor has it that these forms are being revised to make them simpler, but until that is done, potential applicants must learn to cope with those in current use.

Applying to the National Endowment for the Arts

Each program of the Endowment has its own application forms, and prospective applicants are strongly urged to send for the appropriate application-guidelines kit for use in preparing the final application.

The information requested on the forms varies according to the field and the specific guidelines, and the samples with explanations shown here are intended only as a general indication of the kinds of information requested and as an aid in completing the forms. Some forms—those requesting support for dance and theater com-

panies and for professional symphony orchestras, for example—have supplementary information sheets for additional data on fiscal matters, numbers of performances and/or performers, size of staff, and similar items.

The samples shown here on pages 259–264 and 269–270 are the Endowment's Organization Grant Application for the Visual Arts Program and the Individual Grant Application for the Composer/Librettist Fellowships program, two of the major program areas.

The visual arts form includes a special supplementary information sheet to be completed for projects in the crafts fields.

Individual application forms always ask for a summary of the applicant's career or background and usually, but not always, require a description of the proposed activity.

The Work Experience Internship Program has a special short-form application.

ORGANIZATION GRANT APPLICATION

National Endowment for the Arts

(Keyed to numbers on application)

I. *Applicant organization.* The organizations name must be identical with the name as shown in the IRS determination letter for tax-exempt status, or the name in the official document identifying the applicant organization as a unit of either state or local government. Nongovernment applicants must attach to the application one or two copies (depending upon the specific program) of the IRS determination letter. State or local government units must attach to the application a copy of the official document indicating their status within the state or local government. (These documents will not be returned.)

Applications must be accompanied by the signed form Assurance of Compliance (with the requirements of Title VI of the Civil Rights Act of 1964), unless that form has been submitted to the Endowment during the past five years. Application guidelines kits contain copies of the form, which is reproduced on pages 263–264.

II. *Category under which support is requested.* There are several categories in each major program, and the specific category applied

NEA 3 (Rev.) OMB-128-ROOO1

Organization Grant Application
National Endowment for the Arts
Applications must be submitted in triplicate and mailed to the
Grants Office, National Endowment for the Arts,
Washington, D.C. 20506

I. Applicant organization (name and address with zip)	II. Visual Arts Program Category under which support is requested (II)
(I)	III. Period of support requested
	Starting (III) Ending
	month day year month day year

IV. Summary of project description

(IV)

V. Estimated number of persons expected to benefit from this project (V)

VI. Summary of estimated costs (recapitulation of budget items in Section IX)

A. Direct costs (VI) Total costs of project
 (rounded to nearest ten dollars)
Salaries and wages _____ $_____
Fringe benefits _____
Supplies and materials _____
Travel _____
Special _____
Other _____

 Total direct costs $_____
B. Indirect costs _____ $_____
 Total project costs $_____

VII. Total amount requested from the National Endowment for the Arts (VII) $_____

VIII. Organization total fiscal activity Actual most recent fiscal period Estimated for next fiscal period
A. Expenses (VIII) 1. $_____ 2. $_____
B. Revenues, grants & contributions 1. $_____ 2. $_____

 Do not write in this space

Evaluation of prior year(s)' projects [1][2][3][4] Pys $_____ Cps $_____ Audit report [1][2]

IX. Budget breakdown of summary of estimated costs

A. Direct costs

1. Salaries and wages

(IX)

Title and/or type of personnel	Number of personnel	Annual or average salary range	% of time devoted to this project	Amount $

Total salaries and wages	$
Add fringe benefits	$
Total salaries and wages including fringe benefits	$

2. Supplies and materials (list each major type separately)

	Amount $

Total supplies and materials	$

3. Travel

Transportation of personnel

No. of travelers	from	to	Amount $

Total transportation of personnel	$

Subsistence no. of travelers

	No. of days	Daily rate	$

Total subsistence	$
Total travel	$

IX. Budget breakdown of summary of estimated costs (continued)

4. Permanent equipment **(list each item separately)**

	Amount $
Total special	$

5. Other **(list each item separately)**

This section must be completed on every application.

	Amount $
Total other	$

B. Indirect costs

Rate established by attached rate negotiation agreement with National Foundation on the Arts and the Humanities or another Federal agency

Rate _____ % Base $ _____

Amount $ _____

X. Contributions, grants, and revenues *(for this project)*

A. Contributions

1. Cash (do not include direct donations to the Arts Endowment) (X) Amount $

2. In-kind contributions (list each major item)

Total contributions	$

B. Grants (do not list anticipated grant from the Arts Endowment) Amount $

Total grants	$

C. Revenues Amount $

Total revenues	$
Total contributions, grants, and revenues for this project	$

XI. State Arts Agency notification

The National Endowment for the Arts urges you to inform your State Arts Agency of the fact that you are submitting this application.

Have you done so?_____Yes_____No

XII. Certification

We certify that the information contained in this application, including all attachments and supporting materials, is true and correct to the best of our knowledge.

Authorizing official(s)

Signature_____Date signed_____
Name (print or type)_____
Title (print or type)_____
Telephone (area code)_____

Signature_____Date signed_____
Name (print or type)_____
Title (print or type)_____
Telephone (area code)_____

Project director

Signature_____Date signed_____
Name (print or type)_____
Title (print or type)_____
Telephone (area code)_____

*** Payee (to whom grant payments will be sent if other than authorizing official)**

Signature_____Date signed_____
Name (print or type)_____
Title (print or type)_____
Telephone (area code)_____

* If payment is to be made to anyone other than the grantee, it is understood that the *grantee* is financially, administratively and programmatically responsible for all aspects of the grant and all reports must be submitted through the grantee.

Check List

1. Have you attached a copy of your organization's Federal Tax exemption letter or a document identifying the organization as a part of State or local government?

2. Have you summarized the project description in the space provided?

3. Have you completed the summary of estimated cost on page 1, also provided all detail required on pages 2 and 3, and attached all documentation required to substantiate proposed travel cost, purchase of equipment, and indirect cost?

4. Have you provided required detail under Other Support section?

5. Has the application been signed and dated in appropriate places?

6. Have you filed an Assurance of Compliance form?

A negative response to any of the above questions will cause delay in the consideration of this application and will increase the cost of processing.

Assurance of Compliance With National Foundation on the Arts and the Humanities Regulations Under Title VI of the Civil Rights Act of 1964

_____(hereinafter called the "Applicant") **Hereby Agrees That** it will comply with Title VI of the Civil Rights Act of 1964 (42 U.S.C. 2000d) and all requirements imposed by or pursuant to the Regulations of the National Foundation on the Arts and the Humanities (45 C.F.R. Part 1110) issued pursuant to that Title, to the end that, in accordance with Title VI of that Act and the regulations, no person in the United States shall, on the ground of race, color, or national origin, be excluded from participation in, be denied the benefits of, or be otherwise subjected to discrimination under any program or activity for which the Applicant receives Federal financial assistance from the·Foundation; and **Hereby Gives Assurance That** it will immediately take any measures to effectuate this agreement.

If any real property or structure thereon is provided or improved with the aid of Federal financial assistance extended to the Applicant by the Foundation, this assurance shall obligate the Applicant, or in the case of any transfer of such property, any transferee, for the period during which the real property or structure is used for a purpose for which the Federal financial assistance is extended or for another purpose involving the provision of similar services or benefits. If any personal property is so provided, this assurance shall obligate the Applicant for the period during which it retains ownership or possession of the property. In all other cases, this assurance shall obligate the Applicant for the period during which the Federal financial assistance is extended to it by the Foundation.

This Assurance is given in consideration of and for the purpose of obtaining any and all Federal grants, loans, contracts, property, discounts or other Federal financial assistance extended after the date hereof to the Applicant by the Foundation, including installment payments after such date on account of applications for Federal financial which were approved before such date. The Applicant recognizes and agrees that such Federal financial assistance will be extended in reliance on the representations and agreements made in this assurance, and that the United States shall have the right to seek judicial enforcement of this assurance. This assurance is binding on the Applicant, its successors, transferees, and assignees, and the person or persons whose signature appears below is authorized to sign this assurance on behalf of the Applicant.

_____ _____
(Applicant) Applicant's mailing address

By (President, Chairman of the Board, or comparable authorized official)

Dated

Assurance Explanation

The Civil Rights Act of 1964 provides that no person in the United States shall, on the grounds of race, color, or national origin, be excluded from participation in, be denied the benefits of, or be otherwise subjected to discrimination under any program or activity receiving federal assistance. Subject to certain exceptions, Title IX of the Education Amendment of 1972 prohibits the exclusion of persons on the basis of sex from any educational program or activity receiving federal assistance.

Regulations of the National Foundation of the Arts and the Humanities (NFAH) require, as a condition to the approval of a grant, that the applicant execute the "Assurance of Compliance" form, whether or not a comparable form has been filed with another agency.

The applicant referred to in the form is the organization, whose chief executive officer should sign. The name and title of the organization and of the official should be typed on the form. The signed original should be returned to the NFAH. Once a properly executed form has been filed, it will serve as the assurance for all future applications to NFAH.

for should be entered in this section. In the Visual Arts Program, examples are Art in Public Places, Visual Arts in the Performing Arts, and Services to the Field. In the Design Arts Program, sample categories are Livable Cities, and Design: Communication and Research.

III. *Period of support requested.* The NEA generally limits its financial period to 12 months.

IV. *Summary of project description.* Use only the space provided on the application form. Relevant material may be submitted as attachments, but the description in this space should cover only the project for which support is being requested. It should be as clear and concise as possible, stating the intent and purposes of the proposal and including, where appropriate, the names of key personnel.

V. *Estimated number of persons expected to benefit from this project.* Give the estimated number of audience, population, participants, students, *excluding* employees and/or paid artists, who will benefit from the project.

VI. *Summary of estimated costs* (recapitulation of budget items in Section IX). See explanations for each item under Section IX.

VII. *Total amount requested from the National Endowment for the Arts.* This amount should be rounded to the nearest 10 dollars. Each applicant is generally required to obtain at least 50% of the total cost of each project from nonfederal sources.

VIII. *Organization's total fiscal activity.* Expenses and revenues of the organization for the most recent fiscal period, and the estimated figures for the next. These amounts should include earned income, contributions, and grants, including Endowment grants received and anticipated.

IX. *Budget breakdown of summary of estimated costs.*

 A. *Direct costs.* All costs that can be specifically identified with the project.

 1. Salaries and wages. List here those individuals who will be *employees;* consultants and artists who receive fees are shown in A5. Rates must comply with the prevailing minimum compensation set out in the Code of Federal Regulations (Part 505 of Chapter 29). Fringe benefits should be included here if they are not included as indirect costs.

 2. Supplies and materials. Consumable supplies, raw materials for the fabrication of project items, and

items of expendable equipment (defined as equipment items costing less than $300 or with an estimated useful life of less than one year).
3. Travel. Estimates must be in conformance with the standard policies of the applicant organization, and for flight travel, based upon jet economy-air-coach accommodations. Foreign travel must be specifically identified and included in the summary of the project description as a project necessity.
4. Permanent equipment. Includes equipment items costing over $300 with an estimated useful life of one year or more. Purchases must be justified in writing, including a brief description of such equipment, the applicant organization's purchasing procedures, and its policy on the maintenance and protection of its facilities.
5. Other. Consultants, artists, and other professionals whose services are to be obtained under contract who will be paid fees or honoraria. The number of persons, and the applicable fees, rates, or amounts should be specified.
B. *Indirect Costs.* Those costs incurred that are not assignable to the specific activities of the project, sometimes referred to as *overhead*. Indirect costs may be computed by the application of an established rate that has been negotiated between the applicant organization and the Arts Audit Office of the NEA or another applicable federal agency. If a negotiated rate is used, a copy of the negotiated agreement must accompany the application.
Section VI can be filled in from the information in Section IX.
X. *Contributions, grants, and revenues (for this project)*
 A. *Contributions*
 1. All anticipated cash donations for this project (direct donations made to the Endowment through gift transmittal letters on behalf of the applicant are not included).
 2. In-kind contributions at the fair market value of items wholly or partially consumed by the project; includes contributions of professional personnel who will not be reimbursed by the grant.

B. *Grants.* Includes all or a pro rata share of anticipated grants whether wholly or partially restricted for use on this project; do not include the grant requested in this application.

C. *Revenues.* All earned income, regardless of source, expected to be used on this project.

The total of Section IX minus the total of Section X is the amount that should appear in Section VII; generally, Section X should be 50% of Section IX (IXA and IXB).

XI. *State arts agency notification.* Applicants are urged to inform their state arts agency of the fact that they are applying to the NEA for a grant. Current addresses of all state arts agencies are shown in Appendix I.

XII. *Certification.* Signatures of officials authorized legally to obligate the organization, and the fiscal officer to whom grant payments are to be made. The grantee organization is fiscally responsible for the proper use of the funds and for submitting the required expenditure reports.

XIII. The *check list* at the end of the application form for organizations should be reviewed carefully to ensure that the form has been properly and fully completed.

INDIVIDUAL GRANT APPLICATION

NATIONAL ENDOWMENT FOR THE ARTS

(Keyed to numbers on application, see pp. 269–270).

1. *Program category.* Each major program has several categories. In the form shown here for the Composer/Librettist Music Program, categories are numbered. Categories I and II are for a performer, producer, conductor, director, or other person charged with production responsibilities; Category III is for a publication and/or recording representative or other authority in the field. All grants in the Composer/Librettist Music Program are fellowships; in general, all individual grants made by the Endowment are in the form of fellowships. Fellowships in the Visual Arts Program are in the categories of Artists, Photographers, Craftsmen's Apprentice in Crafts, and Art Critics.

2. *Period of support requested.* The time span during which the activity will occur. The Endowment generally limits its grants to a maximum of 12 months.

3. *Description of proposed activity.* Should be clear and concise, stating the intent and purpose of the proposal, and in most cases should be contained within the space provided. The Composer/Librettist Music Program permits the use of additional 8½" × 11" sheets for more detail but asks that all essential elements be shown on the first page of the form itself. Information in this section must be limited to a description of the project for which support is requested. Relevant material prepared for other presentations may be submitted as attachments.

4. *Amount requested.* Requests may not exceed the stated maximum within each category.

5. *Career summary or background.* Includes education and work experience, prizes or honors, and other grants received. Supplemental sheets can be attached for the summary, and for some fellowships, it is a good idea to append any significant reviews, programs, exhibition catalogs, or public notices of the applicant's work. Photographs of previously accomplished work in appropriate fields may also be helpful.

6. *Certification.* Individual applications must always be signed by the applicant.

FOUNDATION AND CORPORATION APPLICATIONS

Most foundations and corporations do not use application forms, but some of them supply applicants with a guide to the kind of information they require.

One small foundation has a very precise and easy-to-follow guide, which states exactly what an application should contain. It is reprinted here with the permission of the foundation, although they asked not to be identified:.

GRANT APPLICATION OUTLINE

(To be used as guide in drafting proposals)

REQUIRED OF ALL APPLICANTS

A. Applicant's status with Internal Revenue Service.

 1. Evidence of nonprofit and tax-exempt status by an accompa-

NEA 2 (Rev.) OMB-128-ROOO1

Individual Grant Application
National Endowment for the Arts

Applications must be submitted in triplicate and mailed to the
Grants Office, National Endowment for the Arts,
2401 E St., NW, Washington, DC 20506
Attn: Composer/Librettist Fellowships

Composer/Librettist Music Program
Category under which support is requested:

I II III ①

Name (last, first, middle initial)

Professional name or Pseudonym

Present mailing address

Telephone

Permanent mailing address

Telephone

U.S. Citizenship
Yes No Visa Number

Professional field or discipline

Birth Date Place of Birth

Period of support requested ②
Starting
 month day year
Ending
 month day year

Description of proposed activity ③

④
Amount requested from National Endowment for the Arts $_____ allocated as follows:
Time $_____ Travel $_____ Materials $_____

Career summary or background
 ⑤

(If additional space is required, use supplemental sheets and staple to the application)

Education

Name of institution	Major area of study	Inclusive dates	Degree

Fellowships or grants previously awarded

Name of award	Area of study	Inclusive dates	Amount

Present employment

Employer	Position/Occupation	Salary

Prizes/Honors received	Membership professional societies

Certification: I certify that the foregoing statements are true and complete to the best of my knowledge.

Signature of applicant _____ Date _____

⑥

nying copy of a letter from the U.S. Internal Revenue Service to this effect, plus a ruling whether or not the organization is a "private foundation."

B. In addition to the above, every application must include:

1. Name and address of institution or organization submitting the proposal. (NOTE: The Foundation does not make grants directly to individuals.)

2. Name(s) of chief administrative officer(s) of applying organization, plus letter from an administrative officer, endorsing the proposal and agreeing that the organization will assume the full responsibilities involved in the proper fiscal management of and accounting for any grant received, and will make certain that any reports required by ——— Foundation are submitted on time.

3. Statement by administrative official that no part of a grant from the Foundation will be used to support propaganda for or in opposition to legislation either enacted or proposed, or in campaigning for or against any candidate for public office, or to employ or compensate officials contrary to Section 494(d) of the Internal Revenue Code.

4. Commitment to submit regularly and on time such progress evaluations and financial reports as are requested by the Foundation. (The Foundation usually requests semiannual progress and financial reports and may request semiannual evaluation reports if appropriate.)

5. List of board members with occupations, number of meetings each year, and average attendance.

INFORMATION RECOMMENDED FOR ALL APPLICANTS

1. Brief description of proposal, including a summary of background information contributing to an understanding of the reason for and purpose of the project.

2. Brief description of plan of development of the project, including when appropriate, a description of method or methods proposed to be used to test outcomes.

3. Expected outcome or results from the proposal.

4. How and by whom will the expected or anticipated results be used?

5. Information on the key personnel involved in the proposed project.

 a. Qualifications
 b. Are they replaceable?
 c. Who will provide overall direction and supervision?
 d. Are all these persons now available in the applying institution? If so, are they on the institution's regular payroll or a project budget? If the latter, what project, and what is the source of funds?

6. Project budget by major headings, i.e., salaries and title of each of the professionals, total of budgets for each of the following classifications: technicians, clerical services, equipment, expendable supplies, travel, etc.

 a. Show amounts applying institution is contributing, either in "kind" or in cash.
 b. Show amounts received from other grant-making agencies.

7. How long will the project run?
8. Has this proposal been submitted to other grant-making organizations, including federal and state agencies? Has it been declined or is it still pending?
9. A statement by grant applicant describing its proposed method(s) of evaluation of the outcomes of the project.
10. Provide a copy of your most recent financial audit.

This is an exceptionally clear statement; not all foundations give the applicant that good an outline. Some of the points should be especially noted.

The "Required of all Applicants" section includes items that are necessary in order for the foundation to comply with legal regulations. Foundation grants can be made only to tax-exempt, nonprofit organizations, and foundations have been restricted since the 1969 Tax Reform Act from funding any activity that engages in propaganda for or in opposition to legislation or in campaigning for or against any candidate for public office.

Other items in that section express the concern of the foundation that the grantee will fulfill its administrative responsibilities in con-

nection with the grant, will manage the funds well, and will submit the required reports.

In the "Information Recommended" section, note that applicants are asked to indicate whether they have submitted the proposal to any other grant-making organization. Not all foundations ask for this information, and there is nothing legally wrong with sending a proposal to any number of foundations. Occasionally, two foundations might jointly sponsor a large project in which they both have an interest. If the application is sent out with the idea of finding two or more funders, each granting agency should be told about the other.

The federal government requires that applicants indicate whether they are applying to other government agencies for support of the same project. This requirement is viewed with alarm by some people, who see in it some sinister implication, but usually it is only to avoid the funding by two federal agencies of the same project, which *is* illegal. Government agencies sometimes get together on such applications and fund them jointly, or they may agree among themselves that it fits one program better, and the others bow out.

Another noteworthy item in the instructions cited above is the request for a description of the proposed methods to be used to test outcomes. The word *evaluation* is often used to describe this requirement, an element that is becoming more essential all the time. Funding organizations want included in the proposal a plan for testing whether or not the project has achieved its stated goals.

Some organizations, particularly small foundations, prefer that the application be submitted in letter form and that it be as brief as possible. Other foundations and some corporations expect a detailed document, including complete information on the organization and on the proposed project. Whether the application is short or long, in letter form or in a detailed document, every request for support should contain the following information:

1. *A description of the applicant organization:* Name, address, Internal Revenue Service identification number, brief history, and purpose.
2. *A description of the proposed project:* What is to be done, where it will take place, who will direct and/or participate in it, time schedule, who will be benefited.
3. *Program objectives:* Why this project is worth doing, what

will be accomplished, why the funding organization should support it, an evaluation plan to determine how well the goal was achieved.

4. *Future of the project:* What happens afterwards. If the idea is new, what will be done to disseminate the information? If it is to continue, how will it be funded?
5. *Budget:* A detailed, itemized listing of costs, with explanation and justification of any unusual items.
6. *Official certifications and signatures:* Approvals of the appropriate institutional officers and certifications of compliance with regulatory provisions.
7. *Appended materials:* Curriculum vitae of key personnel; reviews, articles, or other publicity; letters from community leaders, well-known artists, or others in support of the project; IRS certification of nonprofit status if requested; a printed brochure describing the applicant organization, including names of the board of directors.

GENERAL APPLICATION GUIDELINES

Depending on the nature of the project, the application information may be contained in a letter of two or three pages or in a detailed document divided into sections, with a table of contents.

Following is a guide for preparing a detailed full-length proposal to be sent to any organization that has no standard form. The information is divided into six main categories:

- Cover Page or Letter
- Abstract
- Project Description
- Budget
- Official Certification and Signatures
- Appended Materials

Cover Page or Letter

The cover page serves as an identification tag for the proposal; it should give all the administrative information such as names,

addresses, and telephone numbers to ensure that the document is easily recognized and flows through the right channels. Many large organizations have central receiving offices where all applications are logged in and routed to the appropriate department. The cover page provides the data for getting the application to the right place.

Some basic information should be on every cover page, in addition to any special information that the funding organization requires. The basic items are:

1. Name and address of the funding organization. Applications to federal agencies should also include the name of any other federal agencies to which the proposal is being submitted.
2. Name and address of the applicant organization and name, social security number, and telephone number of the project director.
3. Subject of the proposal.
4. Type of support requested, that is, grant, contract, fellowship.
5. Name, address, telephone number, and title of the institutional fiscal officer to whom the grant funds will be paid.
6. Internal Revenue Service identification number.
7. For federal government proposals, the congressional district.
8. Name, address, telephone number, and title of the institutional official authorized to accept the grant and to negotiate with the funding agency. This is usually the chief administrative officer.
9. Dates of the project—beginning and terminating. (Most grants are given for periods of one year.)
10. Amount requested.
11. Signatures of the project director, institutional official, and fiscal officer.
12. Date application is submitted.

If a covering letter is used, it should contain all of the above information and may include the abstract (see below). Covering letters should be written on letterhead stationery that contains some of the necessary information, such as the names of board members. The cover page is more suitable for government agencies and very

large foundations; the letter is preferable for small foundations and corporations.

Abstract

This is a 100- to 300-word summary of the proposal. In some cases, the entire description may be contained in the abstract. It should state what is to be done, why it is to be done, who will do it, how long it will take, and the major objectives.

The writing should be simple and clear. If technical terms are used, they should be explained.

Project Description

The length and detail of this portion depends entirely on the nature of the project. If the plan is to execute a work of art to be hung in a public building or to be placed in the town square, this can be stated in one or two sentences. An arts education project in a public school or a community center or the production of a new work will require more explanation. Descriptions that are very long should be divided into sections:

1. *Introduction:* State what the project is, explain the background, and describe its relation to the applicant institution; tell why the institution is suited to do it. Discuss the reason that the funding organization should support it; explain who will benefit from it. If this is a new or experimental idea, that should be stated and discussed in terms of its value or potential value to the artistic field or to other arts groups.
2. *Methods of procedure:* State exactly what is to be done and how it will be done. If specialized techniques or new methodology is involved, they should be described and their purpose explained. Avoid jargon, and define any terms that might be unfamiliar to someone outside of the field. National councils and boards of philanthropic organizations are made up of people in many professions, and they may not be familiar with the language of the proposal subject.
3. *Objectives:* Describe the specific objectives; for example, to

compose an opera, to write a book, to produce a play, or to exhibit the work of an artist. The funder should know in specific terms exactly what will result from the grant.

4. *Facilities available:* Describe what facilities are needed for the proposed activity, and tell why those of the institution are particularly suitable. If building alterations, new equipment, or additional space is required, this should be stated and then itemized in the budget section. Very often the existence of the right facilities in the right location is an important factor in the decision to fund a project, especially in the performing arts.

5. *Significance:* If the outcome of a project is in doubt or merely unknown, its significance can be evaluated in two ways: (1) if it succeeds and (2) if it doesn't. New things are usually attempted because of their potential if they turn out well. But some things are worth trying even if they do not succeed, since it may be important to the field to establish the fact that something does *not* work. This is one strong justification for the support of a project when the outcome is uncertain.

6. *Evaluation:* How you will determine whether the objectives were achieved.

Budget

This is the section of the grant application that gives people the most trouble. First, there is the matter of what to include, and then there is the question of how much to request. By the time this section is being written, everyone concerned should have a pretty good idea of how much is to be requested and of what cost categories are acceptable to the funding organization. Nearly all grant makers have some restrictions; some will not fund construction or operating costs; some will allow for indirect or overhead costs, and others will not. These questions should be cleared up in the preliminary discussions, and there should be no surprises for the funding organization when it sees the final budget.

The term *fat* in the budget has come to mean inflating the cost of projects on the assumption that the granting institution will never approve the amount requested; therefore, the fat is the margin of safety, the loss of which will not damage the project. This idea has

been abused to the point of the ridiculous in some cases; a sagacious reviewer can spot an inflated budget and it is likely to evoke a generally negative reaction, which is the last thing an applicant wants.

Planning for contingencies does not require budget inflation. It means having a "fall-back" position or designing the project so that cuts can be made without damaging the basic concept. The institutional contribution might be increased by a slight rise in ticket prices; the number of performances may be cut; travel plans may be altered or costumes redesigned; equipment may be rented instead of purchased outright. If there is reason to believe that the total amount requested will not be awarded, it is a good idea to draw up the original budget as a "maximum" plan and to have some ideas about where savings can be instituted if necessary.

There are two types of cost in the budget, direct costs and indirect (overhead) costs.

Direct Costs

Direct costs are those readily identifiable with the proposed project, such as salaries and fringe benefits, supplies, equipment, and travel. Indirect costs are the overhead expenses incurred by the institution in providing space, administrative services, utilities, security, and janitorial and other services that are shared by all activities at the institution.

Direct costs can be itemized in the following categories:

- Personnel—salaries and wages; fringe benefits; consultant and contract services
- Expendable supplies
- Equipment—purchase and rental
- Travel—foreign, domestic, and local
- Communications—telephone installation and service and toll calls; messenger and cable service
- Publications—brochures, reports, catalogs, programs
- Other costs—all items not included in the other categories

Personnel. This category includes those people employed full time on a project, administrative and technical personnel, and art-

ists. It also includes temporary, part-time persons such as performers who are paid a fee.

1. Salaries and wages: This includes full- or part-time people who are salaried employees. The names, if known, can appear in the proposed budget, with the annual rate of pay and the amount of time to be spent on the project. For example, a project director who expects to spend full time on a one-year grant is shown in an entry reading:

John G. Smith, Project Director, 100% time for
 12 months at $20,000/year $20,000

Part-time employees are shown in the same manner, with the percentage of time to be spent on the grant and the total amount requested for each one. An assistant to the project director who will be employed only if the grant application is approved, and whose name is therefore not yet known, might be shown in this way:

Administrative Assistant to Project Director, 50% time
 for 12 months at $14,000/year ($14,000 × 50%) $7,000

If some personnel costs are to be shared by the institution either on a cost-sharing or a matching basis, the budget should be set up in three columns, as shown below.

In the above examples, if the institution will contribute part of the salaries of each person, that might be indicated as:

1. Personnel

	Total	Requested from Granting Agency	Institutional or Other Contribution[1]
a. Salaries and Wages			
John G. Smith, Project Director, 100% time for 12 months at $20,000/year	$20,000	$10,000	$10,000
Administrative assistant, to project director, 50% time for 12 months at $14,000/year (14,000 × 50%)	7,000	5,000	2,000

The fringe benefits and indirect costs are to be calculated proportionately, as shown in the budget guide.

[1] Amounts to be paid from regular institutional funds or from another outside source.

2. Contract services: Performers, artists, or others who work under contract and are to be paid on a fee basis for a specified service are included in this category. They do not receive fringe benefits and for federal government grants do not figure in the indirect cost calculations based on salaries and wages.

It often happens that the proposal is being written and the budget is being prepared before any agreement is received from individual artists; obviously, an organization cannot offer a contract to anyone until the money is assured. Tentative agreements can be reached, and if this is the case, the names can be used with the stipulation that the agreement is based upon receipt of the funds. There is a great temptation to dress up the proposal by sprinkling famous names through it to impress reviewers and to assume that, after the grant is awarded, there will be a better chance of signing them up. This is foolish, at least, and at most, dishonest. It can backfire in very unpleasant ways, and its potential value is not worth the risk. It is very easy to ask, informally, about the willingness of an artist or a performer to consider an engagement during the coming year provided the money is available and the schedule can be worked out. Then, the name can be used with the stipulation "subject to agreement on fees and schedule."

A reasonable figure must be included in the budget, on the assumption that the named artist or someone of comparable stature will be available for that amount.

3. Fringe benefits: Every employer is responsible for providing employees with certain insurance coverage mandated by law, and most organizations provide additional health and pension coverage.

In dealing with the federal government, nonprofit organizations may negotiate a composite fringe-benefit rate, as a percentage of base pay. For institutions that expect to obtain a sizable number of federal government grants, the convenience of having such a rate is worth the trouble. This rate is negotiated with the regional comptroller of the Department of Health, Education, and Welfare; the current addresses for the HEW offices in each region are given in Appendix I.

Foundations and corporations recognize the necessity for providing employees with fringe benefits, and those that agree to provide salaries expect benefits to be included.

The current level of benefits provided by most employers is somewhere between 20% and 30%, of salaries, and if you use a

composite rate, the total amount would be arrived at by adding up all personnel costs (excluding those engaged by contract) and multiplying by the percentage being used. In the examples given above, assuming the same portions of institutional sharing and a rate of 20%, the fringe benefits entry would read as:

	Total	Requested from Granting Agency	Institutional or Other Contribution
Fringe Benefits			
$27,000 × 20%	$5,400	$3,000	$2,400

If no composite rate is used for fringe benefits, each item must be listed separately and prorated in accordance with the cost-sharing or matching amounts. State unemployment insurance, workmen's compensation, and FICA (social security) as well as health insurance, pension costs, or any other special benefits should be included.

Expendable Supplies. These are consumable items required for the project. They include office supplies as well as production items that will be used up in the course of the project. There is sometimes confusion as to whether an item is "equipment" or "supplies," and this question may have to be cleared up with the grantor. In general, those items that have a life expectancy of more than one year and that cost more than $300 are called equipment. Ballet slippers would be supplies; a dimmer board would be equipment.

Equipment: Purchase and Rental. This category includes all large items that must be purchased or rented, such as electric typewriters, recording instruments, and cameras that are expected to have use beyond the duration of the grant. The ownership of these items after the grant has been terminated requires consultation with the granting agency. Many grantors transfer title of certain items to the institution, but some may retain the option to reclaim large, expensive pieces of equipment. For short-term projects, it is very often more economical to rent than to buy equipment.

Each listed item should show the purchase price or rental rate; rentals should state the exact length of time, the monthly rate, and the total expected cost.

In estimating the purchase price of equipment, current catalogs are unreliable, since inflation outdates most figures before they are printed. Exact costs should be obtained from vendors, and an incre-

ment for inflation should be added if the purchase will be made a year or more after the proposal is being prepared, as is often the case.

Travel: Foreign, Domestic, and Local. Any travel abroad or within the United States that will be of long duration and expensive should be thoroughly discussed in the preapplication negotiations, and approval should be obtained from the granting organization concerning mode of travel and the amounts that are acceptable for per diem costs. Some grantors will allow travel by personal automobile; most require that air travel be by economy class. Per diem rates abroad usually vary with the country visited. Domestic rates are standardized by the agency or organization making the grant.

Local travel may be a significant item in some projects, especially those involving elderly or handicapped persons or children who must be transported to a central location. If public transportation is to be used, the number of round trips to be made and the cost of each can be calculated. If taxicabs or other hired transportation is used, estimate the total based on the distances to be traveled and the number of trips.

Communications. Institutions that have telephones already installed will include in the grant budget an estimate for toll calls. Other communication costs may be for cablegrams, messenger service, or express mail.

Publications. In some cases, the preparation of brochures is essential. Printed reports may also be required. Estimates for catalogs or programs depend on the number required, the size of the publication, and the printer's estimates.

Other Costs. Every project is likely to have some special requirement that does not fit into any of the six specific categories; this is the place to list them. Building alterations, payments of fees to subjects, data-processing costs, duplicating charges, evaluation costs, and expenses for special meetings are examples.

Indirect Costs

Indirect costs is a term used by the federal government, and everyone involved in grant seeking should understand it. In dealing with foundation and corporation donors, it may be clearer to use the term *overhead costs*.

These terms describe costs that cannot be specifically allocated

to any one activity, that is, services or facilities that are used generally by everyone and for everything that takes place in the institution. General operating costs, such as administrative salaries, building and maintenance costs, utilities, library services, security guards, janitors, ticket sellers, and ushers, are all general services or service providers, and no specific portion of their cost can be directly associated with any one activity or project.

The federal government permits institutions to negotiate a standard indirect-cost rate that can be used in all proposals submitted to federal agencies. Nonprofit organizations negotiate the rate with their federal district's Office of the Comptroller of the Department of Health, Education, and Welfare. A listing of the current addresses of the district offices of DHEW is found in Appendix I.

As a rule, private granting organizations will not accept the indirect cost rate established by the federal government. In fact, most state and city government agencies will not accept that rate; a rate or amount must be negotiated separately for every application.

Foundations are usually willing to assist with overhead costs, and sometimes they approve of the addition of a set percentage of the total to cover such costs. This percentage ranges generally from 8% to 15% of the total direct costs. For a grant of $50,000, if the allowable rate for overhead is 10%, $5,000 would be added at the end to make the total $55,000. Many grantors prefer to veil the overhead allowance with some other term. One reason given is that foundation boards of directors object to paying overhead costs, but that is surely not always the case. The foundation representative with whom the applicant discusses the project might suggest an item under "direct costs" such as, "administrative management," for example, or some similar term, for an amount that turns out to be equivalent to a percentage of the total of all other items. In the example given above, if one added an item for "administrative services" to the direct costs at a figure of $5,000, the bottom line would still be $55,000, and no mention would be made of "overhead" or "indirect costs."

Corporations rarely look with favor on paying overhead costs for a project, but some of them make grants for operating expenses that provide support for overhead for all activities of the organization. Also, they will often pay operating costs that can be directly charged to the project, such as overtime for security guards.

The question of overhead costs and the exact amount to be

included should be cleared up with the granting agency before the final budget is prepared.

The federal government's negotiated indirect-cost rates may be stated according to either of two formulas:

1. As a percentage of the total cost of salaries and wages, excluding fringe benefits. In this formula, the total of salaries and wages requested for the project is added up, and that amount is multiplied by the negotiated rate to arrive at the indirect cost amount.
2. As a percentage of the total direct costs. When this formula is used, the total of all monies requested for direct costs is multiplied by the rate.

The inevitable question arises as to which is the most advantageous formula. Since salaries and wages are the major portion of costs in "labor-intensive" activities, more money will be produced for indirect costs if formula (1) is used. If most of the costs are for supplies, equipment, meetings, and conferences, the amount will be greater if formula (2) is used. For most arts groups, formula (2), which bases the indirect cost amount on a percentage of the total requested for the project, would probably yield the most overhead support in the long run.

If the negotiated rate is computed by using formula (1), it will be stated as ———% of salaries and wages, shortened to "———% S&W." The formula (2) rate will be stated as ———% of total direct cost, shortened to "———% TDC." This is illustrated in the Sample Budget on pp. 285–288.

Budget Justification

If any item in the budget is unusual and might raise questions from reviewers, it should be explained in a section of the budget called "Budget Justification." The narrative description of the project should also explain why any unusual costs are anticipated, but if a brief, clear explanatory note is given at the end of the budget section, it will not be necessary to re-read the project description in order to understand why the large item appears in the budget.

First-class travel might be required in some cases, when the granting agency normally approves only economy class fares; fees to

Sample Budget

DIRECT COSTS	Requested from Granting Agency	Institutional or Other Contribution	Total
I. PERSONNEL			
A. Salaries and Wages			
1. Professional Staff			
a. John G. Smith, Project Director, 100% time for 12 months @ $20,000	$10,000	$10,000	$20,000
b. Mary Q. Brown, art instructor, 25% time for 12 months @ $18,000	2,250	2,250	4,500
2. Nonprofessional Staff			
a. Administrative assistant, 50% time for 12 months @ $14,000	5,000	2,000	7,000
b. Clerk-typist, 100% time for 6 months @ $10,000	5,000		5,000
Total Salaries and Wages (IA)	$22,250	$14,250	$36,500
B. Fringe Benefits			
1. Professional staff @ 25%	$ 3,063	$ 3,062	$ 6,125
2. Nonprofessional staff @ 20%	2,000	400	2,400
Total Fringe Benefits (IB)	$ 5,063	$ 3,462	$ 8,525
C. Contract Services			
1. Alice Ball, ballet dancer, demonstration performance and seminar	$ 1,000		$ 1,000
2. Paul Painter, resident artist, 3 months @ $1,500	4,500		4,500
Total Contract Services (IC)	$ 5,500		$ 5,500
TOTAL PERSONNEL (IA, IB, & IC)	$32,813	$17,712	$50,525

Continued

	Requested from Granting Agency	Institutional or Other Contribution	Total
II. EXPENDABLE SUPPLIES			
A. Office supplies (stationery, pencils, pens, typewriter ribbons, notebooks, etc.)	$ 1,500	$ 500	$ 2,000
B. Professional supplies (building supplies for scenery, props, sheet music, costume materials, recording tapes, etc.)	3,000	2,000	5,000
TOTAL EXPENDABLE SUPPLIES (IIA & IIB	$ 4,500	$ 2,500	$ 7,000
III. EQUIPMENT			
A. Purchase of Equipment			
1. Tape recorders (2) @ $300	$ 600		$ 600
2. Musical instruments (list separately)	1,500		1,500
3. Typewriter	700		700
B. Rental of Equipment			
1. U-Haul Truck, 20 days @ $50	1,000		1,000
2. Film projector, 10 months @ $50/month	500		500
TOTAL EQUIPMENT (IIIA & IIIB)	$ 4,300		$ 4,300
IV. TRAVEL			
A. Foreign Travel			
1. One round trip to Stratford, England, for conference and workshop, Aug. 5-12, 1981, John G. Smith, tourist class, airfare $500 Per diem, 8 days @ $75/day 600	$ 1,100		$ 1,100

	Requested from Granting Agency	Institutional or Other Contribution	Total
B. Domestic Travel			
1. Alice Ball, round trip Dallas, Texas, to New York City, air fare $150 Per diem, 2 days @ $100/day 200	350		350
2. Paul Painter, round trip San Francisco to New York City	500		500
C. Local Travel			
1. Public transportation for 20 students to partic- ipate in experiment by bus and subway, approx. 2 round trips each	40		40
TOTAL TRAVEL (IVA, IVB, & IVC)	$ 1,990		$ 1,990
V. COMMUNICATIONS			
A. Telephone: Installation and monthly service		$ 1,500	$ 1,500
Toll charges: $100/month for 12 months	$ 1,200		1,200
B. Messenger service and express mail	300		300
TOTAL COMMUNICATIONS (VA & VB)	$ 1,500	$ 1,500	$ 3,000
VI. PUBLICATIONS			
A. Graphic arts: layout and design of brochure, design of stationery	$ 1,500	$ 1,000	$ 2,500
B. Printing costs, brochure, stationery, project report	3,000		3,000
TOTAL PUBLICATIONS (VIA & VIB)	$ 4,500	$ 1,000	$ 5,500

Continued

	Requested from Granting Agency	Institutional or Other Contribution	Total
VII. OTHER DIRECT COSTS			
A. Postage, document duplicating	$ 750	$ 250	$ 1,000
B. Partition to separate costume shop and dressing rooms	2,000		2,000
TOTAL OTHER DIRECT COSTS (VIIA & VIIB)	$ 2,750	$ 250	$ 3,000
TOTAL DIRECT COSTS	$52,353	$22,962	$75,315

INDIRECT COSTS

50% of salaries and wages, excluding fringe benefits (negotiated rate)	$11,125	$ 7,125	$18,250
GRAND TOTAL	$63,478	$30,087	$93,565
Percentage contributed by applicant institution	32.1%		

INDIRECT COSTS (ALTERNATIVE RATE)

30% of total direct costs (negotiated rate)	$15,706	$ 6,888	$22,594
GRAND TOTAL	$68,059	$29,850	$97,909
Percentage contributed by applicant institution	30.5%		

special technicians or artists may have to be explained. And the costs of some items may vary with the season or with the locality.

Official Certifications and Signatures

Every application must be signed by an official authorized to commit the resources of the institution. This is the top administrative officer—the president or the director—although in large organizations that authority may be delegated. That signature is the granting agency's assurance that if the grant is made, it will be administered in accordance with the grant maker's policies and that all obligations devolving on the institution as a result—the submission of progress and fiscal reports, for example—will be fulfilled.

It is obvious that any verbal agreements between the representative of the grants organization and the applicant should be included in the written application, and the official signing the document should understand exactly what he or she is obligating the institution to, that is, what the signature really means.

A story in *The Reader's Digest* in January 1979, cited the sad plight of a city mayor who, in order to save time, "signed a cover sheet for a grant application," trusting to his staff to fill in the details. The final application that was submitted had the city in the wrong county and contained numerous misstatements of fact. To the red-faced mayor's embarrassment was added the chagrin of failure. The city did not get the grant.

Appended Materials

Documents that support the application, but are not necessary to describe and justify it, can be appended to the main sections. They can be referred to in the body of the application, and the reviewers then have the option of reading or omitting them.

There are some basic documents that ought to be included unless they have been given as part of the main application:

1. A list of the members of the board of the applicant organization, with their business or professional titles, addresses, and telephone numbers.

2. Curricula vitae for all personnel, artistic and administrative, who will be associated with the project.
3. A copy of the Internal Revenue Service letter attesting to the tax-exempt, nonprofit status of the applicant organization.
4. A brochure describing the applicant organization, if available.

Other documents that are helpful with certain kinds of applications are:

5. Letters from community leaders in support of the proposed project.
6. Statements from recognized authorities or artists regarding the competence of the applicant to carry out the activity proposed.

The granting organization should not be inundated with useless material just to make an impressively large package, but documents that support the proposal or testimonials to the credibility of the applicant within the geographic or artistic community can be very helpful, especially if the applicant is not widely known.

The various items of information and appended materials that go with an application are numerous even for a very brief application. It is easy to omit some critical item. After the document has been completed and all signatures and additional materials have been collected, it is a good idea to run through a checklist to see if anything significant has been omitted before the proposal is mailed or delivered. A suggested Proposal Checklist that might be used is shown on p. 291.

More details on proposal preparation can be found in *Grants: How to Find out about Them and What to Do Next.*[2]

For people who have never before prepared a grant application, it is instructive to see samples of some that have resulted in grant awards. One place to see such examples is in *Grants Magazine*, a quarterly publication of Plenum Publishing Corporation, 227 West 17 Street, New York, NY 10011. A section called "Grants Clinic"

[2] Virginia P. White. New York: Plenum Press, 1975. 354 pp.

PROPOSAL CHECKLIST

I. Cover Page or Introductory Letter

II. Abstract: Brief Summary

III. Description of the Project

 A. Introduction: background of the field and need for the proposal project, credibility of the institution, qualifications of the participants, why the funding organization should support it.

 B. Statement of the problem: description backed up with statistics; quotations of authorities; description of the effect the project will have on the problem.

 C. Program objectives: specific, measurable outcome.

 D. Method: how the activity will be designed, what instruments are to be used, how data will be processed for interpretation.

 E. Evaluation: what means will be used to measure the success of the project.

 F. Future of the project: what happens afterward.

IV. Budget

 A. Direct Costs

 1. Personnel: Professional, nonprofessional, fringe benefits, consultants, etc.

 2. Nonpersonnel
 a. Equipment: rental, lease, and purchase
 b. Supplies, consumable
 c. Space: rental or valuation of donated space
 d. Travel: foreign, domestic and local
 e. Telephone service: long-distance, local, installation costs
 f. Publications: graphic arts, printing
 g. Other costs: duplicating, postage insurance, data processing, fees to subjects, building alterations, evaluation costs

 B. Indirect Costs

 C. Budget Justification

V. Official Certifications and Signatures

VI. Appended Materials: curricula vitae of all professional participants; descriptive material on the applicant institution; endorsement letters; other pertinent documents.

features applications that have been successful and critiques on their strong points.

Another publication that contains sample grant proposals is edited by Jean Brodsky and is available from Taft, 1000 Vermont Avenue, NW, Washington, DC 20005, for $9.95. It is called *The Proposal Writer's Swipe File II*, which is comprised of 14 professionally written grant proposals, prototypes of approaches, styles, and structures.

Examples of other people's grants should be used only as guides, so the idea of "swiping" should not be taken too literally. Every application should express an original plan or idea, and the ones that have the best chance of funding are those that are unique in some way. Most such ideas can best be expressed by the originator. If professional proposal writers are used at all, their best service is in organizing the materials into a professional proposal package and perhaps in improving the writing of the project description. But no writer-for-hire can express an original idea with the same enthusiasm or arouse the same excitement about it as the one who cares about it most, the originator—the one who most wants to see it succeed.

The grant-making organization will specify the number of copies of an application to be submitted. In addition to those, a copy should be made for everyone in the organization who might have any need for it, particularly those whose names appear in it and who might receive telephone calls or letters about some part of the application: the fiscal officer of the institution should have a copy, the project director, the chief administrative officer or someone delegated to handle the grants programs, and of course the person who prepared the application. It is foolish economy to wait until the decision has been made before distributing copies. Everyone concerned with the project should be fully informed and prepared in case the granting agency asks for information on some specific point. The concerned personnel will also use the proposal to consider the project in tentative work schedules and activities for the future.

After the application has been submitted, one myth says that all you can do is pray, and in many cases this is true. But everyone should have some understanding of what takes place in granting organizations, how the decision process works, and in some cases, how to follow-up at the right moment.

THE POSTAPPLICATION PHASE

THE REVIEW PROCESS

Decision making about which proposals to fund and which to turn down differ in almost every organization. Even within the federal government, the process is not the same in every agency, and as we know, foundations and corporations are almost all unique in this aspect of their operation.

In some very small foundations, the decision may be made by the chief donor to the foundation. These donors often prefer to have applications in the form of a letter, and a few actually go through the mail, open up the letters, and make two piles, one for "Yes" and one for "No." In such cases, the response is usually very prompt. There have been cases where the applicant received a check in the mail a few days after sending in the request. But this is rare, and it almost always involves very small amounts of money, rarely over $1,000 or $2,000.

Large foundations and even the medium-sized ones that have any staff at all are likely to deliberate longer. Someone acting for the organization, a staff or board member, screens all incoming requests and may be delegated the authority to refuse immediately those that do not fall within the interest areas of the foundation. This is a subjective decision, but the applicant who is told that his project is not in a field that the foundation supports should not attempt to debate the issue. It is almost always futile, and it may jeopardize funding for another project more to the foundation's liking.

The staff member who first reviews an application may write or telephone the applicant to explain why the request cannot be considered, or to suggest that it be revised and resubmitted, or to invite the applicant to come in for further discussion. Some communication with a staff member is very likely to occur before an application is submitted to a final reviewing committee. As stated in the section on the preapplication process, however, this communication usually follows an introductory letter rather than a final application. Then, the formal application is submitted when it is ready to be presented to the board of directors or to the reviewers who make recommendations to the board.

In large foundations, the staff official with whom the applicant

consults may be strongly disposed to support the request but may still have to sell a program chairman or other official on it before it goes to the board for final approval. That is why it is so important to enlist the staff contact as an active supporter from the very first stages if possible. It is also why one can never assume that a favorable attitude on the part of the representative who handles the application ensures funding. Many program people lose battles within their institutions and find themselves explaining to an applicant whom they have encouraged to write and even rewrite an application that, in the final analysis, it was not acceptable.

When this occurs, there is a tendency on the part of the applicant to feel betrayed, to think that he or she has been led down the garden path, but this reaction results from a misunderstanding of the funding organization's structure and procedures. From the very first meeting with a representative of the funding organization, try to ascertain exactly where in the decision hierarchy that person stands. He or she will usually be glad to make this clear in order to avoid any later misunderstanding about his or her role.

In corporations, it is rare that one person will make the decision, except in very small businesses dealing with requests from local groups, in which case, the decisions are often made by heads of companies. In large companies, there is usually a formal procedure for considering requests, and as with foundations, the procedure should be discussed in the preliminary negotiations. Details of this procedure may be given in published literature on the philanthropic programs of the organization.

Federal grant decision-making procedures are a matter of public knowledge and may be outlined in the program descriptions. Brochures and guidelines for applicants often give the dates of award announcements along with the deadline dates for applications. The National Endowment for the Arts (NEA) program guide contains, for each separate program, the deadline date, the date of announcement of rejection or grant award, and the first date on which each grant becomes effective and work can begin. The National Endowment for the Humanities (NEH) guidelines give the date for submission of applications and the earliest date that work on the project can commence.

Program officers at the NEA and other government agencies are usually professionals in the field for which they administer funds. Therefore, not only is their advice valuable as a guide to the policies

and the climate of opinion within the agency, but in some cases, they can offer advice on the project itself. The opinion of the program head can be extremely influential in the final determination, but it is never final. Most grants are put through a review process by ad hoc or standing review committees, and all must be approved by a national council. Endowment chairman have the last word. Councils of the NEA and the NEH are presidentially appointed and are composed of the chairman of the agency and 26 private citizens who have a broad knowledge of and interest in the arts and the humanities. Some council members have special expertise in one particular field, but all NEA councillors share one interest: they care about the arts. Since there is such diversity in the wide-ranging area of activity we call "the arts," it is the rare person who has real expertise in more than one or two fields; therefore, the council depends heavily on the professional knowledge of program officers in the agencies. It is inevitable in such a situation that the influence of the program officer is a critical factor in the final decision. The chart on page 296, titled *"Application/Grant Process"* is a step-by-step outline of the NEA's grant process as it appeared in their 1977–1978 *Guide to Programs*.

The question of whether to inquire about the progress of an application during the period when it is being considered is one that experts differ on. Some say that it impresses the program officials to know you are following up on the application to see that it is not overlooked. Others caution against irritating the agency or organization staff by unnecessary calls, lest the calls prejudice them against your proposal. If calls are made to check on the progress of the processing, they should be polite and worded tactfully in a manner that does not suggest pressure. The best idea is to ask, once it is known that your application is being actively considered, when you can expect a decision and when you may inquire about the decision. The representative of the funding organization will then give you a date to call or say, "Don't call us, we'll call you." The final decisions are known some time before the written notifications can be prepared, and some staff people are willing to say that a project has been approved but that no award can be considered final until the applicant has been notified in writing. Very few will tell you that an application was turned down. Everybody likes to deliver the good news; nobody likes to give the bad news.

No matter what oral information you receive, never, never as-

NATIONAL ENDOWMENT FOR THE ARTS
Application/Grant Process

Applicant/ Grantee	Endowment Offices	Advisory Panels	National Council on the Arts	Procedure
	●			Program Director, in consultation with advisory panel members/experts in the field, National Council on the Arts, and the Chairman of the National Endowment for the Arts, prepares Guidelines announcing grant programs, eligibility for application, application deadlines.
●				Grant program announcements and Guidelines are published, provided to all organizations of known capability, and distributed to a wide mailing list, which includes libraries and press outlets. The Arts Endowment also publishes and distributes an annual one-volume summary of all Guidelines, *Guide to Programs*. Brief descriptions of all Programs are published in the annual *Catalog of Federal Domestic Assistance* sold by the Government Printing Office. Complete Guidelines are printed in the *Federal Register* as they are released.
	●			Potential applicants respond to program announcements and request Guidelines with application forms if they do not already have them.
●				Program Offices or Program Information Office responds to requests and provides Application Guidelines to potential applicants. Applicants review Guidelines and prepare the formal applications.
	●			Applicants submit formal applications. Copy of IRS letter, attesting to an organization's tax-exempt status, must accompany application.
	◉			Applications are reviewed by Grants Office and Program Offices to make sure materials are complete. Reviewed applications are presented to advisory panels for review and recommendation.
		◉		Advisory panels, whose members are professionals from the field, review all applications that fall within the Program Guidelines and comply with the required eligibility and IRS status. Panels recommend those applications to be funded and those to be rejected.
	●			Panel suggestions can be incorporated into the proposed grant. Sometimes, for example, an applicant's budget must be revised; and in these cases, the panel comments are reviewed with the applicant by the Program staff.
			◉	Applications, with all panel recommendations for funding and rejection, are presented to the 26 member National Council on the Arts, which reviews the applications again and makes further recommendations.
	◉			The Chairman, on the basis of recommendations from the National Council on the Arts, approves the applications for assistance. Program Offices, in consultation with the Grants Office, prepare grant letters for the Chairman's signature. The Chairman signs grant award letters signifying approval of the grants. (Program Directors send letters to rejected applicants.)
●				A signed grant letter is forwarded to potential grantee, who must also sign a copy of the letter signifying acceptance of the grant and its conditions.
●				Grantee submits initial request to Grants Office for cash payment— and requests subsequent payments in accordance with terms of the grant.
	◉			Grants Office staff reviews request for each cash payment.
●				Cash payments are authorized and forwarded to grantee.
●				Grantee completes project and submits Final Descriptive and Expenditure Reports to the Grants Office.
	◉			Staff reviews and approves final reports and closes out grant.
◉				Audit of grantee is conducted, if appropriate.

Explanation of symbols used: ● = Operation: To prepare or refer to a document. To complete an application, for example. ◉ = Review: To check an application or report for quality, accuracy, and compliance.

sume that a grant has been made until it is confirmed in writing. Even after a review committee and the council have approved a proposal, things can occur that prevent its being funded. In both the NEA and the NEH, the chairman has the final word. "Approved" is one thing, "funded" is another; sometimes one implies the other, but not always. Some government agencies have a category of "approved but not funded," which means that the proposal is accepted as meritorious and worthy of support but that the funds are not currently available. The proposal will be held in consideration if additional funds are given to the agency. Some proposals placed in this category are never funded. They have an excellent chance in the following competition, and if it is still feasible to do the project, any application that was approved but not funded should be resubmitted at the earliest possible time.

WHAT TO DO WHEN AN APPLICATION IS REJECTED

Everybody knows the first thing to do upon receiving a notice of rejection, but after the tears are dried, what are the next steps?

1. Try to find out exactly why the proposal was not approved.
2. Reexamine the project and determine whether it should be abandoned, resubmitted as is, or revised and resubmitted.

The applicant whose very first attempt to obtain funding is unsuccessful will be discouraged, of course, but it is somewhat comforting to realize that this is not unusual. Most experienced and successful grant-getters have gone through a series of rejections before establishing themselves sufficiently and learning the techniques of negotiating funding for their activities. Persistence is very important.

If it is possible to find out why an application was turned down, this information will provide valuable guidance for the next attempt. It is sometimes impossible to find out from foundations and corporations exactly why a proposal was not funded. They tend to respond with stereotyped replies such as "insufficient funds" or "not in our area of interest," no matter what the real reasons were. They want to avoid any challenge to the decision, and so their replies are phrased to close out any possible appeal. This attitude is some-

times hard to accept, especially if the applicant's research has indicated the opposite of what is said, that is, if you know that funds were available or that the funder has supported very similar activities in the recent past. But private grant-makers are under no mandate to explain their decisions, and it will only antagonize them if you press for an answer. A particularly sympathetic representative in the organization who may have championed your proposal but lost the internal battle might informally tell you exactly why it was turned down. The relationship that was established with that person very early in the negotiation will determine whether you can approach him or her on the matter.

Federal agencies are required to make reviewers' comments available to applicants, and you should always request those comments on a rejected proposal. They will furnish a basis for reassessment of the proposed activity, which should be conducted as objectively as possible. When you have worked on a project for a long time, you tend to identify with it so closely that it is hard to view it with real objectivity, much as it is hard for us to see our loved ones through the eyes of a stranger. The comments of disinterested reviewers may reveal flaws that did not occur to the project designer. Very minor revisions may sometimes improve the proposal sufficiently for resubmitting in the next competition or to another agency. Occasionally, it will be clear that the idea is just not feasible and should be abandoned. And sometimes, the reasons for rejection really have nothing to do with the merit of the proposal, and it should be resubmitted immediately.

No proposal is totally worthless. The very act of thinking through a project and writing it up in a well-organized, detailed form is an intellectual exercise that forces clear thinking about one's future activities. Even if a proposal fails to find outside funding, it may serve as part of a long-range plan for the arts organization for reconsideration after other goals have been realized.

WHAT TO DO WHEN YOU RECEIVE A GRANT AWARD

Jump for joy. Lift a glass. Celebrate. Of course. The campaign to get support for a project has some similarity to a military struggle. During the thick of the battle, it seems that if victory can only be achieved, everything else will fall naturally and beautifully into

place. But as we know too well, the aftermath of a victorious military venture can bring problems that seem almost as great as the war itself. And the same can be true of grant awards. Once the elation has subsided and the hard facts begin to be faced, the joy of the victory may be dampened a bit by the realization of the responsibility it implies. The commitments made in the proposal must be met, and every award carries with it stipulations regarding the administration of the project, reporting to the granting agency on the progress of the work as well as on the expenditures, and the fulfillment of promises made for cost-sharing or other institutional contributions.

Government awards often include a statement of acknowledgment and acceptance of the award that must be signed by an official authorized to commit the grantee institution, usually the administrative officer who signed the application for the institution. In most cases, this is the only form of acknowledgment that is necessary. However, if a staff member has been helpful in the negotiations, by all means write that person a note expressing your thanks and appreciation.

Foundation and corporation awards almost always follow consultation with a representative of the granting organization, and you should write that person immediately to thank him or her for the assistance.

Before doing anything else, read all of the instructions included with the grant regarding its administration. Then, copies of the award should be sent to every department of the grantee institution that will be concerned with the grant. These will be the same departments that received copies of the application when it was submitted. It is very important for the fiscal office to have complete copies of the instructions regarding expenditure reports and use of funds that usually accompany the award.

The project director must establish and maintain very close liaison with the fiscal office and see to it that the proper account or accounts are set up and that arrangements are made for buying equipment, hiring personnel, assigning space, or any other needs resulting from the grant. The director must also coordinate the project with other members of the organization who may be involved in scheduling productions or providing publicity or other institutional services. And if other organizations or representatives of other groups are involved, all of them should be fully informed.

The expertise required for the administration of a grant differs in several significant ways from that required to obtain the grant. But the project director who planned carefully, gave meticulous thought to drawing up the budget, and executed the internal coordination properly will have much less trouble with the administration than one who neglected those things or delegated them to a subordinate. On very large projects, the director will need assistants or an assistant to handle the day-to-day management of the grant, but program decisions and the authorization of expenditures from grant funds should be very closely supervised by the person in charge of the activity, the "principal investigator" or project director.

A major criticism that grant makers from the corporate sector, as well as others, level at arts organizations is that they are often badly managed.

No less an authority than Peter F. Drucker, writing on "Managing the 'Third Sector'" in *The Wall Street Journal* in October, 1978, said, "By now . . . the Third Sector has become important, so big and so costly that we need to focus on how it is being run." Drucker defines the third sector as that element of society that is neither public (governmental) nor private in the old sense of the private business sector. He discusses the need for better management in museums, hospitals, libraries, symphony orchestras, civic groups, public interest groups, and others, which he calls "service institutions."

Artists have over the centuries prided themselves on their separation from the crass commercial world, but the business community is now one of the major supporters of the arts in the United States. And it is becoming clear that artists who expect businessmen to make the effort to understand their art should not be surprised if businessmen expect them to be able to add.

A number of organizations have been formed, some at the instigation of the profit-making sector, to assist nonprofit groups in improving their organization and management and to provide them with service and/or expert advice free or at a reasonable cost. Some of these were mentioned in the preapplication section. One such organization, mentioned earlier, is Volunteer Lawyers for the Arts, whose function is to provide artists and arts groups with legal assistance and advice.

The Publishing Center for Cultural Resources, 152 West 42 Street, New York, NY 10036, is a nonprofit corporation created to

help nonprofit educational organizations achieve economical and effective publication, and it assists in publishing by providing manpower, skills, space, and equipment. It receives support from the New York State Council on the Arts for its New York program, and from the NEA and the Ford Foundation for its national program. Museums, historical societies, architectural preservation groups, and other nonprofit educational groups with a printing or publishing project may request assistance through the Publishing Center.

A number of books on managing the arts organization have been written, but there is no one authoritative book on the subject. A periodical mentioned earlier, *Arts Management*, contains information and references on managing arts organizations.

A comprehensive bibliography has been compiled under the auspices of the National Endowment for the Arts for the purpose of helping board members and managers of cultural institutions to find sound information and ideas related to their needs. It is titled *Arts Management: An Annotated Bibliography*, and was compiled by Linda Coe and Stephen Benedict. The bibliography is divided into six sections: "Management"; "Planning and Program Development"; "Fundraising and Technical Assistance"; "Marketing and Public Relations"; "Governing Boards"; and "Research and Public Policy." It also has a listing of other useful bibliographies. *Arts Management: An Annotated Bibliography* can be ordered from the Publishing Center for Cultural Resources, 152 West 42 Street, New York, NY 10036, for $3.00.

One of the most frequent questions that arises about the management of a grant is, what happens if we get halfway through and realize that there is no way to complete the project or to achieve the objectives we have set? This situation frightens grantees into rushing to conceal the fact that they are in trouble or into trying to bluff it out and pretend that everything is going along well. Either course is a mistake. The only thing to do is go to the granting agency—the representative with whom you negotiated the grant, if possible—and explain the situation in detail. Since many of the staff are professionals in the fields of the applications they handle, he or she might be able to give some helpful advice or recommend an outside consultant who can help. In some cases, the granting institution will even make money available to bring in an outside consultant in order to save a project and see it through to a successful conclusion. It is no disgrace, and not even unusual, to have some unanticipated

circumstance affect the ability of a person or an organization to produce something that was planned with every reason for confidence a year earlier.

Once a granting organization has put its money into an activity, it has a stake in seeing that it succeeds, and from the moment you are awarded a grant, you should consider the grantor an ally. If the venture fails, the grantor stands to lose by it, and if it succeeds, the grantor will be proud of having participated in bringing about something worthwhile. Therefore, when unexpected problems arise, the grantor should be informed and consulted immediately.

Every grant award carries with it a commitment to provide the granting organization with some kind of final report. The enforcement of this requirement varies widely, especially in foundations. Small foundations with limited staff assistance may be rather careless about following up on reports. But in recent years, when foundation activities are so strictly controlled by federal regulations, most of them are rather careful about collecting these reports. Foundations that publish an annual report are particularly interested in having good projects to write about. Many of them insist on detailed final fiscal statements.

Corporations also insist on final reports, and the grantee who expects to apply for a renewal of a grant or who anticipates future support from a corporation had better comply with all the corporation's demands for progress and expenditure reports.

Government agencies are likely to be very insistent on reports, the federal government particularly. The National Endowment for the Humanities has a record of being adamant on this point and has been known to tell institutions that they will not be awarded another grant until overdue reports from previous awards have been submitted. The fiscal officer of the grantee institution is responsible for expenditure reports; the principal investigator or project director is responsible for progress reports.

Like the rejected application, the final report may serve purposes other than the original one. The complete story of a project often turns out to be a good publicity story for the organization. It may be suitable for a professional magazine or journal; it may be material for a news story; or it may be an important contribution to the institution's archives for its historical value. Interesting, detailed, and well-documented final reports are one of the best means

of building an institution's credibility with a granting organization. A report on a project that the granting institution can point to with pride will almost certainly ensure a warm welcome the next time it is approached by that same grantee.

The Patron Is Us

Theories abound concerning the exact nature and the genesis of artistic creativity. It has been suggested, for example, that music may be a language none of us has to learn, since we may inherit it by virtue of being born human, as we inherit the ability to weep. Pythagoras and his followers believed in a "music of the spheres," kept in tune with the universe by fundamental acoustical and numerological rules.

Literature on the subject of dance includes explanations that the dance style of each cultural tradition symbolizes the patterns of movement essential to the survival of the group in its particular environment.

The beginnings of painting, carving, and the forming out of metal, wood, stone, and precious gems of objects that please the senses are lost in time, and the impulses that drive man to create in these ways are little understood.

The origins of the forces that culminate in something called *the imagination* and that impel man to express that inner experience by forming tangible symbols are lost in the anthropological mists; but some reasonable assumptions can be made concerning the creations that emerge from those forces and that survive for generations. One thing we can be sure of is that whatever survives must be valued, protected, and cherished by someone. And we can logically assume that the impulse to artistic creation would have died out in primitive societies, where each man was responsible for providing his own food and other daily necessities, without the support of persons or groups who were pleased by works of art.

This reasoning forces us to the conclusion that the final arbiter of what survives as a symbol of the culture of a time or a place is not the artist but the patron—the one who enables the artist to work and who sees to the preservation of the results.

Artistic works that have endured for ages are frequently assumed, merely because they have lasted, to be representative of the best of a period. However, we have no way of knowing that for certain, since it may be only what the rich and powerful of that time and place considered to be the best. If today is at all reflective of the past, we can be sure that governing rulers and the moneyed class did not always select and treasure the best in art or anything else. This is not to disdain our heritage, which is indeed rich, or to imply that much of the best was not preserved. But who can say what great works of unsurpassed beauty have been lost to us from the past for want of an appreciative patron?

In this, the latter half of the twentieth century, and particularly in the United States, we live in an age when the common man can, by exerting his citizenship rights, influence the creation and preservation of works of art, a prerogative formerly reserved only for the privileged classes. The opportunity is there. To make it a reality, the population or at least a reasonable fraction of it, must express its preferences and tastes in a way that influences decisions about what is supported.

In relation to government grant making, legislative bodies must be made aware of the desires of their constituencies. In the private sector, community foundations are supported by private donations and by gifts from wills and bequests; their officers are selected from the community. The individual donors who support such organizations have a strong voice in the policy making and in the decisions about what will be funded.

The general public no longer has to accept the standards of the few with money and power to commission artists of their choice and to decide which works exemplify the greatest achievements of our time. Everyone can have a voice, and we have a commitment to ourselves to be heard. We have not only the opportunity but the obligation to participate in selecting what we leave to future generations as symbols of our culture. We must therefore foster the creation and preservation of what we believe in because, for better or worse, a society perpetuates what it supports.

Appendix I

Alabama Alabama State Council on the Arts and Humanities
114 North Hull Street
Gallagher House
Montgomery, AL 36130

Alaska Alaska State Council on the Arts
619 Warehouse Avenue, Suite 220
Anchorage, AK 99501

Arizona Arizona Commission on the Arts and Humanities
6330 North Seventh Street
Phoenix, AZ 85014

Arkansas Arkansas Arts Council
Suite 500, Continental Building
Main and Markham Streets
Little Rock, AR 72201

California California Arts Council
2022 J Street
Sacramento, CA 95814

Colorado The Colorado Council on the Arts and Humanities
Grant-Humphreys Mansion
770 Pennsylvania Street
Denver, CO 80203

Connecticut	Connecticut Commission on the Arts 340 Capitol Avenue Hartford, CT 06106
Delaware	Delaware State Arts Council Office of the Arts, Department of State State Office Building 820 North French Street Wilmington, DE 19801
District of *Columbia*	D.C. Commission on the Arts and Humanities District Building Office of Communications, Room 226 Washington, DC 20005
Florida	Fine Arts Council of Florida Division of Cultural Affairs Department of State The Capitol Tallahassee, FL 32304
Georgia	Georgia Council for the Arts and Humanities Suite 210 1627 Peachtree Street NE Atlanta, GA 30309
Guam	Insular Arts Council of Guam P.O. Box 2950 Agana, Guam, 96910
Hawaii	Hawaii State Foundation on Culture and the Arts 250 South King Street, Room 310 Honolulu, HI 96813
Idaho	Idaho Commission on the Arts % Statehouse Boise, ID 83720
Illinois	Illinois Arts Council 111 North Wabash Avenue Room 700 Chicago, IL 60602
Indiana	Indiana Arts Commission Union Title Building, Suite 614 155 East Market Street Indianapolis, IN 46204

Iowa	Iowa State Arts Council State Capitol Building Des Moines, IA 50319
Kansas	Kansas Arts Commission 509A Kansas Avenue Topeka, KS 66603
Kentucky	Kentucky Arts Commission 302 Wilkinson Street Frankfort, KY 40601
Louisiana	Louisiana State Arts Council Division of the Arts P.O. Box 44247 Baton Rouge, LA 70804
Maine	Maine State Commission on the Arts and the Humanities State House August, ME 04330
Marianas	Department of Community and Cultural Affairs Commonwealth of the Northern Mariana Islands Office of the Governor Saipan, Northern Mariana Islands 96950
Maryland	Maryland Arts Council 15 West Mulberry Baltimore, MD 21201
Massachusetts	Massachusetts Council on the Arts and Humanities 1 Ashburton Place Boston, MA 02108
Michigan	Michigan Council for the Arts Executive Plaza 1200 Sixth Avenue Detroit, MI 48226
Minnesota	Minnesota State Arts Board 2500 Park Avenue Minneapolis, MN 55404
Mississippi	Mississippi Arts Commission 301 North Lamar Street P.O. Box 1341 Jackson, MS 39205

Missouri	Missouri State Council on the Arts Raeder Place 727 North First Street St. Louis, MO 63102
Montana	Montana Arts Council 1280 South Third Street West Missoula, MT 59801
Nebraska	Nebraska Arts Council 8448 West Center Road Omaha, NE 68124
Nevada	Nevada State Council on the Arts 4600 Kietzke Suite 134, Building D Reno, NV 89502
New Hampshire	New Hampshire Commission on the Arts Phenix Hall 40 North Main Street Concord, NH 03301
New Jersey	New Jersey State Council on the Arts 109 West State Street Trenton, NJ 08608
New Mexico	New Mexico Arts Division 113 Lincoln Avenue Santa Fe, NM 87503
New York	New York State Council on the Arts 80 Centre Street New York, NY 10013
North Carolina	North Carolina Arts Council North Carolina Department of Cultural Resources 407 North Person Street Raleigh, NC 27611
North Dakota	North Dakota Council on the Arts 309D Minard Hall North Dakota State University Fargo, ND 58102
Ohio	Ohio Arts Council 50 West Broad Street Suite 3600 Columbus, OH 43215

Oklahoma	Oklahoma Arts and Humanities Council Jim Thorpe Building 2101 North Lincoln Boulevard Oklahoma City, OK 73105
Oregon	Oregon Arts Commission 835 Summer Street NE Salem, OR 97301
Pennsylvania	Commonwealth of Pennsylvania Council on the Arts 3 Shore Drive Office Center 2001 North Front Street Harrisburg, PA 17102
Puerto Rico	Institute of Puerto Rican Culture Apartado Postal 4184 San Juan, PR 00905
Rhode Island	Rhode Island State Council on the Arts 334 Westminster Mall Providence, RI 02903
Samoa	American Samoa Arts Council P.O. Box 1540, Office of the Governor Pago Pago, American Samoa 96799
South Carolina	South Carolina Arts Commission 1800 Gervais Street Columbia, SC 29201
South Dakota	South Dakota State Fine Arts Council 108 West 11 Street Sioux Falls, SD 57102
Tennessee	Tennessee Arts Commission 222 Capitol Hill Building Nashville, TN 37219
Texas	Texas Commission on the Arts P.O. Box 13406 Capitol Station Austin, TX 78711
Utah	Utah Arts Council 617 East South Temple Street Salt Lake City, UT 84102
Vermont	Vermont Council on the Arts 136 State Street Montpelier, VT 05602

Virginia

Virginia Commission for the Arts
400 East Grace Street
First Floor
Richmond, VA 23219

Virgin Islands

Virgin Islands Council on the Arts
Caravelle Arcade
Christiansted, St. Croix
U.S. Virgin Islands 00820

Washington

Washington State Arts Commission
9th and Columbia Building Mail Stop FU-12
Olympia, WA 98504

West Virginia

Arts and Humanities Division
West Virginia Department of Culture and History
Science and Culture Center
Capitol Complex
Charleston, WV 25305

Wisconsin

Wisconsin Arts Board
123 West Washington Avenue
Madison, WI 53702

Wyoming

Wyoming Council on the Arts
122 West 25th Street
Cheyenne, WY 82002

Appendix II

State Education Agency (SEA)—Arts Directors/ Coordinators

Alabama
Marshall Spann
Coordinator of the Language and Fine Arts Section
State Department of Education
Montgomery, AL 36130
(205) 832-3190

Alaska
Marilou Madden
Director of Education Program Support
State Department of Education, Pouch F
Juneau, AK 99811
(907) 465-2830

Arizona
Raymond G. Van Diest
Fine Arts Director
State Department of Education
1535 West Jefferson
Phoenix, AZ 85007
(602) 255-5233

Arkansas
Leon L. Adams, Jr.
Specialist, Music Education
State Department of Education
Little Rock, AR 72201
(501) 371-1963

California

Louis P. Nash
Fine Arts and Humanities Consultant
Office of Curriculum Services
State Department of Education
721 Capitol Mall
Sacramento, CA 95814
(916) 322-4015

Colorado

Jerry Villars
Consultant in School Improvement
Accreditation and Accountability Services
State Department of Education
1362 Lincoln Street, Room 305
Denver, CO 80203
(303) 839-2111

Connecticut

Robert J. Saunders
Arts Education Consultant
State Department of Education
165 Capitol Avenue, Box 2219
Hartford, CT 06115
(203) 566-5223

Delaware

James R. Gervan
State Supervisor, Arts and Music Education
State Department of Public Instruction
Townsend Building
Dover, DE 19901
(302) 678-4885

*District of
Columbia*

Frank Maxwell
Acting Supervising Director
Music Department
La Salle Elementary School
Riggs Road and Madison Streets, NE
Washington, DC 20011
(202) 576-6252

Florida

Neil Mooney
Art Consultant
State Department of Education
305 Winchester Building
Tallahassee, FL 32304
(904) 488-5694

Georgia

Frank Crockett
Consultant in Music
State Department of Education
Annex Building
156 Trinity Avenue, SW
Atlanta, GA 30303
(404) 656-2490

Hawaii

Stanley Yamamoto
Education Specialist, Art Education
State Department of Education
1270 Queen Emma Street
Honolulu, HI 96813
(808) 548-6341

Idaho

Bert Burda
Music Consultant
State Department of Education
Len B. Jordan Building
Boise, ID 83720
(208) 384-2281

Illinois

Mina Halliday
Education Specialist
Speech/Drama Education
State Office of Education
100 North First Street
Springfield, IL 62777
(217) 782-2826

Indiana

Barry M. Patrick
Art Consultant
Division of Curriculum
State Department of Public Instruction
State House
Indianapolis, IN 46204
(317) 633-4507

Iowa

Laura Magee
Arts Education Consultant
State Department of Public Instruction
Grimes State Office Building
Des Moines, IA 50319
(515) 281-3264

Kansas George Neaderhiser
 Music Education Specialist
 State Department of Education
 120 East Tenth Street
 Topeka, KS 66612
 (913) 296-3916

Kentucky Robert Elkins
 Consultant, Music Education
 State Department of Education
 1828 Capitol Plaza Tower
 Frankfort, KY 40601
 (502) 564-3505

Louisiana Myrtle Kerr
 Supervisor of Art and Humanities
 State Department of Education
 P.O. Box 44064
 Baton Rouge, LA 70804
 (504) 389-5265

Maine Virgilio Mori
 State Music Consultant
 State Department of Education and Cultural Services
 Augusta, ME 04333
 (207) 289-3451 X2541

Maryland Harold H. Lott
 Consultant in Art
 State Department of Education
 P.O. Box 8717 BWI Airport
 Baltimore, MD 21240
 (301) 796-8300 X465

Massachusetts Pat Mazza
 Arts Specialist
 Curriculum and Instruction
 State Department of Education
 31 St. James Avenue
 Boston, MA 02116
 (617) 727-5759

Michigan Barbara Carlisle
 Fine Arts Specialist
 State Department of Education
 Lansing, MI 48909
 (517) 373-1484

Minnesota	Mary Honetschlager Education Specialist State Department of Education Capitol Square Building 550 Cedar Street St. Paul, MN 55101 (612) 296-4074
Mississippi	Sandra Nicola Art Specialist State Department of Public Instruction P.O. Box 771 Jackson, MS 39205 (601) 354-6876
Missouri	Richard L. King Curriculum Coordinator State Department of Education Jefferson City, MO 65101 (314) 751-2625
Montana	Kay Burkhardt Arts Consultant State Department of Public Instruction Helena, MT 59601 (406) 449-3116
Nebraska	Stephen Lahr Arts Coordinator for Curriculum Services State Department of Education 301 Centennial Mall Lincoln, NE 68509 (402) 471-2446
Nevada	George Hastings Education Consultant State Department of Education Capitol Complex Carson City, NV 89710 (701) 885-5700, X245
New Hampshire	John Gray Consultant, Arts Education State Department of Education 64 North Main Street Concord, NH 03301 (603) 271-2402

New Jersey Sherwood Wilson
Director of Educational Improvement Centers
State Department of Education
Trenton, NJ 08625
(609) 292-8390

New Mexico Rollie Heltman
Music Specialist
State Department of Education
Education Building
Santa Fe, NM 87503
(505) 827-5391

New York Vivienne Anderson
Special Assistant to the Executive Deputy
 Commissioner
State Department of Education
Washington Avenue
Albany, NY 12234
(518) 474-7744

North Carolina James Hall
Director, Division of Cultural Arts
State Department of Public Instruction
Raleigh, NC 27611
(919) 733-7467

North Dakota Roger Kolsrud
Coordinator of Fine Arts and Music
State Department of Public Instruction
Capitol Building
Bismarck, ND 58505
(701) 224-2281

Ohio Jerry Tollifson
Supervisor, Art Education
State Department of Education
65 South Front Street
Columbus, OH 43215
(614) 466-4274

Oklahoma Peggy Long
Arts in Education/Theatre Specialist
State Department of Education
2500 North Lincoln
Oklahoma City, OK 73105
(405) 521-3361

Oregon

Delmer Aebischer
Specialist, Music Education
State Department of Education
700 Pringle Parkway, SE
Salem, OR 97310
(503) 378-3602

Pennsylvania

Clyde M. McGeary
Chief, Division of General Education
Bureau of Curriculum Services
State Department of Education
Harrisburg, PA 17126
(717) 783-1832

Rhode Island

Donald R. Gardner, Jr.
Coordinator, Program Development
State Department of Education
Roger Williams Building
Providence, RI 02908
(401) 277-2821

South Carolina

Thomas A. Hatfield
Art Consultant
State Department of Education
705 Rutledge State Office Building
Columbia, SC 29201
(803) 758-2652

South Dakota

Robert L. Huckins
Director, Student Services
Division of Elementary and Secondary Education
Department of Education and Cultural Affairs
Pierre, SD 57501
(605) 224-3371

Tennessee

Robert Daniels
State Department of Education
Cookeville, TN 38501
(615) 528-5431

Texas

Philip Manning
Program Director
Instrumental Music Specialist
Texas Education Agency
201 East 11th
Austin, TX 78701
(512) 475-3653

Utah

Charles Stubbs
Specialist, Fine Arts
State Board of Education
250 East 5th South
Salt Lake City, UT 84111
(801) 533-5061

Vermont

H. Donn McCafferty
Chief, Secondary Education and Humanities
State Department of Education
State Office Building
120 State Street
Montpelier, VT 05602
(802) 828-3111

Virginia

Baylor E. Nichols
Associate Director of Fine Art
State Department of Education
Box 6Q
Richmond, VA 23216
(804) 786-2610

Washington

James Sjolund
Director of Comprehensive Arts Education Program
State Superintendent of Public Instruction
Old Capitol Building
FG–11
Olympia, WA 98504
(206) 753-4155

West Virginia

Al Canonico
Curriculum Development Specialist, Physical
 Education
Capitol Complex
Building 6, Room B–330
State Department of Education
Charleston, WV 25305
(304) 348-2687

Wisconsin

Earl Collins
Supervisor, Art Education
State Department of Public Instruction
126 Langdon Street
Madison, WI 53702
(608) 266-3395

Wyoming

Kathy Erickson
English Consultant/Gifted and Talented
State Department of Education
Hathaway Building
Cheyenne, WY 82002
(307) 777-7411

Appendix III

STATE HUMANITIES COMMITTEES

Alabama	Alabama Committee for the Humanities and Public Policy Birmingham-Southern College Birmingham, AL 35204 (205) 324-1314
Alaska	Alaska Humanities Forum 429 D Street, Room 211 Loussac Sogn Building Anchorage, AK 99501 (907) 272-5341
Arizona	Arizona Humanities Council 112 North Central Avenue, Suite 304 Phoenix, AZ 85004 (602) 257-0335
Arkansas	Arkansas Endowment for the Humanities University Tower Building Little Rock, AR 72204 (501) 663-3451
California	California Council on the Humanities in Public Policy 312 Sutter Street San Francisco, CA 94105 (415) 391-1474

Colorado	Colorado Humanities Program 855 Broadway Boulder, CO 80302 (303) 442-7298
Connecticut	Connecticut Humanities Council 195 Church Street Wesleyan Station Middletown, CT 06457 (203) 347-6888, 347-3788
Delaware	Delaware Humanities Forum 2600 Pennsylvania Avenue Wilmington, DE 19806 (302) 738-8491
District of Columbia	D.C. Community Humanities Council 419 Monroe Hall George Washington University Washington, DC 20052 (202) 676-7543
Florida	Florida Endowment for the Humanities LET 360 University of South Florida Tampa, FL 33620 (813) 974-4094
Georgia	Committee for the Humanities in Georgia Georgia Center for Continuing Education Athens, GA 30601 (404) 542-5481
Hawaii	Hawaii Committee for the Humanities 2615 South King Street, Suite 211 Honolulu, HI 96826 (808) 947-5891
Idaho	The Association for the Humanities in Idaho 1403 West Franklin Street Boise, ID 83702 (208) 345-5346
Illinois	Illinois Humanities Council 201 West Springfield Avenue Champaign, IL 61820 (217) 333-7611

Indiana	Indiana Committee for the Humanities 4200 Northwestern Avenue Indianapolis, IN 46205 (317) 925-5316
Iowa	Iowa Board for Public Programs in the Humanities Oakdale Campus University of Iowa Iowa City, IA 52242 (319) 353-6754
Kansas	Kansas Committee for the Humanities 112 West Sixth Street, Suite 509 Topeka, KS 66603 (913) 357-0359
Kentucky	Kentucky Humanities Council, Inc. 206 Ligon House University of Kentucky Lexington, KY 40508 (606) 258-5932
Louisiana	Louisiana Committee for the Humanities Box 12, Loyola University New Orleans, LA 70118 (504) 865-9404
Maine	Maine Council for the Humanities and Public Policy P.O. Box 7202 Portland, ME 04112 (207) 773-5051
Maryland	The Maryland Committee for the Humanities, Inc. 330 North Charles Street, Room 306 Baltimore, MD 21202 (301) 837-1938
Massachusetts	Massachusetts Foundation for the Humanities and Public Policy 237E Whitmore Administration Building University of Massachusetts Amherst, MA 01003 (413) 545-1936

Michigan	Michigan Council for the Humanities Nisbet Building, Suite 30 Michigan State University East Lansing, MI 48824 (517) 355-0160
Minnesota	Minnesota Humanities Commission Metro Square Suite 282 St. Paul, MN 55101 (612) 224-5739
Mississippi	Mississippi Committee for the Humanities 3825 Ridgewood Road Room 111 Jackson, MS 39211 (601) 982-6752
Missouri	Missouri State Committee for the Humanities, Inc. 6920 Millbrook Boulevard St. Louis, MO 63130 (314) 889-5940
Montana	Montana Committee for the Humanities P.O. Box 8036 Hellgate Station Missoula, MT 59807 (406) 243-6022
Nebraska	Nebraska Committee for the Humanities 1915 West 24 Street Room 216 Kearney, NE 68847 (308) 234-2110
Nevada	Nevada Humanities Committee 4765 Brussels Avenue (Center for United Campus Ministry) Las Vegas, NV 89109 (702) 784-6587
New Hampshire	New Hampshire Council for the Humanities 112 South State Street Concord, NH 03301 (603) 224-4071

New Jersey	New Jersey Committee for the Humanities Rutgers, The State University C N 5062 New Brunswick, NJ 08903 (201) 932-7726
New Mexico	New Mexico Committee for the Humanities 1805 Roma N.E. The University of New Mexico Albuquerque, NM 87131 (505) 277-3705 (Albuquerque) (505) 646-1945 (Las Cruces)
New York	New York Council for the Humanities 33 West 42 Street New York, NY 10036 (212) 354-3040
North Carolina	North Carolina Humanities Committee 1209 West Market Street Greensboro, NC 27412 (919) 379-5325
North Dakota	North Dakota Committee for the Humanities and Public Issues Box 2191 Bismarck, ND 58501 (701) 258-9010
Ohio	The Ohio Programs in the Humanities 760 Pleasant Ridge Avenue Columbus, OH 43209 (614) 236-6879
Oklahoma	Oklahoma Humanities Committee Executive Terrace Building, Suite 500, 2809 Northwest Expressway Oklahoma City, OK 73112 (405) 840-1721
Oregon	Oregon Committee for the Humanities 418 S.W. Washington, Room 410 Portland, OR 97204 (503) 241-0543

Pennsylvania

Public Committee for the Humanities in Pennsylvania
401 North Broad Street
Philadelphia, PA 19108
(215) 925-1005

Puerto Rico

Fundación Puertorriqueña de las Humanidades
Box 4307
Old San Juan, PR 00904
(809) 723-2087

Rhode Island

Rhode Island Committee for the Humanities
86 Weybosset Street, Room 307
Providence, RI 02903
(401) 521-6150

South Carolina

South Carolina Committee for the Humanities
2801 Devine Street
McCrory Building
Columbia, SC 29205
(803) 799-1704

South Dakota

South Dakota Committee on the Humanities
University Station, Box 35
Brookings, SD 57006
(605) 688-4823

Tennessee

Tennessee Committee for the Humanities
1001-18th Avenue South
Nashville, TN 37212
(615) 320-7001

Texas

Texas Committee for the Humanities
UTA Station, P.O. Box 19096
Arlington, TX 76019
(817) 273-3174

Utah

Utah Endowment for the Humanities in Public Policy
10 West Broadway
Broadway Building, Suite 200
Salt Lake City, UT 84101
(801) 531-7868

Vermont

Vermont Council on the Humanities and Public Issues
Grant House, P.O. Box 58
Hyde Park, VT 05655
(802) 888-5060

Virginia	Virginia Foundation for the Humanities and Public Policy One-B West Range University of Virginia Charlottesville, VA 22903 (804) 924-3296
Washington	Washington Commission for the Humanities, Inc. Olympia, WA 98505 (206) 866-6510
West Virginia	The Humanities Foundation of West Virginia Box 204 Institute, WV 25112 (304) 768-8869
Wisconsin	Wisconsin Humanities Committee 716 Langdon Street Madison, WI 53706 (608) 262-0706
Wyoming	Wyoming Council for the Humanities Box 3274 University Station Laramie, WY 82701 (307) 766-6496

Appendix IV

The Foundation Center

REFERENCE COLLECTIONS OPERATED BY THE FOUNDATION CENTER

The Foundation Center
888 Seventh Avenue
New York, NY 10019

The Foundation Center
1001 Connecticut Avenue, NW
Washington, DC 20036

The Foundation Center
Kent H. Smith Library
739 National City Bank Building
Cleveland, OH 44114

The Foundation Center
312 Sutter Street
San Francisco, CA 94108

REGIONAL COOPERATING COLLECTIONS

Alabama

Birmingham Public Library
2020 Park Place
Birmingham, AL 35203

Auburn University at Montgomery Library
Montgomery, AL 36117

Alaska

University of Alaska, Anchorage Library
3211 Providence Drive
Anchorage, AK 99504

Arizona

Tucson Public Library
Main Library
200 South Sixth Avenue
Tucson, AZ 85701

Arkansas

Westark Community College Library
Grand Avenue at Waldron Road
Fort Smith, AR 72913

Little Rock Public Library
Reference Department
700 Louisiana Street
Little Rock, AR 72201

California

Edward L. Doheny Memorial Library
University of Southern California
Los Angeles, CA 90007

San Diego Public Library
820 E Street
San Diego, CA 92101

Colorado

Denver Public Library
Sociology Division
1357 Broadway
Denver, CO 80203

Connecticut

Hartford Public Library
Reference Department
500 Main Street
Hartford, CT 06103

Delaware

Hugh Morris Library
University of Delaware
Newark, DE 19711

Florida

Jacksonville Public Library
Business, Science, and Industry Department
122 North Ocean Street
Jacksonville, FL 32202

Miami–Dade Public Library
Florida Collection
One Biscayne Boulevard
Miami, FL 33132

Georgia

Atlanta Public Library
10 Pryor Street SW
Atlanta, GA 30303

Hawaii	Thomas Hale Hamilton Library University of Hawaii Humanities and Social Sciences Division Honolulu, HI 96822
Idaho	Caldwell Public Library 1010 Dearborn Street Caldwell, ID 83605
Illinois	Donors Forum of Chicago* 208 South LaSalle Street Chicago, IL 60604 Sangamon State University Library Shepherd Road Springfield, IL 62708
Indiana	Indianapolis–Marion County Public Library 40 East St. Clair Street Indianapolis, IN 46204
Iowa	Public Library of Des Moines 100 Locust Street Des Moines, IA 50309
Kansas	Topeka Public Library 1515 West 10 Street Topeka, KS 66604
Kentucky	Louisville Free Public Library Fourth and York Streets Louisville, KY 40203
Louisiana	New Orleans Public Library Business and Science Division 219 Loyola Avenue New Orleans, LA 70140

* Reference collections operated by foundations or area associations of foundations. They are often able to offer special materials or provide extra services, such as seminars or orientations for users, because of their close relationship to the local philanthropic community.

All other collections are operated by cooperating libraries. Generally, they are located within public institutions and are open to the public during a longer schedule of hours and also offer visitors access to a well-developed general library research collection.

Telephone individual libraries for more information about their holdings or hours. To check on new locations call toll free 800-424-9836 for current information.

Maine	University of Southern Maine Center for Research and Advanced Study 246 Deering Avenue Portland, ME 04102
Maryland	Enoch Pratt Free Library Social Science and History Department 400 Cathedral Street Baltimore, MD 21201
Massachusetts	Associated Foundation of Greater Boston* 294 Washington Street, Suite 501 Boston, MA 02108
	Boston Public Library Copley Square Boston, MA 02117
Michigan	Henry Ford Centennial Library 16301 Michigan Avenue Dearborn, MI 48126
	Purdy Library Wayne State University Detroit, MI 48202
	Michigan State University Libraries Reference Library East Lansing, MI 48824
	University of Michigan—Flint UM-F Library Reference Department Flint, MI 48503
	Grand Rapids Public Library Sociology and Education Department Library Plaza Grand Rapids, MI 49502
Minnesota	Minneapolis Public Library Sociology Department 300 Nicollet Mall Minneapolis, MN 55401
Mississippi	Jackson Metropolitan Library 301 North State Street Jackson, MS 39201

Missouri	Clearinghouse for Midcontinent Foundations* University of Missouri, Kansas City School of Education Building 52nd Street and Holmes Kansas City, MO 64110
	Kansas City Public Library 311 East 12 Street Kansas City, MO 64106
	The Danforth Foundation Library* 222 South Central Avenue St. Louis, MO 63105
	Springfield–Greene County Library 397 East Central Street Springfield, MO 65801
Montana	Eastern Montana College Library Reference Department Billings, MT 59101
Nebraska	W. Dale Clark Library Social Sciences Department 215 South 15 Street Omaha, NE 68102
Nevada	Clark County Library 1401 East Flamingo Road Las Vegas, NV 89109
	Washoe County Library 301 South Center Street Reno, NV 89505
New Hampshire	The New Hampshire Charitable Fund* One South Street Concord, NH 03301
New Jersey	New Jersey State Library Governmental Reference P.O. Box 1898 185 West State Street Trenton, NJ 08625
New Mexico	New Mexico State Library 300 Don Gaspar Street Santa Fe, NM 87501

New York

New York State Library
Cultural Education Center
Humanties Section, 6th Floor
Empire State Plaza
Albany, NY 12230

Buffalo and Erie County Public Library
Lafayette Square
Buffalo, NY 14203

Levittown Public Library
One Bluegrass Lane
Levittown, NY 11756

Plattsburgh Public Library
15 Oak Street
Plattsburgh, NY 12901

Rochester Public Library
Business and Social Sciences Division
115 South Avenue
Rochester, NY 14604

Onondaga County Public Library
335 Montgomery Street
Syracuse, NY 13202

North Carolina

North Carolina State Library
109 East Jones Street
Raleigh, NC 27611

The Winston-Salem Foundation*
229 First Union National Bank Building
Winston-Salem, NC 27101

North Dakota

The Library
North Dakota State University
Fargo, ND 58105

Ohio

Public Library of Cincinnati and Hamilton County
Education Department
800 Vine Street
Cincinnati, OH 45202

Oklahoma

Oklahoma City Community Foundation*
1300 North Broadway
Oklahoma City, OK 73103

Tulsa City-County Library System
400 Civic Center
Tulsa, OK 74103

Oregon	Library Association of Portland Education and Documents Room 801 SW Tenth Avenue Portland, OR 97205
Pennsylvania	The Free Library of Philadelphia Logan Square Philadelphia, PA 19103
	Hillman Library University of Pittsburgh Pittsburgh, PA 15260
Rhode Island	Providence Public Library Reference Department 150 Empire Street Providence, RI 02903
South Carolina	South Carolina State Library Reader Services Department 1500 Senate Street Columbia, SC 29211
South Dakota	South Dakota State Library State Library Building 322 South Fort Street Pierre, SD 57501
Tennessee	Memphis Public Library 1850 Peabody Avenue Memphis, TN 38104
Texas	The Hogg Foundation for Mental Health* The University of Texas Austin, TX 78712
	Dallas Public Library History and Social Sciences Division 1954 Commerce Street Dallas, TX 75201
	El Paso Community Foundation* El Paso National Bank Building, Suite 1616 El Paso, TX 79901
	Funding Information Library* Minnie Stevens Piper Foundation 201 North St. Mary's Street, Suite 100 San Antonio, TX 78205

Utah	Salt Lake City Public Library Information and Adult Services 209 East Fifth Street Salt Lake City, UT 84111
Vermont	State of Vermont Department of Libraries Reference Services Unit 111 State Street Montpelier, VT 05602
Virginia	Richmond Public Library Business, Science, and Technology Department 101 East Franklin Street Richmond, VA 23219
Washington	Seattle Public Library 1000 Fourth Avenue Seattle, WA 98104 Spokane Public Library Reference Department West 906 Main Avenue Spokane, WA 99201
West Virginia	Kanawha County Public Library 123 Capitol Street Charleston, WV 25301
Wisconsin	Marquette University Memorial Library 1415 West Wisconsin Avenue Milwaukee, WI 53233
Wyoming	Laramie County Community College Library 1400 East College Drive Cheyenne, WY 82001
Puerto Rico	Consumer Education and Service Center Department of Consumer Affairs Minillas Central Government Building North Santurce, PR 00908
Mexico	Biblioteca Benjamin Franklin Londres 16 Mexico City 6, D.F.

Appendix V

DEPARTMENT OF HEALTH, EDUCATION, AND WELFARE (HEW) REGIONAL OFFICES

ADDRESS	GEOGRAPHICAL AREA
Region I John F. Kennedy Federal Building Government Center, Room 1512 Boston, MA 02203	Connecticut, Maine, Massachusetts, New Hampshire, Rhode Island, Vermont
Region II 26 Federal Plaza, Room 3300 New York, NY 10007	New Jersey, New York, Puerto Rico, Virgin Islands
Region III 3535 Market Street Philadelphia, PA 19104 *Mailing address:* P.O. Box 13716 Philadelphia, PA 19101	Delaware, District of Columbia, Maryland, Pennsylvania, Virginia, West Virginia
Region IV 101 Marietta Tower Atlanta, GA 30323	Alabama, Florida, Georgia, Kentucky, Mississippi, North Carolina, South Carolina, Tennessee

Region V
300 South Wacker Drive, 35th
 Floor
Chicago, IL 60606

Illinois, Indiana, Michigan,
Minnesota, Ohio, Wisconsin

Region VI
1200 Main Tower Building, 11th
 Floor
Dallas, TX 75202

Arkansas, Louisiana, New
Mexico, Oklahoma, Texas

Region VII
601 East 12 Street
Kansas City, MO 64106

Iowa, Kansas, Missouri, Nebraska

Region VIII
Federal Office Building
1961 Stout Street
Denver, CO 80202

Colorado, Montana, North
Dakota, South Dakota, Utah,
Wyoming

Region IX
50 United Nations Plaza
San Francisco, CA 94102

Arizona, California, Guam,
Hawaii, Nevada, American
Samoa, Trust Territories of
Pacific Islands

Region X
Arcade Plaza Building
1321 Second Avenue
Seattle, WA 98101

Alaska, Idaho, Oregon,
Washington

Appendix VI

Acronyms

AAE	Alliance for Arts Education
AAFRC	American Association of Fund-Raising Counsel, Inc.
AAM	American Association of Museums
ACA	American Council for the Arts (formerly Associated Councils of the Arts)
ACC	American Crafts Council
ACUCAA	Association of College, University, and Community Arts Administrators
AFI	American Film Institute
AHP	Arts and Humanities Program
AHS	Arts and Humanities Staff
AIVF	Association of Independent Video and Filmmakers, Inc.
ARIS	Academic Research Information System
ASOL	American Symphony Orchestra League
BCA	Business Committee for the Arts
CAA	College Art Association of America
CAA	Community Action Agencies
CART	Community Arts Residency Training
CDC	Community Development Corporations
CEN	Central Educational Network
CETA	Comprehensive Employment and Training Act
CFDA	*Catalog of Federal Domestic Assistance*

COSERV	National Council for Community Services to International Visitors
CPB	Corporation for Public Broadcasting
CSA	Community Services Administration
CSG	Community Service Grants
CULTURE	Creative Use of Leisure Time Under Restrictive Environments
EDA	Economic Development Administration
EEN	Eastern Educational Television Network
EIN	Employer Identification Number
ESAA	Emergency School Aid Act
ESAA-TV	Emergency School Aid Act, Educational Television
FAPRS	Federal Assistance Program Retrieval System
FR	*Federal Register*
FTP	Federal Theatre Project
FY	Fiscal Year
HEW	Department of Health, Education, and Welfare
HUD	Department of Housing and Urban Development
ICA	International Communications Agency
IMS	Institute of Museum Services
IRS	Internal Revenue Service
LEA	Local Education Agency
LEAA	Law Enforcement Assistance Administration
MFRC	Management and Fund Raising Center
MN	Pacific Mountain Network
NACAA	National Assembly of Community Arts Agencies
NAPNOC	Neighborhood Arts Programs National Organizing Committee
NASAA	National Assembly of State Arts Agencies
NCAH	National Committee, Arts for the Handicapped
NCFA	National Collection of Fine Arts
NEA	National Endowment for the Arts
NEH	National Endowment for the Humanities
NFAH	National Foundation on the Arts and the Humanities
NPR	National Public Radio
NTIA	National Telecommunications and Information Administration

OE	Office of Education
OED	Office of Economic Development
OIAA	Office of Inter-American Affairs
OMBE	Office of Minority Business Enterprise
PATH	Port Authority Trans-Hudson Corporation
PBS	Public Broadcasting Service
PHS	Public Health Service
SAF	Southern Arts Federation
SEA	State Education Agency
SECA	Southern Educational Communications Association
SFCP	Special Foreign Currency Program
SMU	Southern Methodist University
SOS	Senior Opportunities and Services
SYRP	Summer Youth Recreation Program
USIA	U.S. Information Agency
VLA	Volunteer Lawyers for the Arts
VUCG	Volunteer Urban Consulting Group, Inc.
WIAL	Washington International Arts Letter
WPA	Works Progress Administration

Index